The Creative Arts

A Process Approach for Teachers and Children

FOURTH EDITION

Linda Carol Edwards

College of Charleston
Charleston, South Carolina

PEARSON

Merrill
Prentice Hall

Upper Saddle River, New Jersey,
Columbus, Ohio

Library of Congress Cataloging-in-Publication Data
Edwards, Linda Carol.
 The creative arts : a process approach for teachers and children / Linda Carol Edwards.—
4th ed.
 p. cm.
 Includes bibliographical references (p.) and index.
 ISBN 0-13-170028-6
 1. Arts—Study and teaching (Preschool) 2. Early childhood education. I. Title.

LB1140.5.A7E396 2006
372.5′044—dc22 2005045912

Vice President and Publisher: Jeffery W. Johnston
Publisher: Kevin Davis
Editor: Julie Peters
Editorial Assistant: Michelle Girgis
Production Editor: Sheryl Langner
Production Coordination: Linda Zuk, WordCrafters Editorial Services, Inc.
Design Coordinator: Diane Lorenzo
Photo Coordinator: Monica Merkel
Cover Designer: Bryan Huber
Cover Image: Corbis
Production Manager: Laura Messerly
Director of Marketing: Ann Castel Davis
Marketing Manager: Amy Judd
Marketing Services Manager: Brian Mounts

This book was set in Galliard by Carlisle Communications, Ltd. It was printed and bound by Courier Stoughton, Inc.
The cover was printed by Phoenix Color Corp.

Photo Credits: Art Brewer/Getty Images Inc. – Stone Allstock, p. 138; Linda Carol Edwards, p. 116 (bottom); David Herbert, p. 1; Cavas Gobhai, p. 29; David Mager/Pearson Learning Photo Studio, p. 35; Pam Seabrook Ohlandt, pp. 4, 11 (top), 12, 30, 49, 54, 59, 65, 79, 81, 83, 86, 97, 98, 103, 108, 112, 116, 122, 125, 142, 144, 149, 154, 155, 168, 170, 172, 174, 187, 193, 194, 199, 203, 214, 220, 229, 231, 235, 250, 254, 255, 256, 265, 269, 272, 273, 278, 310; Maria Mansfield Richardson, p. 8; Anne Vega/Merrill, pp. 281, 283; Mary White, p. 163

Pearson Prentice Hall™ is a trademark of Pearson Education, Inc.
Pearson® is a registered trademark of Pearson plc
Prentice Hall® is a registered trademark of Pearson Education, Inc.
Merrill® is a registered trademark of Pearson Education, Inc.

Pearson Education Ltd. Pearson Education Australia PTY, Limited
Pearson Education Singapore, Pte. Ltd. Pearson Education North Asia Ltd.
Pearson Education Canada, Ltd. Pearson Educación de Mexico, S.A. de C.V.
Pearson Education—Japan Pearson Education Malaysia, Pte. Ltd.

10 9 8 7 6 5 4 3 2 1
ISBN 0-13-170028-6

To Sara J. Burton

who worked patiently and effectively with me throughout the year I spent researching, writing, and revising the fourth edition. Her attention to detail, her sensitivity to my approach, and her commitment to professionalism have greatly enhanced this book.

To my students

and practitioners everywhere who devote their professional lives to the advancement of the artistic and creative process in early childhood. Over the years they have taught me a great deal about creativity and the arts, and this book reflects their contributions.

All the words I utter
And all the words I write
Must spread out their wings untiring,
And never rest in their flight, . . .

From "Where My Books Go" by W. B. Yeats

Educator Learning Center: An Invaluable Online Resource

Merrill Education and the Association for Supervision and Curriculum Development (ASCD) invite you to take advantage of a new online resource, one that provides access to the top research and proven strategies associated with ASCD and Merrill—the Educator Learning Center. At **www.educatorlearningcenter. com,** you will find resources that will enhance your students' understanding of course topics and of current educational issues, in addition to being invaluable for further research.

How the Educator Learning Center Will Help Your Students Become Better Teachers

With the combined resources of Merrill Education and ASCD, you and your students will find a wealth of tools and materials to better prepare them for the classroom.

Research

◆ More than 600 articles from the ASCD journal *Educational Leadership* discuss everyday issues faced by practicing teachers.
◆ A direct link on the site to Research Navigator™ gives students access to many of the leading education journals, as well as extensive content detailing the research process.
◆ Excerpts from Merrill Education texts give your students insights on important topics of instructional methods, diverse populations, assessment, classroom management, technology, and refining classroom practice.

Classroom Practice

◆ Hundreds of lesson plans and teaching strategies are categorized by content area and age range.
◆ Case studies and classroom video footage provide virtual field experience for student reflection.
◆ Computer simulations and other electronic tools keep your students abreast of today's classrooms and current technologies.

Look into the Value of Educator Learning Center Yourself

A four-month subscription to Educator Learning Center is $25 but is **FREE** when packaged with any Merrill Education text. In order for your students to have access to this site, you must use this special value-pack ISBN number **WHEN** placing your textbook order with the bookstore: 0-13-197195-6. Your students will then receive a copy of the text packaged with a free ASC pincode. To preview the value of this website to you and your students, please go to **www.educatorlearningcenter.com** and click on "Demo."

Discover the Early Childhood Education Website Accompanying This Book

The Merrill Education Early Childhood Resources Website: A Virtual Learning Environment

Technology is a constantly growing and changing aspect of our field that is creating a need for content and resources. To address this emerging need, Merrill Education has developed an online learning environment for students and professors alike—Early Childhood Education Websites—to support our textbooks.

In creating an Early Childhood Education Website, our goal is to build on and enhance what the textbook already offers. For this reason, the content for each user-friendly website is organized by topic and provides the professor and student with a variety of meaningful resources. Common features of an Early Childhood Education Website include:

For the Professor—

Every Early Childhood Education Website integrates **Syllabus Manager™,** an online syllabus creation and management utility.

- **Syllabus Manager™** provides you, the instructor, with an easy, step-by-step process to create and revise syllabi, with direct links into Early Childhood Education Website and other online content without having to learn HTML.
- Students may logon to your syllabus during any study session. All they need to know is the web address for the Early Childhood Education Website and the password you've assigned to your syllabus.
- After you have created a syllabus using **Syllabus Manager™,** students may enter the syllabus for their course section from any point in the Early Childhood Education Website.
- Clicking on a date, the student is shown the list of activities for the assignment. The activities for each assignment are linked directly to actual content, saving time for students.
- Adding assignments consists of clicking on the desired due date, then filling in the details of the assignment—name of the assignment, instructions, and whether or not it is a one-time or repeating assignment.
- In addition, links to other activities can be created easily. If the activity is online, a URL can be entered in the space provided, and it will be linked automatically in the final syllabus.

◆ Your completed syllabus is hosted on our servers, allowing convenient updates from any computer on the Internet. Changes you make to your syllabus are immediately available to your students at their next logon.

For the Student—

◆ **Introduction**—General information about the topic and how it will be covered in the website.
◆ **Web Links**—A variety of websites related to topic areas.
◆ **Timely Articles**—Links to online articles that enable you to become more aware of important issues in early childhood.
◆ **Learn by Doing**—Put concepts into action, participate in activities, examine strategies, and more.
◆ **Visit a School**—Visit a school's website to see concepts, theories, and strategies in action.
◆ **For Teachers/Practitioners**—Access information you will need to know as an educator, including information on materials, activities, and lessons.
◆ **Observation Tools**—A collection of checklists and forms to print and use when observing and assessing children's development.
◆ **Current Policies and Standards**—Find out the latest early childhood policies from the government and various organizations, and view state, federal, and curriculum standards.
◆ **Resources and Organizations**—Discover tools to help you plan your classroom or center and organizations to provide current information and standards for each topic.
◆ **Electronic Bluebook**—Paperless method of completing homework or essays assigned by a professor. Finished work can be sent to the professor via email.
◆ **Message Board**—Virtual bulletin board to post and respond to questions and comments from a national audience.

To take advantage of these resources, please visit Merrill Education's *Early Childhood Education Resources* Website. Go to **www.prenhall.com/edwards,** click on the book cover, and then click on "Enter" at the bottom of the next screen.

Preface

The creative arts are our universal language—the language of our imagination, of musicians and dancers, painters and sculptors, storytellers and poets. They are the rhythmic language of the dancing five-year-old using her body to re-create the graceful movements of a swimming dolphin. The creative arts are the silent language of the first grader who uses his imagination to go places he has never been—those faraway places that bring adventures beyond his daily routine. The language of the arts is revealed through the painters and sculptors who choose not to be restrained by convention as they represent their understanding of color, shape, and form in ways that are personally satisfying and pleasing. The creative arts are the language of children adding original dialogue and new ideas to a story line during the enactment of a familiar story.

The creative arts are one of the most revealing of all human activities. They are the ways we communicate the very essence of our aesthetic experiences—our powerful, essential, and lasting ways of bringing beauty into our world. The arts are never dry, boring, or mundane. They provide a pathway for people of all ages to reach into new unfoldings and understandings of themselves. Imagery, music and movement, the visual arts, creative drama, sculpture, and literature broaden and enrich our lives by enabling each person, whether 6 or 96 years old, to express feelings and ideas in a multitude of ways and through many different forms and modes of expression.

When I wrote the third edition of this text more than four years ago, I sought to convey the importance of the process of creativity in the arts and to broaden our understanding of how teachers acquire knowledge and skills when actively engaged in the creative arts process. I also emphasized that it is the human being, not the art activity, that should be at the center of the experience. My objective remains unchanged.

This new edition presents a comprehensive and up-to-date survey of professional research, while continuing to provide links between theory and practice. The approach is one of nudging teachers to attend to the importance of research and contemporary thought regarding the arts. At the same time, the narrative frames complex theoretical ideas in ways that are meaningful and significant to the adult who has chosen teaching as a profession.

Throughout the book I use the word *teacher* to describe the adult who is charged with the care and well-being of children. When I refer to teachers, I am including the preservice college student enrolled in a teacher education program, the student teacher embarking on a teaching career, practicing teachers, master teachers, college professors, and other professionals who are dedicated to enriching the lives of children.

The teacher is essential in helping children find venues for creative expression and growth, and once teachers tap into their own creativity, they are better equipped to assist children with creative expression that is appropriate to their own developmental potentials. What this edition does, then, is move the teacher away from a reliance on prescribed activities and an endless array of uniform products toward a more secure sense of everyone's ability to engage in the creative process—regardless of product. And how do we accomplish this?

The overall framework through which this information is presented follows the continuum of the affective domain—a developmental framework that moves you along on your journey to becoming a teacher or to becoming a more enlightened and articulate experienced teacher. As you move through the chapters and the continuum, you will progress from the basic, first levels of affective development to the highest. Your awareness of your growth through these levels will heighten your sense of your own creative abilities and those of your students. The organization and structure of the book, in addition to features in the chapters that support the development of creativity, will also contribute to your learning and growth.

Organization and Structure

Chapter 1 of the text presents four statements summarizing the central themes and ideas about the creative arts that are woven throughout the book. Chapter 2 addresses the process involved in being creative. Chapters 3 through 8 are organized into specific categories of the creative arts: exploring feelings and images, introducing music and movement, celebrating the visual arts, encouraging play and creative drama, experimenting with three-dimensional art, and planning for literature. Chapter 9 considers two topics of general importance to all teachers: building a bridge between self-understanding and creativity, and the process toward the self-actualization of teachers.

Vignettes

Each chapter begins with a true story, collected from my own years as a teacher and from the experiences of practicing teachers and student teachers. These stories set the stage for each chapter and highlight children's involvement in the creative arts process in real-life settings. These glimpses into the creative activity of children can serve as discussion starters for introducing, overviewing, concluding, or reviewing concepts, and they provide a wide range of experiences to observe and to reflect on.

Special Content Coverage

Many chapters also present, in separate sections, overviews of four important components of the learning environments in today's classrooms: developmentally appropriate practice, children with special needs, personal and professional growth of teachers, and viewing the arts through a multicultural context.

◆ The sections on *Developmentally Appropriate Practice* present concrete experiences and ways to maintain practice appropriate to the developmental levels of children.

◆ Sections about *Students with Special Needs* discuss how to provide creative arts experiences for all the children in your classroom.

◆ The *Personal and Professional Growth* feature in each chapter includes experiential exercises that relate to your personal and professional experiences and enable you to understand creative arts concepts as they relate to your personal life.

◆ Each chapter also includes an expanded discussion of Gardner's multiple intelligences theory as well as coverage of global art, which introduces you and your children to the richness of the arts found around the world.

Appendixes

Appendixes on children's literature, songs, fingerplays, and guided imagery provide a ready resource for hands-on creative arts experiences for teachers and children. These resources offer a quick reference for locating materials for use in classrooms; many are mentioned throughout the book.

References

More than 300 references to the professional literature are cited in the book, and a complete list appears at the end of the text. This reference list provides a compendium of recent research and up-to-date work in the field of the creative arts. More than 90 new citations have been added to this fourth edition, which reflect the expansion of the base of theory and research that supports the creative arts.

New to This Edition

Many changes and major revisions to the fourth edition provide a comprehensive look at the creative arts and how the arts can expand our understanding of the teaching and learning process.

A Family's Role in Developing Creative Arts at Home

Each content chapter contains strategies for encouraging family involvement in the creative arts. These process-oriented activities are appropriate for caregivers and children and are written with the home environment in mind.

The Literature Connection

Children's literature is a wonderful resource for learning about the arts and creativity. Each chapter includes recommended children's books that teachers can use to enhance children's experiences in the creative arts and provide a literature connection to the

content of the chapter. An annotation is included so the teacher can select books *about* the arts to read while children are participating *in* the arts process.

Integrating the National Standards for Visual and Performing Arts Education

These sections provide in-depth coverage on why we must look to these standards as challenges for bringing the arts back into the mainstream of the curriculum. This edition focuses, in an appropriate way, on the National Standards for Music Education, Dance Education, Theater Education, and the National Standards for Arts Education. Also provided, through examples, are ways in which we as teachers and teacher educators can make interconnections between the content-specific standards in the arts and the other content areas of the early childhood curriculum.

Children's Drawings and Paintings

Included in this edition are visual images of children's work. These images are included as examples of the various stages of a child's creative development. All of the drawings and paintings were gifts from the children at the Miles Early Childhood Development Center at the College of Charleston.

The Creative Arts as Viewed Through a Multicultural Context

The arts are ideally suited to address the wonderful diversity of children in today's schools. The arts provide teachers with a multicultural avenue for seeing diversity from viewpoints that may be different from our own. The multicultural coverage in this fourth edition is expanded through both content and examples that deepen the multicultural coverage. This focus on viewing the arts through a multicultural context is included to highlight its great potential as a resource for creative expression and awareness of the diversity of global arts.

Quotations

The powerful words of philosophers, musicians, dancers, artists, writers, and actors throughout this edition promote new ways of thinking about the arts. Some quotations are presented to provoke serious thought, while others use humor to convey a message. All provide inspiration to teachers for including creative arts education in the lives of young children.

Contemporary Theories and Models

This fourth edition is made more comprehensive through expanded coverage of Lev Vygotsky and Parson's theory of aesthetic development. Vygotsky's work provides a foundation for understanding the social formation of learning. Parson's theory is noteworthy in that he presents us with a systematic way of viewing aesthetic

awareness and development in the arts. His theory is particularly relevant to the aesthetic sections in the National Standards for Arts Education.

Multiple Intelligences Theory

Since the publication of the third edition, Howard Gardner has expanded his theory of multiple intelligences to include naturalist intelligence, and most recently he presents evidence for a possible existential intelligence. Gardner's multiple intelligences theory provides a framework for approaching multiple intelligences and the implications of this theory for creative arts education. Each chapter also presents an area of multiple intelligences theory in concert with creative arts contents. For example, the chapter on creative drama is grounded in interpersonal and interpersonal intelligences.

Research

More than ever before, research studies and theoretical contributions provide a comprehensive view of why the arts are an integral component of education for all learners, especially children. To accurately reflect this growth, current and relevant research is included in this new edition to provide the foundation for continued study of the arts. Practical articles and references to which teachers can refer for additional information are also provided.

Margin Notes

The book also supports your learning through the use of margin notes that provide suggestions and alternative ways for reinforcing and enriching your learning. These notes are particularly helpful for outside assignments; extended research; classroom arrangement; individual, cooperative, and large-group activities; and as suggestions for establishing professional contacts with artists outside the field of education.

I hope you will find this fourth edition of *The Creative Arts: A Process Approach for Teachers and Children* an informative and challenging approach to your role as a facilitator of the creative arts process in your own child-centered school arena. Those new to teaching will find avenues for structuring their first classroom environment to create an inviting atmosphere in which the children will have not only the freedom but also the permission to explore the process of creativity through many art forms. Experienced teachers will find the courage to break away from the old confines of having all children draw, make, move, or create the same thing at the same time. They will be encouraged to view the arts as an orchestral score, with much room for interpretation. This view of the creative arts provides an endless range for educators to contribute to the development of each child's inherent artistic potential. Whether we are aspiring teachers, seasoned educators, early care and education providers, or college professors, we need to be open to examining a significant departure from the way creative arts are typically taught in teacher education programs, and we need to recognize the role of the adult in facilitating children's development as artists and as creative thinkers.

Acknowledgments

Many people inspired me as I was writing the fourth edition, and it has been enhanced by the combined efforts of a talented team of professionals at Merrill/Prentice Hall. Julie Peters, my editor, provided thoughtful support and encouragement. I am deeply indebted to Julie for her insight and foresight, her enthusiasm, and her faith in my writing and in this book.

I am very grateful to have worked with Linda Zuk and WordCrafters. Linda provided guidance and personal support when I needed it most. Every author should be fortunate to have Linda on her team. This fourth edition was greatly enhanced by the talent and creativity of Sheryl Langner, who understood the importance of this edition and who made the publication possible. Kathy Kirkland is acknowledged for her creative artistry in selecting the wonderful photographs that illustrate the book. I am also grateful for Karen Winget for her skill at indexing, Amy Gehl for keeping the production flowing smoothly, and Lori Junk for creating the magic wand icon and pulling together all the other icons and the page design. These women represent the finest example of professionalism. The text design and the expertise of all the production and editorial staff at Merrill/Prentice Hall and WordCrafters are apparent in the book's presentation and appearance.

I was also fortunate to have the professional suggestions of my friend Margaret W. Humphreys, former Director of the Miles Early Childhood Development Center (ECDC), College of Charleston, and the talented teachers at the ECDC, including Phyllis Gates, Pam Ohlandt, and Mary White, who shared their stories of children with me. I am also thankful to Richard Latham, who provided the wonderful examples of children's art. I owe a debt of gratitude to Susan Gurganus, the College of Charleston, for her important contributions to the sections on children with special needs. In addition, a very special first-grade teacher, Jane Schuler, is acknowledged and thanked for the illustrations she drew for the sections on Multicultural Arts in Context.

I would like to express my sincere appreciation to the following professors, who provided timely and helpful reviews of the manuscript: Elaine Clift Gore, Georgia Southern University; Linda Huber, Ball State University; Bryna Rifkind, San Francisco State University; and Cheryl Wright, University of Utah.

I appreciate and wish to acknowledge the support of friends and colleagues who provided guidance with grace during the writing process: Cavas Gobhai, Jane Schuler, Annette Godow, Martha Nabors, and Helen Gorini. I also owe a great deal of thanks to Rebecca Isbell and Karen Paciorek for providing collegial and personal support. I am grateful for the assistance provided by graduate assistant Sara J. Burton. I feel honored to have had the opportunity to collaborate with her.

Finally, I wish to express my deepest appreciation to my students. I am especially thankful for their encouragement and support. They all recognize the importance of their roles in providing the very best, high-quality creative arts programs that support children's early learning. These students are the future of the arts in early childhood education.

Linda Carol Edwards

Brief Contents

Contents

chapter 4 Introducing Music and Movement 98

chapter 5 Celebrating the Visual Arts 149

Note: Every effort has been made to provide accurate and current Internet information in this book. However, the Internet and information posted on it are constantly changing, so it is inevitable that some of the Internet addresses listed in this textbook will change.

About the Author

Linda Carol Edwards is a professor of Early Childhood in the School of Education at the College of Charleston, Charleston, South Carolina, where she teaches both graduate and undergraduate courses in the visual and performing arts. Her degrees include a BA from Pembroke State University, and an MEd and EdD from the University of Massachusetts at Amherst. Before moving to the college level, she taught kindergarten for 12 years in the public schools of North Carolina.

Dr. Edwards is the author of *Music: A Way of Life for the Young Child*, Fifth Edition (Merrill/Prentice Hall). She has been published in *Young Children, Science and Children, Journal of Early Education and Family Review, Dimensions in Early Childhood,* and the *Kappa Delta Pi Record*. She also serves on the advisory board of *Annual Editions: Early Childhood Education*. In addition, Dr. Edwards's experience has enabled her to create graduate programs in early childhood education that have received NCATE/NAEYC approval.

As an advocate for arts education for young children, she takes the opportunity to present at local, state, and national conferences about the importance of the visual and performing arts in the lives of young children.

chapter 1

Beginning the Journey

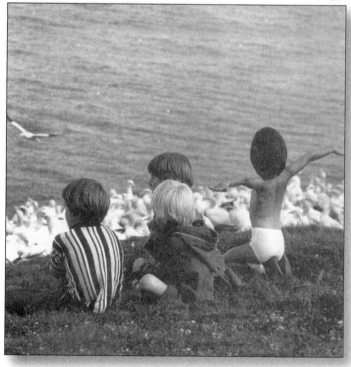

There are five essential elements which are needed for any society to survive and thrive: Truth, Beauty, Adventure, Art, and Peace.

Godfrey, 1992

*L*ien captures her favorite activity, "swimming in the ocean," by moving her paint-filled brush across the flat surface of the paper. A few days later, she creates an ocean and a dolphin from a formless lump of clay. When her teacher tells the class that they are listening to a recording of George Frideric Handel's "Water Music," this same five-year-old moves about the room leaping and diving. She explains to her teacher that she is a dolphin swimming alongside a sailboat, splashing water on the people aboard. In each case, she is using the visual and performing arts to explore ways of expressing her feelings and sensory experiences in tangible, symbolic form. This child is making a conscious effort to arrange colors and shapes, sounds and movement, and other sensory phenomena to communicate her ideas and feelings about herself and what she knows about the world.

Children need to express themselves and to communicate with others. They fulfill these needs most effectively through personal expression, creative exploration, and action. The visual and performing arts provide concrete experiences in which children may encounter and interact with the world in ways that are unique and special to them. Young children, in particular, are drawn to the arts because "messing about" with creative arts materials is both natural and satisfying. Children represent their thoughts and feelings as they become involved in the sensory pleasures of painting a picture, molding clay into shapes, or listening to sounds that tap into their inner thoughts and feelings. This process encourages exploration and the interpretation of what they know about the world. Children need to explore all of their senses and discover what they can do with them. It is through the process of exploring the arts that they build a rich storehouse of ways to state what they need to say. The primary importance of these experiences is their meaning for the child. These experiences have increased power and significance when their message is shared with and accepted by others as a means of communication.

One of the most significant needs of all human beings is a feeling of positive self-worth. Young children are just beginning to learn about the world, and because they are still amateurs, they make mistakes, they get confused, and they do not always get things just right. They need a positive reaction from the adults around them, and they need to be recognized for their own individual value. The creative arts process is wonderfully inviting to young children because the process does not require that they "know" how to create representational art forms or that they understand the specialized techniques involved in ballet. In creative and artistic expression for young children, there is no one correct response and no right or wrong way to re-create swimming with dolphins or any other creative means of expression they might pursue. The creative and artistic process

For the most intimate, most profoundly moving universal experiences we needed a more subtle, more sensitive set of symbols than the written and spoken word. And this richer language we call the arts.

Ernest L. Boyer

is a safe way for young children to try out, explore, experiment, and learn about the most important thing. . . themselves. Experiences that enable children to express themselves through the arts nurture their inner life. When children feel a sense of accomplishment and self-confidence through artistic exploration, they experience feelings of personal satisfaction and positive self-image. Nurturing the arts in the early childhood classroom should be considered essential simply because of the richness it brings to children's lives.

Setting the Stage

Appropriate experiences in the creative arts for young children depend in part on the knowledge each teacher brings to the encounter. Although most teachers of young children acknowledge the creative arts as a legitimate and essential component of the curriculum, many still rely on product-oriented activities rather than valuing the process of making art. What are and what are not creative arts for young children, and what can we do to ensure that our young children truly experience the creative arts process when they are involved in the arts?

I invite you to take a look at several classrooms. Too often we forget what it is like to let children's imaginations take flight. Children's imaginations soar automatically; unfortunately, many of us have been "educated out" of being creative and imaginative. Challenge your imagination to find your own pictures for the following early childhood classrooms.

The Toddler Room with the Yellow Door

We are in one of the toddler rooms at a local preschool. The teacher has placed several containers of finger paint in the art center, along with large sheets of paper and smocks. During center time, and after a very brief introduction to painting with fingers, the center is available to any children who decide to use the material. The teacher observes as several toddlers begin to become intimately involved with the finger paint. As they taste it, their expressions reveal that these children have discovered that finger paint does not taste very good. Most of the children begin touching the paint with one finger, then two fingers, and then with the full senses. Before long other toddlers join in the fun, and the art center is alive with paint, new color creations, and happy two-year-olds.

The Toddler Room with the Blue Door

In the toddler room across the hall, the teacher has been reading the story of *Frederick* by Leo Lionni to the children. Frederick, as you may recall, is a little mouse that uses his imagination to gather sunshine and colors when all the other mice are gathering grain and corn. The mice are gathering things that they will need for the upcoming winter. The teacher and the assistant are passing out colored paper cut into pink and brown circles. Each child also gets a small paper cup and a small container of white glue. The teacher shows the children a mouse that she made by gluing the

Creativity is feeling free to be flexible and original, to express one's own ideas in one's own way.

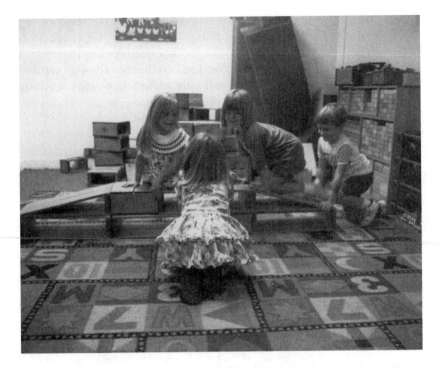

colored circles onto the paper cup. Then she demonstrates the step-by-step process by which she made her mouse. The assistant shows the children the mouse that she made and tells the children that they, too, can use the circles and cups to make a mouse just like hers and the teacher's. She encourages the children to look carefully at the two little mice and then moves about giving guidance and directions. When several of the toddlers have difficulty getting the circles in the right place on the cup, the teacher and assistant finish the project for them.

The Kindergarten

The teacher and the children are rehearsing for a play that they will present at the upcoming parent/teacher meeting. The children have been practicing for weeks, and this is the final rehearsal before the big performance. Having memorized all of the lines from one of their favorite stories, they are ready to present *The Three Billy Goats Gruff* to their parents. The dress rehearsal begins, the curtain rises, and these five-year-olds give a perfect performance, complete with correct dialogue, staging, and costumes.

The Block Room

Next, we go into the block room. We see another group of five-year-olds building a bridge with hardwood blocks. As we listen more closely, we hear the children repeating the words "tramp, tramp, tramp" as they parade up and down their makeshift bridge. Their teacher moves closer to the group and tells them that they

sound like the goats in *The Three Billy Goats Gruff.* With that suggestion, one child crawls under the bridge, and the next words we hear are "Who's that tramping across my bridge?" Another child picks up a small rug and says, "Hey, this will be the meadow." The play continues for the next 20 minutes, during which time the story line is changed several times. At one point the smallest billy goat starts describing how he and his friends can trick the troll with cake and ice cream!

Appropriate or Inappropriate Practice

Think about the first two rooms—the toddler room with the finger-paint activity and the toddler room where children are making a mouse. In the finger-paint activity the children were invited to experiment with finger paint. They had a choice to explore this new art material or to go to a center of their own choosing. Those who decided to go to the art center had the freedom to experience the properties of finger paint; to organize the paint in ways that expressed a thought, experience, or idea; or to simply use the finger paint to find pleasure in using their fingers, hands, or elbows to move the paint all over the paper. They may even end up with a product. This activity enables the children to be involved in a process during which creative impulses can take shape. The teacher has opened the door for these children to become absorbed in what the process has to offer rather than in how their products will look at the end of the activity. The children have been given permission to respond to internal rather than externally imposed criteria. They are working with the art materials in ways that challenge their ideas rather than following step-by-step procedures to represent the teacher's thoughts and ideas.

In the mouse-making activity the creative process is, at best, questionable. The children are responding to a dictated, step-by-step procedure that expresses the ideas of the teacher, or more likely, those of a recipe in a crafts book, not their own childlike ideas of how they can glue shapes to cups to make something they have imagined. Step-by-step procedures that lead children toward a model finished product may help children learn to sequence or follow directions, but we cannot call that art, nor can it be considered a creative process. Having 18 or 20 cup-and-paper mice that the teacher probably had to finish anyway may give the children something to take home at the end of the day, but projects of this type are really not much better than coloring ditto sheets. Children soon learn to accept the myth that they can never make, in this case, a mouse as "good" as the teacher's.

The five-year-olds in the block room are tramp, tramp, tramping over the block bridge and grazing on a rug meadow. These children are involved in dramatic play, which is appropriate for young children. Dramatic play must not be confused with creative drama. McCaslin (2000) defines both terms. She describes dramatic play as the

> free play of the very young child in which he explores his universe, imitating the actions and character traits of those around him. . . it has no beginning and no end, and no development in the dramatic sense. Creative drama is more structured. It may make use of a story with a beginning, middle, and an end. . . . It is, however, always improvised drama. (p. 6)

What have these children (and their teacher) created out of hardwood blocks, an old rug, and the process approach to creating art? They made their bridge, a

child suggested that they use the rug for the meadow, and now they are about to embark on the serious business of interpreting the story in ways that have meaning and purpose to them. As this process continues, new dialogue evolves and adds a different dimension to the story line; new characters appear; some parts of the story are omitted; and a new, more interesting plot develops. These children are involved in a process of self-expression that facilitates movement, gesture, language, communication, flexible thinking, new approaches to an old idea, original ways of approaching the story line, and elaboration of original ideas. The play is child initiated and encouraged by a well planned, creative environment. This is the process of developing the ability to think creatively. This is also the performing arts at their best.

As for the children involved in the dress rehearsal, this is a good example of the product approach. Expecting young children to memorize words and actions and then rigorously follow them is not the way to encourage the development of creative thinking. In addition, it gives children the clear message that the teacher's way is the right way, and the only way, to interpret the story. Who is to say that the troll cannot be tricked into submission with cake and ice cream? Children are the most natural and creative creatures on Earth, and when we set the stage in ways that are meaningful and appropriate, we open yet another window through which children can nurture what is already an innate gift. Let's look at a situation in which a child takes her creative expression one step further.

Isabella: Extending the Stage

Six-year-old Isabella's favorite fingerplay is "Little Cabin in the Woods." She uses the power of her imagination, her feeling states, and her motor ability to make her own little rabbit for performing the fingerplay. She is not imitating her teacher or her peers; she creates her own version of a little rabbit in ways that please her perfectly. Now, when Isabella does *her* "Little Cabin in the Woods," what else is happening? Her actions could be viewed as an accomplishment in rote memorization that would satisfy one of the core objectives for first-grade children, or she could be showing us much more important aspects of development. In particular, she is not confined to the formal memorization tasks experienced by the five-year-old billy goats during their dress rehearsal.

When she is involved in this fingerplay, Isabella is using her imagination, her problem-solving skills, her knowledge of the world, and her feelings to show how her little rabbit looks, hops, experiences fear, and resolves a dilemma. Finally, Isabella decides what she will do to take care of and comfort her little rabbit. She is giving order and structure to her thoughts. She is clarifying concepts such as fear, safety, and security. She is gaining an understanding of how the little rabbit used reasoning and logic to get out of a somewhat frightening situation. And she is doing all of this creatively.

The last line of the fingerplay is "safely you'll abide." When Isabella and her friends were playing in the housekeeping center, their teacher, Miss Pepita, noticed that they were moving blocks from the block center into the housekeeping center. They were using the small hardwood blocks to make very small beds. The children then repeated the fingerplay, rocking the little imaginary rabbits, gathering imagi-

nary blankets, and kissing the rabbits good night. After "little rabbit come inside," they sang instead, "safely on your side." Miss Pepita observed perceptively that, although the children had changed the words, the mood, feeling, and affect were the same. These children were nurturing and taking tender care of an imaginary rabbit. They had simply substituted "safely on your side" for the more abstract and complicated vocabulary of "safely you'll abide." Just think about the language skills Isabella is developing. She substituted familiar vocabulary, and did it in context, for a word she did not understand! She interpreted the song based on her own experiences and knowledge of reality. This probably would not have occurred had she been forced to memorize her "lines" for a performance.

The Creative Arts: A Process Approach for Teachers and Children, Fourth Edition, introduces a wide range of ways for looking at creative abilities, creative processes, the arts, and the role they play in creativity. As adults, we cannot *bring* experiences to children, nor can we make them meaningful or important. What we *can* do is provide the setting and invite children to create experiences that have meaning and importance to *them*. But this book is not just about children and your role as their teacher; it also focuses on the artistic, creative, and affective development of *you* as an adult and how you view your own artistic, creative, and affective potential and abilities.

Nature of the Book

This book is about children and adults. It is about children and the artistic, creative process, and it is also about you, the artistic and creative adult. The text is designed to stimulate personal reflection, self-exploration, and self-expression. *The Creative Arts,* Fourth Edition, invites you to engage in the processes of creativity so that you can better foster creative and artistic growth and participation in your own classroom. My goal is to enhance the creative and artistic abilities you bring to the experience, your perceptions, memories, feelings, concerns, attitudes, and values about the arts. The emphasis is on process, rather than product, as you learn how to tap into your own creativity. When you have found your own creative and artistic spark, you will be better equipped to help children engage in the creative process. The creative arts experiences you will encounter throughout the book may not make you into an accomplished artist, musician, actor, or dancer, but they will encourage you to move away from a reliance on prescribed activities and uniform, prescribed products. A process approach to exploring the creative arts will move you toward a more secure sense of your own ability to engage in the creative process—regardless of product.

A process-oriented approach to the visual and performing arts involves a heightened sensitivity and awareness of what you are doing while you are doing it. A product approach is more concerned with the final outcome or product than with the experience of creating. When we are concerned about how our art compares with that of others, we are focusing on product. When we experiment and discover new ways to work with art materials or think of a new and different way to move our bodies to a musical recording, we are focusing on process.

How successful we are at encouraging the creative process in children may depend in large part on our own experiences in the arts. I found the following quote especially insightful:

> I want to thank so many people, but especially my mother Brandy, who taught me that all my finger paints were Picassos and I didn't have to be afraid. (Jodie Foster's acceptance speech after winning her Academy Award for Best Actress, 1988)

Different people approach the creative arts in different ways, depending on what their particular experiences have been. The following section illustrates the differing perceptions developed in adults with different experiences.

Adult Development in the Arts

Several college students stand outside a classroom waiting for the first class of the course Creativity and the Arts to begin. They have heard through the department grapevine that they will be expected to paint and dance and write scripts for plays in which they will have to actually act out different parts. One or two of the students are genuinely excited about the possibilities for involvement in the arts, but there is a certain reserved panic on the part of most:

"I can't draw."
"I don't have a creative bone in my body."
"I couldn't carry a tune in a bucket."
"I am so clumsy, if she grades me on my dancing my G.P.A. is shot."

Begin thinking of creativity in terms of your own growth as well as the growth of the children in your care.

I AM CREATIVE

ALL OF THE STUDENTS IN MY CLASS ARE CREATIVE

Overall, their feelings range from reluctance and hesitancy to fear of being judged on their talent or lack thereof.

Is innate talent a prerequisite for being creative? The answer is an unequivocal no. *Creativity* is not a synonym for *talent*. Does a teacher have to be an actor to engage children in improvisation or a musician to bring meaningful musical experiences to children? Do you have to be an accomplished artist to express ideas through shaping a lump of clay? The answer, again, is no. Experiences that lead you to use your creative abilities when bringing the arts effectively to children can also lead *you* toward increased understanding of the nature of the arts and a heightened sensitivity to your own expressive and creative potential. You do not need to have great talent to be a creative person. However, you must be willing to take some risks, to try new ways of doing familiar things, to open yourself to the possibility of discovering something new about yourself, and to trust yourself enough to try.

> A teacher who has never gone through the process of creating in a specific art material may never understand the particular type of thinking that is necessary to work with clay, paint, or whatever. This means that the teacher must have been truly involved in creating with materials, not in dealing with them in an abstract way by reading or mechanically carrying out some project. The material and the expression should be as one. (Lowenfeld & Brittain, 1987, p. 62)

Lowenfeld and Brittain's words, although they may seem dated to some in the profession, have significant meaning for those of us embarking on a teaching career. If we do not have personal experiences with the arts, we really cannot understand how our children feel when they enter into the process. For that reason, and for more reasons discussed later, the creative arts encounters in this book are written to be experienced by you. They are carefully designed to encourage you to refresh or rekindle or maybe discover for the first time the importance that the arts and the creative process have had or can have on you, both professionally and personally. There are many activities in this book that emphasize the process rather than the product. As a result, your understanding of the creative process and the arts will take on new dimensions. Fears and the old notion that you need to be a "real" artist to bring the world of the arts to children will begin to disappear; excitement about working with arts materials and art ideas will emerge, and you will discover your own expressive and creative ways of entering this wonderful process. Alfred Balkin (1990) put it another way:

> Be it music, or art,
> or theater, or dance,
> Creativity hinges on
> taking a chance. (p. 31)

Let's take a chance together.

One easy way to begin getting comfortable with the idea of expressing creativity *yourself* is through an activity that comes naturally to most teachers: reading literature to children. To that end, several related pieces of literature are introduced in each chapter. The children's literature feature in this chapter is "Children's Literature and Creative Teachers." It presents books through which teachers encourage

Children's Literature and Creative Teachers

My Great-Aunt Arizona by Gloria Houston, HarperTrophy, 1997.

Arizona is a teacher who teaches generations of children in the same one-room school house that she attended. Arizona's quiet yet meaningful life reminds us of the magical place a special teacher can hold in our hearts.

The Art Lesson by Tommy dePaola, The Putnam & Grosset Group, 1989.

Tommy wants to be an artist when he grows up and is excited about meeting his first-grade art teacher. Then he finds out that she expects him to copy her pictures. This wonderful picture book is a shining example of one little boy's quest to fulfill his own ways of artistic expression.

Ruby the Copycat by Peggy Rathmann, Scholastic, 1997.

Ruby has a very perceptive teacher who helps her discover her own creative resources, which keep Ruby literally jumping for joy! This book is fun, expressive, character-oriented, and done in colorful pencil-and-ink drawings.

children to discover or express their own creativity. The children's literature features in other chapters focus on the specific content of the chapter. For example, in chapter 4 the literature focuses on children, teachers, and music.

Themes of the Book

This chapter introduces some central themes and ideas about the arts and the creative process that are woven throughout the text:

 ◆ The creative arts are essential to the intellectual, affective, social, and physical development of children and adults.
 ◆ An awareness of self and an acceptance of differences are facilitated by personal experiences in the creative arts.
 ◆ The creative arts encourage an awareness of the important role of the affective domain in the development of sensitivity, values, and perceptions of self and others.
 ◆ The integration of creative arts content with an emphasis on the affective development of teachers facilitates understanding of creative processing and heightens teacher sensitivity to the creative efforts of children.
 ◆ A culturally sensitive approach to introducing children to art from around the world helps young learners construct a worldview of cultural similarities and to valuing differences.

As these themes are developed and expanded, you will begin to see that the educational process outlined in this book is systematically and deliberately designed

Think of a course in creative arts education as a magic door opening to show the magnificent beauty of all the arts.

to facilitate a continuous interchange between the teacher, the student learning to become a teacher, and the child. We are all involved, no matter what our ages, our abilities, or our backgrounds, in a never-ending process of discovering our creative potential. Creative arts education continues throughout our life span, whether we are young children, experienced teachers, or students. Throughout our life span, we move continuously through remembered childhood experiences, the contrasting needs and demands of learning to teach young children, and the awareness of ourselves as creative teachers. The dynamics of these interchangeable roles, and the

Group sharing and reflection are an integral part of the process of artistic discovery.

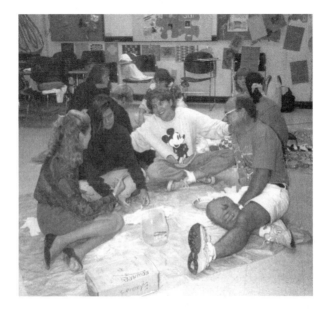

processes involved, require an awareness of the *élan vital,* the spirit whose very essence infuses the interplay balancing this triangle.

What Are the Arts?

Defining "the arts" sounds like an easy task: We all know what the arts are, we have an idea about what artists do, and we know what art looks like. However, providing a concrete definition of the visual and performing arts turns out to be far more involved than you might imagine.

For the scope of this book, the "arts" are defined as dance, drama, music, visual arts, and literature.

Dance: body awareness, fundamentals of movement, creative expression, multisensory integration

Drama: creative dramatics, pantomime, improvisation, characterization, play production

Music: sound, pitch, rhythm, singing, playing, musical games, listening, creative movement

Visual Arts: self-expression, visual and tactile art, print and craft media, analysis and interpretation

Literature: poetry, illustrations, writing, award-winning books, storytelling, reading, and speaking

Additional definitions of the varied components of the arts are aesthetic perception (impression), creative expression (interpretation in action), historical and cultural heritage (exposure to art from around the world), and aesthetic valuing

Children naturally combine movement, drama, and sound to interpret stories in ways that are right for them.

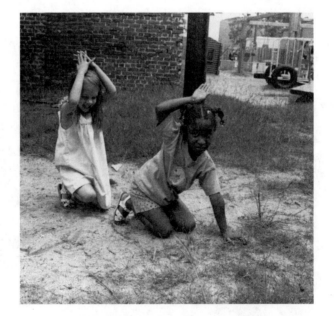

FIGURE 1–1 Components of the Arts

Aesthetic Perception	Creative Expression	Historical/ Cultural Heritage	Aesthetic Valuing
Impression	Interpretation in action	Exposure to art from around the world	Appreciation
All encompass a wide range of knowledge, concepts, and skills in the ARTS			
• Basic arts concepts and skills	• Factual or contextual learning about the arts in history and culture	• Higher-order or critical thinking skills to solve aesthetic problems and analyze works of arts	

(appreciation). Together, these aesthetic lenses encompass a wide range of knowledge, concepts, and skills in the arts, including basic arts concepts and skills, factual or contextual learning about the arts in history and culture, and higher-order or critical thinking skills required to solve aesthetic problems and analyze works of art (*Gaining the Arts Advantage: President's Committee on the Arts and the Humanities and Arts Education-Partnership*, 1999). Figure 1–1 presents a graphic overview and serves as a summary for this discussion.

NATIONAL STANDARDS FOR ARTS EDUCATION

In a policy statement written for *Arts Education Policy Review* (1996), Thomas A. Hatfield, Executive Director of the National Art Education Association, addresses basic questions in educational reform. He states, in part, that

> what is needed is a nationally coherent vision of what it means for all our students to become artistically literate. . . the phrase "all students" reflects the social commitment that standards apply to students regardless of background (gender, ethnicity, or economic condition); circumstances, or ambition. "National" means a nationwide agreement on what defines successful arts learning and the school practices that support that learning. (Hatfield, 1996)

A Brief Look at History

I believe that it is important at this point in your reading to present some coverage of recent historical events that have had an impact on arts education in general and the role of the arts in the schools in particular. As funding for the arts continues to dwindle and financial support for the arts seems to be at an all-time low, we will all be well advised

To obtain a copy of National Standards for Arts Education: What Every Young American Should Know and Be Able to Do in the Arts (ISBN 1-56545-036-1, MENC stock #1605), please contact Music Educators National Conference. (Contact information is provided at the end of the chapter 2.)

to be familiar with the changes that have occurred in arts education just in the past 10 years. With that said, the following section presents a very brief history of contemporary arts education and the people in power who have the most influence on the future of arts education in this country.

Throughout the nation, the vital role of arts education is being acknowledged. After its initial omission, the federal government has recognized the arts as one of the eight core subjects American students should be taught. In February 1994, the United States Congress passed the Goals 2000: Educate America Act, which finally gave the arts the status that Sir Herbert Read had demanded as long ago as 1926. In our lifetime, this status is being recognized! The Educate America Act states, among other goals, that "By the year 2000, all students will leave grades 4, 8, and 12 having demonstrated competency over challenging subject matter including English, mathematics, science, foreign languages, civics and government, economics, *arts,* history, and geography. . . " (Getty Newsletter, 1994–1995, p. 8).

In anticipation of this new law, the Consortium of National Arts Education Associations was formed to write voluntary national standards for what the outcome of arts education should be—that is, what students should know and be able to do in the arts at various grade levels. The professional arts education associations that comprise the Consortium—the American Alliance for Theatre and Education (AATE), Music Educators National Conference (MENC), National Art Education Association (NAEA), and National Dance Association (NDA)—have been active participants in reshaping the image of art as a "soft" subject and giving the arts their place in the curriculum along with mathematics, science, and languages. (Addresses for Consortium members are included at the end of this chapter.) Several initiatives set forth by these professional organizations include development of standards in the arts, supporting states in the creation of K–12 curriculum frameworks based on the national standards in the arts, and expanding the National Assessment of Education Progress (NAEP) to include the arts.

Less than a month after the passage of the Educate America Act, the Consortium presented the new standards to United States Secretary of Education Richard Riley. There were three sets of measurements for each art form, including

1. one for the end of the fourth grade,
2. another for the end of the eighth grade, and
3. a third for high school graduation.

In your local telephone book, find the listings for arts organizations in your community. Select a performance that sounds interesting to you, and make a date with someone in your class to attend the event.

The work of the Consortium was published as *National Standards for Arts Education: What Every Young American Should Know and Be Able to Do in the Arts* (1994). The standards stress that students should create art as well as become proficient in performing or producing in at least one art area, and they should have a basic understanding of the content of arts from the perspectives of history, culture, and aesthetics. The idea of having national standards and a systematic evaluation of children's accomplishments may sound like an impossibility to some. However, we can look to these standards as challenges for bringing the arts back into the mainstream of essential subject areas, and as teachers, we are in a unique position to do just that. In a 1994–1995 publication,

James M. Clarke, past president of the NAEA, reflected on the meaning of standards in the arts and challenged every school and each teacher to attend to the long-term implication of these national goals:

> [These standards] are intended to raise the quality of visual arts education, but they can do that only if they are adopted in every school. We know children will work to the level of expectation that is put before them, and the standards are a way of turning this to the student's long-range advantage. (Clarke, 1994–1995, p. 9)

In a report written by the President's Committee on the Arts and the Humanities, John Brademas, Chairman of the Committee, describes a vital cultural life as essential to a functioning democracy. In this document, *Creative America,* Brademas reflects the conviction that "a thriving culture is at the core of a vital society. . . the creative force of the arts and the humanities strengthens our democracy [and] unlocks the human potential for creativity and lifts us beyond our isolated individualism to shared understanding" (1997).

The interconnection between the arts, culture, and democracy is described by Benjamin Barber (1996), who believes that we

> share a dependency on one extraordinary human gift, imagination. Imagination is the key to diversity, to civil compassion and to commonality. The arts and humanities are civil society's driving engine, the key to its creativity, its diversity, its imagination and hence its spontaneousness and liberty. (p. 12)

So, what do decades of research tell us about how the arts contribute to this view of arts, society, and our shared humanity? We know

- that an arts education contributes significantly to improved critical thinking, problem posing, problem solving, and decision making;
- that, as with language and mathematics, the crux of an arts education involves the communication, manipulation, interpretation, and understanding of complex symbols;
- that developing fluency in artistic expression and understanding fosters higher-order thinking skills of analysis, synthesis, and evaluation;
- that the arts are multimodal, addressing and fostering the multiple intelligences of student (spatial abilities, for example, develop through drawing and sculpture, mathematical-logical abilities through producing and listening to music, kinesthetic or physical abilities through dance, interpersonal skills through drama);
- that the arts develop a person's imagination and judgment, permitting each individual, in Maxine Green's classic phrase, to create "as if" worlds, places where we see the world afresh (Cortines, 1997, p. 5).

Art is an important part of our common culture in that it—like the humanities—provides us with some of our most salient examples of the breadth and depth and complexity of human nature. And art, no less than philosophy or science, issues a challenge to the intellect.

William J. Bennett

This position represents only one of the many reasons that a commitment to the arts is essential in today's educational arena. However, if we listen to John W. Gardner, we begin to realize that

> every healthy society celebrates its values. They are expressed in the arts, in song, in ritual. They are stated explicitly in historical documents, in ceremonial

speeches, in textbooks. They are reflected in stories told around the campfire, in the legends kept alive by old folks, in the fables told to children. . . . Indeed, the Constitution, in addition to being an instrument of governance, is an expression of pledged values. (1996, p. 2)

The arts in education are an absolute necessity. If, in this day and time, we do not tap into the creative side of a young person's brain in every possible way, then we will not have the innovation and the economic and cultural growth experience that this country must have (Riley, 1998). In 1999 Richard Riley spoke to the National Assembly of Music Educators National Conference in Reston, Virginia, and gave a very personal and important message to those of us in the audience. He said, in part:

As a child, I took piano lessons for three or four years. I was not destined to become a great musician. But I know that, through music, children learn to reach for their very best. You have all witnessed the intensity with which children prepare for a recital. They practice and practice until they can play the piece without errors. Imagine if, when they are a few years older, they approach a geometry test with the same intensity. Then imagine if they continue to strive for excellence as college students, as citizens, and as parents. (1999, p. 1)

When the arts reside at the core of educational programs, experiences that result in articulation through art—through music, dance, drama, the visual arts, and literature, and all communicative and expressive thought—we broaden and enrich the child's potential as an individual and as a member of society.

Art Education and the Young Child

The National Art Education Association (NAEA) states that art is one of the most revealing of human activities, as well as one of the richest sources for understanding cultures, because the earliest things we know of ourselves are recorded in visual forms and images. A comprehensive arts education promotes the attainment of knowledge, understandings, and skills that contribute to the student's intellectual, social, emotional, and physical development.

A comprehensive arts education program also is the perfect place to begin increasing children's awareness of a variety of cultures, and plays a key role in affecting children's long-term beliefs (Boutte, 2000). Saul and Saul (2001) caution teachers to move away from the "tourist approach" (p. 38) to teaching multicultural education wherein we "visit" different cultures, never to discuss them again. Multicultural experiences for young children should become a part of the child's artistic awareness throughout the whole year.

Ernest Boyer, of the Carnegie Foundation for the Advancement of Teaching and a noted expert on the arts, emphasizes the importance of arts education and has identified three reasons we need arts education in our schools. It is difficult not

to pay attention to his view of art as "one of mankind's most visual and essential forms of language, and if we do not educate our children in the symbol system called the arts, we will lose not only our culture and civility, but our humanity as well" (Boyer, 1987, p. 16). Figure 1–2 presents a summary of the reasons Boyer feels that the arts can make such a difference in a child's school experiences.

Boyer's points go directly to the heart of what we, as educators, believe is important to a child's artistic development. Art education for children is providing a variety of materials and opportunities for self-expression. The impulses to explore, to manipulate, or to change ways of expression or the way the body moves, all find outlets in the arts. Young children can organize materials—be it paint, a story line in a book, or props for improvisation—to express ideas, feelings, and concepts. These are not separate entities; they are interrelated, and the more knowledge a child has of the nature and structure of creative expression the more each of these entities enriches and nourishes the other. The creative arts *process* provides a pathway for children to reach into a new creative unfolding and understanding of themselves.

As children experience the arts, they discover new ways of representing their world in ways that can be seen, felt, and heard. We need only to sit back and watch children creating to see that they bring their own personal feelings, experiences, sensory impressions, and imaginations to the artistic experience. They also enter into the process in ways that are unique, different, and right for them. This process is a transformation of each child's inherent artistic potential, and the result is a wonderful, exciting, and significant reflection of the child as artist.

As children manipulate and explore the properties of paint, music, clay, or movement, they begin to develop concepts about their experiences. Through the arts they discover the hardness and plasticity of clay, the smoothness and roughness of different textures, the soft and sustaining bell tone of a suspended triangle, and the floating weightlessness of a silk scarf. Touching, seeing, and hearing are all intricately intertwined in these experiences of the creating child. The very intimate involvement of children with sensory exploration heightens sensory awareness and provides a solid base for future artistic creation.

FIGURE 1–2 Boyer's Vision for Creative Arts Education

- Arts education helps children express feelings and ideas words cannot convey.
- Through the language of the arts we can help integrate our splintered academic world. Students are not gaining insight or perspective or a sense of wholeness. They urgently need to see connections, and finding patterns in the disciplines can be accomplished through the arts.
- Arts education is necessary because the arts provide the child with a language that is universal.

The Goals of a Process Approach

A process approach to creativity can be viewed in several different ways. Torrance (1995) views the process as a way of sensing problems or gaps in information, forming ideas or hypotheses, testing and modifying these hypotheses, and communicating the results. Davis expands on Torrance's views:

> It can refer to a sequence of steps or stages through which the creative person proceeds in clarifying a problem, working on it, and producing a solution that resolves the difficulty. The creative process can refer to the techniques and strategies that creative people use, sometimes consciously and sometimes unconsciously, to produce the new idea combinations, relationships, meanings, perceptions and transformations. (2000, p. 60)

Regardless of how mysterious these ideas seem on the surface, there are some relatively straightforward ways to approach the creative process. More specifically, the following goals deserve your full attention. Take some time to identify those goals that already come easy for you, and mark those that you perceive as a personal challenge.

- Play around with ideas.
- Explore a wide variety of materials and methods for using them.
- Take advantage of accidents, such as mixing the wrong colors.
- Seek out activities that provide sensory pleasure.
- Welcome discoveries about media.
- Cooperate in the give-and-take of ideas.
- Honor the unexpected.
- Solve problems or dilemmas through trial and error.
- Allow your feelings and emotions to lead you in the process of creating.
- Create change in your old ways of approaching artistic challenges.
- Appreciate your own point of view.
- View the process as a way to communicate your thoughts and feelings without words.
- Acknowledge your insights and give them value.
- Initiate a new way of creating; suggest an idea for alternatives.
- Find something positive to say about your work (Edwards 2002, p. 17).

Torrance, in his manifesto for children (1983), provides us with enlightened goals for our art education approach with children. His manifesto challenges us to nurture creativity in our classrooms and to find appropriate ways to honor and support the development of creativity in our children and in ourselves. The following points are included among the challenges in his manifesto:

- Don't be afraid to fall in love with something and to pursue it with intensity.
- Know, understand, take pride in, practice, develop, exploit, and enjoy your greatest strengths.

◆ Learn to free yourself from the expectations of others and to walk away from the games they impose on you. Free yourself to play your own game.

◆ Do what you love and can do well.

◆ Learn the skills of interdependence (p. 78).

Diversity and Multicultural Art in Your Classroom

There has always been diversity in children's classrooms. Differences in cultural origins, lifestyles, abilities, needs of individual children, gender, religion, and ethnicity all bring a richness to classroom settings that few other environments hold. What works for one child may not work for another, and vice versa. For example, children with physical disabilities may have different ways of moving their bodies to music than children who have hearing disabilities. Children with cultural backgrounds different than your own may give interpretations to creative drama experiences that differ from the ones you expect. What is needed and valued in a creative arts program in an urban school is very different from the creative arts program that guides the one-room school in Ingomar, Montana, where teacher Chris French, a former student of mine, has only four children this year. But for all the differences our students encounter in early childhood settings, our role is that of facilitator. We provide the materials in the environment for our children to create, question, explore, and experience their own ideas in action.

Because of the growing diversity in our classrooms, it seems imperative to begin the development of world understanding during the early years, while the child is most impressionable and receptive. Children need to become sensitive to the diversity of the classroom culture, to the diversity in their neighborhoods and community, and to the diversity of the world's cultures. One way teachers can facilitate this process is by introducing children to a wide variety of visual and performing art activities from around the world.

Chapters 3 through 8 in this fourth edition describe activities that allow children to create and explore multicultural art ideas within the cultural context. These global activities are based on customs and celebrations, and each focuses on the process of learning about the world, not the product. They provide the steps for exploring and creating, which we all know is the most important process for growing children. With each of these activities you and your children will discover the contributions of many cultures to the world of art.

The key to bringing meaningful, appropriate, and relevant global arts experiences to children is to focus on *your* attitude toward diversity and *your* willingness to learn about global arts education. Besides, I have always found it to be an interesting and informative exercise to delve into my own cultural background and more recently into the background of some of my closest friends. As teaching professionals, we cannot nearsightedly stay within the bounds of our own experiences, nor can we divorce ourselves from the backgrounds and differences of the children

in our classrooms. When your class includes children with disabilities and children from varied ethnicities and cultures, you may have to modify your plans for creative arts experiences to accommodate these differences, but this should not, in any way, hinder your ability to bring the arts to each child in your class.

As you begin to think about the diversity of your children and presenting multicultural and global arts within a cultural context, examine your own attitude and biases about other countries. You might think of this in terms of your own background—your race, your culture, your genealogy and region of ancestry. As you reflect on your own cultural history, you will be able to move from the artistic process or task to what art in a cultural context means to you personally.

Art from Around the World

What Is Your Role?

Recently, when I was visiting a local school to observe a student teacher, I was invited to have lunch with a very lively group of five-year-olds. During our conversation over the cafeteria lunch table, I asked one of the children if he had always lived in Charleston. He looked at me with a puzzled look, the kind that implies how dumb adults can be at times, and replied: "I don't live in Charleston. I live in Sandy Ridge." I asked him if Sandy Ridge was in Charleston, and again, he gave me a look of total exasperation, tapped his finger firmly on the table, and with the tone of voice that only a five-year-old can effectively use, said: "I said I don't live in Charleston. I live in Sandy Ridge!" I found out later from his teacher that Sandy Ridge designates a rural area of Charleston County and gets its name from the Sandy Ridge Community Center.

Is it any wonder that when we introduce young children to art from other parts of the world, they have little, if any, idea of where that part of the world is located? We can show them on a map, or we can point to another continent on a globe, but young children have a limited concept of space, and what they do understand is usually centered on the space in their homes, their neighborhoods, and the route they take each day to and from school. Because we know, from a developmental perspective, that this is true, how can we introduce the art of cultures beyond and including the Western Hemisphere to explain the customs, mores, and thoughts that different cultures offer through their art? Too many well-meaning early childhood teachers have, in the name of multicultural art, presented children with exotic curios from India, Africa, Central America, and other cultures rich in visual arts traditions without providing ample historical background of the art or the cultural reasons for creating the art. The goal of multicultural art understanding is knowledge, and this knowledge lies with you, the teacher.

Multicultural Art in Context

To effectively teach young children about art from around the world, you must learn as much as possible about why a particular art exists, how it is made, the purpose for its creation, who was responsible for making it, the social origins of the art,

and the historical and aesthetic properties that make the art central to a particular culture. In other words, you must know enough about the art to make it come to life for you and your children. For example, it would be a disservice to your children to bring into your class a fish banner from Asia unless you can involve your children in a parallel activity that enables them to express themselves through what they know about fish and banners within the context of their own lives.

Where does a teacher begin when deciding how to introduce art from another culture? The process begins with you. Ask yourself some of the following questions. Your answers might give you some insight or motivation to research a particular culture.

- What cultures are represented by children in *your* classroom?
- What cultures are represented by families in your school and community?
- What art from other cultures attracts you?
- What is it about the masks of West Africa, the ancient mosaics of Israel, or the pottery of the Pueblo nation that catches your attention or strikes your aesthetic chord?
- When you are window shopping or looking through mail-order catalogs, are there art objects from other cultures that catch your eye?
- Have you ever taken a trip to visit another country? Was the art appealing or attractive to you? In what way?

Common sense tells us that unless we, as teachers, are genuinely interested in and knowledgeable about the art we present to children, they will not see art from other cultures as either exciting or something about which they want to know more.

Many years ago when I was in third grade, my teacher brought a cornhusk doll to school. She described it as a doll made by "Indians" and said that little Indian children did not have anything else to play with, so they made dolls out of corn. I always thought this was peculiar, because I had learned in first grade that the children of the Iroquois nation used dried apples to make their dolls. Both experiences left me totally confused because cornhusks and dried apples were outside my realm of understanding. Fortunately, my mother explained the whole issue to me, but the explanation and road to understanding *should* have come from my teachers.

How do you make art from around the world relevant to your children and their experiences? Figure 1–3 gives suggestions for selecting multicultural art to use as a basis for inspiring children's creativity.

Designing a Lesson Plan

Approach your introduction to art from around the world in the same way in which you would approach a unit on trees, flowers, and other things that grow. Follow these steps to develop a lesson plan for introducing young children to art from around the world:

1. Place books about your newfound art in the classroom.
2. Display examples of the art in places where children can touch it, move it around, and tell stories about it.

FIGURE 1–3 Multicultural Art in Context

- ◆ Read about the art from around the world and look at pictures and photographs from the following:
 - ◆ West Africa: tie-dyeing, masks, and sculpture
 - ◆ The Middle East: hieroglyphics, tapestry weaving, and mosaics
 - ◆ Europe: Swedish cookie stamps, paper cutouts, and the flower-related arts of Germany
 - ◆ Asia: calligraphy, paper making, woodblock printing, and lacquerware
 - ◆ Central America: yarn paintings, clay figures, and carved gourd designs
 - ◆ Mexico, South America, and the Caribbean Islands: seed necklaces, maracas, and Haitian designs in steel
 - ◆ The United States and Canada: Navajo weaving, sand painting, quillwork, and scrimshaw
- ◆ Select an art form that is most appealing to you.
- ◆ Allow your natural curiosity to seek additional information about the art form and fill in the missing links in your own understanding.
- ◆ Expose yourself to other kinds of art that are indigenous to this culture, compare the art to other cultures, and take yourself to a local travel agent to collect brochures and photographs of the region you have chosen. On the way home from the travel agent, stop by your local public library and pick up additional books that may not be available in your school library.
- ◆ Learn as much as you can before moving to the next step, which is writing a lesson plan.

3. Tell children *accurate* stories about where the artist lived, worked, and played, and why the art was important to what the culture believed and valued.

4. Give meaning to what your children are experiencing, and offer suggestions that enable them to identify and attend to the cultural nuances of the production of the art.

5. Do not expect or require that your children create pieces of art as beautiful as the examples you provide; rather, use the opportunity to expand their knowledge of art from all over the world, and then allow them to recreate what they see and know about the culture using the familiar art supplies from their own classroom.

6. Art from around the world should not be copied as a literal art form. It will have meaning only if your children bring their own experiences and their personal interpretations and understanding to the process of re-creating the particular art you have introduced. You might find that their involvement in the production of shadow puppets from Indonesia takes on the familiar shapes of the characters in the folktale you read just before lunchtime.

The results of this approach to art from around the world can be enlightening and perceptive. You will have to read, study, and plan, but because you are a teacher, you cannot really do any less. Our goal for children is to explore new ways of seeing art from other cultures, not to learn the methods for making replicas.

Theoretical Perspectives
Intellectual Development

The theory, research, and philosophy of development in the early childhood years provides a deeper understanding of young children, the way they construct knowledge about their world, and the ways through which they most effectively learn. The following sections present a theoretical perspective based upon the "whole-child" view of the intellectual, social, and emotional development of children.

Piaget's Stages of Intellectual Development

Piaget and Inhelder (1969) describe intellectual development as a series of stages through which children make qualitative changes as they acquire new knowledge. Although this model for intellectual development in children should not be rigidly interpreted, it does offer a guide for understanding how children construct and integrate knowledge. The approximate ages attached to the stages are variable, and we must be careful not to categorize children into a particular stage based on chronological age alone. A child does not wake up on the morning of her second birthday to find herself firmly settled into the preoperational stage of development, nor are all children capable of dealing with metaphor and analogy the day each turns 12. In fact, a child may exhibit some behaviors that could be classified as being in the preoperational stage while performing other tasks that are concrete operational. Figure 1–4 provides an overview of the sensorimotor, preoperational, and concrete operational stages of development.

Piaget was most interested in the question underlying his theory: "How do human beings construct knowledge?" He believed that intelligence evolves through a series of stages and developmental processes.

FIGURE 1–4 Piaget's Stages of Cognitive Development in the Early Childhood Years

Stage	Age	Description
Sensorimotor	0–2 years	Cognitive development depends upon sensory experiences and motor actions. Grasping, manipulation, and other tactile and kinesthetic sensations provide impetus for beginnings of thought.
Preoperational	2–7 years	Children acquire representational skills such as language, mental imagery, symbolic play, and drawing. They have an egocentric view of the world and view situations from their own perspective.
Concrete Operational	7–11 years	Children can use logical reasoning rather than relying on perception about concrete events. They can conceive of other people's viewpoints and simultaneously take into account more than one perspective. They do not, however, understand highly abstract concepts.

The Sensorimotor Stage The first stage, *sensorimotor* operations, involves the child's reception of and reaction to the senses and motor activity. The child's behavior is based on reflexes. Children grasp, touch, and manipulate objects and have a strong sense of sound, smell, and taste. The major accomplishment during this stage is the development of "object permanence," or knowing that an object exists even though it cannot be seen, heard, or touched. Children systematically repeat behaviors and gradually coordinate them into predictable chains of behavior. They learn concepts through exploration and exposure to new experiences.

The Preoperational Stage The second, or *preoperational,* stage is characterized by the child's ability to represent objects and events through deferred imitation, symbolic play, drawing, mental imagery, and spoken language. In deferred imitation a child will imitate something that he has seen before but does not exist in the here and now of the child's experience. For example, a child may imitate an adult reading a book while there is no adult around to serve as a model. During symbolic play, children pretend (blocks become cars) or play make-believe ("You be the father, and I'll help you make dinner"). Young children need little motivation to begin exploring drawing, moving to music, sculpting clay, or attending to a poem, and the visual and kinesthetic pleasure the activity brings. While at first they may simply be responding to the visual attraction of a beautifully colored marker, they may later begin to recognize form in their scribbling. In later phases of drawing, children will attempt to represent objects or experiences that have meaning or importance to them. These first attempts at representational drawings may not be recognizable by adult standards, but they are nevertheless meaningful and relevant to the child. A major accomplishment during the preoperational stage is the onset of language. Children learn that they can use words as substitutes for objects and actions.

The Concrete Operational Stage The third stage of Piaget's theory is *concrete* operations. The concrete operational child is capable of symbolic representation and understanding of reversible operations. At this stage, children can classify as they relate to groups of objects and order objects in a series. For example, children can classify sets of objects according to similarities and can reason about the relationships between classes and subclasses of objects. Concrete operational children also demonstrate the principle of *conservation,* or the ability to recognize the difference between volume and size. Decentering begins as children become aware of others' viewpoints and their interpersonal encounters become more cooperative (Piaget & Inhelder, 1969).

According to Piaget, children must be actively involved in constructing their own knowledge because they understand only what they discover or interpret for themselves. True knowledge occurs inside the child and is processed and understood as the child is actively involved in hands-on, real-life experiences. As children experience art, music, drama, dance, and poetry, they are provided opportunities for integrating mental representations in symbolic ways that promote intellectual development.

Vygotsky and Intellectual Development

The work of Vygotsky (1978) provides a foundation for understanding the social formation of learning. He theorized that children learn thought, language, and volition as they interact with others to master tasks or as they work independently on lesser complex operations. Specifically, Vygotsky believes that learning occurs, in part, when assistance from others is within the "zone of proximal development," defined as "the distance between a child's actual developmental level, as determined by independent problem solving, and the higher level of potential development, as determined through problem solving under adult guidance or in collaboration with more capable peers" (Vygotsky, 1978, p. 86).

As we observe our children at play, we discover how they are developing new concepts, skills, and competencies (Hoorn, Nourot, Scales, & Alward, 1999). One of Vygotsky's most important contributions to understanding child development is his assertion that the "zone of proximal development" is the level at which the child is comfortable and confident when exploring a task or activity while at the same time not being bored or frustrated by it. Vygotsky believes that a child's learning is optimal when functioning at this level. As children master tasks at this level, they will have the confidence and intrinsic motivation to engage in activities that require higher levels of thought and actions. Vygotsky also argued that every function in development begins at the social level through social interaction and then at the individual level (Vygotsky, 1978). This is one of the reasons why children should be encouraged to talk to and interact with their peers and adults. He believes that social interaction is the generator of thought. "Children not only speak about what they are doing, their speech and action are part of one and the same complex psychological function" (Vygotsky, 1986, p. 43). It is through talking, discussing, listening, and problem solving that children develop new concepts, skills, and competencies.

Children need activities that give them something about which to talk. This is one reason why it is important to establish a classroom atmosphere that encourages children to converse informally as they work together on a block-building activity; improvising sociodramatic play; engaging in kitchen play; or using objects to represent ideas, events, other objects, or situations. Our role as teacher is to facilitate discussions on how children worked on a project, how they got the idea for an improvisation, or why they decided to use yellow crayons to represent a certain food in the kitchen center. "As children talk, listen, and discuss shared experiences, they gain insights into one another's perceptions of the experiences, how others view the world" (Seefeldt, 2000, p. 158). Vygotsky's theory and his understanding of how social interaction relates to child development gives us even more reasons to stop giving children socially isolated activities such as ditto masters and premarked papers. Formula-laden and preprinted color-sheet activities undermine creativity and place emphasis on "alone work" and "being quiet." These types of activities may keep the noise level in your classroom at a *pianissimo*, but they do nothing to challenge children's intellectual development.

FIGURE 1–5 Intellectual Opportunities Through the Arts

When children are engaged in the creative arts process, they have opportunities to

◆ express what they see, feel, think, and want to communicate
◆ explore and experiment with sound, texture, color, pretending, and creating
◆ express ideas and feelings about themselves, their environment, and the world as they understand it
◆ strengthen their ability to imagine, create, and observe
◆ learn to use judgment without criticism
◆ use a variety of materials to solve problems
◆ develop a more mature vocabulary to use in discussing, exploring, and inquiring about different experiences
◆ gain confidence in their ability to express themselves
◆ define problems and seek solutions
◆ make decisions
◆ increase their awareness and use of kinesthetic experiences
◆ develop visual, auditory, and kinesthetic awareness and change it to artistic expression
◆ form concepts of what they want to draw, how they want to dance, or how they will act out a story
◆ rearrange and alter materials for self-satisfaction
◆ lengthen attention span and increase attending skills
◆ practice resourcefulness and alternatives
◆ gain a sense of self-direction, initiative, and independent thinking

The Arts and Intellectual Development

How do the arts contribute to these rich and comprehensive theories of intellectual development? When children are involved in the creative arts process, they have many opportunities to expand basic concepts, memory, problem-solving skills, and language. At the same time, as we begin to see connections between children's understanding and the creative arts, we will be more aware of how the arts may be extremely beneficial in the overall intellectual growth of a child. Figure 1–5 provides a description of just a few of the opportunities for intellectual development through the arts.

Emotional and Social Development

By the time children reach the age of three, they have established relationships with families, peers, and others outside their home and school environments. By the time they are four or five, they are capable of expressing and labeling a wide range of emotions. Teachers who are concerned about the social and emotional growth of their children must be aware of the contributions of the psychoanalytic theorist Erik Erikson. His comprehensive work provides us with a solid theoretical framework that underlines the importance of facilitating the emotional and social development of the children in our classrooms.

FIGURE 1–6 Erikson's Theory of Psychosocial Development

Trust versus Mistrust	Birth to eighteen months
Autonomy versus Shame and Doubt	Eighteen months to three years
Initiative versus Guilt	Three to six years
Industry versus Inferiority	Six to twelve years
Identity versus Role Confusion	Adolescence
Intimacy versus Isolation	Young adulthood
Generativity versus Stagnation	Mature adulthood
Integrity versus Despair	Old age

Erikson's Psychosocial Development

Erikson (1963) presents a series of psychological conflicts or crises that human beings must resolve in the development of personality. The outcomes of these conflicts can have positive or negative effects on ego development. The resolution of each conflict is dependent on relationships with others in our environment, and the positive outcome of these conflicts during a lifetime is important in the building of a positive self-esteem and positive feelings about ourselves and others. As with Piaget's theory of intellectual development, Erikson's stages are age related and, again, teachers must use caution in thinking that children may be in only one stage of development. Figure 1–6 summarizes Erikson's psychosocial conflicts.

During the first year, a child learns that the world is a trustworthy place and that she can trust those around her for sustenance, protection, and affection, or she develops feelings that she cannot trust those around her because her needs are not met. During the toddler stage, she begins to assert her choice and will as she develops some degree of independence. If she is too restricted by the external, over-control of her caregivers, she learns to doubt her abilities. This results in a loss of self-esteem. By the time she reaches age three, and until around her sixth year, her motor and intellectual abilities are increasing, and she begins assuming more responsibility for initiating and carrying out her ideas. When her attempts at initiative are not accepted by those around her, she develops feelings of guilt because of her misbehavior.

Older children, ages six through twelve, develop feelings of self-worth through mastery and achievement of their accomplishments and interactions with others, or they come to feel inferior in relation to others. The realization of possible failure leads to guilt and fear of punishment.

The Arts and Social/Emotional Development

For all young children, the arts provide a social arena in which they can communicate ideas and feelings to others. Very often young children cannot pinpoint a feeling, much less sort through all of the confusing vocabulary associated with emotional or affective stages to put that feeling into words or behavior. They can,

FIGURE 1–7 Emotional and Social Opportunities Through the Arts

When children are engaged in the creative arts process, they have opportunities to

- work as individuals and as members of an interacting and cooperative group
- take turns and share materials, equipment, and space
- respect others' rights, opinions, and feelings
- develop group leadership and followership qualities
- discuss, explore, and inquire about different experiences in the arts
- respect themselves through their accomplishments
- share personal concerns, feelings, and positive regard for one another
- plan, problem solve, and maintain an environment of positive support for self and others
- use participatory methods for decision making
- feel influential and of value to the group process
- build self-esteem
- support social development by sharing and asking questions
- express deeply personal thoughts and feelings that may be otherwise unacceptable
- identify fears and learn to manage them
- excel in a particular area and feel recognized
- gain a sense of acceptance in a group
- feel that their efforts are worthwhile
- feel valued by others
- develop communication skills

however, express and represent feelings through drawing, painting, pounding clay, or acting out a part during improvisation. When children make art, they are going about the serious business of learning about themselves and others in their world. They are in tune with their inner world and the external environment of things, people, and happenings (see Figure 1–7). Children involved in the process of creating and discovering the creative arts are probably closer to touching both of these worlds than at any other time. Every art encounter requires that children use intellectual, social, and emotional skills, concepts, and knowledge throughout the creative process. For example, go back to the first page of this chapter and reread the story about five-year-old Lien swimming with dolphins. First she needs to remember what she knows about dolphins, sailboats, and large bodies of water. She conveys her understanding of sailboats and things that float on water. Then she has to coordinate the movements of her body with the rhythm of the music while imitating the movements that most closely resemble those of a swimming dolphin. Next, she organizes what she knows about how dolphins swim alongside sailboats and the social interaction that takes place as she flips her fins to splash water on the people aboard. Finally, after what may have been less than five minutes in the planning, she presents a beautifully orchestrated water dance. What a sophisticated representation

A simple creative task such as building a sand castle increases the child's awareness and artistic expression.

of her ability to integrate her perceptions and ways of communicating with her world—a truly magnificent event!

Perhaps Robert Alexander's very powerful and poetic description best summarizes the value of arts education for all children:

> As children journey amid the creative splendor of the mind-heart-soul, their imaginations are constantly opening new doors and windows, showing new avenues of approach and hinting at mysteries which lie beyond what they can see. . . . In the act of creation, children are closer to their truth than at any other time. . . . Thoughts and feelings are experienced with magnificent clarity, crystal sharpness and control. All of life's bewildering chaos is transformed into harmony and truth. In the art of creation children are truly free. (1985, p. 5)

Throughout this book you will find a series of boxes that provide practical content information to share with families, and relevant ideas and/or activities that they can use at home with children when they explore the creative arts process together.

The work of Vygotsky (1978) and Erikson (1963) focus on the aspect of education that provides children with experiences that are in their zone of proximal development (where children can master some skills and are challenged to move to a higher level) and to building a positive self-esteem and positive feelings about ourselves and others (Edwards, 2002).

When children feel successful in their creative arts experiences, they gain confidence that enhances and builds a more positive self-concept.

Aesthetic Development

Definitions of aesthetics vary considerably. For the purposes of this chapter, *aesthetics* is defined as an area of the arts concerned with feelings and responses to color, form, and design. There is a basic need to make sense of and appreciate the world in which we live. When children have opportunities to view and explore beautiful things in their classroom, or in the world, they begin to appreciate the uniqueness of a pleasing and sensory rich environment (Schirrmacher, 2002).

Parson's Stages in the Development of Aesthetic Responses

Parson (1987) presents us with yet another theory of stages in the development of the arts through his views of aesthetic awareness of the arts.

1. Stage one is characterized by an interest in color favorites, pictorial representation, a personal connection to the subject, and an enjoyment of painting.

A Family's Role in Introducing the Arts at Home

- ◆ Caregivers must react in a prompt, responsible, and caring way to the artistic and creative efforts of children.
- ◆ The child should feel secure in the attention, love, and care of the family.
- ◆ Caregivers, especially, should be models for children and be open to showing surprise, interest, and attraction to the natural world and all that's happening—from the wag of a dog's tale, a spider's web, a late afternoon shadow, to even bubbles popping in the bathtub.
- ◆ Families should show pleasure and delight in everyday things that could otherwise be mundane chores and routines.
- ◆ Children should be free to playfully enact their imaginative stories and get lost in the fun and creativity of play.
- ◆ Caregivers must accept children's emotions and talk to them about their hurts and fears with reassuring attentive and responsive actions and voices.
- ◆ "Wonder becomes possible when children can risk being themselves without there being any risk at all" (Haiman, 1991, p. 52).

2. Stage two, beauty and realism, is characterized by the viewer liking a painting because it is beautiful and represents reality. The subject of the work of art is judged for its realistic qualities.
3. Stage three is characterized by the observer noticing what kind of feelings the work of art produces, regardless of the subject's beauty or realistic qualities.
4. Stage four, style and form, is when the viewer is aware of his or her ability to interpret a painting.
5. Stage five is autonomy. At this level, judgment is individually based, yet the observer has the need for discussion and intersubjective understanding (Parson, 1987).

When using this model, teachers can ask appropriate questions to individual children and in small groups so that children can express their thoughts about a particular work of art and can listen to the ideas, feelings, and thoughts of others.

Gardner's Theory of Multiple Intelligences

The areas of intellectual, emotional, and social development have fascinated scholars, learning theorists, and art educators for decades. The different theoretical influences provide points of view through which we can interpret how children learn and grow when they are involved in the creative arts process. Another theory that

is being applauded by educators is that of Harvard University's Howard Gardner. His work has far-reaching implications for teaching professionals and is especially significant in making us aware of the different forms of intelligence.

The Nine Intelligences: Implications for Teaching

Gardner proposes that instead of having one all-encompassing intelligence, human beings have at least nine separate and distinct intelligences. In his 1983 book *Frames of Mind,* he identified seven intelligences that all people possess in varying strengths and degrees: linguistic, logical-mathematical, spatial, bodily/kinesthetic, musical, interpersonal, and intrapersonal. In 1997 Gardner introduced an eighth intelligence: naturalistic intelligence (Checkley, 1997). Most recently, in an address to the American Educational Research Association, Gardner (2003) discussed the eight intelligences and concluded that there is ample evidence for a naturalist intelligence and suggestive evidence as well for an *existential* intelligence (the intelligence of big questions).

Think back to the beginning of this chapter and the description of our five-year-old, Lien, "swimming in the ocean." The significance of this story is the way it reveals a unique profile on several intelligences operating simultaneously. The child uses spatial intelligence when transforming her perceptions of swimming in the ocean into a visual representation. She exhibits a sensitivity to music and uses her body to leap and dive across her classroom. As this occurs, she is tapping into musical and bodily/kinesthetic intelligence. She uses linguistic intelligence to explain to her teacher who she is and what she is doing. When she splashes water on the people aboard the sailboat, she is demonstrating interpersonal intelligence, or the capacity to respond appropriately to other people. When Lien is "swimming in the ocean," she demonstrates naturalistic intelligence as she shows a strong affinity to another species (dolphin) in the environment and the Earth. She is also showing us her intrapersonal intelligence as she draws upon her own feelings as a guide to her behavior.

A principal value of the multiple intelligence perspective lies in its potential contribution to educational reform, *especially* reform that leads to a universal understanding of the value the arts hold for the development of all intellectual capacity. When I was thinking about how to introduce you to Gardner's writings, I remembered how fascinating his ideas are and how much his work has contributed to my own understanding of learning and intelligence. His research has made a tremendous difference in my approach to teaching, and I hope that you will also gain some valuable insights that will be useful as you approach the education of young children.

In 1979 Gardner was asked by a Dutch philanthropic organization, the Van Leer Foundation, to study the nature and realization of human potential. His first assignment was to summarize what had been established about human cognition and the human cognitive potential based on the cognitive science and neuroscience of previous decades.

Prior to beginning the Project on Human Potential, Gardner had begun sketching out a book called *Kinds of Minds,* in which he argued that the mind is capable of different kinds of things and that the term *intelligence* had been defined

too narrowly. Once he began exploring this broader perspective, Gardner made a decision to call the different kinds of minds "intelligences."

In an address presented to the Orton Dyslexia Society in Philadelphia, Gardner referred to his decision to use the word *intelligences* when he said,

> This was a feisty thing to do. If I had called them talents, people would have said, "Oh, yes, yes, people have many talents," and then would have just gone on about their business. . . . If I called what I was doing *intelligences,* this would be a direct challenge to people who think they know what it is. . . . So I decided to call what I was studying intelligences, and my prediction was successful. (1987b, p. 22)

Next, Gardner needed a definition of an intelligence, so he defined the word as "an ability to solve a problem or to fashion a product which is valued in one or more cultural settings." Gardner's definition of intelligences suggests that intelligence has to do with (1) problem solving and (2) fashioning products, such as writing an orchestral score or a play, or making a painting, or creating scientific theories, or using one's hands and body as mimes do. Through Gardner's work, the mystique surrounding the notion of intelligences, particularly that attributed to psychometricians whose business it is to study intelligence, is beginning to fade, while the functional use of the term has become more accessible to teachers, administrators, and other educators.

Interview the people in your group and ask them to tell you which of Gardner's intelligences they each feel best describes them.

Gardner said there was nothing sacred about the number when he came up with his list of intelligences. Nor, as he put it, "do I claim that I have necessarily identified the right intelligences. Of course, I think that I have. . . what I am trying to argue is that intelligence is basically a pluralistic concept." The intelligences are illustrative of how people become problem solvers and problem finders, how they learn, and how they develop. Gardner's intelligences will be discussed in detail in chapters throughout this book. For example, bodily/kinesthetic, musical intelligence, and logical-mathematical intelligence will be addressed in chapter 4, titled Introducing Music and Movement. When we think of rhythm, meter, time signature, note value, and especially counterpoint, we see that the capacity to discern logical and/or numerical patterns is definitely related to music and movement.

In addition to intelligence and emotional and social development, we also must examine creativity and the creative process that contributes in one way or another to the actualization of creative potential. Indeed, it would be difficult to isolate intellectual, emotional, and social development from the totality of the creative process itself. The next chapter focuses on several elements of the creative process and includes some important information related to models of creativity.

> *To some extent the term creativity has become too popular. The words creativity or creative are applied like sparkling paint to book titles, do-it-yourself projects, or performance groups. Still, we must not lose sight of the tremendous importance that the development of creative thinking can have for us, both as individuals and as a society.*
>
> —Viktor Lowenfeld

Addresses of Visual and Performing Arts Organizations

American Alliance for Theatre and Education (AATE)
Theatre Department/Arizona State University
P.O. Box 872002
Tempe, Arizona 85287–2002
phone: (602)965–6064
e-mail: aateinfo@asuvm.inre.asu.edu

Music Educators National Conference (MENC)
1806 Robert Fulton Drive
Reston, VA 20191
phone: (800)336–3768
fax: (888)275-MENC
e-mail: mbmenc@vais.net

National Art Education Association (NAEA)
1916 Association Drive
Reston, VA 20191–1590
phone: (703)860–8000
fax: (703)860–2960
e-mail: naea@dgs.dgsys.com

National Dance Association (NDA)
1900 Association Drive
Reston, VA 20191
phone: (703)476–3436
fax: (703)476–9527
e-mail: nda@aahperd.org

Understanding the Creative Process

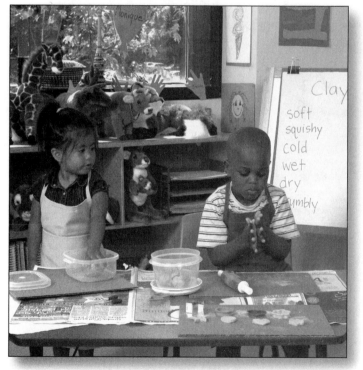

*Everyone is creative: we are born not only ready
but anxious to act upon the creative proclivity within us.*

M. Goldberg, 2000

Last year Mr. Rodriguez taught two brothers ages four and five named Xiang and Wang. Earth clay and modeling clay were always available in the art center. Xiang was fascinated with "real" earth clay. His brother Wang preferred modeling clay. One day Xiang and Wang were sitting side by side experimenting with the two types of clay. They pounded it, pushed it, folded it, and smoothed it out. Mr. Rodriguez observed that they were both involved in the process of exploring the properties of these two very different types of clay. As Xiang's earth clay started to dry, he poured a little water on it and poked holes in the clay. Then he poured water into the holes and continued to work the clay until it became soft again. As Wang observed his brother pouring water onto his earth clay, he decided to pour water onto his modeling clay. He looked puzzled as his clay did not absorb water like Xiang's did. During this entire time, both children were working independently and were focused on the process involved when working with their clay. In the meantime, Mr. Rodriguez was observing this process and saw this as the perfect teachable moment to explain the unique properties of both kinds of clay. Had Mr. Rodriguez not been the astute observer that he was and not allowed Xiang and Wang to explore and become involved in the process of playing with clay, this teachable moment might not have ever happened.

The Creative Process

What are the most important issues to consider when we talk about creativity? There are three focusing questions that provide a framework for studying the creative process. These questions can serve as discussion starters, thus helping you integrate the content of this section with the broad scope of the creative process.

1. How do we define creativity?
2. What are the stages of the creative process?
3. What are the characteristics of creative people?

Use these questions as a framework for approaching and synthesizing this section and for forming your own answers.

Defining Creativity

Creative endeavors	Creative financing
Creative approaches	Creative writing
Creative production	Creative team-building
Creative potential	Creative advertising
Creative management	Creative problem solving
Creative processing	Creative leadership

These familiar phrases are used frequently in education, business and commerce, and the social sciences. The popularity of these terms points to the fact that people in general are interested in creativity. For those of us involved in the arts *and* creativity, it is encouraging that our colleagues in other fields are taking a look at how creativity transcends all aspects of human endeavor. On the other hand, these terms represent what Balkin refers to as the "overused, misused, confused, abused, and generally misunderstood" use of the word *creativity* (Balkin, 1990).

What is this thing called "creativity"? There are hundreds of definitions of creativity ranging from the dictionary definition "characterized by originality; imaginative," to the Latin word *creare,* from *creo,* which means "to produce, create, make, bring forth, beget, give origin to." When we consider the dictionary definition and the Latin root, the mystique surrounding this elusive word takes on even more complexity. Carl Jung, often described as the father of Gestalt psychology, wrote extensively about creativity, memories, dreams, symbols, and the universal images that have existed since the earliest time. He described creativity as a reaction to stimulus that may be causally explained; but the creative act, which is the absolute antithesis of mere reaction, will forever elude the human understanding (Jung, 1933). Even the great Greek philosopher Homer claimed that creativity was the result of inspiration from the muses. Plato, the first art and literary critic of importance, wrote numerous discussions describing the inspiration received from the gods through the nine muses and credited these muses with bringing creative inspiration to poets, actors, historians, musicians, astronomers, and dancers. While conceptualizing a precise definition of creativity is beyond the scope of this book, several definitions are included because of their implications and applicability to the creative and artistic endeavors of young children.

> **Gobhai:** "The ability to make unobvious connections" (personal communication, 2004).
> **Csikszentmihalyi:** "Creativity refers to people who experience the world in novel and original ways . . . individuals whose perceptions are fresh, whose judgments are insightful, who make important discoveries that only they know about" (Levinson, 1997).
> **Edwards:** "The proactive, purposeful impulse to extend beyond the present, characterized by originality, imagination, and fantasy" (2002, p. 12).
> **Prince:** "An arbitrary harmony, an unexpected astonishment, a habitual revelation, a familiar surprise, a generous selfishness, a vital triviality, a disciplined freedom, an intoxicating steadiness, a repeated initiation, a difficult delight, a predictable gamble, an ephemeral solidity, a unifying difference, a demanding satisfier, a miraculous expectation, an accustomed amazement" (1982, p. 25).
> **Franken:** "Creativity is defined as the tendency to generate or recognize ideas, alternatives, or possibilities that may be useful in solving problems, communicating with others, and entertaining ourselves and others" (1994, p. 396).

In a serious search for the definition of creativity, we would be well served to take note of Torrance's uplifting and challenging definition. Figure 2–1 reflects Torrance's infinite wisdom. His view is an indication of being truly in touch with our creativeness.

FIGURE 2–1 Creativity According to Torrance

Creativity is digging deeper.

Creativity is looking twice.

Creativity is crossing out mistakes.

Creativity is talking/listening to a cat.

Creativity is getting in deep water.

Creativity is getting out from behind locked doors.

Creativity is plugging in the sun.

Creativity is wanting to know.

Creativity is having a ball.

Creativity is building sand castles.

Creativity is singing in your own way.

Creativity is shaking hands with the future.

Source: Torrance, 1992, p. 5.

Lauren Orth, a colleague and former student of Torrance's, remembers a lecture in which he described the moment of enlightenment by using a Japanese term. She says he called this the search for *Satori*. Satori is the moment of enlightenment, the "Eureka" that comes after periods of preparation and incubation. The art experience for young children can provide the means of delving into the stages of the creative process while exploring some of the characteristics enjoyed by other creative individuals.

Remember, however, that the intrinsic value of an art experience for the young child is in the process.

There will be times in your teaching career when parents will say to you: "Does my child ever really make anything during art time?" Too often, children will feel the pressure to "make" something or "paint" a picture to take home at the end of the day. Sometimes young children are caught between what you tell them about the creative process and what their parents expect to see as a result of paint stains on clean white socks! As a developmental specialist, you must explain your rationale and the purpose of early childhood art experiences to your parents so that they will understand why the process is, at this time in a child's life, more important than the actual product. Once you have a working knowledge of the "process versus product" issue, you can begin to articulate the nature of the process to parents.

Process and Product

When someone is involved in creating something, there are usually two very distinct activities taking place. The first has to do with the *process*. The second relates to the *product*. The creative process is seen as a

sequence of steps or stages through which the creative person proceeds in clarifying a problem, working on it, and producing a solution that resolves the difficulty. The cre-

ative process can also refer to the techniques and strategies that creative people use, sometimes consciously and sometimes unconsciously, to produce the new idea combinations, relationships, meanings, perceptions, and transformations. (Davis, 2000, p. 60)

The creative *product* is the output of the person, the material or the concrete representation that results from the process. For young children it may be their painting, their dance, the image represented in a sculpture, or whatever results from the child's need to communicate thoughts or feelings. For an adult, the product could be needlework or participation in a local theater group. The process and the product are both important, and it is often difficult to pinpoint where the process ends and the product begins. Children vacillate between processes of creating and producing and, in fact, may rework or repeat the process before producing a satisfying product. This is true for adults as well.

Looking at the creative *process*, the focus shifts from end-states or outcomes to doing and experiencing in the here-and-now moment. This shift of focus requires personal acceptance of what we are doing while we are doing it. Attending to the here and now process is not an easy thing for many of us to do. In addition, we seem to have little time in our lives to focus on our awareness of things as they are happening around us or to us. In the process of creating art in the here and now, the presence of the material, the music, the improvisation, or the dance is real. What we created in the past is in the past. We may have a painting to look at or a video of our dance to view, but these are, nevertheless, a part of our past. Because the future is yet to come, we can only speculate about how we will draw or sing or mold clay or compose a poem. A process approach to the visual and performing arts experience provides us with an immediate environment to develop and expand our awareness of the here and now so that we can truly focus on how we are engaging in creating rather than on *what* we are attempting to paint or sculpt or improvise.

Many adults have had little experience with process-oriented arts experiences. Consequently, they approach the idea of taking a course in the visual and performing arts with a great measure of anxiety and concern. Because of these fears, it is necessary to develop a keener sense of awareness on a fairly simple level and gradually build to a point where we are no longer molded, controlled, or restricted by ideas, perceived judgments of others, and things outside of our own experiences. As we become more and more aware of the importance of the process in exploring the arts and all of the possibilities the arts hold for us personally, we can sing, dance, paint, write poetry, and pantomime in ways appropriate and right for us. When this happens, we are no longer bound to the use of materials that results in 30 stereotypical similar "works of art." It is at this point that we can allow ourselves to be open and to explore all of the possibilities the process of creating art holds for each of us.

Although this approach to the artistic process may be new to some and may even be threatening to others, this book, with its emphasis on the affective domain, is arranged along a continuum of internalization; that is, the affective elements of knowing and learning in the here and now of the moment are presented in a chapter-by-chapter sequence. Descriptions of the categories in the affective domain are arranged so as to build on what you have already experienced to ensure your success in becoming aware of the next level. The first one introduces the concept of receiving (or attending to) the arts as a content subject area. The last one deals

with your giving the arts a position of some power to guide your commitment to the value they hold for us as adults as well as for children.

One of my students brought me the following story written by Helen Buckley Simkewicz. After reading it in class, we had a lengthy discussion about children's creative potential and how we as teachers, sometimes unknowingly and unintentionally, discourage creative expression.

"The Little Boy"
by Helen E. Buckley Simkewicz

Once a little boy went to school.
He was quite a little boy,
And it was quite a big school.
But when the little boy
Found that he could go to his room
By walking right in from the door outside,
He was happy.
And the school did not seem
Quite so big anymore.
One morning,
When the little boy had been in school awhile,
The teacher said:
"Today we are going to make a picture."
"Good!" thought the little boy,
He liked to make pictures.
He could make all kinds:
Lions and tigers,
Chickens and cows,
Trains and boats,
And he took out his box of crayons
And began to draw!

But the teacher said: "Wait!
It is not time to begin!"
And she waited until everyone looked ready.

"Now," said the teacher.
"We are going to make flowers,
And he began to make beautiful ones
With his pink and orange and blue crayons.
But the teacher said, "Wait!
And I will show you how."
And she drew a flower on the blackboard.
It was red, with a green stem.
"There," said the teacher,
"Now you may begin."
The little boy looked at the teacher's flower.

Then he looked at his own flower.
He liked his flower better than the teacher's.
But he did not say this,
He just turned his paper over
And made a flower like the teacher's.
It was red, with a green stem.

On another day,
When the little boy had opened
The door from the outside all by himself,
The teacher said:
"Today we are going to make something with clay."
"Good!" thought the little boy. He liked clay.
He could make all kinds of things with clay:
Snakes and snowmen,
Elephants and mice,
Cars and trucks,
And he began to pull and pinch his ball of clay.
But the teacher said,
"Wait! And I will show you how."

And she showed everyone how to make
One deep dish.
"There," said the teacher, "Now you may begin."

The little boy looked at the teacher's dish.
Then he looked at his own.
He liked his dishes better than the teacher's.
But he did not say this.
He just rolled his clay into a big ball again,
And made a dish like the teacher's
It was a deep dish.

And pretty soon
The little boy learned to wait,
And to watch,
And to make things just like the teacher.
And pretty soon
He didn't make things of his own anymore.
Then it happened
That the little boy and his family
Moved to another house,
In another city,

And the little boy
Had to go to another school.

This school was even bigger
Than his other one,
And there was no door from the outside
Into his room.
He had to go up some big steps,
And walk down a long hall
To get to his room.

And the very first day
He was there,
The teacher said:
"Today we are going to make a picture."
"Good!" thought the little boy,
And he waited for the teacher
To tell him what to do.

But the teacher didn't say anything.
She just walked around the room.
When she came to the little boy
She said, "Don't you want to make a picture?"
"Yes," said the little boy.
"What are we going to make?"
"I don't know until you make it," said the teacher.
"How shall I make it?" asked the little boy.
"Why, any way you like," said the teacher.
"And any color?" asked the little boy.
"Any color," said the teacher.
"If everyone made the same picture,
And used the same colors,
How would I know who made what,
And which was which?"
"I don't know," said the little boy,
And he began to make pink and orange and blue flowers.
He liked his new school . . .
Even if it didn't have a door
Right in from the outside!

Do you ever remember being in a situation like that of the little boy, cautious to experiment with your creative abilities or to follow your own creative instincts? Just like the little boy in the story, we are all born with our own creative abilities and among these are those that can be classified as artistic.

Experiential or Experimental?

This approach to the arts, creativity, and affective development is *experiential*. An experiential approach is not the same as an *experimental* approach. We are involved

It has been proved beyond any doubt that such imitative procedures as found in coloring books and workbooks make the child dependent in his thinking; they make the child inflexible because he has to follow what he has been given. They do not provide emotional relief because they give the child no opportunity to express his own emotions; they do not even promote skills and discipline, because the child's urge for perfection grows out of his desire for expression; and finally, they condition the child to adult concepts which he cannot produce alone, and which therefore frustrate his own creative ambitions.

Viktor Lowenfeld

in an experiential approach to learning when we engage in an activity or process and we do not know what the steps will be along the way. In experiential learning situations we do not know what the outcome will look like, and we are really not aware of *how* we will reach an outcome or if indeed there even *is* an outcome.

Experiential encounters take courage because, in essence, there is no road map or table of contents. We are guided by our experience, our perceptions, our imaginations, and our interaction with material and other people. The experiential approach to creative awakening and exploring the arts is more like a journey in a foreign land than a designated set of objectives and procedures to be rigorously followed to a final destination.

Experimental refers more to the scientific approach to discovery. When we experiment, we examine the validity of a hypothesis or make a test to demonstrate a known truth, and we usually have a theory to guide our expected outcome.

Think of an experiential approach as an orchestral score with room for interpretation, improvisation, and an endless range of dynamic happenings. As we approach the arts from this perspective, we allow ourselves to write and conduct the nuances and intricacies of our own original score. The whole process of experiential education reminds me of a quote I heard many years ago that summarizes the experiential approach to knowing and learning: "Of magic doors there is this: we don't see them even as we are passing through."

How do we begin writing our symphony? What are some of the stages we might experience as we explore the process? The literature essentially agrees that there are four basic stages in the creative process (Boles, 1990; Sapp, 1992; Wallas, 1926). The first well-documented model of the creative process was provided by Wallas in 1926. (Even though these stages originated in what may seem like ancient times to you, please give them your full and undivided attention. Decades of professional scrutiny certainly give a great deal of credibility to his ideas!)

Models of Creativity

The Wallas Model of the Creative Process

Wallas proposed four primary *stages* in the creative process:

1. preparation
2. incubation
3. illumination
4. verification

Preparation is the process of gathering information, reviewing data or materials, identifying the problem, and locating resources or whatever else is needed at the outset to tackle the task.

Incubation involves letting things develop without consciously working on them, allowing unconscious free-association to take place while the individual is involved in a different or unrelated activity, or letting go of direct concentration on the task at hand.

Illumination is the *Satori,* the moment of enlightenment, the aha! or eureka, the new idea, or the synergistic combination or solution that is exciting and pleasing.

Verification occurs when the excitement has passed and we test the concept and critically analyze the solution.

Balkin (1990), while confirming Wallas's model, adds another stage to follow verification—the "re" factor. According to Balkin,

> This is where the work really begins and perseverance must triumph; it is the heart of the process: The creative person must continually *re*think, *re*consider, *re*place, *re*fine, *re*do, *re*affirm, *re*process, *re*write, and *re*conceptualize. What better lesson could children learn in coping with life than the importance of the "re" component? It is the essence of problem solving. (p. 30)

We can also conclude that the "re" factor is a major addition to thinking about the creative process, whether we are involved in making music, painting, dancing, acting, writing a poem, or working on a solution to a problem.

Another consideration that is important to this discussion is the characteristics that creative people demonstrate as they engage in the creative process. The link between the stages and the *characteristics* of the creative process is significant. If we understand this link, we will see how these two processes work simultaneously in an integrated manner.

Torrance's Characteristics of Creativity

Torrance, a pioneer in the study of creative abilities, identified four characteristics, or abilities, that are essential to the creative process:

- fluency
- flexibility
- originality
- elaboration

Torrance's findings suggest that creative ability is the ability to produce a variety of ideas, both verbal and nonverbal, and to allow a free flow of associations related to ideas and thoughts (fluency); to explore various ways of approaching problems or solutions and looking at situations from many different perspectives (flexibility); to have a new or novel idea or to produce something unique, to put a new stamp on something that already exists (originality); and to embellish or extend thoughts and ideas, to add detail or finishing touches (elaboration).

The finger-paint activity in the toddler room with the yellow door encourages children to be fluent in their thinking. The open-ended approach to discovering the properties of finger paint allows children both to talk about what they may or may

not create *and,* as they move the paint around on the paper, to participate in a free-association of thoughts and ideas about the process (fluency). They may think about a number of ideas or solutions to what they want to do with the paint and paper. The activity also enhances children's ability to think about different ways to approach it, turning their papers around to view their paintings from a different perspective (flexibility). They might think of ways to mix the colors to make new colors (originality) or decide to add glue and glitter (elaboration) to make their paintings different from those of other children.

This process-oriented, child-directed activity provides children an opportunity to stretch their ways of thinking and further develop their creative abilities. These children have been given permission to extend their thought processes, and the teacher who is well grounded in theories of creative development understands and honors the intellectual structuring that is taking place.

The topic of creative process also includes the person involved in the process. Are there certain personality traits that increase the likelihood that the creative process will occur?

Characteristics of Creative People

As with all areas relating to creativity, the personality traits of creative people have been defined, recorded, and reported for decades. Major research devoted to this topic (Csikszentmihalyi, 1997; Daniels, 1995, 1997; Davis, 2000; Gardner, 1983, 1987a, 1991; and Torrance, 1962, 1979, 1984) provides an exhausting list of characteristics and personality traits associated with creative individuals. The following list is by no means all-inclusive, but it is gleaned from some of the more prominent scholars in the field. Creative people are

independent	open to affective states
adventurous	self-confident
curious	intrinsically motivated
aware of others	flexible
spontaneous	tolerant of ambiguity
conscientious in convictions	perceptive
determined	unconcerned with impressing
playful	others
childlike	introspective
passionate in task involvement	open-minded
reflective	expressive
attracted to novelty	challenged to discover
open to experience	

It is important at this point in our thinking about creativity and characteristics of creative people that we focus on the important work of Csikszentmihalyi (1997). The next section presents Csikszentmihalyi's views and ideas about creativity in general. As you read his words, keep in mind that he is one of the major scholars in the field of creativity.

According to Csikszentmihalyi (1997), the ways in which creativity is commonly expressed are

1. Persons who express unusual thoughts, who are interesting and stimulating—in short, people who appear to be unusually bright.
2. People who experience the world in novel and original ways. These are (personally creative) individuals whose perceptions are fresh, whose judgments are insightful, who may make important discoveries that only they know about.
3. Individuals who have changed our culture in some important way. Because their achievements are by definition public, it is easier to write about them (e.g., Leonardo, Edison, Picasso, Einstein, etc.)(p. 25–26).

Characteristics of the Creative Personality

1. Creative individuals have a great deal of energy, but they are also often quiet and at rest.
2. Creative individuals tend to be smart, yet also naive at the same time.
3. Creative individuals have a combination of playfulness and discipline, or responsibility and irresponsibility.
4. Creative individuals alternate between imagination and fantasy at one end, and rooted sense of reality at the other.
5. Creative people seem to harbor opposite tendencies on the continuum between extroversion and introversion.
6. Creative individuals are remarkably humble and proud at the same time.
7. Creative individuals to a certain extent escape rigid gender role stereotyping and have a tendency toward androgyny.
8. Generally, creative people are thought to be rebellious and independent.
9. Most creative persons are very passionate about their work, yet they can be extremely objective about it as well.
10. The openness and sensitivity of creative individuals often expose them to suffering pain yet also a great deal of enjoyment (Csikszentmihalyi, 1997, pp. 58–73).

Find someone in your class whom you do not know very well. Discuss with this person the characteristics of creative people. Note which of these qualities you also possess, and identify areas that you wish to strengthen or develop in yourself.

We can all see ourselves in several, if not many, of these descriptors of creative people. If at first you did not see one that seems to describe you personally, go back and read the list again, and this time, give yourself permission to claim a few for yourself. These are universal characteristics, and sometimes we just have to look a little deeper to acknowledge just how creative we really are!

A Case Study of Self

The realization of having experienced the four stages of the creative process (including Balkin's "re" factor) usually comes days or even weeks after the verification stage. The following story illustrates one of my own experiences with the process.

Children's Literature and Creativity

Wilfrid Gordon McDonald Partridge by Mem Fox, illustrated by Julie Vivas, Kane/Miller Book Publishers, 1984.

Wilfrid experiences moments of creativity as he gathers gifts for his old friend Nancy.

It Looked Like Spilt Milk by C. G. Shaw, Scholastic, 1947.

This book presents a continuously changing white shape silhouetted against a blue background. Young readers have fun guessing what the shape is.

Christina Katerina and the Box by P. L. Gauch, Coward, McCann & Geoghegan, Inc., 1998.

Christina experiments with a box that housed the new refrigerator, finding many ways to use the box creatively.

I was invited to give the keynote address for an early childhood conference at a very prestigious university. The conference chair gave me the topic and asked if I would also do two seminars following the opening session—one for undergraduates and one for graduate students. I spent the next couple of months preparing for the address and for the seminars. When I arrived on campus and met with the conference chair, I discovered that while I had correctly prepared for the keynote address, I had misunderstood what she wanted me to present during the seminars. In other words, I was 900 miles from my resources, my file cabinet, my databank, and my notes on the topics. Not having a clue as to what I would do, I checked into the hotel feeling overwhelmed, unprepared, frustrated, and angry at myself for having misunderstood what I was expected to present.

The hotel room was the standard room with two double beds, a color television, and a phone. I put all the notes I did have (which were of no help at all) on one bed, and I sat on the other. At this point, I was not sure whether to cry, try to get by as best I could, or simply call the conference chair and tell her that I was unprepared and could not conduct the seminars. My good judgment told me that I was exhausted from the East-Coast-to-West-Coast plane trip and should just rest and regroup before making any decisions. In the meantime, I kept glancing at the yellow legal-sized handwritten notes I had scattered all over the other bed. I was also thirsty for a tall glass of something cool to drink. I called room service; they brought up a fresh glass of lemonade; I turned on the television, sat back, and tried to relax.

As I was relaxing, I remembered that there were several articles that I could use sitting on a friend's kitchen table back home. This friend and colleague, Dr. Martha

Nabors, and I were working on a grant proposal, and I had left the articles with her the last time we worked together. I called her, and over the course of several hours of long-distance calls, I had enough information on the seminar topic to get started.

By this time I was hungry, so I called room service again, and they brought my dinner. I put my telephone notes aside and began watching an old movie on television. I became very absorbed in both my dinner and the movie, and for a brief period I forgot about my dilemma and really did not think about the seminars that were now less than 16 hours away. Some time before the end of the movie, I noticed that my concentration on Julie Andrew's mode of dress was being interrupted by other thoughts about the telephone notes. I wanted to see the end of the movie, but I was distracted by flashes of ideas that seemed to be creeping in and out of my thoughts. These thoughts were so disruptive that I picked up the notes and began to circle words and phrases while still trying to stay with the story line of the film.

The creative thinker is flexible and adaptable and prepared to rearrange his thinking.

A. J. Cropley

In what seemed like a flash of inspiration, my thoughts were bombarded by an idea! In an instant I had a complete plan, a whole solution, and a total conceptualization of how I would design the seminars. The idea was wonderful—it was exactly what the conference chair wanted—and I felt elated. I spent the next four hours outlining both presentations.

When the presentations concluded the next morning, I was even more delighted by the positive response of the participants. Did my idea work? Were the seminars what the conference participants needed and wanted? Two weeks later, after what seemed like an eternity, the conference evaluations complete with individual comments finally arrived. The conferees were pleased, the chair was happy, and the comments were good. While the prospect of failure had crossed my mind more than twice (which is describing the event in its most positive terms), the end result was quite positive.

After I returned home from the conference, I was talking with Dr. Nabors about the professional trauma of being unprepared for such an important event. After she had listened to my story, she very wisely pointed out to me that I had, indeed, been practicing what I often preach . . . I had experienced the phases (or stages) of the creative process without realizing what I had done.

Wade through the events of my story and identify those stages that I was involved in during the creative *process*. Surely, after all you have learned about how these discoveries may have occurred, you will have your own memories about how similar aha!s have happened to you. To be a teacher of young children is to recognize how you, I, and children demonstrate day after day a level of knowledge and ways of knowing that celebrate the individual as a new thinker capable of creative acts.

Affective Development

A child's immersion in affective states while encountering the arts has a positive dimension. Because of its unity and potency, an affect may well have an integrating and structuring effect on the child's experiences, influencing both his perception and his creation of objects.

Gardner, 1973

Teachers and children often share gifts of the heart in some of the most unexpected places.

Learning and meaning come to a person through three main sources. These are generally regarded as *cognition,* conveyed through knowledge, comprehension, application, analysis, synthesis, and evaluation; *affect,* revealed through receiving, responding, valuing, organizing, and characterizing by values; and *psychomotor,* as evidenced by body awareness, spatial awareness, balance, and fundamental motor skills. Woven throughout these domains of knowing and learning are the more subtle aspects of our humanness that form the foundations for who we are and how we are uniquely different from each other. Our thoughts, feelings, multisensory perceptions, and imaginations enable us to be different from one another just as our fingerprints are all different and unique.

It is significant that the interrelationship of thought, feeling, and action that characterizes the creative experience is also the focus of the "whole-child" approach to education. New ways of looking at human development, especially Gardner's theory of multiple intelligences, have certainly led to a heightened concern about teaching practices that foster the development of the child's thoughts, feelings, and physical activity. The arts have tremendous potential for broadening and stretching our understanding of these seemingly diverse modes of learning. Our thoughts, emotions, actions, and imaginations operate simultaneously. It is the connection of these to the creative arts process that evokes the types of receiving and responding that enable children to grow affectively as well as cognitively.

Because the arts are naturally inviting to young children, it is through these creative endeavors that children gain the experience they need for further development in the affective domain. When children are involved in expressing their feelings, as well as using their power of imagination, sensory responses, and thinking processes, growth in all three domains of learning is broadened and deepened.

Children share the spontaneity—the natural propensity to create art—not different from accomplished artists, while lacking the inhibitions about the end product or the self-consciousness about perfection in performance that interfere with the creative process of adults. As children receive sensory impressions and express them through the arts, they begin to build an ordered conception of their world. The creative arts encounter offers openness to multisensory expression found in few other disciplines. When children's experiences include the elements of touch, sound, and visualization, they are extending their horizons of perception and enlarging their capacity to perceive their world more richly.

In the act of creating art, children look inward and are closely in touch with their feeling states. This, in turn, enables them to be more flexible and open in their ability to express emotions as they arise. It is through this process that children's affective content is permitted to surface and be expressed; they develop the ability to experience and express emotion as it arises. Children need both affective and cognitive abilities to function effectively in the world. The arts and creative experiences both nurture and enhance the development of affective ways of knowing and learning that are inherent in all human beings. The search for an organized expression of feeling, knowing, and acting is a part of every child's consciousness and therefore must be an integral part of their educational repertoire. What may be of even greater importance is that the arts, filled with the richness of texture, the wealth of color, the fluency of movement, and the beauty of words, provide children with the positive affect that is a part of the magic of self-understanding and self-validation.

Once while attending the National Training Laboratories Institute, (N.T.L), I asked the facilitator of my group to tell me when I would know that I was meeting all of the needs of my kindergarten children, or if that was even possible. She answered my question later when she gave me a slip of paper on which she had written a bit of Jungian wisdom. I read her note, but I did not fully understand her message. A few days later, I experienced the "aha" when the meaning of Jung's words became crystal clear. I now consider her note to be one of the greatest gifts of my teaching career:

> There are, besides gifts of the head, also gifts of the heart, which are no whit less important, although they may be easily overlooked because in such cases the head is often the weaker organ. (Jung, 1954, p. 199)

Jung's quote became a metaphor for me. It dissolved all of my confusion about how I should teach and helped me to understand why the gifts of the heart, the "affective domain," are so very important to our view of children as well as to our view of self.

The term *affective* is used throughout this book because it is more inclusive than *feelings* or *emotions*. As a guide to affective development, each chapter focuses on one component of the continuum of development in the affective domain. The affective-based experiences provide numerous learning activities designed to provide a structure through which you can attend to your own affective development. They range from inviting you to become involved in basic human interaction encounters to integrating personal creative expression into your own professional and personal life. You will find these activities at the end of each chapter under the heading Personal and Professional

Growth. You are encouraged to participate in these at whatever level you feel most comfortable. You will also be invited to take part in all of the creative process activities that are designed for your children to enjoy. As you read the chapters and participate in the actual process of creating and making your own works of art with the here-and-now materials provided, you will begin to understand the impact that consciously attending to your own affective development can have on your growth as a teacher.

Although theory is always with us as we think about how we can be better teachers, I remember from my four years in a teacher preparation program how I was sometimes confused by the magnitude of definitions I had to sort through and the explanations I was supposed to understand. Aline Kilmer must have known how I felt when she penned the following words:

> Many excellent words are ruined by too definite a knowledge of their meaning. (Attributed to Aline Kilmer, 1954, p. 103)

I agree with Kilmer and the notion that simpler is sometimes better. For this reason, I offer the following definitions for clarity of discussion. Remember, though, that no matter how simply (or how eloquently) definitions are worded, there are always other interpretations and points of view.

Affective: existing in the feeling or disposition to honor the quality of our emotions; the emotional aspect of experiencing and learning, including our wishes, desires, joys, fears, concerns, values, and attitudes as influenced by our memories, our perceptions of events and other people, or our ideals

Emotions: nonverbal states of consciousness in response to our environment, internal state, or experience

Feelings: descriptors given to emotional states regarding the personal meaning of something to the person experiencing an emotion

Domain: belonging to something contained within certain limits, a sphere of activity or dominion

Creativity: the proactive, purposeful impulse to extend beyond the present, characterized by originality, imagination, and fantasy

Learning: the differentiation, integration, and generalization of experience

The Continuum of Affective Development

Development in the affective domain occurs on a continuum, beginning with one's willingness just to be open to experiences and concluding with our exhibiting a lifestyle that is related to a particular phenomena, in this case the arts. A brief overview of the continuum is presented here so that you can become familiar with the terms. Each category will be discussed in detail in later chapters.

Receiving: refers to one's willingness to *attend* to particular phenomena (music, visual arts, drama, poetry, and dance)

Responding: refers to active participation on the part of the learner (singing, painting, acting, writing, dancing)

Valuing: concerned with the worth or value a person attaches to a particular object, phenomenon, or behavior (appreciation of the visual and performing arts)

Organization: concerned with bringing together different values and the building of an internally consistent value system (recognizes the role of the arts in the education process)

Value complex: a state in which an individual has controlled his or her behavior for a sufficiently long time to have developed a characteristic lifestyle (demonstrates self-confidence and self-reliance in engaging in artistic and creative endeavors)

An affective approach to studying creativity and the arts is based on the idea that self-knowledge—how you make sense of your affective qualities of being, developing, and learning—is a vital component of the "worthwhile" knowledge you need to become a teacher of the arts. Although not a newly professed goal in education, an emphasis on knowing oneself in order to actualize potential has perhaps not occupied the central position it should. The discussion that follows focuses on the concept of self-knowledge and the relationship of self-understanding to the creative and artistic process.

The Teaching/Learning Atmosphere

Everybody is intimidated about making marks on paper or marks on canvas. Freedom should be first before judgment and self-criticism.

David Smith, American sculptor

What conditions will make your involvement in the process of exploring the arts likely, and what type of classroom atmosphere will facilitate your involvement in the affective domain? An atmosphere that has the following conditions will help all of us to become more actively involved in the creative arts process:

1. **Psychological safety.** It is safe to try. This is the atmosphere that is created by all members of the group. Time and energy are spent on sharing information and building a sense of community. When we feel accepted by others, we are less threatened and more willing to enter into new experiences.

2. **Comfort zone.** We are assured that we can deal with events and are secure enough to take risks. We accept mistakes with ease and good humor and acknowledge our accomplishments and appreciate the accomplishments of others.

3. **Encouragement.** Peers, colleagues, and teachers encourage self-direction, self-motivation, and autonomy by initiating activities designed to extend knowledge, explore possibilities, and expand horizons. Everyone maintains an open and inquisitive mind.

4. **Fulfillment.** Our own beliefs and values about the arts and creativity are shaped by our experiences. We are open and receptive to learning and affirm our fulfillment with enthusiasm and satisfaction.

A group of my students identified the following aspects as necessary to enter into and respond to the creative process:

- being assured that I will not be expected to be talented
- being accepted by my peers
- trusting my professor to be nonjudgmental
- belonging to a community of learners
- having some choices in decision making
- genuineness on the part of the professor
- opportunities for cooperative learning
- appreciation of my cultural values
- shared problem solving
- clear expectations of my role in the class
- activities that foster cooperation rather than competition

A Family's Role in Developing Creativity at Home

Many experts believe that families of creative children enjoy spending time being directly and actively involved in the fantasy play and the creative efforts of children. In many ways, we believe that caregivers of creative children are childlike themselves. Ellermeyer (1993) reminds us that "parents can directly influence the development of creativity in their children by promoting fantasy in play and curiosity in the early childhood years. Parents of creative preschoolers are generally conceptually abstract thinkers, patient, flexible, open-minded, insightful, and afford their children a high degree of independence" (p. 61). The following environments are conducive to the development and nurturance of creativity of young children:

- provide many possibilities for cooperative role-play that children can change at their whim
- encourage children to create games with spontaneity, without family interference
- always have materials and items available for children to engage in "secretive" play, such as a blanket thrown over an old card table
- provide toys that promote creativity by allowing children to explore and discover, such as hard wooden blocks

Nurturing the arts must be considered in the early years because of the richness they bring to a child's life.

DEVELOPMENTALLY APPROPRIATE PRACTICE

The term *developmentally appropriate practice* is used throughout this book to refer to practices that are appropriate for children. The DAP (developmentally appropriate practice) and DIP (developmentally inappropriate practice) terms were conceptualized during the development of the National Association for the Education of Young Children's (NAEYC) accreditation system and are now widely accepted by teachers, parents, policy makers, and others in the professional arena who work with young children. In a position statement first published in 1987 and revised in 1997, NAEYC thoughtfully suggests that a high-quality early childhood program provides a safe and nurturing environment that promotes the physical, social, emotional, and cognitive development of young children while responding to the needs of families (Bredekamp & Copple, 1997).

Developmentally appropriate practices as outlined by NAEYC address five major factors that affect quality programs for young children:

1. age appropriateness and individual appropriateness,
2. curriculum,

3. adult–child interaction,
4. relationship between the home and program, and
5. developmental evaluation of children.

Each of these areas is discussed at length in clearly defined terms. The format of these discussions includes specific examples that contrast developmentally appropriate practice with inappropriate practice. There is enormous value in these clear and easy-to-read examples. For example, appropriate practice for a primary-grade curriculum is described as "designed to develop children's self-esteem, sense of competence, and positive feelings toward learning." In an adjoining column, inappropriate practice is described as "Children's worth is measured by how well they conform to group expectations, such as their ability to read at grade level and their performance on standardized tests" (Bredekamp & Copple, 1997, p. 23).

The chapters that follow will provide you with more information about DAP in music and movement, the visual arts, drama, three-dimensional art, and literature. As you read more about DAP, you can begin to make knowledgeable choices about how you will design creative arts experiences for your children.

Table 2–1 provides an overview of the themes discussed in Chapter 1. It presents an advance planner for exploring the stages in the creative process, the continuum of the affective domain, multiple intelligence theory, and personal and professional growth. This advanced organizer should prove useful as you continue your reading and classroom activities.

PERSONAL AND PROFESSIONAL GROWTH

It is now time for a transition. You have worked alone, you have read many words and definitions that have given you a lot to think about, and you have reviewed a variety of opinions about the arts and the creative process. I imagine that more than once, you have brought your own experiences to this process and, hopefully, you have taken some time to look at your own inner resources.

In addition to the implicit goals of this book and the themes woven throughout these pages, this journey continues with an emphasis on some of the personal and professional ideals that affect your own growth as teachers of young children. The topic is *support systems* and who and what we need as support in our role as teachers. To whom can we look for support, how do we define people who support us as teachers, and how do we know if we are getting the support we need, both personally and professionally? The next activity focuses on these questions and provides a forum for discovering some answers.

Developing a Personal and Professional Support System

Teaching has been referred to as a lonely profession. Preservice teachers in seminars and professional teachers in graduate school, workshops, and short courses often reveal feelings of isolation due to a lack of opportunity to discuss educational ideas and professional issues with friends and colleagues. It is ironic that, in a profession in which we interact with children every minute of the schoolday from morning until afternoon, we find ourselves isolated from each other. With all the demands

TABLE 2–1 Personal and Professional Growth in the Creative Process

Stages in the Creative Process	Continuum of Affective Domain	Multiple Intelligences Theory	Personal and Professional Growth/Your Affective Development
	Chapter 1: • Setting the Stage • Beginning the Journey		
	Chapter 2: • Understanding the Creative Process		• Developing a Personal and Professional Support System • Support System People
	Chapter 3: • Attending/Receiving • Exploring Feelings and Images		• Searching for That Special Teacher
Preparation	Chapter 4: Responding • Introducing Music and Movement	Musical, Bodily Kinesthetic, Logical-Mathematical Intelligences	• Instrument Improvisation
Incubation	Chapter 5: Valuing • Celebrating the Visual Arts	Spatial Intelligence	• An Awareness of Self
Illumination	Chapter 6: Organization • Encouraging Play and Creative Drama	Personal Intelligences	• Steps Toward Integration • Your Gunnysack
Verification	Chapter 7: Value Complex • Experimenting With Three Dimensional Art	Naturalist Intelligence	• Teaching: Attitudes, Beliefs, and Behaviors
	Chapter 8: • Planning for Literature	Linguistic Intelligence	• Poetry for Teachers
	Chapter 9: • Beginning a New Adventure		• Gifts From the Wise One • Good Words

placed on us, it is rare when we have the time or luxury to talk about experiences or issues that influence our effectiveness as professionals. Indeed, it is even rarer when we, who are learning the skills for guiding and supporting children, have the opportunity to develop the skills for guiding and supporting each other. By developing and implementing a systematic means of gaining and giving support, we can all take real steps to stop the primary causes of isolation and gain the support we so rightly deserve.

You can use the following structured experience, Support System People, for several purposes, depending on your own individual situation:

1. You can reestablish contact with friends and colleagues who share similar personal and professional concerns.

2. This could be a golden opportunity to establish new relationships that can provide support when you experience stress, tension, or conflict, whether in this class or other courses in which you are involved this semester.

3. Enter into this activity with the idea that you can develop new skills and identify resources that will contribute to your personal and professional expertise. Look to your colleagues and your instructor as potential sources for leading to a larger network of support as you continue your commitment to being an effective and supportive teacher.

This is a small-group activity with four or six people in each group. You will each need paper and pencil.

Procedure

1. As a first step in looking at your own internal support systems, list at least three things that you do well or three qualities that you value in yourself. After a few minutes, choose a partner and use *I* statements to talk about your internal strengths. For example: "I value my honesty," or "I work very well with children." Use this opportunity to maximize your internal strengths and practice giving yourself credit for these strengths.

2. Stress is a major reason why we all need support. To help you get in touch with the stresses in your life, think of three things that cause you stress and write them on your paper. These might be physical, environmental, interpersonal, or simply the generalized stress that human beings encounter in day-to-day living.

3. After everyone in your group has identified his or her stresses, find partners and spend a few minutes talking with each other about all these stressful things.

4. Take a look at your current support system and identify the people who are providing support for you. You can do this by completing the form provided and writing down the names of all of the people who supply support in the special areas (see Figure 2–2).

5. When everyone has had time to complete the form (usually 15 to 20 minutes), join your partner again and spend a few minutes talking about the status of your current support system. Consider the following questions: Is my current support system balanced? In what areas do I need more support? What would I like my support system to give me? What do I have to offer someone else? How can I increase my current support system? Am I "overloading" any one person?

6. When you think you have completed an accurate assessment of your support system, return to the large group. The whole group should talk about any insights, discoveries, feelings, or thoughts that may have occurred during the process.

During the semester in which I wrote this book, one of my students came to me after class concerned that his support system list was lacking in what he perceived as being very important areas. I confessed that mine, too, is seldom fully balanced and that, as teachers, we must utilize all of the wonderful colleagues and peers we have in our day-to-day lives as possible members of our professional and

FIGURE 2–2 Support System People*

Below is a description of some of the functions human relationships can provide. Read the descriptions and enter the names of the people in your life who fulfill that function in your relationships with them. Think of friends, family members, neighbors, and colleagues. Although some individuals in your life can fulfill more than one specialized function, try to think of individuals who provide you with a special resource.

Function	People
Intimacy. People who provide me with closeness, warmth, and acceptance. People who allow me to express my feelings freely and without self-consciousness. People I trust who are readily accessible to me. People who provide nurturing and caring.	_____ _____ _____ _____
Sharing. People who share common interests or concerns because they are "in the same boat" or in similar situations. People who are striving for similar objectives. People with whom I share experiences, information, and ideas. People with whom I can exchange favors.	_____ _____ _____ _____
Self-worth. People who respect my competence in my role as a student, preservice teacher, teacher, or administrator. People who understand the difficulty or value of my work or performance in that role. People I respect who can recognize my skills, especially when I may be unsure of myself.	_____ _____ _____ _____
Crisis/Overload. People who can be depended upon during a crisis to provide assistance. People who provide tangible services or make resources available, often experts in solving particular kinds of problems and not necessarily the type with whom I would choose to have a close personal relationship.	_____ _____ _____ _____
Stimulation/Challenge. People who can motivate me to explore new ways of doing things. People who challenge and stimulate me.	_____ _____ _____ _____

*Adapted from a Human Interaction Laboratory, NTL Institute. Bethel, Maine, 1993. Used with permission.

personal support group. As I said at the beginning of this exercise, to ask for support does require some element of risk, but in my experience with other early childhood professionals, when I have asked for support, there has usually been someone in the same situation who not only was glad to offer assistance but also was honored that I should ask in the first place. Early childhood educators seem to have an understanding of all of the human characteristics of intellectual, social, and emotional needs and expectations. We also have great expectations for meeting the needs of our children. We should be equally as aware of the nurturing we need as the teachers of these children. I encourage you not to understimate the support your peers can provide. The affirmation is immeasurable.

Creative minds have always been known to survive any kind of bad training.

Anna Freud

chapter 3

Exploring Feelings and Images

It is only with the heart that one can see rightly;
what is essential is invisible to the eye.

A. Saint Exupery, *The Little Prince*

*I*magine that you are floating in a beautiful tropical sea. The sun shines warmly, with golden rays of radiant light that seem to nestle on the water's surface and then curl all around you. Soft, fluffy clouds wander aimlessly in the sky above, and you feel light as a feather as you float effortlessly in these tranquil waters. The glimmering sea illuminates the pastel blue of the sky, reflecting the colors of turquoise and aquamarine on the surface of the water below. As sunbeams reflect on the water, you can see the clean, white, sandy bottom; the sand glistens like scattered pearls. A gentle breeze purrs through the air, and the soothing water around you makes little lapping sounds. In the distance, you hear the soft tinkling of wind chimes floating across the air from a passing sailboat. You are very close to the shore and can dip your hand into the shallow, shimmering, sun-warmed water to touch a pink abalone shell. Turn your head and see the light rays dancing on the small rippling waves. Look across the surface of the water and see the nearby sandy beach. You see lush green plants, tall swaying palm trees, and exotic, fragrance-filled wild orchids. It is a lazy summer afternoon, and you are fully present with yourself and the luxurious comfort of the water. You feel relaxed, safe, and content in this tropical paradise.

When I prepare my syllabus for the course Curriculum and Development in Early Childhood, I always include a cover page on which there is just one line. This quote by Sylvia Ashton Warner is the first thing my students read when I give them their syllabus for the course: "Before I can teach others, I must first teach myself" (1964, p. 6). One of the most important things we can do as aspiring teachers or seasoned educators is to acknowledge our own potential for growth in the affective domain and to be aware of the emotional and personal self-growth that either takes place or does not. In Chapters 1 and 2, I discussed creativity, multiple intelligences, affective development and the arts, self-knowledge, and the teaching–learning atmosphere. These discussions provide a foundation for building your understanding of the impact affective development has on our ability to be successful teachers and creative individuals. As you read and responded to your own thoughts and ideas about these areas of study, you should have begun to understand and appreciate the relevance of affective considerations and their impact on your growth as a teacher. Jung emphasized the importance of the affective domain in the education of teachers as being essential to adults who choose teaching as a career: "What the educational system must provide is not just brilliant teachers, but teachers who can touch our human feelings and on whom we can look back with appreciation and gratitude" (1954, p. 144). A more recent research study (Walls, Nardi, Von Minden, & Hoffman, 2002) concluded that the affective domain was significant in students' descriptions of the best teachers they had encountered. "Caring about students was

particularly prevalent in the description of effective teachers. They were described as warm, friendly, and caring. Conversely ineffective teachers were said to create a tense classroom, and were described as cold, abusive, and uncaring" (p. 45).

The affective development of teachers cannot be more important than it is today. For these reasons, and more, it is critical for us to be thoroughly knowledgeable regarding the theories of affective development and research that support the inclusion of the affective domain. Both provide a clear rationale for giving affective education equal status with intellectual development. With all of this in mind, let's look at some important information researchers and educational leaders have provided. The writings of these scholars are important to our knowledge and understanding. Further, it is of paramount importance for us to be articulate when conveying the value of affective development to each other, parents, and administrators. For us to be articulate about the nature of the affective domain and the relationship between the affective elements of knowing and learning and the creative arts, we must first have a clear understanding of what this all means to us as teachers. In the sections that follow, I discuss teacher education and the affective domain and provide information relating to some of the research that supports this area of study.

The Affective Domain

The affective domain pertains to the practical life—to the emotions, the passions, the dispositions, the motives, the moral and aesthetic sensibilities, the capacity for feeling, concern, attachment or detachment, sympathy, empathy, and appreciation.

Sterling M. McMurrin, 1967

As teachers and future teachers, we have an intuitive understanding of how our emotions, feelings, and other affective states affect how we interact with children and with each other. There are essential personal qualities and skills required of those of us responsible for teaching young children. The inclusion of affective education is not only necessary; it also is an area of human development that must be addressed if we are to be truly successful in our efforts to educate the whole person. As teachers, we must find a balance between cognition and affect. When we develop instructional objectives based solely on the cognitive domain (comprehension, application, analysis, synthesis, and so on), we are not presenting a balanced approach to all of the ways in which children can learn. To achieve this balance, education must be concerned with the total person, with the development of all domains of learning.

The process of educational reform is well underway. Educational practices that have been constrictively narrow and inadequate in facilitating the development of *all* areas of human potentialities are being countered by reform that gives more prominence within the curriculum to the affective and emotional needs of individuals. These changes are based, in part, on the rapid changes occurring on our planet, and a demand for relevance to the individual and accountability for the collective needs of our society. Early childhood educators realize the importance of

swinging the back-to-basics pendulum to a more balanced position between skill acquisition and affective ways of knowing and learning. Most teachers understand that simply to address the portion of the anatomy from the neck up is not enough. We are more than our thoughts; we are also feelings and emotions.

Proponents of affective education recognize the development and understanding of personal knowledge (feelings, desires, fears, concerns, values, attitudes) as essential to living in our human society. In her classic work *Teacher,* Sylvia Ashton Warner (1964) encourages us to look toward a balance between cognition and affect as a means of helping children grow up in their own personal way into creative and interesting people. Valett expands on Warner's ideas regarding the importance of affective education when he writes:

> If education is to prepare individuals to live joyous, humane, and meaningful lives, it must be concerned with helping to prepare them to more adequately cope with human needs. If a person proves incapable of meeting his needs together with those of others in his social system, it is improbable that he will be able to live a joyful, humane, or meaningful life. (Valett, 1977, p. 13)

These observations can be summarized by Tolstoy's thoughtful analogy that "People cannot be treated without love, just as one cannot handle bees without care. Such is the nature of bees, if they are carelessly handled by a person, they hurt both themselves and him" (Tolstoy, 1963, p. 317). Thus, he goes straight to the heart of affective education.

Teacher Education and the Affective Domain

Affective education is not new. The ancient Greeks were among the first to stress the importance of developing the whole person, including intellectual, physical, *and* affective potentialities. During the 18th century, Jean-Jacques Rousseau (1712–1778) gave us his description of the ideal education in *Emile.* He specified affective education with great detail by outlining a curriculum for educating the "natural man" who would be capable of living and *feeling* life to its fullest potential.

Since then, modern scholars of affective education have furthered the ideas about the importance of expanding the content and kinds of knowledge that can be explored through the affective domain. Dewey (1950) was among the first contemporary theorists to propose that schools give time and attention to affective development as an integral part of the total school experience. In the early 1970s, Weinstein and Fantini developed a comprehensive curriculum for affective education that was implemented in the inner-city schools of Philadelphia. Their clear vision statement has relevance for the challenges teachers face: "Education in a free society should have a broad human focus, which is best served by educational objectives resting on a personal and interpersonal base and dealing with students' concerns" (Weinstein & Fantini, 1970, p. 18). If we move forward a few years, we will find that the ideas of these scholars, from the Greek sages to contemporary theorists, are being further developed, conceptualized, and written into all areas of the curriculum.

Let's continue moving through this mini history lesson by noting the contributions of Carl Rogers and his views on the importance of linking teacher education to affective education. Rogers (1961) wrote extensively about positive regard, respect, and caring as being essential to any helping relationship. Some of you may not have thought of teaching as being a helping relationship, but if you consider all that we do with and for young children, there is no escaping the fact that teaching is indeed one of the most important of the helping professions. Each of our classrooms is a small community of learners engaged in activities designed to meet our needs and the learning needs of our children. As a teacher, you provide the base from which learning experiences are launched. If one accepts Rogers's views and believes that a teacher's role is, in part, a helping relationship, then it is reasonable to assume that we are responsible for designing educational settings that create an atmosphere that facilitates free expression of ideas and affect and encourages individuals to know and accept themselves—in other words, to grow "affectively." I agree totally with this view of education. The great teachers I have known have always understood the power inherent in a positive classroom atmosphere and have been keenly aware of the value of an individual's needs for affective expression, whether the student was four or forty years old.

The foundation laid by these early writers is the focus of several prominent writers of the 1980s and 1990s. As a result of years of study, Snow (1991) concluded that the cognitive and affective elements of teaching and learning must be thoroughly integrated in all educational endeavors. Gardner (1991) calls for a restructuring of our schools and urges us to teach by using approaches with an openness to affective expression, and Wood (1996) encourages educators to view affective education in the schools as being one of the most important aspects of total human development. The messages of these scholars are well worth our keeping in mind. However, recent research is also available for us to consider.

What Does the Research Tell Us?

There are literally hundreds of research studies that support the inclusion of affective education in the curriculum. I have selected some of the studies I think have particular relevance to teacher preparation and education. Those of you who have a special interest in research and how conclusions are drawn from research studies should examine the articles referenced in this section. They will provide you with detailed information regarding the structure and design of the studies discussed in this section. For the time being, take note of the findings and think about how the research relates to your growth as a teaching professional.

Jausovec (1989) suggests that there is evidence linking affective states to the development of insight. Insight can be closely associated with the moment of "aha" described by Wallas in his stages of the creative process. Considering what you have learned so far about the affective domain, what conclusions can you draw about the relationship between the affective elements of feelings, concern, or empathy and the development of insight? Dudek and Verreault (1989) and Russ (1988, 1996) found substantiated relationships between access to feeling-related thoughts and divergent thinking. When we are open to feeling-laden thoughts and affective

states, we are aware of the cognitive material in our experiences, and it is the affective content that heightens our sensitivity to the material. We may find affective pleasure in the challenges the material presents (excitement and tension when working on a task) or find deep pleasure and passion when solving a problem or completing a task. How do these affective processes relate to our capacity for divergent thinking—thinking that encompasses free-association, open-endedness, fluidity of thought, and unexpected ideas?

When narrowing our review of the research to focus specifically on your role as a teacher and the children in your classroom, there is still more for us to learn. Stout (1999) reported that effective teachers possess more warmth and empathy than do ineffective teachers. The characteristics of warmth and empathy and our ability to convey these to children are deeply ingrained in the affective domain. These are feeling states and intrinsically motivated abilities that enable us to connect with the affective-laden experiences of our children. The important message being proposed by these research findings is that children are more likely to exhibit positive growth if their teachers communicate high levels of warmth and empathy than those taught by teachers who provide minimal levels.

In Chapter 2, I talked about the classroom atmosphere and conditions that encourage creativity. Classroom atmosphere also has an impact on other aspects of learning. Good and Brophy (1987) found that teachers who exhibit caring and a positive philosophical attitude toward children create more pleasant classroom atmospheres where children actually learn more. The Walls et al. (2002) research also reported on the importance of a pleasant classroom environment:

> Effective teachers were said to know how to create an effective learning environment. They were organized, prepared, and clear. Ineffective teachers consistently were indicted for their inept pedagogy, boring lectures, and unproductive learning environments. Effective teachers were described as caring about learning and teaching. "Enthusiasm" or "enthusiastic" often appeared in these descriptions. (p. 47)

In addition, Walls et al. (2002) conclude that their best teachers focused on classroom activities that involved the students in authentic learning, interactive questioning, and discussion. Affective education is a necessary component for genuine learning, no matter what the age of the learner.

This cursory review of the literature supporting the development of the affective domain as a legitimate area of study should serve as a constant reminder as to why affective development that includes attitudes, interests, appreciations, feelings, emotions, and predispositions is critical to all areas, aspects, and levels of the education process. In his essay "On Scientific Truth" (1934), Einstein noted that "Not everything that counts can be counted and not everything that can be counted counts." These wise words reflect the subjective nature of growth in the affective domain . . . it is part of those magic doors that we do not see, even as we are passing through.

With all of that said, I want to take a look at what goes on inside a person who guides the development of the affective domain. The words of the fox, uttered to the little prince when they were preparing to say goodbye, presents the more humanistic side of affective development, which in many cases strikes a chord much closer to our own personal experiences.

It is only with the heart that one can see rightly; what is essential is invisible to the eye.

A. Saint Exupery, *The Little Prince*

Think of these wise words as an analogy. If the cognitive domain focuses on aspects of knowing through our intellect, the affective domain focuses our awareness on our hearts. Education cannot be fully effective without the inclusion of affective considerations. The relationship between basic human concerns (our needs, emotions, attitudes, and values) and learning is inextricable. We know that the inner needs for a positive self-concept, identity, and connectedness that individuals bring to a learning environment have a powerful influence on the learning process. These are the intrinsic drives that motivate each of us to want to learn. The intent of including the affective domain is not to assert its primacy over cognition or to erect a wall between cognition and affect. It is, rather, a way of legitimizing the ways in which we learn about our beliefs, attitudes, feelings, and concerns to facilitate a harmony between affect and cognition. When we have this balance, learning can occur at an optimal level.

Affective Characteristics of Teachers

The affective characteristics of teachers often make the biggest impression on learners and seem to have the most lasting impact on the lives of students. Over the past several years, I have been conducting a research project with graduate students enrolled in the creative arts course. Every semester we identify those characteristics we most remember about our favorite teachers. Included in the criteria for "favorite teacher" are items such as

1. the teacher who influenced me the most,
2. the teacher whom I knew liked and respected me,

In becoming a teacher, you must develop very specialized sensitivities to children's feelings, thoughts, wishes, interests, and special capacities or gifts they may have.

3. the teacher who most positively impacted my life, and
4. the teacher I would most enjoy seeing again.

Review your course syllabi for this semester. Identify and list objectives or activities that focus on the affective development of children or that address the affective domain of knowing and learning of college students such as yourself.

The results have shown overwhelmingly, across semesters and with each different group of students, that favorite teachers are positively correlated with the affective characteristics they exhibited when teaching. The majority of the descriptors graduate students use when identifying their favorite teachers are related to the affective domain: *feelings, concerns, interests, desires, values,* and *attitudes.* Attributes associated with the cognitive domain, such as knowledge of content information or problem-solving abilities, are always included but are usually far down the list of words used to describe memorable or favorite teachers.

The affective component of knowing and learning is often referred to as the "hidden curriculum." It is expressed in incidental learning or modeling that takes place when, for example, your children remind you that you are not wearing the charm bracelet you usually have on your wrist each day. In your own situation, you may become aware that when talking to a group of children you are using your hands or turning your head in very much the same way as your favorite professor does in class. In the case of teacher education, the hidden curriculum often surfaces in the process of learning about ourselves as we explore affective content. As an initial step toward exploring the affective domain, this chapter introduces the technique of *guided imagery* to encourage you to experience the first major category on the continuum of development in the affective domain. We will start with the first level of the taxonomy of affective development, which is *receiving.*

The Continuum of Development in the Affective Domain: Receiving/Attending

Receiving (or *attending*) refers to your willingness to attend to the existence of certain phenomena or stimuli. Receiving implies that you will listen attentively and be aware of what you are experiencing in the here and now of the moment. An important goal of the work you will be doing as a teacher is to develop an increasing awareness and sensitivity to your imaginative and creative potential. You will be focusing on a different kind of content—the content of self. This process of learning about ourselves is really not very different from the self-knowledge units we prepare for children, which are given titles such as All About Me. In addition, just as we want children to learn more about others, as well as themselves, when involved in a self-knowledge unit, you should become more aware of your attitudes and feelings about the community of adult learners of which you are now a part. This is an important step in confidence building, in supporting each other, and in understanding your own ability to be imaginative and creative. At the same time, you will be experimenting with some new behaviors, laughing often, being serious sometimes, and all the while, loosening the reins on your imagination and your ability to imagine.

You are just coming together as a group and may be feeling some of the same feelings described in Chapter 2 by the students anticipating their class in creative arts education. I encourage you to establish an informal learning environment, to

be conscious of what you are experiencing, to respond positively to yourself and others, and to do your best to feel free from the anxiety of producing a product so that you can actively participate in the imaginary experiences to come. An atmosphere of trust and acceptance is necessary for learners of all ages to exercise their imaginations freely, to explore their own creativity, to develop spontaneity, and to discover personally meaningful ways to enter into the world of creative expression. According to Yenawine (2003), people can overcome their own fears and limitations by sharing observations and insights with others.

> A group of people brings a breadth of information and experience to the process, even if it is not experience with art. Importantly, the synergy of people adding to each other's observations and bouncing ideas off one another enables a "group mind" to find possible meanings in unfamiliar images much more productively than any individual alone could do. (p. 12)

The creative atmosphere must be relaxed, high in levels of trust, and low in competition. These are essential elements for a positive learning experience. Use this arena for experimenting, discovering, and recognizing your own talent for creative self-expression.

I chose to introduce the art of receiving in connection with guided imagery because, when coupled, these processes support each other and provide a relatively safe arena for you to enter what for some of you may be an "unknown land." As you begin your first experiences with guided imagery, be open to the affective states of receiving and attending as these processes may allow your imagination to create images and fantasies you have not experienced before. It is through this process that you can be an active participant without doing any "acting." On the surface, it will appear that you are passively participating, but the colors, the images, and the fantasy play that are created right inside your head are quite the opposite of passive; it is action, especially creative action, at its best!

Think of the following guidelines as an optional assignment. You can choose to become an active participant in the discovery process or you can close your mind to the affective pleasure you may gain from the rich images just waiting to bloom. The importance of actively participating in the art of receiving and attending is

1. to exercise your own imaginations,
2. to explore your own creativity,
3. to enhance your spontaneity,
4. to overcome your fears of performing,
5. to reduce your inhibitions,
6. to support each other while practicing imagery techniques, and
7. to exhibit your own creativity in a nonjudgmental atmosphere.

The next section includes a discussion about the brain, that wonderful piece of your anatomy that enables you to do all of the things about which you have been reading. From the frontal lobe to the stem that connects to the other parts of your body, your brain controls your ability to think, your capacity to feel, and your capacity to move a single finger simply by sending an internal message.

Two Hemispheres of the Brain

In his influential work on brain research for educators, *A Celebration of Neurons,* Sylwester (1995) wrote that "the brain is less like a computer and more like a rich, layered ecology of a jungle environment" (p. 18). Goleman (1995) reminded us that people actually have two minds: a thinking mind and a feeling mind. Sometimes these two minds work together and sometimes they work against each other. Goleman's description of how the brain evolved and how it functions makes the message very clear.

> From the most primitive root, the brain stem, emerged the emotional centers. Millions of years later in evolution, from these emotional areas evolved the thinking brain of "neocortex," the great bulb of convoluted tissues that make up the top layers. The fact that the thinking brain grew from the emotional reveals much about the relationship of thought to feeling: there was an emotional brain before there was a rational one. (p. 10)

There is general agreement that each hemisphere prefers certain tasks, and even though the whole brain is involved in all learning and information processing, it is well established that the left hemisphere is dominant for more logical, analytic, and verbal processing. The right hemisphere is primarily a synthesizer, more concerned with the overall stimulus configuration, organizing and processing information in terms of gestalts or wholes. The right hemisphere is responsible for space-oriented tasks; it is the seat of creative and artistic activity. In short, the right hemisphere is dominant in the ability to form images all at once and perceives the "whole" picture rather than the parts. The right hemisphere of our brains holds the seeds for insight and intuition and gives us the "aha" or "eureka" that Wallas (1926) talks about when discussing the process of creativity.

We have all known people who are highly verbal, logical, and analytical. Left-brain individuals operate through step-by-step reasoning and seem to excel in verbal tasks and sequential analysis. They remember facts in a computer-like fashion and have little difficulty in processing language related to reading, writing, and mathematical computations. People who are predominately left-brain do not long for a "mystical union with the universe"; they just want to know the facts. They use left-brain activity to assemble bits of information into a coherent whole. In other words, left-brain people move from the parts into the whole, whereas for right-brain individuals the reverse is the case. Scientists, mathematicians, and computer experts are good examples of people who prefer operating from the left hemisphere.

Right-brain individuals are holistic thinkers who rely on intuition and insight. These people approach life from the whole or gestalt, rather than operating in a sequential, step-by-step fashion. Much of the brain processing related to "seeing" three-dimensional images, patterns, and connections among patterns has to do with right-hemisphere activity. As mentioned earlier, the right hemisphere is the cradle of creativity. Artists, musicians, actors, and high-level managers are deeply involved in the holistic and simultaneous functions of the right hemisphere. We are only beginning to realize the importance of the research on specialization in the brain's hemispheres, but if it continues in the direction it is now going, the findings will lend a strong measure of support for educators developing systematic and

sophisticated curricula that facilitate the multiple-processing systems of both hemi-spheres of the brain. Including the arts as an established part of the core curriculum, all of which require right-hemisphere dominance, can provide the stimulation needed for right-hemisphere activity. The arts provide a catalyst for right-hemisphere activity and are critical to helping people experience and discover their visual, symbolic, cre-ative, simultaneous, and intuitive ways of learning. Figure 3–1 shows a general de-scription of the function of both hemispheres of the brain. Refer to this figure for clarification as you move into the next section about guided imagery and right-brain activity.

Guided Imagery and Right-Brain Activity

Guided imagery, developed out of the Gestalt movement in psychology, has been studied for the last 30 years (and was used for many more years before empirical studies became a measure of significant learning) as a technique for connecting an individual's body, emotions, senses, and perceptions. Mental imagery, our ability to make pictures in our minds, is also the focus of more recent research (Block, 1993; Gilkerson, 1998; Goff & Torrance, 1991; Myrick & Myrick, 1993). Guided im-agery, sometimes referred to as guided fantasy or fantasy journeys, is an important tool for allowing us to tap into the intuitive and creative abilities of our brain's right hemisphere. According to Yenawine (2003), "art is the most complex form of ob-ject and imagery" (p. 6). Guided imagery is a process of inner-directedness, of go-ing within and experiencing levels of consciousness where more images are accessible. These holistic, intuitive, and often insightful moments of consciousness provide a stage for perceiving many stimuli simultaneously.

Guided imagery provides adults and children with opportunities to create sym-bols and images that are flexible and original in thought. Our images are fluent and ever-changing. In the process of pretending and imagining, people can invent and elaborate on images that are as original and individual to them as their fingerprints. An image is not a product; it is an original perspective, a free flowing of ideas that comes to the individual through sensory and descriptive stimuli. Because guided imagery is a process and not a product, attention must be given to the process if it is to be developed.

Singer (1975) reports that there are two major systems for coding and storing material—a verbal-linguistic code and an imagery code. Throughout our own ed-ucational process, most of us became proficient in learning the verbal-linguistic sys-tem. Historically, schools have been concerned only with the linear and sequential processes of the left hemisphere of the brain and, at best, have given minimum em-phasis to the visual/holistic modes of consciousness and their functions. More re-cent emphasis on right-brain processing has begun to focus schools on the desirable outcomes of a more balanced approach to how people learn.

A classic example of how the imagery system works is the task of determining how many windows are in your house. Pause right now in your reading and con-sider the following question: "How many windows are in your house, apartment, dorm, or wherever you live?" Think about it for a moment before continuing to read. When asked to describe the number of windows in our homes, most people will close their eyes, create a mental image of their house, and then use the image

FIGURE 3-1 Left/Right Hemispheric Functions

Left-Hemisphere Processing	Example
Analysis	Analysis refers to the ability to separate something into component parts or constituent elements, such as conducting a scientific investigation into the properties of DNA.
Step-by-Step Tasks	We use this process when solving a complex mathematical problem, diagramming a sentence, or following the directions for programming our VCR.
Logic	We use logic when drawing reasonable conclusions based on inference, demonstration, or events, especially as distinguished from invalid or irrational arguments. The deliberations of a trial jury reflect logical processing.
Verbal Tasks	We use verbal tasks when we speak or write. Reading, writing answers to exam questions, and talking our way out of a difficult situation, such as why we shouldn't get that traffic ticket, are examples of how we use the left hemisphere when processing language.
Facts, Computations, and Linear/Sequencing	An example of using facts to compute anticipated outcomes is a person who recalls a wide range of materials, such as weather patterns, and then draws conclusions about the number of hurricanes that will form during a year's time.

Right-Hemisphere Processing	Example
Visual, Spatial Tasks	The painting of a picture or the process of designing a navigational system are examples of how we use visual, spatial processing.
Holistic or Gestalt	When we speak of a holistic or gestalt view of ourselves or the world, we are referring to our ability to be aware of how we integrate the cognitive, affective, and physical states of being. The gestalt or whole occurs when the three domains of knowing and learning are so completely integrated that all domains are interdependent each upon the other. This constitutes a harmoniously functioning human being.
Intuitive	This is our ability to "know" something without rational thought or direct inference. The word comes from *intuitionism,* a doctrine that states that there are some basic truths that we know intuitively. When you say to someone: "It just feels right," you are using your intuition!
Nonverbal Tasks	When we use body language, such as rolling our eyes when we disagree with someone, or when we cross our arms across our chest to define our personal space, we are using nonverbal gestures to express our thoughts.
Images, Dreams, Insights	Think of the images that came into your mind when you were reading the guided imagery about swimming and floating in the tropical sea. Remember the last time you found yourself gazing out the window, while allowing your mind to wander into a daydream, or the moment when you experienced the "aha" or "eureka" when contemplating the solution to a problem? These are all examples of how the right hemisphere gives the gifts of images, dreams, and insight.

in their mind's eye to actually see the number of windows and where each is located. We remember quickly when visual images are evoked. Guided imagery allows us to respond to our imagery codes *before* using our verbal-linguistic system, which in many cases is insufficient for the task.

Right-hemisphere processes such as visual, intuitive, imagining, feeling, and nonverbal ways of knowing are beginning to take their place as a critical dimension of the teaching-learning process. The even better news is that the arts, in all their varying ways of touching our intuitive, feeling, and imaginative creative potential, are now recognized as a "core" subject that can, in effect, open the window to learning through the right hemisphere.

We have certainly not come full circle in our efforts for a balanced curriculum. We are, however, beginning to make the shift toward redressing an imbalance that has traditionally emphasized the left hemisphere over the right. A balanced approach to human development that includes art, music, dance, drama, and all of the other art forms sets the stage for the buds of consciousness in both hemispheres to develop and flourish.

Guided Imagery and Creativity

Guided imagery can be used as a tool for unlocking creativity. It is a process that combines our inner states of awareness (or consciousness), personal experiences, and imagination in a free flow of thought or visual representation. Guided images are planned experiences, read or spoken by someone other than ourselves, that provide stimulus words or suggestions during a state of relaxation. The words we hear serve as a guide to our own creative abilities to make mental pictures, and each of our images is as different as our life's experiences. Our "mind's eye" is unique to us and the perceptions we bring to our ways of knowing and creating. Murdock (1987) offers us a visual metaphor for guided imagery when she writes: "Using imagery is like eating an artichoke. When we peel off the tough outer petals of the artichoke, we find the softer, more subtle inner petals and tasty core of the fruit" (p. 10).

A key element in encouraging the use of imagery is relaxation. When we are relaxed, our heart rate slows down, we let go of tension, and we are able to momentarily "quiet" the external chatter and distractions of the outside world. As we relax and acknowledge our ability to "come to quiet," we allow deeper thoughts and feelings to emerge and images to form much the same way as they do during daydreaming. It is in this period of relaxation that the inner-directed activities of the right hemisphere increase. The words or sounds that serve as a catalyst provide us with opportunities to focus inward in order to explore visual, intuitive, nonverbal states of awareness.

The process of "making pictures in your mind" facilitates artistic expression, personal awareness, and awareness of others. Time and space are not a problem during imagery. We can go places we have never been; we can become anything or anyone we want to be. We can visit a familiar place that has special meaning, or we can have an adventure that we might not, realistically, be able to have during the reality of everyday life. For example, we cannot actually fly as an eagle with outstretched

wings, but in guided imagery we can catch the wind that lifts the wingspan of a golden eagle and soar in unison to see the vastness of the Earth through the eagle's eyes. If you ask a colleague to tell you about an eagle, she will usually respond with facts stored in the left hemisphere of her brain. If you ask her to *become* an eagle and tell you how it feels to glide with the clouds over the tall peaks of mountain terrain, she will call upon the insights of right-hemisphere activity.

Thinking About Guided Imagery and Self-Actualization

Guided imagery opens a door to what Maslow, one of the most influential leaders in humanistic psychology, described as "inner-directedness" and the need of human beings to be quiet, listen to themselves, and pay attention to what is happening within. Maslow's insight into the journey toward self-actualization is particularly relevant to this discussion of guided imagery because Maslow believed that inner-directedness, or the ability to focus on the present moment, is a dimension of self-actualization. Self-actualizing people are mentally quiet, direct attention within, and listen to their inner selves. When individuals are inner-directed, they are more spontaneous in the here-and-now moment (Maslow, 1971). As we become more mindful of our images, the immediate time frame of the moment creates a heightened inner-directedness. We consult our own personal collection of learnings, experiences, emotions, and impressions to create personal images that belong only to us.

When I examine myself and my method of thought, I come to the conclusion that the gift of fantasy has meant more to me than my talent for absorbing knowledge.

Albert Einstein

In our stress-filled, hustle-bustle world of high-performance expectations (both from within and from external sources), we might be well served also to listen to what Maslow (1971) has to say about anxiety. Remember what my own students had to say in the creativity course: "reserved panic," "reluctance to enter," "hesitating," and feeling "petrified of being judged on a perceived lack of talent." Maslow was not unlike anyone who listens and pays attention to the wisdom others can bring to their journey for finding peace and quiet in the complexity of their inner world. He also reported that outer-directed individuals experience a great deal of stress and anxiety because they perceive the future as being out of control. The self-actualizing person has the ability to "stop" listening to the demands of the outside world and the verbal chatter of the left hemisphere in order to be in tune with deeper and more personal thoughts and feelings.

Why Study Guided Imagery?

If you were to conduct an electronic search for articles and books (using the ERIC database, for example) lending support for visualization techniques in the educational process, you would find many references on right-hemisphere activities that encourage imagining and on educational implications for using guided imagery as part of the curriculum. Educators use guided imagery in a multitude of ways. Silvestri, Dantonio, and Eason (1996) report that students who practiced relaxation/imagery response improved their ability to control acting out behavior. They also report that the technique helped students minimize the effects of stress and anxiety when taking standardized tests. Imagery used before reading or listening to

stories can help children learn to sequence events or consider possible outcomes or alternatives. Gambrell and Koskinen (1982) found that children involved in guided imagery before reading had a higher level of literal comprehension than those who were involved in the imagery after they had read the story. A later study (Gambrell & Bales, 1986) concluded that involving poor readers in guided imagery "encouraged constructive processing, continued effort, and sustained concentration" (p. 21). Through imagery, children make connections between their own experiences and the words on a printed page.

Close your eyes and picture the last place where you enjoyed a vacation or a special time of relaxation. Take a private imagery journey and see if you can experience the colors, textures, smells, sounds, tastes, and feelings you had while you were there.

Educators are not the only professionals for whom imagery is a relevant and important resource for incorporating creativity and imagination into ways of knowing and learning. The scientific and medical communities also recognize the importance of imagery in the development of individual creative potential, the ability to focus, a more open-minded approach toward problem solving, and the achievement of new levels of human growth and development. The next section takes a look at how imagery is used in professions outside the education realm.

Imagery in Other Professions

Mathematicians and scientists use imagery when solving problems or imagining solutions to scientific investigations. NASA uses guided imagery techniques in astronaut training as a means of "cognitive rehearsal" for the myriad of events shuttle crews might experience during space missions. Albert Einstein recounted his conceptualization of the theory of relativity as being directly related to an image. While watching sunbeams filter through his eyelashes, he imagined himself traveling on a ray of light. As he held on to the image, allowing his mind to wander and capture more of the image, he experienced the sudden "aha" or creative illumination of exactly what it would be like to ride a sunbeam. It was in this moment of relaxation that he pieced together the theory of relativity for which he is now famous. An image that may seem less pleasant than the idea of traveling on a sunbeam, but is nevertheless significant, is described by the chemist Kekule. He discovered the molecular structure of the benzene ring while experiencing an image of a snake swallowing its own tail!

The advantages of using mental imagery also have been embraced by the medical community. Researchers are investigating the role of imagery and its effect on the physical well-being and health of individuals. Significant results have shown that different forms of imagery can reduce stress and can restore the body's natural ability to fight off disease. Furthermore, research has shown that the use of guided imagery and relaxation techniques can bring about a release in psychophysical tension through lowered heart rate, pulse, respiration, and metabolism (Achterberg, 1985; Green & Green, 1977; Korn & Johnson, 1983).

Relaxation techniques and guided imagery have been successful in helping people believe in their ability to recover from disease, control pain, and diminish fears and anxieties. For more than 40 years prepared childbirth practitioners and the expectant mothers who participate in childbirth classes have used guided imagery to help mothers reduce fear and tension and, therefore, pain. Teaching women to associate birth with pleasant feelings and mental images, such as a

peaceful mountain scene, not only lessens discomfort but also has important psychological as well as physical results (Dick-Read, 1972; Pelletier, 1985; Simonton & Matthews-Simonton, 1984).

Now, let's focus more on the implication of guided imagery for the development of artistic potential. How do artists use guided imagery in the process of artistic endeavors? This question is an important one.

Imagery in the Arts

Artists use mental images to create patterns of color and balance or to envision a figure in space or a sculpture in a garden. Beatrix Potter imagined how Peter Rabbit would look, how he would think, and what kinds of mischief he could find for himself. Peter, Mrs. Rabbit, and Mr. McGregor were certainly born in Potter's imagination. The legendary American painter Georgia O'Keeffe used her mind's eye to see deep within the hidden essence of flowers:

> I know I cannot paint a flower. I cannot paint the sun on the desert on a bright summer morning but maybe in terms of paint color I can convey to you my experience of the flower or the experience that makes the flower significant to me at that particular time. (Cowart & Hamilton, 1987, p. 4)

Actors imagine what it is like to be and portray the complex personalities of different people and to detach themselves from situations and events once the curtain has closed. The Oscar-winning actress Meryl Streep has not had personal experiences with the many characters she portrayed in her film career, but she is skilled at using imagery to give voice, movement, and feeling to her characters.

Musicians also use imagery when capturing the quiet of daybreak or the roll of thunder in compositions that have the power to evoke those same images in the listening audience. One of the world's greatest composers, Wolfgang Amadeus Mozart, used his own mental images as sources for many of his great musical compositions. In describing images he had when composing *Entfuhrung,* he discussed Belmonte's aria:

> Would you like to know how I have expressed it, and even indicated his throbbing heart? By the two violins playing octaves. You feel the trembling, the faltering—you see how his throbbing breast begins to swell; this I have expressed by a crescendo. You hear the whispering and the sighing—which I have indicated by the first violins with mutes and a flute playing in unison. (Schonberg, 1981, p. 105)

We move from the composers, who first penned musical notations on a piece of paper, to the dancers who interpret music through movement and dance. Here we will find examples of how dancers use guided imagery to attend to the emotional content of a musical selection and translate it into a bodily kinesthetic mode of movement and dance. Guided imagery is especially effective as dancers practice certain movements in their minds. As they engage in this kind of mental rehearsal, they develop a sense of confidence and mastery in their ability to communicate feelings through movement. Researchers in dance education investigating the value of guided imagery for enhancing learning and performance of dance concluded that "imagery may be especially useful in the learning of dance technique

and movement skills, and it can be used to promote communication between the dance teacher and students by improving conciseness and accuracy of description" (Hanrahan & Salmela, 1986, p. 18).

The field of dance is rich with research examining the role of guided imagery and dance (Overby, 1988; Solomon, 1987; Suinn, 1976; Wolfolk, Murphy, Gottesfeld, & Aitken, 1985). When we read about these dancers' experiences with guided imagery, the conclusion is inescapable: Guided imagery is a strategy that holds powerful potential for the development of dance movements and expression of these movements.

Are there any other avenues for those of us who are not musicians or dancers to gather images for other areas of creative potential? The answer is a resounding yes. There is a poem in all of us—a poem waiting to be written and waiting to take form in free verse or the commonest of all poetic meters, the iambic pentameter. The form you choose to express your poetic lyrics is unimportant. What is important to this discussion is how we look at the printed lines and the sounds and phrases poets give us as a rhythm of the meaning and feeling of their thoughts and affect.

Poets capture images in words that enable the rest of us to hear, see, smell, taste, and feel the images conveyed. The poet's imagination brings us to awareness, captures our emotions, and leaves us in a state of complete surrender. Read the words of the poet Sarah Cameron Edwards (1993) and "see" how your own mind's eye creates images for you.

Scotch Broom

While walking in the yard
This morning
I nearly passed them by,
But out of the corner of my eye I saw
Little yellow bells
Hanging on long green stems.
It is a cold day in
February,
But the rays of the sun are warm on the
Corner of the fence where the
Scotch Broom grows.
Scotch Broom?
I wonder if many
Decades ago a
Woman was leaving her
Home in Scotland to come to a
New country, and
As she walked through her garden
Thought
"I must carry a slip of this with me,
It would be a lovely remembrance of home."

By Sarah Cameron Edwards (1922–1998). © Linda Carol Edwards.

Images abound. Images are in every way a part of who we are as teachers, as children, and as thinking, knowing, and sensing human beings. Images are an inescapable part of our being and our ways of understanding and knowing. Even in the midst of what seems to be a cultural prejudice against curriculum activities that stimulate the imaging, intuitive, and holistic activities of the right hemisphere of the brain, there is a rich history of individuals who have shown their right-hemisphere dominance to demonstrate their intelligence. Poets, musicians, artists, and dancers, and many other right-hemisphere literates, create an electric synergy between the modes. This synergy is a shift away from an individual, analytic consciousness and toward a holistic mode. This shift is brought about by training the intuitive side of ourselves so that we can make the transition from an analytic mode to a more emergent, or gestalt, mode of consciousness. Development of the right hemisphere and imagining potential of children and adults surely contributes to the awakening of creative and artistic potential.

Imagery and Children's Art

Guided imagery is the perfect resource for encouraging children to discover and create art. The very process of imagining colors, painting mind's-eye pictures while listening to music, creating an imaginary form from a lump of clay, or dramatizing a swimming dolphin moves children into a mental environment that is rich with ways to explore the arts. Exploring different ways of experiencing the arts through guided imagery plays an important role in tapping a child's ability to create. When children become deeply involved in the imagery process, they experience the arts as something that is intrinsically satisfying and rewarding. Each child gets to be the artist, musician, sculptor, and dancer in every experience, and the source of every creation comes from within the child. This discovery is extremely important to the development of creative and artistic potential.

These experiences help to facilitate children's awareness of all the arts in ways that allow them to express their ideas nonverbally, in an imaginary artistic form. Children can go beyond the concrete presentation of objects by experiencing all of the aspects of a particular object. For example, through guided imagery children can experience a different dimension of those things that are familiar to them—things they have physically touched or seen or experienced firsthand. If there are trees in their neighborhood, they can imagine a grove of trees with different-colored bark or leaves, nesting places for birds, the way they sway in the breeze, all the colors the trees show during different seasons, and the clouds floating over them *before* they actually express their images in painting, sculpture, movement, or poetry. As they use their mind's eye to see a tree in this grove, they experience all the qualities the tree brings to their imaginations. They can smell the leaves, touch the bark, listen to the birds as they sing in the treetops, and then express their personal knowledge of the tree in an artistic representation. The important part of using guided imagery with the arts is what the children see with their imagination, not the product they produce as a result of their mental images. As children begin to understand how each image is different for each person and learn to respect each other's mind's-eye pictures, we will probably hear less and less the familiar phrases

of "Mine is not as good as his," and "I can't make my picture look like Ali's." To my mind's eye, one of the greatest benefits of using guided imagery in harmony with the arts is that we will no longer have 20 or 30 identical trees or snowmen or Thanksgiving turkeys displayed around the room! This, in and of itself, would certainly be a relief to many creative teachers.

The most important point is this: Guided imagery allows children and adults to see things that are influenced by their own personal experiences, both past and present. In other words, images we see in our own imaginations are as unique and different as the spring buds that appear after a long winter's night. To look at this from a theoretical perspective, we can go to Piaget. Each human being stores ideas in a structure Piaget calls a "schema."

> Each schema the child holds is actually the sum total of all the impressions, associations, experiences, and emotions that the child has about the topic. Therefore, any visualization or imagining activity that a teacher guides children through will necessarily result in a wide variety of images about any topic. A child's response to guided imagery depends upon the schema of each individual child and just how fully each child's schema has been activated, or brought to the conscious mind, by the stimulus. (Cecil & Lauritzen, 1994, p. 38)

Figure 3–2 gives you some ideas for using guided imagery in your classroom.

Later in this chapter, you will find specific guidelines for introducing guided imagery to children. Before you begin planning your own imagery activities for

FIGURE 3–2 Ideas for Guided Imagery

Guided Imagery	Artistic Experience
Things That Grow	Ask your children to imagine that they are tiny seeds, tucked deep in the warm ground. Let them use their mind's eye to come up through the ground and grass as they grow into strong trees or beautiful flowers.
Musical Instruments	Introduce musical instruments by using guided imagery as you encourage children to imagine different ways of playing the instruments. Invite your children to listen with their imaginations to the different sounds and tones the instruments make.
Literature	Use guided imagery before reading stories or poems to allow children to form their own images of the characters or events that they will encounter when hearing the story or poem read to them.
Sensory Exploration	Take an imaginary shape and color walk or a texture walk. Encourage children to use their imaginations to see colors and shapes, smell the fragrances, touch the textures, or taste the delicious fruits that may be hanging on the trees.
Dance and Movement	Use stimulus images to suggest exploration of movement and interpretive dance. Encourage your children to imagine how they will dance or move about the room. Play recordings of a variety of musical compositions containing different rhythms and ask your children to imagine how they would move to each piece of music.

children, though, it is important that you read and understand the sequential nature of using guided imagery before you actually implement the process. You will find additional guided imagery scripts and activities in Appendix 4. The section that follows is designed as an invitation for you to fully experience this process. Sit back and participate in what can be a very relaxing and rewarding experience.

Guided Imagery for Teachers

There are four phases or basic steps involved in guided imagery:

1. centering
2. relaxing with awareness
3. imagining
4. processing

These are important steps for you to remember, and each one is a process unto itself. These steps are also sequential in nature, as the process of centering enables us to relax, while at the same time we are very actively forming images in our mind's eye. The last step, processing, is just as important as the first three steps. Each of these steps will be discussed at length with examples to help you begin to translate theory and research into practical application.

Centering

One of the most important gifts we can give children and ourselves is a lesson on how to be *centered*. Our lives are constantly bombarded with chatter (usually from the left hemisphere), clutter from the outside world, and our own fast-paced ways of life. It is often difficult, and sometimes seemingly impossible, for us to find time to be quiet, to reflect, to pause, or to center ourselves—simply to "be." When we are centered, we experience a feeling of balance; we feel grounded and fully connected to our intellectual, physical, affective, and psychomotor states of being. As a way of beginning to understand the art of centering, use your mind's eye to imagine the following:

> You are a giant pine, standing tall and quiet under the clear blue sky. Your forest floor is covered with deep and age-softened humus. Withered leaves moisten the ground around you. Fondling grasses grow around your feet, and green boughs weave a canopy over your head. Low, flute-like breezes sweep waves of light through your branches, and there is a silent hush in the forest beyond. Your roots stir deep within the stony ground, and you stand with pride and dignity atop a bed of centuries-old granite. Your mighty trunk sways with the rhythm of the mountain and you, in your majesty, are solidly connected to the Earth. Your roots are firmly planted. You are centered between what lies securely hidden deep within the Earth and your branches that reach upward toward the sunlight. You are fully still . . . fully quiet . . . fully centered.

Centering is a process by which we can find a place of inner stillness. To be centered is to take some time out to allow our intellect, physical responses, affective

Whereas some children's drawings represent real objects, other children put crayon to paper in a desire to express an image, idea, or emotion.

states of awareness, and imaginations to work in harmony. Remember what Maslow said about self-actualizing people needing times of solitude and how Gardner describes intrapersonal intelligence as our ability to know ourselves? When we practice the art of centering, we simply become more aware of ourselves than we are now, and in the process we begin to feel more balanced and in control, not only of our inner selves but of the external environment as well. Centering is *experiential;* that is, we must experience it in order to know and understand what it is. Some of my students have described being centered in the following ways:

- ◆ I felt like I had an imaginary string going through the top of my head and following all the way through me until it disappeared into the floor. I could sway from side to side, but never lost my balance.
- ◆ It was like standing on the head of a pin knowing I wouldn't fall off!
- ◆ I felt like one of those old spinning tops, not spinning, but very still and quiet, perfectly balanced and never toppling over.

The following activity can be considered as a practice session in centering. It provides an opportunity for you to use your imagination to find the location in your body of your own place of balance, your center. All of us have a centering place; we just have to find it. For some of you, it may be in your upper torso; for others, the

feeling of centeredness may come from the soles of your feet or the palms of your hands. Send your imagination on a Finding Your Center journey, and allow your mind's eye to wander through your body until it finds just the right place.

The centering activity involves the use of small stones or pebbles. A good way to begin is to take a walk outdoors where everyone can find a stone or pebble with at least one flat side. Test out several stones until you find one that will balance on the top of your head. The stone should weigh enough for you to notice but should not be so heavy that it is uncomfortable. If you haven't already done so, this is the time to read *Everybody Needs a Rock!*

Finding Your Center

Hold your stone in your hands and stand very still. Plant your feet softly on the floor and center your legs and body in perfect alignment. Pay attention to your breathing and see if you can breathe more deeply and smoothly. Allow yourself to relax a little and ease your feet around until you feel balanced. If you feel any tightness in your legs or rigidness in your feet, allow them to accept the support of the floor (or the earth, if you are outside). Close your eyes. Carefully place your stone on the top of your head. See if you can find a good spot where your stone can rest comfortably and where it feels like it will stay for a few minutes. Bring your arms and hands back down to your sides and let them relax. Pay attention to the weight of the stone. Feel the weight as it sits on top of your head. Breathe deeply and smoothly, letting all of your awareness focus on your stone. Your stone is balanced and still. It is simply "being." It is not chatting; it is not moving. The only thing your stone has to do is rest on top of your head. All you have to do is allow it to be there. You are fully aware of the presence of your stone, and neither of you has to do anything except "be." The stone simply exists. It is open and receptive to your physical support and does not need to do anything except rest on your head. The stone and you are perfectly balanced, still, and centered.

Now, as you breathe in, use your arms and hands to remove the stone and hold it in your hands for a moment. Focus your awareness on the spot where your stone was resting and see if you can still feel the weight or imagine the weight on the top of your head. Stay focused for a few minutes and then get ready to open your eyes. Open your eyes and let the light come in. Wiggle your fingers and toes a little and feel your other muscles begin to move. When you feel like stirring, take a good stretch and find a comfortable place to sit or lie down.

I always keep a centering stone handy for those times when I need to calm down and use my stone to help me center myself. You might want to tuck your stone away for safekeeping. You never know when you might be in a state of mind where you could use a moment of quiet centering. This chapter presents many opportunities for you to practice the art of centering as you become more and more involved in using guided imagery.

You will notice that a pattern will develop and that there is some repetition throughout the guidelines. If you are a novice, especially when it comes to using guided imagery as a tool for encouraging creativity, the repetition should help you to become comfortable with the process. Should you be an old pro when it comes to using guided imagery in the classroom, do not allow the repetition to lessen your own creative approach to writing scripts for imagery experiences.

When fully centered, children are still, quiet, relaxed, and aware.

Relaxing with Awareness

During the Finding Your Center exercise, you focused on your breath while practicing being alert and aware. This lays the foundation for learning how to *relax with awareness,* the second phase of the guided imagery process.

In order to relax, we need to be comfortable. Some adults and children prefer to sit in a comfortable chair or on a big pillow with their backs supported by the wall. Others find it easier to relax if they lie down and stretch out on the floor. Although sitting is traditionally associated with relaxing with awareness, there is certainly no rule book or set of expectations surrounding the "how" of relaxing with awareness. The most important aspect of this phase is that children and adults find positions that are comfortable so that they are not intimidated or concerned about how they might look to others or how others choose to enter the process.

The word *awareness* comes from the Old English *gewaer,* which means "watchful, vigilant" and, as far as my research shows, was coined more than 900 years ago, some time around the year 1095. To be aware implies paying attention to the present existence of something, an alertness in drawing inferences from what we experience, and an intuitive perception of intangibles or of emotional states or qualities.

In other words, to be aware is to be cognizant or fully conscious. On the continuum of affective development, to be aware is to attend to what we are experiencing.

The word *attention* finds its roots in the Latin *attendere,* "to stretch forward." When I am practicing relaxing with awareness, I sit very quietly and imagine that I am leaning slightly forward, as if I were listening to a beautiful piece of music or trying to see the last bit of color in a fading sunset. My body is relaxed but my mind is at rapt attention and stretched forward in anticipation.

When we relax with *awareness,* we enter fully into every image with total attention. In the beginning, this is not always possible. I have had many students, both adults and children, fall fast asleep during guided imagery exercises and have even heard (in my own mind's eye) an orchestra of different tones, pitches, harmonies, and rhythms of melodious snoring! Those among us who are just beginning to explore the process often become so relaxed that sleep finds its way into the room and, as with the "sandman and sleepy heads," an ordinary classroom can be transformed into the Land of Nod. If this happens to you, please be gentle with yourself. As with most things that are worthwhile and are important skills to be learned, mastering relaxing with awareness takes practice and time. Young children will often fall asleep, and when they do, I remind myself that they probably need it! No one can force a creative mind to bloom. However, as adults, we can give ourselves permission to cultivate the process of discovery. For our children, we can plant the seeds for relaxing with awareness in the same way that we teach them how to place one lace over the other as they learn to tie their shoes.

The next activity is presented as another practice session. This time, the focus is on relaxing with awareness. This process demands energy, determination, and thoughtfulness. You will need a tape recorder and an audiotape of background instrumental music to accompany the reader of the text. Turn the lights down low and play the music very softly in the background. It is important to keep your spinal column erect. When we slump, our breathing is interrupted and this puts a strain on our whole body. From a purely psychological and physiological view, our bodies and our minds need a free flow of oxygen. One thing we do not want to do is position our bodies in such a way as to add stress when we are trying to reduce it.

Relaxation Exercise

Find a quiet place to sit or lie down. Some of you may prefer to sit on the floor or lean against a wall while others may be more comfortable lying down. Regardless of the position you choose, make sure your back is straight so that your breath can enter and leave your body in a smooth and uninterrupted manner. Take a couple of minutes to notice if you are in a comfortable position. If you need to move around a little, go ahead, and see if you can find a position that feels comfortable and relaxing. Close your eyes. Notice if you feel any tension or stress in any part of your body. Relax your body even more and pay attention to your breathing. Breathe in . . . and breathe out; breathe in, and breathe out. You are becoming more and more relaxed. Breathe in, and breathe out; breathe in, and breathe out.

Focus your awareness on your feet. Notice how they feel. Take a deep breath and squeeze the muscles in your feet. When you breathe out, allow the muscles in your feet to relax. Now focus your awareness on your legs. Notice how they feel. Take a deep

When relaxing with awareness, children should choose a position that is comfortable for them.

breath and tense the muscles in your legs. Hold the tension for just a moment and when you breathe out, allow your legs to relax. Focus your attention on your abdomen. Breathe in and notice how you can tighten the muscles in your abdomen. Breathe out and allow all the tension to leave your abdomen.

Now focus your awareness on the muscles in your shoulders. Breathe in and allow your shoulders to relax. Notice how your shoulders drop when you give them permission to relax. Focus your awareness on your facial muscles, your jaw, your eyes, your nose, and your mouth. Take a deep breath and squeeze all the muscles in your face. Breathe out, and let go of all the tension you were holding in your facial muscles.

Now focus your awareness on your breath. Notice how gently you are breathing. You are breathing calmly and quietly. Take a few minutes to enjoy the relaxation you are feeling. It is now time to return to the here and now of our room. Use your hands to cover your eyes to shade them from the light. Slowly open your eyes and allow the light to filter in through your fingertips. Focus your awareness on the floor (or chair, or wall, or earth, if you are outside), and notice how it supports your body. Wiggle around a little bit and gradually awake your body from this relaxation. Get up slowly, feeling completely rested and alert.

When I was teaching my own class of kindergartners, we put a sign on our classroom door that read: "Do Not Disturb—Great Minds at Work." My principal at that time was an avid reader and scholar, and he understood the value of guided imagery in the development of the whole child. More than that, he knew that any interruption during the guided imagery process would destroy the concentration of the children. Fortunately for me and my children, he respected the process of "thinking" more than he expected to find "product-proof" of how my children were learning to be creative. Needless to say, he had a strong sense of professional and personal responsibility for promoting children's full participation of both hemispheres of the brain.

What is now proved was once only imagined.
William Blake

Imagining

Someone once suggested to me that I "empty my mind" before beginning an imaginary journey. That suggestion left me in a perplexed state because I knew that random thoughts were always rising and vanishing in my mind. I also knew my thoughts were what is described as left-brain chatter, and I knew that even though I could manage to bring them to a certain point of quietness, it would be close to impossible for me to completely shut them down. The more I thought about emptying my mind, the more I was unable to concentrate on the imagery! The winds of my active left brain could not be totally stilled. I also felt (and imagined) that if everyone else could empty his or her mind, then there must be something inferior about mine.

It is not necessary or even desirable to stop the winds of thought that come into our minds when we are imagining. Fleeting thoughts, which naturally fluctuate in our minds, will not hamper or diminish our ability to imagine the sights, sounds, colors, smells, or tactile images during guided imagery. Although it is important to "come to quiet" during the guided imagery process, do not work to expel your thoughts; just try not to dally with them. Let thoughts come and go as they will. Use your energy to concentrate on the images formed before you. This is not an either-or situation. Everything you bring to the process, including random thoughts, is a part of who *you* are and should be recognized and acknowledged. Think of these thoughts as an internal "call waiting." You can put them on hold until you are ready to address them.

Let's review the sequence of steps involved in guided imagery that we have covered thus far.

◆ *Centering* occurs when we have a feeling of balance, a feeling of being grounded in our own psychological center.
◆ *Relaxing* with awareness occurs when we allow our minds and bodies to be quiet and calm and, at the same time, be fully present and consciously aware (in mind and body) of each moment.
◆ *Imagining* is the process of using our imagination, or mind's eye, to create mental images. In *guided imagery,* the material or script used should be selected to encourage safety, comfort, and relaxation.

In my own experience, I have found that after I have enjoyed a guided imagery activity, I have felt much freer to respond to creative impulses I might have previously thought were next to impossible. As our powers of creative potential deepen and mature, we are able to translate these experiences into our everyday creative ways of teaching and learning.

When we are using our mind's eye to be creative, we can enjoy a certain amount of self-indulgence. In guided imagery, no one knows our images, and there are no critical judges to assess or evaluate what we have created. As we concentrate and become more aware of how to externalize our creative abilities, our fears are transmuted into self-confidence and assuredness that we *are* creative and can, indeed, be successful in opening the doors of the creative process to ourselves and to others.

◆ *Processing* is the last stage in guided imagery. This is an extremely important stage that allows you to share your experiences with others. It is also a time when you can draw, paint, or dance the images that have emerged, or write about them in your learning journey.

Processing

When guided images are over, it is important to allow some time for talking or reflecting. Both children and adults seem to need some freedom to process their experiences. Children are usually eager to describe their images and enjoy giving elaborate detail of all they have seen. Adults, on the other hand, seem to need more direction or are more comfortable sharing in small groups or with just one other person.

It is important, however, to discuss the experience. Each person should be allowed to reveal his or her experiences, but no one should be forced to talk about all the images that came to mind. When you think of the word *discussion*, remember that the processing time is an opportunity for reflection, not a test of how many images one person had or a measure of image quality. Begin by asking each other some open-ended questions. For example, you might ask,

What did you like best about the guided imagery process?
Tell me about one memorable event from your guided imagery journey.
What feelings did you have when you imagined being a giant pine with flute-like breezes sweeping through your branches?
What kinds of things came to mind when you were searching for your centering place?

Children's Literature and Feelings and Images

And Shira Imagined by Giora Carmi, The Jewish Publication Society, 1988.
 Shira uses her imagination to picture images of ancient lands.
Where the Wild Things Are by Maurice Sendak, Harper & Row, 1964.
 Max's imagination carries him to a rumpus of the wild things and then carries him home safely where he finds his supper waiting.
Everybody Needs a Rock by Byrd Baylor, illustrated by Peter Parnall, Aladdin Paperbacks, 1985.
 Ten rules for finding a rock. "Not just any rock," Baylor is careful to note, "but a special rock that you find yourself and keep as long as you can—maybe forever."

Guided Imagery and Children

Before you take the first step toward introducing young children to guided imagery, it is essential that *you* understand the process and have personal experience in guided imagery "imagining." After practicing your own ability to see pictures in your mind's eye, you will begin to realize the value and will feel more comfortable in introducing children to the part of the mind that creates, imagines, and dreams. The sensitive and thoughtful teacher will carefully consider the following guidelines while beginning to develop skills, strategies, and methods for incorporating guided imagery into the classroom.

Using Guided Imagery with Children

1. *Before using guided imagery with children, try out the guided imagery on yourself.* Read the script to yourself and be aware of how the images form, or have a friend or colleague read the script while you experience the images. This will help you practice your timing and appreciate what children will be experiencing, and it will let you add to the guided imagery or delete passages from it that do not feel right or provide little stimulus for your imagery system.

2. *Tell the children what you, as a group, will be doing.* It is important for children to understand that their images belong to them, that they can choose to use their imagination and take a journey in their mind, and that they are always in control. If children do not like an image, they can "erase it" with their imagination. You might start by saying,

Children often prefer lying down or sitting next to a friend during guided imagery time. When they open their eyes to "peek," it is nice to have a friend nearby.

We are going to take an imaginary journey by making pictures in our minds. This journey will be a lot like pretending, and all the pictures will be like movies in your head. You can use your imagination to make anything you would like. If you want to change your picture, you can also use your imagination to erase it and make a new one.

3. *Give children suggestions to help them relax.* It usually does not take children as long to relax as it does adults, so a few simple sentences are all children need to hear in order to relax. For example, you might say,

Find a place in our room where you can relax without touching anyone else. You can lie down with a pillow or mat, or, if you wish, you can just sit somewhere on the floor where you can be quiet. If you are lying down or sitting in a comfortable position, make sure your back is straight so that you can breathe easily. Close your eyes and let your body and mind rest. Take in a nice, slow breath and let it out. See if you can relax your body and breathe so quietly that no one can hear you. Breathe in . . . and out . . . and in . . . and out. Try to relax a little bit more until your mind and body are very still.

4. *Reassure your children that there are no right or wrong imaginary pictures.* During guided imagery, we do not have to do anything or "see" anything in the same way as others see images. We can just let the images come as we relax and attend to what we are hearing or feeling. Also, children need sufficient wait time to allow their images to form. There is no need to hurry. When children or adults are rushed, they often draw blanks and begin wondering why their imaginations do not work as well as those of their friends or colleagues.

5. *Always make guided imagery safe.* For example, if the guided imagery is about holding a pet, tell your children, "This pet is just the perfect pet for you," giving the children a choice in choosing the pet that is right for them. Using a statement such as "Your pet loves to stretch out and lie in the warm sun," encourages children to relax and focus on being warm and safe. "You and your special pet are walking along a beautiful path in a forest. The path leads you to a fence, and on the other side you see a deer standing in a field of green grass." The fact that there is a fence between the child and the deer provides an element of safety. When using guided imagery with children, you should use all the words you can think of to make sure the children are comfortable during the imagining process.

I observed a graduate student leading a group of undergraduates on a guided imagery involving an abandoned store. This store was in a large city on a neglected side street. It was dusk and the lights of the city were reflecting in the wet streets. One of the students became very upset because she had recently been mugged and had her purse stolen during a vacation to a large metropolitan city. The safety guides were not in place, and instead of relaxing and enjoying the treasures waiting to be discovered in the abandoned store, this student experienced fear and anxiety. Guided imagery should evoke positive creative images, not images that make us nervous or fearful.

6. *Beginning imagery exercises should be simple.* Guided images that focus on the senses are particularly useful in the early stages of the process. At first, some

children may have trouble keeping their eyes closed, but once they are familiar with the process, most children will look forward to relaxing and creating their own images. It is also helpful to have soft music playing in the background. Music is soothing to children and can usually help them quiet down and relax. Ask children to imagine something that is familiar, such as a toy, a special food, or a pet. Encourage them to imagine how the object feels, whether it is soft or hard, whether it smells, and whether it has color or taste. For example, you might begin a multisensory guided imagery activity by saying the following:

> Imagine you are holding your very favorite toy. Use your imagination to touch your toy with your fingers and think about whether it is hard or soft. Use your imagination to see the color of your toy, or are there many colors that you can see? Let your imagination show you how you play with your favorite toy and think about all the things you do when you and your toy are playing.

7. *Write guided imagery journeys based on children's experiences.* Once your children are familiar with guided imagery, you can write scripts specifically designed to enhance their personal, concrete experiences. If you live near the ocean, write an imagery script about walking along the beach, smelling the sea breeze, and feeling the waves. Ask the children to find something on the beach, pick it up, and feel it. Then allow the children to continue the imagery on their own.

> Today we are going to take an imaginary trip to the beach (or whatever landscape or seascape your children know well). As you breathe quietly, imagine that you are walking along a (insert your own landscape here). It is a warm and lovely day. The sun is warm, and (add your own descriptions here). Look up at the sky. Listen to the sounds that you hear (insert your own sounds here). The gentle breeze feels so good, and you like the smell of the (your landscape).
>
> Now, use your imagination to see something lying in front of you. Walk up to the object and take a close look. Think for a minute if you would like to pick up the object and take it home with you or if you want to leave it here. If you do want it, place it in your pocket. If you do not want it, just take some time to enjoy looking at it. You can decide and you can stay there as long as you wish. This is such a beautiful place and everything feels wonderful.
>
> Now it is time to leave (your landscape) and return to our room. When you feel like you are ready to be back in our room, open your eyes, take a big stretch, and look around until you see me.

If you live in the mountains, take an imaginary hike up a mountain trail. If you live in the city, take a trip to the zoo or visit a tall building. You know the experiences of your children. Because you are in the process of discovering *your* creative potential, you can use the experiences and knowledge of your children to design guided imagery exercises especially for your own special group.

8. *Always prepare children to return to the here and now of the classroom.* You must be sensitive to the transition children make from being in an image state to the concrete reality of their very own room. Close the guided imagery exercise with comforting and familiar images by saying the following:

> It is time for you to let your imagination take a rest. Think about our classroom and remember how it looks. Think about who is in the room, and listen for little sounds that you have heard before . . . the air conditioner or heater, voices, the rain outside.

When you feel ready, wiggle your fingers a little, stretch your feet, and open your eyes. When you open your eyes, take a nice, long stretch and *look around the room until you see me.*

I have added emphasis to the last phrase of the paragraph describing the transition process because it is a phrase I want you to remember and use, each and every time your children are in transition. As adults, it is easy for us to assume that our children know we are always present, but some children may be so totally involved with their images that they forget that they are actually in the classroom. This is a part of the message I gave you earlier: Guided imagery must involve elements of safety, and to your children, you are the safest person at school.

9. *When guided imagery experiences are over, children need time to reflect or maybe talk about their images.* At the conclusion of a guided imagery exercise, give your children an opportunity to tell where they have been and what they have seen, heard, felt, or imagined. The inner experiences of your children must *never* be judged, interpreted, or evaluated in any way. For young children, this is simply a time of sharing what they saw and how their images made them feel. Likewise, children should be encouraged to respect each other's images, understanding that everyone's images are different and special.

Timing is also something to consider. For very young children between the ages of two and three, guided imagery exercises should be short. The total process of relaxing and imaging should be no longer than five or six minutes. If they last any longer, you will have a room filled with sleeping children. Older boys and girls can attend to a script for as long as it is interesting and thought-provoking. I have known five-year-olds to attend to a guided imagery exercise for 20 or more minutes. I also have observed a class of third graders, exhausted at the end of a busy day, fall asleep after the introductory relaxation stage. Guided imagery should not be used as a transition activity or as a filler exercise at the end of the day when your children are tired and already overextended. The best time to tap into their imaginative potential is when they are most alert. The number of minutes involved in the process depends on your own knowledge of your children's capacity to focus.

10. *Enjoy the process yourself.* When you are reading a script about a favorite toy or a beloved pet, allow your imagination to soar with images that are special to you. When I attend to the guided imagery about favorite toys, I always think of my collection of snow domes. When I read the script that suggests that I think about a loved pet, I always remember my cat, whose name was Cat, and relive my memories of how regal and beautiful she was. It takes practice to experience guided imagery at the same time you are offering one to your children, but with time and patience, you can enjoy some of these moments right along with your children.

The guidelines for using guided imagery are not really as complicated as you might "imagine," although each step in the process is as important as the one before and the one after. Figure 3–3 gives an overview and summary of these steps.

A very wise friend once gave me some very pertinent and useful advice about keeping lists. He advised that if a list made my life easier, contributed to my feelings of well-being, or made me feel more secure, then I should use it. Figure 3–3

FIGURE 3–3 Preparing for Guided Imagery

1. Read the script to yourself to see if it makes any sense.
2. Tell your children what you are asking them to do.
3. Provide time for your children to relax.
4. Let your children know that there are no right or wrong imaginary pictures.
5. Make guided imagery safe.
6. Keep guided imagery exercises for young children simple and concrete.
7. Write guided imagery exercises that are appropriate to your own children's experiences and knowledge.
8. Always prepare your children for the transition from an imagery state to the real place that is their concern.
9. Allow children to talk about their images.
10. Enjoy the process yourself.

> *It seems only logical that encouraging children to be explorers and questioners rather than passive acceptors cannot help honing creativity, thinking and learning.*
>
> Starko, 1995, p. 114

is one that meets all of my friend's requirements. It is also one that you will want to have readily available as you give the gift of guided imagery to your children.

Emphasize to your children that the imagination can bring anything to light. They can use their mind's eye to journey to unknown places, to bring objects or toys to life, to see movement or images in color and music, or to create new or different situations in their daily lives. They can look at clouds and imagine where they have been or what they have seen, listen to music and imagine what the composer looked like, observe animals or birds and imagine how they talk to each other or what their houses look like on the inside, or simply close their eyes and imagine who or what is making all the sounds they hear. Images of special, happy events can help a sad or troubled child feel better. Holding an imaginary kitten or imagining a butterfly on a flower can be soothing and calming. Encourage children to imagine a dream before nap time or bedtime, or imagine a funny or comical outcome to a stressful or frustrating experience. Using the imagination is certainly not limited to a guided imagery activity. Sometimes we just have to give children permission, or maybe a suggestion for incorporating imagery and fantasy into the here and now of their lives, for them to begin using their imaginations in ways that are important and useful for them.

Exploring Guided Imagery Through a Multicultural Context

The following activities are designed to introduce your children to three little boys: Liang from China, Little Gopher from the Indian people of the American Plains, and Kofi from West Africa.

A Family's Role in Developing Feelings and Images at Home

The following activity for families and children introduces the idea of using theme-related projects that take place in the classroom and adapting them for caregivers and children to do at home. Another goal for this activity is to provide caregivers with a developmentally appropriate learning experience based on the same or similar experiences children have had in schools with their teacher. This activity also encourages verbal interaction between parent and child and engages children in a low-risk activity.

◆ Read the book *Everybody Needs a Rock* by Byrd Baylor.
◆ Take your child on a nature walk to find a rock. You might find one around your home, at a nature store, or at a home improvement store.
◆ Ask your child to hold his or her rock and find a comfortable place to sit. With quiet instrumental music playing in the background, ask your child to close his or her eyes and listen to the following guided journey.

Imagining Your Rock

Hold your rock gently in your hand and close your eyes. Use your imagination to see if you can remember the color of your rock. What shape is your rock? How heavy or light is your rock? Is it as light as a feather, as heavy as a baseball, or as heavy as a book? Does your rock remind you of anything? Rub your fingers over your rock and see if you can feel smooth places or lumps. Hold your rock against your forehead and see if it is cool or warm. Put your rock up to your ear and see if it makes any sounds. Keep holding your rock in your hand and use your imagination to see if it looks the same as it did a few minutes ago. Remember to keep your eyes closed. Use your imagination to draw a pretend picture of your rock in your mind. When you are ready, open your eyes and look around until you see me.

◆ Ask whether your child has anything to say about the journey with the rock. Allow your child to say what he or she would like to say, but do not force your child to talk. Some journeys are best kept secret.

Chinese and American Indian Folktales

Liang and the Magic Paintbrush (1988) by Demi is an enchanting Chinese folktale that tells the story of a little boy who longs to paint but has no paintbrush. One day he finds a magic paintbrush and finds that whatever he paints with it comes to life.

The Legend of the Indian Paintbrush (1988) by Tomie de Paola is a story about a little Indian boy called Little Gopher who had a dream vision come to him about bright and beautiful colors. He created the tools he needed and used them to paint the stories of his people. One day his brushes and colors were transformed into beautiful wildflowers!

Read these delightful stories to your children and then ask them to "imagine" what they would do with their own magic paintbrushes, or write your own special script to help children use their mind's eye to create images.

Painting Dream Visions

After you have read dePaola's *The Legend of the Indian Paintbrush,* provide your children with a piece of thin white cardboard. Mix tempera paints using the colors that Little Gopher used and let each child paint his or her own dream vision on the cardboard. If the children want to talk about their personal dream visions, that is fine, but *please do not force them to tell you a long story or provide a lengthy description of what they have painted*. As an extension activity, you might talk with a local plant retailer to see whether the store actually has any Indian paintbrush flowers that you could bring to class, or you could just download some colored images from the Internet for your children to enjoy.

West African Stories

Kofi and His Magic, by Maya Angelou, is a delightful story of a young Ashanti boy who lives in a West African village that is famous for its fine kente cloth. Kofi is an engaging boy whose vivid daydreams transport him to other places. The book has appealing color photos and a lyrical text.

After you have read the story about Kofi, you might also read *Kente Colors,* by Deborah M. Newton Chocolate, an informational book about the making of kente cloth. Kente cloth is made from threads of different colors. The weavers use red, green, yellow, blue, black, and gold threads to weave the strips of cloth. Weavers work together at their looms outside on the compound near their houses. Weaving from sunrise to sunset has been the tradition of the West African families for hundreds of years.

Weaving Your Own Kente Cloth

Select one of the guided imagery scripts for children, and ask a friend or colleague to read it while you imagine.

A wonderful idea for you and your children to explore the qualities of kente cloth is to use colored paper strips to weave your own. Begin by giving each child a blank piece of construction paper and then give each child precut strips of kente cloth colors (red, yellow, blue, green, black, and gold). Children can paste the colored strips onto the piece of plain paper while creating their own unique designs.

Guided Imagery Scripts for Children

Following is a script for a guided imagery exercise you can implement with children. I hope this will become a seed for many guided imagery scripts you will write for your own children. See Appendix 4 for additional guided imagery scripts that you can use for children from the age of two to adults.

A Very Special Basket

Settle down in a very comfortable place and let your mind and body be very still. Take in a nice big breath and then blow it all out. Imagine that I am walking around the room and I have a very special basket filled with wonderful things. My basket holds many special treasures that only you can see.

Imagine that I am going to give each one of you a gift from my very special basket. Imagine that I am walking up to you and holding the basket so that you can see all the things that are inside. I pass the basket to you and you reach in and take one of the very special treasures. Look at it and feel it. Is it big? . . . small? . . . round? . . . flat? Does it have many different shapes? Is your special treasure warm or cold? Is it soft . . . or is it hard? Does your special gift have a nice smell . . . or a sweet and wonderful taste?

I want you to keep your special gift, so think about a place you can put it where it will be safe. Take your gift to that safe place and tuck it away. Now that your gift from my very special basket is in a safe place, it is time to come back to our classroom. Listen to the sounds of our room. . . . Listen to my voice. Open your mouth and see if there is a yawn in there. Wiggle around a little and open your eyes. Look around the room until you see me.

I have found that when using this guided imagery with young children, they usually are eager to tell about their gift from the very special basket and are especially interested in keeping the hiding place a secret! Recently, several days after we had been on this particular imagery journey, a five-year-old took me aside to show me her imaginary gift transformed into a clay sculpture. After she spent a good deal of time describing it in exquisite detail, she whispered to me, "It was easy to hide my 'imagine' present, but I can't find a place to hide this."

Sometimes children will remember their images and long after you have forgotten about the experience will create some type of concrete or material representation. When this happens naturally and spontaneously, you will know that your children are enjoying the guided imagery journeys and are busy at work developing their imagery system for coding and retrieving knowledge. Remember, though, that imagery exploration is intrinsically rewarding, and the process of exploring imagery is what is most important.

DEVELOPMENTALLY APPROPRIATE PRACTICE

For young children, guided imagery provides many opportunities to explore the imagination, to draw upon previous memories, to allow various senses to participate in a spontaneous manner, to create positive emotional feelings, and to experience all

FIGURE 3–4 Developmentally Appropriate Practice

◆ Encourage children to tell you what they would like to imagine and write scripts that include their own personal experiences.

◆ Provide guided imagery journeys that stimulate auditory, kinesthetic, olfactory, and gustatory exploration.

◆ Provide intellectual challenges whereby children become engaged in an interactive relationship with some aspect of the image.

◆ Assume a nonjudgmental attitude toward your children's images. Your positive, accepting attitude must prevail all the time.

◆ Remember that body position is a highly personal matter and allow your children to choose which position is best for them.

◆ Provide opportunities for children to experience images in all domains. While participating in a guided imagery, children can imagine physical movement (moving their bodies and using fine-motor skills), gain awareness of their feelings while exploring the affective domain, and develop social skills by imagining a solution to a conflict or making decisions about sharing toys and other classroom materials. Intellectual development is facilitated as children imagine making decisions, writing an imaginary story in their minds, or organizing their plans for completing a project, such as building a tower in the block center.

◆ Provide safety and security in all guided imagery scripts. Never ask children to imagine scary things or life events that could make a child feel insecure, afraid, or alone.

the wonder and magic of make-believe. Figure 3–4 provides an overview of developmentally appropriate practice when using guided imagery with children.

The Special Children in Your Classroom

Most teachers of young children will encounter children who are impulsive and lack self-control and self-management strategies. Some of these children will even be classified as seriously emotionally disabled or diagnosed with attention deficit hyperactivity disorder. Typical intervention programs for children with these characteristics include instruction in delaying impulsive actions and self-management techniques. Many early childhood educators have successfully used relaxation techniques and eventual self-instruction in relaxation using visual imagery with these children.

Susan Gurganus, a colleague and expert on children with learning disabilities, says that we must "address the special needs of children who may lack the experiences necessary to form images" (Gurganus, personal communications, 2004). Gurganus reminds us that a child's home environment or mental disabilities may require us, as teachers, to plan stimulating experiences such as hikes, picnics, trips to the zoo, or a field day at a local park and to use these experiences as a basis for writing scripts for guided imagery. During this same conversation, Gurganus offered some cautionary insight into how many children are developing schema of the reality of their worlds when she related that television is *becoming* the experience of our children. She has observed children describing and writing about events from television programs and talk shows as if they were personal experiences.

For children with reading disabilities, a visual imagery strategy has been effective in improving reading comprehension skills. Researchers at the University of

Kansas Center for Research on Learning have developed the *Visual Imagery Strategy* as a component of their research-based learning strategies curriculum (Schumaker, Deshler, Zemitzsch, & Warner, 1993). Their data have shown that students' comprehension and retention increase in proportion to the quality and quantity of the visual images children make while reading passages.

In my experience as an early childhood teacher and as a college-level facilitator of aspiring teachers, I think we have all encountered the emotionally handicapped child who displayed great difficulty with self-control and self-management. Gurganus's expertise in understanding a child's self-management techniques must be noted. She believes that children can be taught to delay their initial impulses and, in fact, relax themselves through relaxation exercises, followed by visual imagery suggestions, in a process of learning to manage themselves in ways that are intrinsically rewarding and welcomed by their peers.

Children with cerebral palsy have shown significant improvement in learning by using guided imagery to imagine how their muscles might move in ways that are totally unfamiliar, whereas other guided imagery experiences have been shown to improve the visual imagination of children with visual impairments. Gurganus reminds us that sensory impairments (visual and hearing) may limit the experiences of children and may challenge the teacher to devise alternative approaches for guided imagery experiences. For example, a student with a visual impairment should focus on the sounds and textures within the script. A child who has no hearing may have to be guided through the script in segments, opening and closing her eyes to receive each descriptive piece. Images should focus on visual and tactile experiences in this situation. Images with references to vibrations and movement would also be appropriate. Pairing auditory or visual images with images using other senses can increase the cognitive awareness (improve the visual or auditory imaginations) of children with sensory impairments. For example, a guided imagery that describes fluffy white clouds could include an analogy with fluffy cotton balls. Or a trip describing the sounds of the wind could be paired with a description of the wind blowing through one's hair. We would all be well served to listen to what Gurganus has to say about the ways in which we can bring the creative arts, through guided imagery, to the active participation of each child.

PERSONAL AND PROFESSIONAL GROWTH

You already have read a great deal about guided imagery. Now it is time for you, the adult learner, to become an active participant. The learning process involved in participating in guided imagery invites you to concentrate on *receiving,* the first major category of the affective domain. *Receiving* involves attending with awareness and concentrating on your willingness to receive the images that come into your mind's eye *and,* at the same time, concentrating on the process as you experience it.

Your participation in guided imagery exercises involves no physical movement or any risk of failure in the eyes of others. As I have said before, only you, the imaginer, will know how much you are attending to the images seen through your mind's eye and to what extent you are willing to create images. If you are reluctant

to give your imagination some seeds for growth, you can choose to make your grocery list or think about what you might be doing after class. No one except you will know what is (or is not) going on during the process. By approaching guided imagery in this manner, we all take responsibility for the amount of energy we elect to expend in exploring our ability to use our imaginations creatively. The following guided imagery exercise is designed to encourage you to use your imagination and creative abilities. It is presented with the following affective goals in mind:

- Listen attentively.
- Attend to auditory stimuli.
- Show sensitivity to the importance of imagery.
- Acknowledge awareness of creative potential.
- Concentrate on relaxing.

This guided imagery exercise focuses on your personal and professional growth as an educator. It will assist you in identifying the special characteristics of the most influential and special teacher you have known. It will also help you collect data to assess your own personal teaching style and to project your potential for becoming one of those memorable teachers.

Searching for That Special Teacher

Find a good spot in the room where you can be comfortable and have your own private space. Wiggle around a little until you find a way of sitting or lying down that is completely comfortable. Now close your eyes and let your muscles relax. Give in to the support of the chair or floor.

We are going on a journey to look for your favorite teacher. Scan the years of your childhood . . . adolescence . . . adulthood . . . and remember all the teachers who touched your life. (Pause longer here, for two or three minutes.) As you were bringing these teachers before your mind's eye, there were probably one or two that kept coming back to visit. Take another moment and identify the ones who were most special. . . . As you remember them, bring one teacher to the center of your mind's eye who stands out from all the others. Think of the characteristics that made this teacher your favorite. Was it attention . . . caring . . . teaching style . . . attitude . . . warmth . . . knowledge . . . intellect . . . good looks . . . dedication . . . values . . . knowledge of content? Describe this teacher to yourself. Think of all the words that enhance your memory of this special teacher. Continue to think about your teacher for a minute or two. Now it is time to leave this teacher and prepare to return to the here and now of our room. Remember the words you thought of to describe this special teacher and keep these words focused in your memory. Stay with your experience for a moment . . . and when you are ready, notice once again the sounds you hear . . . the warmness or coolness of this room . . . the thoughts you left behind a few minutes ago . . . and the reality of other people who are near to where you are right now. In your own time, bring yourself back to a full consciousness of this time and this place and stretch a little. Wiggle your fingers and toes . . . and return to the here and now of this place. Open your eyes and look around to see your friends and me.

The following suggestions are offered as a means of *processing* this special teacher-guided imagery exercise.

The teaching process is one of using "self as instrument." Compare your descriptions of the special teachers you have known with those of your colleagues. Do they share any similar attributes?

1. Individually and before the chatter begins, write down all the words you can think of that describe the special teacher you brought into your imagination.

2. When you have completed your own personal list, pair up with someone sitting near you and share the information on your lists.

3. Now combine the words on both of your lists and come up with a new list of descriptors that incorporates the characteristics common to both lists. Do not change any words you wrote; simply combine them so that there is no repetition. In other words, if you both have *caring* written on your individual lists, when you combine them, list *caring* once and not twice. If only one of you wrote the word *intelligent,* include it on the new list.

4. Each pair joins with another pair to form groups of four. Go through the same procedure of combining your lists until you have one master list of descriptors.

5. Talk among yourselves about how these characteristics are representative of the affective, cognitive, or psychomotor domain. Depending on the level of comfort in your group, you might use this time as an opportunity to talk about what makes you a special teacher and how you see yourself in some of these characteristics.

Imagination is the supreme master of art as of life.

Joseph Conrad, 1857–1924

chapter 4

Introducing Music and Movement

We are the music makers, and we are the dreamers of dreams . . .

Arthur O'Shaughnessy, 1881

It was time for the annual holiday program. Because I had a background in music, my principal appointed me chair of the program committee. I was excited! This was my first year teaching, my first class of five-year-olds, and the principal wanted me to be in charge of the program. I decided that our whole K–3 school would perform The Nutcracker Suite, *complete with costumes, music, props, and all the embellishments. I was eager to impress the parents and the other teachers, so I decided to teach my kindergarten girls the ballet, "The Waltz of the Flowers," and my kindergarten boys, "The Dance of the Toy Soldiers." For weeks I taught these children perfect steps, perfect timing, turn right, stand still, curtsey, and step and turn. At first my kindergartners seemed to enjoy it, but as the days and weeks went on, they started resisting going to practice or would actually beg not to have to do "the program" again. On several occasions some complained of being tired while others had great difficulty with self-control . . . disrupting, acting inappropriately, hitting, and being generally unhappy. However, we did make it to the big night. The parents loved the performance. We all congratulated ourselves on a wonderful program. I remember talking with a first-grade teacher about how much the children loved it and what a good time they had. The truth is that the children were exhausted. They were fidgety and irritable, tired and pouty. Some even fell asleep before the program ended.*

After a long weekend, the children returned to school and seemed to be the happy, well-adjusted children they had been before I had this brilliant idea of producing The Nutcracker. *Young children, as we all know, are so resilient. In the weeks that followed, they did not want me to play any music during center time. I would put on a Hap Palmer album, and they would argue about the right and wrong way to "get up in the morning." Why would kindergartners turn against the sacred Hap Palmer? I tried playing more of their favorites—Prokofiev's* Peter and the Wolf *and Debussy's* La Mer—*and, of course, the music from* The Nutcracker. *My children did not want to hear the music from the ballet; they did not want me to play any music at all. Just the mention of the word* dance *or* costume *or* program *would change the mood of our whole classroom environment. Although it took some time—several weeks as I remember—my children finally came back to music. By early spring they were again requesting their favorite music and especially enjoyed listening to the "Spring" movement from Vivaldi's* Four Seasons *(Edwards & Nabors, 1993, pp. 77–81).*

When I was thinking about how to begin this chapter, the story you just read came back into my mind's eye like a recurring bad dream. These events actually took place in my life and the lives of my kindergarten children. I have since managed to forgive myself, because at the time I knew very little about the importance of the musical process and was only aware of a *performance*, product-oriented approach to music in early childhood. My own creative arts courses had provided enough *cookbook* music projects to last me for years.

It was not until some time later that I came to know that I had forced these little children to perform (under the name of "creative arts" and, more specifically, "dance") in ways that were totally inappropriate for children their age. Not only had I involved these children in inappropriate practice, but I also had imposed my own ideas of how to be a waltzing flower or a toy soldier without regard as to how they might interpret or create their own ideas, thoughts, images, or forms of expression.

Now let's leave these dancing children for a moment and take a look at how you might respond to an invitation to move and dance. The next section continues the discussion on the affective domain that I began in Chapter 3 and introduces the second major category on the continuum of affective development: *responding*.

The Continuum of Development in the Affective Domain: Responding

Earlier I encouraged you to attend to the information about guided imagery, as well as to be open and receptive to new experiences you might encounter *through* the process of exploring guided imagery. The second major category on the continuum of affective development, *responding*, refers to active participation on the part of the learner. At this level, I invite you to move beyond simply *attending* to a particular phenomenon, as you did when attending to guided imagery, and to *react* by doing something and becoming actively involved. Throughout this chapter, you will have an opportunity to move beyond the level of minimum awareness (receiving) and become an active participant in the music and movement activities. *Responding* means that you are willing to participate; that you show interest in the content; and, most importantly, that you take pleasure in, enjoy, or gain some satisfaction by responding to a variety of musical experiences.

How do *you* feel about expressing your ideas through music, creative movement, or dance? Are you musical? Do you enjoy singing "Happy Birthday" to loved ones or dancing with friends when the music is so good you just cannot sit still? Have you ever noticed yourself tapping your foot in rhythm with a great band or standing to applaud for an encore at the end of a beautifully orchestrated symphony? Most of us probably have some of these musical competencies, while others have a deeper connection with music either as consumers or performers. Whatever our current level of musical involvement, any effort we make toward increasing our musical abilities and talents certainly falls under the broad definition of being creative.

Schlessman (2003) defines creativity as "a step beyond competence" (p. 6). She goes on to say that in being creative, people take steps beyond what they usually do. When thinking about creativity in this light, such a definition gives all teachers the dignity to be creative. I believe that most of us who have chosen teaching as a profession are willing to venture into new and different situations. In this case, the adventure involves exploring music. After all, musical happenings occur spontaneously as we hum a familiar melody or sing along with a favorite recording artist.

However, if you are saying to yourself, "I really can't sing," do not worry. A beautiful singing voice is not a requirement for bringing meaningful musical experiences to young children. You can recite or chant fingerplays and action songs. The rhythm is more interesting to children than the melody. You can use CDs, simple instruments such as an autoharp or melody bells, or the talents of a musical volunteer. If your body just does not feel rhythm in movement or dance, begin slowly by experimenting with the different types of movement presented in this chapter and open yourself to the possibility of discovering something new about yourself and your musical creativity. Your children will respond to you, their teacher, and your enthusiasm, interest, and spontaneity. If you trust yourself enough to try, your children and their responses will help build your confidence.

The experiential activities in this chapter are designed to encourage you to *respond* as you explore movement, dance, instrumentation, songs, and fingerplays. You will experiment with pitch, melody, and rhythm while learning about percussion and tonal instruments. You (yes, you!) can use these simple rhythmic songs and rhythm instruments to continue developing your self-confidence, your imagination, your ways of self-expression, and your own innovative and creative ideas for using these with children.

Responding to these activities and actively participating may come easy for some of you. Some of you might already feel uncomfortable as you realize that you will soon be exploring and experimenting with ways of moving through space, singing or chanting, or playing instruments. Remember that there is safety in numbers. Imagine for a moment that you are opening a window to your own personal creativity and that you may see something new and exciting. Be assured, though, that if a storm approaches or lightning flashes, you can close your window and watch and enjoy the movement and music of others.

Now let's take a look at how children respond to music and movement. More specifically, how do young children enjoy music and movement?

Music and Movement: Enjoyment and Value for Children

Young children are action-oriented. Singing, moving, and dancing are not only fun, but they also provide young children opportunities to listen, respond, imitate, and use their voices, fingers, hands, arms, and bodies in ways that are creative and uniquely theirs.

In his classic book *Teaching the Child Under Six* (1981), Hymes writes about the "style and swing" of the young child in one of the clearest, most articulate descriptions I have ever encountered. Hymes must know more about the qualities of young children than most people in our profession. He reminds us of the following ways in which young children "flow" differently from their older brothers and sisters:

◆ Young children are not good sitters.
◆ Young children are not good at keeping quiet.
◆ Young children are shy.
◆ Young children are highly egocentric.
◆ Young children want to feel proud, big, and important.
◆ Young children have their private dream world.
◆ Young children are very tender.
◆ Young children are beginners.
◆ Young children are hungry for stimulation.
◆ Young children are earthy, practical, and concrete-minded.
◆ Young children are acquiescent.
◆ Young children are illiterate (pp. 38–46).

Hymes also says that our capacity and willingness to live with these qualities makes the crucial difference between a good classroom (and teacher) and one that does not fit the age or provide child-appropriate experiences for young children.

How does Hymes's description of the style and swing of young children apply to music and movement? The answer lies in our approach and our attitude toward developing musical experiences for children that are action-oriented. They need room to move both indoors in the classroom and outside in the play yard. Dancing, rhythmic movement, and action songs all provide ample opportunity for action. A former graduate student coined a phrase that seems especially appropriate here: "Sitting still and being quiet is not a marketable skill" (Cain, personal communication, 2004). Because young children are not good at being quiet, they need the freedom to make a joyful noise by singing, playing instruments, and making up singsongs and chants as they play and work. Shy children should be given opportunities to play with musical ideas in small groups. Hymes calls these groups "safe personal clusters." When you see or hear shy children gingerly exploring the properties of a triangle and mallet or singing quietly to themselves during center time, remember that they are tentative in their efforts and may not yet be ready to join the whole-class activities. The egocentric nature of young children will show in their excitement when they stop you in the middle of an activity and say, "Watch me do the little rabbit song all by myself"; "I can move just like a butterfly"; or "I went to the circus and they had a band that played clown music." They begin their sentences with *I*, and the sensitive teacher takes time to listen to the musical news children bring to the classroom.

The main purpose of including music and movement in the classroom is enjoyment. Through music and movement young children express themselves, explore space, develop language and communication skills, increase sensory awareness, and express themselves through rhythm, gesture, time, and space.

These girls are using their imaginations to explore different ways of moving across a sandy space.

Four Important Reasons for Including Music in the Classroom

Van der Linde (1999) outlines six reasons why the importance of music and movement activities should not be underestimated. Among these are four that are particularly relevant here:

1. *Mental capacity and intellect.* There is a connection between music and the development of mathematic thinking. Mathematic concepts are developed as children sing counting songs.
2. *Mastery of the physical self.* Children develop coordination that aids muscular development. They begin to understand what they can do with their bodies as they run, balance, stretch, crawl, and skip.
3. *Development of the affective aspect.* Through music and movement children learn acceptable outlets to express feelings and relieve tension. Music may also convey a specific mood through which children reveal their feelings and emotions.
4. *Development of creativity.* Music can create an imaginary world that stimulates a child's creativity. A box can become a drum, a stick can be transformed into a horn, or a broom could become a dance partner. Children make up songs or give new words to old songs for pure enjoyment (pp. 2–5).

It is sometimes all too easy to miss the opportunity to expand on the music and movement experiences of a child's budding musical awareness. The imaginary world, the dream world, is a private place where children can sort out ideas before actually implementing those ideas. They can imagine how a butterfly moves from flower to flower before re-creating their own interpretation of pretending to fly like a butterfly. Teachers must encourage imagery and fantasy throughout music and movement activities. It is a natural resource that children bring with them to the classroom and one that encourages the development of musical processes that are foundational to future thinking and perceptual organization. Tender children who are just beginning to discover their ability to soar like an eagle, dance with the flowers, sing for the pure joy of hearing their own voices, or pretend to gallop swiftly like a pony look to their teacher to provide a safe place where they can explore all the possibilities their bodies, minds, and voices hold for musical and bodily kinesthetic development.

Young children love to repeat things. They want to "sing it again!" and "move like a zigzag!" They are hungry for ideas that tap into their curiosity of how the eensy-weensy spider goes up the waterspout; they want to move and dance when the spirit strikes them. They need teachers who will design a variety of rich musical experiences to help them test out things for themselves. We can play a recording by Raffi, Greg and Steve, or Ella Jenkins but we must give children permission to test out their own ways of interpreting what they hear in ways that are right and personal to them.

A good classroom is geared to music. A sensitive teacher celebrates the clumsy and often awkward beginnings children make in their attempts to move rhythmically. Caring about the whole child means honoring all aspects of his or her musical expression. An awareness of the values of musical encounters provides the wise teacher with many choices and worthwhile possibilities for immersing children in a rich variety of songs, fingerplays, and other musical experiences.

A child's awareness of music begins very early. Infants can be comforted by quiet singing, music boxes, and musical toys. As they make cooing sounds and begin babbling, infants experiment with different tones and rhythmic patterns. Typical toddlers can frequently be observed clapping, dancing, or parading around the room trying out different ways of moving to musical beats and rhythmic patterns. Young children are sensitive to musical sound and respond freely and joyfully to different tempos and beats. At the same time, they discover new and different ways to use their bodies and voices.

If you can talk, you can sing. If you can walk, you can dance.
Zimbabwe proverb

Throughout the childhood years, children's major accomplishments in musical development in turn support many developmental milestones. One important by-product of exploration of music and movement is language development. Communication for the very young child is largely nonverbal, and music and movement can enhance and expand the child's repertoire of communication skills and abilities. Children experiment with familiar word patterns as they combine words with a tune. They imitate rhythmic patterns and combine these with physical activity as they communicate through movement or dance. Children play with words as they change the lyrics to familiar songs or

make up chants to accompany their play activity. Verbal and motor cues help children to remember new words or sequences of words. They experience regular beats, changes in tempo, accents, and synchronization, all of which are an integral part of communicating in words and sentences.

As with all areas of the curriculum, developmentally appropriate music and movement activities will be successful only if you, the teacher, understand why music and movement are important tools for assisting children in constructing knowledge about their world and helping them make sense of their experiences. Admittedly, music and movement *can* be used in an integrated curriculum to enhance other subject areas such as the language arts, but as Metz (1989) cautions, "Simply using music in an educational setting does not insure that children's musical perceptions are developing . . . we need to focus on music as 'an end in itself'" (p. 89).

I further believe that we, as teachers, must be well versed in not only *how* to bring musical experiences to children but also *why* music is so essential to the young child's overall development. One way to facilitate our understanding of the why is to look at the perspective that developmental theory has to offer. The next section provides some insight into why children need music in their lives and why music stands alone as an important subject area.

Theories of Musical Development

Children possess a natural awareness and sensitivity to musical sounds. They explore music with more spontaneity than any other age group, and they venture forward into music and movement activities with their voices, their bodies, and their own feeling states. The whole child is involved. Each child's affective, cognitive, and psychomotor responses to a musical encounter are the hallmark of creativity. Gardner provides us with a very perceptive observation that paints a lovely picture of a child and his music when he writes:

> The child attending to a piece of music or a story listens with his whole body. He may be at rapt attention and totally engrossed; or he may be swaying from side to side, marching, keeping time, or alternating between such moods. But in any case, his reactions to such art objects is a bodily one, presumably permeated by physical sensations. (1973, pp. 152–153)

Gardner's Theory of Multiple Intelligences: Musical, Bodily-Kinesthetic, and Logical-Mathematical

Musical Intelligence

This intelligence involves the ability to perceive, produce, and appreciate pitch (or melody) and rhythm, and our appreciation of the forms of musical expressiveness. Composers, performers, musicians, conductors, or the child attending to a piece of

music all possess a great deal of musical intelligence. Conductor and composer Leonard Bernstein, late composer and performer Ray Charles, classical composer Igor Stravinsky, conductor Zubin Mehta, renowned 20th-century pianist Arthur Rubinstein, and guitarists and songwriters James Taylor and Eric Clapton are all examples of individuals with immense musical intelligence.

Bodily Kinesthetic Intelligence

The ability to control one's body movements and to handle objects skillfully are the core components of bodily kinesthetic intelligence. Gardner specifies that bodily intelligence is used by dancers, choreographers, athletes, mimes, surgeons, craftspeople, and others who use their hands and bodies in a problem-solving kind of way. Classic examples of individuals whose skills are embodied in this form of intelligence include American dancer and choreographer Alvin Ailey; Katherine Dunham, the first choreographer and dancer to bring African dance to the American stage; Charlie Chaplin and Buster Keaton, the great silent clowns of the past; and contemporary masters of humorous characterizations such as Robin Williams and Bill Cosby. Athletes such as Wilma Rudolph and George Foreman also excel in grace, power, and accuracy.

Logical-Mathematical Intelligence

Mathematicians, scientists, and composers certainly have this form of intelligence, which involves a sensitivity and a capacity to discern logical or numerical patterns (including rhythm, meter, time signature, and note value) and the ability to handle long chains of reasoning. The capacity to explore patterns, categories, and relationships can be heard in the four-part harmony and counterpoint music from the Baroque era. An example of logical-mathematical intelligence in composers is revealed in Johann Sebastian Bach's colossal work, *The Art of Fugue,* often referred to as a transmission of a purely abstract theory. In any case, *The Art of Fugue* is an excellent example of logical-mathematical intelligence, carrying pure counterpoint to its height. Read the following description of *The Art of Fugue,* and see for yourself if you do not agree that Bach's work is as complex as any mathematical equation you have ever tried to resolve.

> It starts with four fugues, two of which present the theme, the others presenting the theme in contrary motion (that is, back to front). Then there are counterfugues, in which the original subject is inverted (turned upside down) and combined with the original. There are double and triple fugues, several canons, three pairs of mirror fugues. To make the mirror reflection doubly realistic, the treble of the first fugue becomes the bass of the second fugue, the alto changes into a tenor, the tenor into an alto, and the bass into a treble, with the result that No. 12:2 appears like 12:1 standing on its head. (Schonberg, 1981, p. 43)

Certainly, not everyone will understand what that all means, but it does make a good case for including logical-mathematical intelligence in this chapter on music and movement!

Some examples of people who demonstrate high end-states of logical-mathematical intelligence include Bach, scientists Albert Einstein and Madame Curie, biologist Ernest Everett Just, and botanist George Washington Carver.

The concept of musical, bodily kinesthetic, and logical-mathematical intelligence suggests that our ability to produce and appreciate rhythm, pitch, and timbre while appreciating the many forms of musical expression, and our ability to use our bodies and handle objects skillfully, deserve to be nourished so that, as human beings, we can function at our fullest potential. According to Gardner (1983), our own success, as adults, in musical, bodily kinesthetic, and logical-mathematical competency may have been helped or hindered by experiences during our early childhood years. Gardner challenges educators to recognize these separate intelligences and to nurture them as universal intelligences that serve important functions in children's cognitive, affective, social, and physical development.

Supporting Musical, Bodily Kinesthetic, and Logical-Mathematical Intelligence

As you prepare to guide young children in these areas of intelligence, remember to plan for a broad range of hands-on learning activities. Introduce your children to Marcel Marceau and the great tradition of mime. Show them how the artistic form of mime integrates body movement and the ability to use the body in expressive, nonverbal ways. Give your children crayons and paper and encourage them to "draw" Pachelbel's *Canon in D*. Provide opportunities for children to use their bodies as a medium of expression; let them dramatize or role-play stories or different outcomes to traditional folktales. Introduce physical awareness exercises and use kinesthetic imagery to increase body awareness. Videotape the dances of your children and allow them to observe and reflect on the dances they have created.

Gardner's Message to Teachers

If we are to be teachers committed to the development of all of a child's intelligences, we must provide music and movement activities as a means of fostering these important areas of human potential. To do anything less is to deny children an opportunity to function at their fullest. In a 1991 interview, Daniel Gursky quotes Gardner as saying:

> To get teachers to think deeply about their strengths, their students' strengths, and how to achieve curricular goals while taking those strengths and different profiles seriously is a huge job. Teachers can't be expected to become "multiple intelligence mavens" but they should know where to send students for help in, say, music or dance. (Gursky, 1991, p. 42)

Gardner's statement does not, however, get us "off the hook" or give us permission to assign musical and bodily kinesthetic development solely to the music, dance, or physical education specialist. Music, movement, dance, physical awareness, and physical activities deserve the same natural assimilation in the early childhood curriculum as do storytelling and nap time.

Keep a camera loaded with film so you can capture a creative moment in progress.

Beginning the Process of Planning

Children need to be provided with the circumstances for the development of all of their capabilities. When nurturing children's musical intelligence, we should provide a variety of experiences to support musical expression. For example, sing simple songs or let your children hear you humming, listen to music throughout the day, or play instruments to signal transition periods or to announce special happenings. Play background music in the classroom, and play special recordings regularly during specific times, such as after lunch or just before the children leave at the end of the day. Select many different varieties of musical compositions and styles to encourage your children to use their imaginations to see musical imagery. Introduce musical concepts that focus on the great classical composers and how classical compositions sound different from, for example, commercial musical jingles. Use music to help children relax after a period of high-energy activity. Play Debussy's *La Mer* (The Sea) before reading *One Morning in Maine* or a lively jazz recording just before you read *Ben's Trumpet*.

Educators have intuitively emphasized musical and physical activity as a part of children's learning experiences, but until recently we have perhaps failed to realize fully the musical and bodily kinesthetic learning that can take place when we purposely and systematically offer activities and experiences that nurture and support

these two important areas of learning and knowing. Curricula designed to facilitate the development of musical and bodily kinesthetic intelligence must be promoted through child-appropriate learning activities and teaching methods. Children at a very early age can begin to form concepts of music, movement, and dance that will serve as the base for later intellectual growth. Moreover, all children deserve opportunities to learn in ways that suit their individual and highly personal modes for knowing, learning, and processing information.

Basic Stages of Early Musical Development

Before you begin thinking about ways to plan and implement music and movement experiences for young children, it is important for you to have an understanding of the basic stages of early musical development. Figure 4–1 provides, descriptively, an overview of musical development and suggests ideas for music and movement activities for children between the ages of two and six years old.

This overview of early musical development provides you with an important framework for developing goals for music and movement experiences with your children. Another very important point for you to consider in this process is the National Association for the Education of Young Children's position statement on developmentally appropriate practice.

DEVELOPMENTALLY APPROPRIATE PRACTICE

The concept of developmentally appropriate practice provides a clear description of appropriate practice for programs serving the full age span of early childhood. A summary of these important guidelines as they relate to music, dance, and other musical experiences is provided in Figure 4–2 as a means for furthering your understanding of the role you play in providing musical experiences that match your children's developmental levels.

Remember that these developmentally appropriate practices represent the minimum amount of what we should be doing to expand children's musical and movement experiences! (Bredekamp, 1987; Bredekamp & Copple, 1997).

The Special Children in Your Classroom

It is very important for you to remember that all the children in your classroom can enjoy movement and music activities. Children with disabilities should never be excluded from experiencing the joy that music can bring to their lives. You might have to make modifications in some activities to help your children with disabilities enter into the process, but you must view this extra planning as yet another way of giving special gifts to each child entrusted to your care. Gee (1997) and Gurganus (personal communication, 2004) offer the following suggestions for engaging children with disabilities in music and movement activities.

"Planning for Special Needs." Design a plan for introducing fingerplays to children who are visually impaired.

FIGURE 4–1 Developmental Stages in Music and Movement

The Two-Year-Old:

♪♪ Rocks, sways, moves up and down, enjoys clapping games, fingerplays, and action songs.

♪♪ Experiments with imitating rhymes and rhythms and responds to music through body movement.

♪♪ Can learn short simple songs and enjoys experimenting with instruments and sounds.

♪♪ Listens to music and occasionally matches body movement to simple musical beats.

♪♪ Responds to songs with simple patterns.

♪♪ Explores space by moving forward and backward, up and down.

♪♪ Can move low to the floor or walk on tiptoe.

♪♪ Experiments with voice and sings or hums at play.

The Three-Year-Old:

♫♪ Sings along on certain phrases of familiar songs.

♫♪ Can establish and maintain a regular beat.

♫♪ Sings songs with repetitive words and sings in tune.

♫♪ Talks and sings during many activities.

♫♪ Is consistent in rhythmic responses and can accomplish sudden stops or "freezes."

♫♪ Enjoys listening to recorded music and responding to or imitating the motions of others.

♫♪ Suggests words for songs or additional verses to songs.

♫♪ Is interested in rhythm instruments.

♫♪ Enjoys when grown-ups play with him or her and provide simple rhythmic patterns to imitate.

♫♪ Can learn simple fingerplays.

♫♪ Claps in different tempos and at different levels when imitating an adult.

The Four-Year-Old:

♪♪♪♪ Has improved voice control and rhythmic responses.

♪♪♪♪ Makes suggestions for musical activities.

♪♪♪♪ Adds words to songs and creates songs on instruments.

♪♪♪♪ Creates new rhythms.

♪♪♪♪ Enjoys singing and is more aware of sounds and rhythms in the environment.

♪♪♪♪ Takes the lead in adding to the movement learned earlier by changing direction, time, or force.

♪♪♪♪ Imitates movement of animals, machines, or other familiar objects or people.

♪♪♪♪ Can learn longer and more complicated fingerplays and songs.

♪♪♪♪ Has increased ability to master song lyrics.

♪♪♪♪ Combines creative drama with movement and singing.

♪♪♪♪ Matches and classifies sounds according to volume and pitch.

♪♪♪♪ Reproduces rhythmic patterns vocally and with instruments.

♪♪♪♪ Memorizes fingerplays, chants, and action songs.

♪♪♪♪ Forms basic concepts such as loud-soft and fast-slow.

FIGURE 4–1 (continued)

The Five- and Six-Year-Old:

♩♩♩♪ Sings complete songs from memory.

♩♩♩♪ Enjoys songs and dances with specific rules and patterns.

♩♩♩♪ Moves rhythmically to a regular beat and can keep time with music.

♩♩♩♪ Has greater pitch control and rhythmic accuracy.

♩♩♩♪ Uses abilities and individual talents together and musical understanding begins to take form.

♩♩♩♪ Can learn simple dance steps and adapt them to rhythms.

♩♩♩♪ Plays instruments with more precision and accuracy.

♩♩♩♪ Has a large repertoire of songs.

♩♩♩♪ Understands changes in tempo and dynamics and uses music to enhance dramatic play.

♩♩♩♪ Works well with a partner and with small groups in musical activities.

♩♩♩♪ Enjoys group singing in which everyone has a turn and is especially interested in musical games in which words are often repeated.

♩♩♩♪ Has a longer attention span when listening to records and other recorded music.

♩♩♩♪ Can compare several sounds and pitches.

FIGURE 4–2 Developmentally Appropriate Practice

◆ Teachers must sing with the children, do fingerplays, and take part in acting out simple stories such as "The Three Bears" with children participating actively.

◆ Adults have to structure the physical environment to provide plenty of space and time indoors and outdoors for children to explore and exercise such large-muscle skills as running, jumping, galloping, or catching a ball. We also need to stay close by to offer assistance as needed. The old days of the teacher sitting in a chair during outdoor activity has, fortunately, disappeared.

◆ Adults in the classroom provide many experiences and opportunities to extend children's language and musical abilities. We introduce children to nursery rhymes and fingerplays; encourage children to sing songs and listen to recordings; facilitate children's play of circle and movement games such as "London Bridge," "The Farmer in the Dell," and "Ring Around the Rosie"; and we present simple rhythm instruments as *real* instruments.

◆ Children must have daily opportunities for aesthetic expression and appreciation through hearing a variety of musical forms and compositions.

Children With Physical Disabilities

You should make sure that your children with physical disabilities are comfortable and in a position that makes them feel balanced and positioned so that they can see and move their arms, hands, legs, or heads. Also, make sure that there is an adult near the children to observe them and to ensure they are comfortable throughout the activity. Introduce songs that use the children's names or allow

A loft is a great place for children to find the privacy they often need to figure out what sounds an instrument can produce.

them to sing about what they are wearing or how they are feeling. Remember to focus on aspects of who they are as people rather than on their disabilities. Select movement songs that use the parts of the body that the children with physical disabilities can move so that they can participate fully. For example, if a child has difficulty with arm movement, plan an activity that allows for total body swaying or activities that emphasize head movements. If she is working on speech sounds, motor skills, eye-hand coordination, or other particular skills, design your activities in ways that allow her to practice these skills in a pleasurable and nonthreatening manner.

Children with Hearing Impairments

For children who are hearing impaired, plan rhythmic activities such as clapping and chanting to help them develop a feel for rhythm. Use visual clues so that they can clap along with the other children. Children with hearing impairments should

also have opportunities for free movement that is not related to sound or visual clues, so that they can experiment with different ways of creating their own movements. Let your children play instruments and feel the vibrations that come from striking a triangle or strumming an autoharp. Xylophones and melody bells are excellent instruments for children with hearing impairments because of the different vibrations each produces. Wood blocks, sticks, and maracas also enable children to feel vibrations. Although they may not hear the sound of the blocks or the click of the sticks, they can feel the vibrations as the blocks pass over each other and as the sticks strike, and they learn to play them rhythmically. Maracas have tactile appeal, and children can feel the vibrations as they shake these instruments. Many children with hearing impairments can hear good-quality, low-pitched drums. As they listen to these low pitches, they can also notice the feel of the vibrating drumhead. When children with hearing impairments place their hands on a portable tape player, they can feel the vibrations of a deep-bass pulsation through their hands. You may also gently take the child's hands and assist him or her during a clapping activity.

Gurganus (personal communication, 2004) recommends placing the tape player on the floor and turning the bass to the maximum volume. Invite children with hearing impairments to take off both shoes so that the vibrations of the bass can be felt through the feet. This enables them to feel the beat of the music so that they can move their bodies, arms, and heads to the rhythm of the musical beat. The children's own experiences when feeling rhythm and beat through vibrations is more important and meaningful than teacher-assisted instruction.

Children with Visual Disabilities

You will want to give special consideration to your children with visual disabilities when planning music and movement activities. Make sure they are seated next to an adult and that they have their own physical space. Talk about the music, describe the instruments, and encourage the children to explore the physical properties of a variety of instruments. You may need to show the children how to hold and play an instrument because they cannot use visual clues to learn these techniques. Playing instruments that require children to coordinate one hand with the other, such as rhythm sticks or triangles, may be difficult for children with visual disabilities. You can help a child be successful at playing by holding the instrument still while he or she plays it. Movement activities are often frightening to children with visual disabilities. You must be sensitive to this fear and design movement activities that begin with stationary movements, such as bending or swaying. Once your children are comfortable moving in one spot, you can gradually extend the movement experiences to safe ambulatory motions such as crawling or rolling, because these keep the child in contact with the floor. Children with visual disabilities can learn how to hop and gallop or perform other more complicated movements, but you may have to show them physically how to do these movements. The important thing to remember is to make sure the child with visual disabilities feels safe and knows that you or another adult is always close by. Figure 4–3 provides an overview for music and movement for children with disabilities.

FIGURE 4–3 Music and Movement for Children with Disabilities

Music and movement experiences are as important to children with disabilities as they are to all the other children in your classroom. You must make modifications in your activities to help these children express themselves as freely as they can, while deriving all the benefits the musical experience provides. The following general guidelines will help you begin to plan music and movement activities for children with disabilities:

◆ Provide helmets as safety devices for children with limited balancing skills.

◆ Give hand signals as well as verbal signals, and face children each time you make a suggestion.

◆ Encourage children in wheelchairs to use facial expressions to represent how they feel as they move themselves or are pushed by you or others in the group.

◆ Provide tactile clues for children with visual disabilities and visual clues for children with hearing disabilities.

◆ Allow children with limited finger movements to use other body parts when mimicking fingerplays.

◆ Provide carpet squares so children will have an awareness of boundaries in the general space.

◆ Pair children who are visually impaired with other children who can provide personal, verbal clues (Broughton, 1986).

◆ When you are unsure about how to plan music and movement experiences for children with disabilities, seek the advice of the specialist in your school or district.

Many elements of the music and movement curriculum are evident in current early childhood programs. Teachers who know how to plan and "set the stage" for singing, dancing, playing instruments, and expressive movement to emerge are those who achieve the most important goals of music and movement activities. You will have to decide how to best arrange your environment so that it presents your children with an imaginary stage that invites them to enter freely into the music and movement activities you design. Your own resources and creative approach to musical experiences are the keys to a successful music and movement curriculum.

The Stage Awaits: Music and Movement for Young Children

There is a wealth of music and movement experiences that are appropriate for young children. Children move their bodies in expressive ways, they dance to the beat of the rhythms they hear, and they sing with a spontaneity unmatched by even the most melodic adult voices. Music and movement activities fill the early childhood classroom with radiant happy faces and laughing, joyful children. This section explores music and movement for young children and introduces several aspects of music and movement, including dance, singing, playing instruments, dramatic movement, and action songs.

Children's Literature and Music

Ben's Trumpet by Rachel Isadora, Mulberry Books, 1979.

> Ben loves to hear the Zig Zag Jazz Club musicians play jazz. Ben pretends to have a trumpet of his own. The neighborhood children laugh at him until the trumpeter from the club invites Ben to play with the band.

Amazing Grace by Mary Hoffman, illustrated by Caroline Binch, Dial Books for Young Readers, 1991.

> Grace loves stories and spends a lot of time acting out the stories that she reads and the stories that her Nana tells her. When it is time to audition for roles in the play *Peter Pan,* Grace amazes everyone with her interpretation of the flying Peter Pan.

Song and Dance Man by Karen Ackerman, illustrated by Stephen Gammell, Knopf, 1988.

> Grandpa demonstrates, for his visiting grandchildren, some of the songs, dances, and jokes he performed when he was a vaudeville entertainer.

Children and Dance in the Classroom

Isadora Duncan, one of the greatest dancers of the 20th century, is credited with having announced before a performance: "If I could *tell* you what I mean, there would be no point in dancing." Her powerful statement certainly exemplifies how young children approach the process of movement and dance.

As teachers, our prime concern should be to nurture, develop, and deepen children's abilities to respond affectively to the sounds, melodies, and rhythms generated by music. Music and movement represent ways of knowing as well as ways of expressing feeling and allow children to move beyond the common ways of experiencing their world and expressing what they know about it.

> A dance is one instant of life—a vibratory piece of energy. A great piece of sculpture is never contained; it reaches out to affect the space around it. We exist in space—that is the energy of the world, and each of us is a recipient of that energy, if he so wills. (Mazo, 1991, p. 34)

If we think back to Gardner's description of "the child attending to a piece of music," we cannot deny that dance—experiencing the flow of the music with our bodies—is a metaphor for connecting diverse experiences through a means of symbolic form and imagery.

Eloquence is in the eye of the beholder. Teachers must celebrate the innocence and grace children bring to the process.

With all of our understanding and acceptance of music, movement, and dance, it is of vital importance for the early childhood teacher to have both the willingness and the sensibility to provide experiences in these ways of knowing for young children. To be better prepared to plan music, movement, and dance activities for your children, you should be aware of how young children explore these creative processes and how you can begin to stretch their horizons.

Basic Dance Movements

When movement experiences and the sensations of moving are connected to the expressive and imaginative powers of the mover, we have dance. Dance involves a heightened kinesthetic awareness, a bodily intelligence, and a sharpened perception of movement as an aesthetic experience.

Although dance may be an eloquent art form, it is nevertheless a form of expression that can be made easily accessible to young children. There is general agreement among practitioners, theorists, and writers dealing with the nature of dance as to what basic movements form an overall conceptual framework for dance and dance education (Dimondstein, 1971; Frosch-Schroder, 1991; Laban, 1948; Moravcik, 2000; Neely, 2001; and Van Der Linde, 1999). All dance movements are a blending of three basic qualities: space, time, and force. Other factors that influence movement are flow, weight, body awareness, and relationships with others or objects. In addition, movement

Child's definition of dance: "It's talking. Telling something with your body. Not using words, just using your body to talk."
G. A. Flemming

can occur through locomotion, nonlocomotion, representational responses, or a combination of two or more body movements. If all this sounds a bit complicated, please relax. One of the most effective ways you can help children to develop the art of dance is to promote significant discussion about the meaning of these terms.

It is important to talk with children about the vocabulary of music and movement. Young children may not have the language skills or knowledge to use words such as *time* in a musical context. They may relate time only to when they get up in the morning or to adults giving a clock significant meaning. Introduce music and dance vocabulary at the same time your children are listening to music or exploring rhythm and beat so that the words are connected to their actual activity. Do not "lecture" children or teach them words and terminology out of context; instead, use accurate vocabulary unobtrusively as a means of describing what your children are experiencing.

The other thing you can do to expand your awareness of the language and the meaning of these words in a musical context is to respond to the creative movement process, not as one who is a dance-educator "giving" dance to children, but rather as a regular classroom teacher who becomes actively involved in sensing your own feelings for creative movement:

> When children see adults working creatively, they understand this is something that people do in real life, something that gives enjoyment and satisfaction, and is not just a classroom exercise. In this way, children are able to move away from relying entirely on explanations and secondhand information, and have the chance to witness the behaviors and even the physical movements involved. (Dixon & Chalmers, 1990, pp. 16–17)

Again, it is important to remember that we are focusing on the *process* of movement, not on the *product*.

Following is a description of each term used in movement and dance.

Space This word refers to the manner in which we use an area for movement. This can be either a "personal space" that no one else can enter or a more expansive area of "general space," which is everywhere else. Children need to be aware that once they are in a space, whether standing or sitting, that space becomes occupied. In movement and dance the perception of space is viewed in relation to the body, the space of others, and the unoccupied place or general space.

You can help children define their personal space by asking them to extend their arms while turning around and around to make sure they cannot touch anyone else. You might tap their imaginative powers by asking them to pretend that they are moving inside a very large bubble. Young children can carry their personal space with them as they move during locomotor activities. Leaping, jumping, skipping, and sliding are examples of locomotor activities that involve moving from one place to another.

Locomotor activities require a large, uncluttered space. You do not need a space as large as a gymnasium; a large, open area in your classroom or even outdoors is more than adequate. It is important to remember that your children need to hear you and your suggestions during movement activities. In a large, oversized

room the children will have difficulty seeing and hearing you. If you find, however, that a large area is the only space available to you, you can easily solve the problem of the children not being able to hear you by using a percussion instrument (drum or tambourine) as a signal to children when it is necessary for them to stop and listen. Movement invites squeals of delight, laughter, and many other appropriate "child sounds." A signal can provide structure and predictability to music and movement experiences, both of which are important in establishing and maintaining a secure and trusting environment in which your children feel safe to explore the process.

Time Time is a quality of tempo or rhythm. A movement can be slow or fast (time) and a succession of muscular relaxations and rests (rhythm). The speed of movement can change from faster to slower. A child's sense of tempo can be facilitated by a simple, percussion accompaniment that provides beats or a grouping of beats. In movement and dance, rhythm comes from two sources: either from music, wherein children hear rhythm as it is produced through sound, or from dance, wherein children create rhythm from their movements. Moreover, the tempo of a movement can be a series of rhythmic changes involving a total kinesthetic response by which a child organizes and interprets tempo and rhythm through both internal and external stimuli (that is, what they hear in the music and the spontaneous feelings and emotions they feel in their bodies).

Time for young children is not "keeping time" or "being in time" with the music. Rather, it is an opportunity for children to be involved in exploration and improvisation of the qualities of tempo and rhythm. Dimondstein (1971) cautions us not to ask children to "dance by the numbers." Allow children to respond in ways that they can control their bodies and broaden the scope of their rhythmic expression.

Force The concept of force is also important in movement and dance. Children experience light, heavy, sudden, or sustained qualities of movement that require varying degrees of muscular tension. As children explore different qualities of force, they can experience the difference between pushing and pulling and between heaviness and lightness. They become aware of balance and the transference of body weight. Most important, perhaps, is that through an exploration of force, children may begin to understand the idea of being "centered," or controlling their bodies from a place of balance from which energy is released and controlled.

The centering exercises provided in Chapter 3 will help children locate the place in their bodies where they feel most balanced. These centering activities can be extended here to help children realize how far they can lean or how they can move from a hop to a slide without losing their sense of balance. For example, there are sustained movements expressed as smooth, easygoing flows of energy, such as lifting an imaginary heavy object. There are swinging movements whereby one part of the body moves around another, such as swinging our arms in a circle over our heads. Percussion movement requires a sudden, quick, sharp release of energy, as when we shake a hand or a leg or our whole selves. Percussion movement can be facilitated by using instruments that produce sounds by

hitting or beating. Children can discover the amount of force they use when beating a drum or hitting a triangle.

Locomotor As the term might imply, locomotor is the quality of moving through space. Walking, running, jumping, hopping, skipping, leaping, sliding, and galloping are examples of locomotor movements. Nonlocomotor movements are stationary. Children move in ways that do not require them to move away from their area. Examples of nonlocomotor movement include stretching, bending, turning, twisting, swinging, and curling.

Throughout all of these expressive movement and dance encounters, children explore direction (straight, forward, backward, up, down), levels (high, low, or somewhere in between), relationships (above, below, over, under, through, around), and position of movement (horizontal, vertical, diagonal). Children also learn to organize the available space in relation to themselves and in relationship to objects and other individuals. As children experiment with and explore all of these different ways of creative movement, they are developing body control and confidence in the power and ability of their own bodies. Best of all, they are finding intrinsic pleasure in "being" the creator of movement and dance rather than "imitating" a prescribed "follow me and do as I do" approach.

Young children *are* beginners, and they are just beginning to make discoveries about the vast repertoire of expression that comes through movement and dance. There is plenty of time for them to take formal dance lessons in the next 20 or more years of formal "schooling" that lie ahead.

Selecting Songs, Fingerplays, and Instruments

Singing songs, moving to music, and transforming little fingers into birds, rabbits, or falling rain form the basis for many types of musical expression. Young children who have positive and pleasurable experiences with rhythm and movement will want to repeat these experiences. Young children sing spontaneously while they play. As shown in the following example, they make up nonsense chants and songs as they experiment with variations in rhythm, pitch, and volume: Jane listens as her teacher magically transforms his fingers into two little blackbirds, one named Jack and one named Jill. She attends to the story line and the actions of this fingerplay and begins to respond with a few words and finger movements of her own. When she moves to the outdoor classroom, she lifts her arms and flies around the play yard singing, "This is Jack and this is Jill!"

This four-year-old finds intrinsic pleasure in learning a new fingerplay, and the enthusiasm of her teacher and his seriousness about the process have transcended circle time. A simple fingerplay has become a part of this child's universal experience—in this case, that of flying around the play yard.

Singing with Young Children

Songs for toddlers should be short and easy to sing and should have a steady beat. Songs should also have a lot of repetition, as children will often remember the

chorus of a song long before they learn all the words to the verse. When pitching songs for young children, be sure that the range is well within their vocal abilities. Try pitching songs in the range between middle C up to G, a fifth above. If you do not know where middle C is located on the piano keyboard, find someone in your class who can find middle C on a piano, or ask your professor to show you how to find a middle C chord on an autoharp. You can also find a piano and, beginning at the far left of the keyboard, count the white keys until you get to the 24th white key: this is middle C.

As children develop their singing voices, their range extends, sometimes by as much as an octave above and below middle C, and they can sing with a much wider vocal range. Remember that if your singing voice is not one that you are comfortable using or enjoy hearing, you can still introduce and sing songs with your children. There are not many of us who have beautifully trained singing voices, so if you do not have an image of strumming a guitar as you accompany yourself while singing to a group of children, you are most likely in the majority! Your children will always be more interested in the interchange and interaction than they are in your perfectly pitched, or unpitched, singing voice.

Young children enjoy a variety of songs and especially seem to like songs that have personal meaning, such as songs about their names, body parts, clothes, feelings, and special occasions such as birthdays. Songs about children's interests—home and family, things that happen at school, and animals and pets—are appealing. Songs about animals, in which children can imitate or make animal sounds, capture children's interest and encourage them to become involved in singing activities.

Interview a music specialist in a school near you to determine how often children in music classes are exposed to classical music. How does the music specialist introduce classical music to children? What kinds of classical music experiences are provided for the children? Bring your notes to class and report on your findings.

When you first introduce songs to young children, they will probably not sing every word or follow every phrase. If the song has repetition or a chorus, children will usually join in on the words or lines they hear most often. Do not be discouraged when you first introduce a song and your children sing just a word or two or do not match your pitch or sing with your tune. By the time you have sung it several times, your children will begin to pick up the lyrics and melody and will say, "Let's sing it again!" It is very important for you to have a large repertoire of songs and chants available "in the moment." Teachers must constantly search for new songs and fingerplays, as they are an invaluable resource in the day-to-day happenings in the early childhood classroom.

Selecting Songs for Singing

Out of the hundreds of songs that you can introduce to children, there are several categories of songs that seem to be most often used in the early childhood classroom. Following are categories and examples of songs that you might consider learning before beginning your singing debut with young children. They also provide opportunities for *enactive* and *iconic* experiences as children begin to tap into their musical and bodily kinesthetic intelligence. You, however, are the only one who needs to know about the theoretical framework supporting the musical concepts at work. For

your children, singing and moving must be a purely pleasurable experience and not a "teaching method" for activating budding young composers or maestros.

Old Traditional and Folk Songs. Many traditional and folk songs come to us from all around the world, and most tell a story and convey a simple message that children can understand. Some favorites of mine include the following:

"Where Is Thumbkin?"
"This Old Man, He Played One"
"I'm a Little Teapot"
"Two Little Blackbirds"
"Miss Mary (Molly) Mack"

Nursery Rhymes The melodies of nursery rhymes are always favorites of young children. Because of their simple and catchy melodies, they are easy to sing and most appropriate for the young child.

"Mary Had a Little Lamb"
"Twinkle, Twinkle, Little Star"
"London Bridge"
"Here We Go 'Round the Mulberry Bush"

Lullabies Lullabies are wonderful for quieting and calming children after active periods or before nap time. They are also useful when encouraging children to imagine that they are rocking a little bunny or a baby doll to sleep. I have spent many special moments singing lullabies to children and watching their sweet eyes close for some much-needed sleep.

"Hush, Little Baby"
"Rock-a-Bye Baby"
"Are You Sleeping?"
"Lullaby and Good Night"

Fingerplays and Action Songs

Fingerplays are, in a sense, a type of rhythmic improvisation. They have strong appeal to young children because there is usually repetition of melody, words, and phrases. There seems to be some magic in transforming a tiny finger into a "Thumbkin" or a rabbit, or in "shaking all about" during "The Hokey Pokey." In fingerplays and action songs, the words provide suggestions or directions on what, how, when, and where to move. In general, children enjoy the continuity of hearing and playing with the fingerplays and action songs from the beginning to the end. If the fingerplays are short (or led by a teacher) and action songs are simple and repetitive, children can learn the actions or movements after doing them a few times. With longer fingerplays and action songs, it is still important that children first hear

the entire song. When children are familiar with the content, lyrics, and melody, you can always divide the song or fingerplay into smaller, more manageable parts. Echo chants and fingerplays, such as "Let's Go on a Bear Hunt," are very easy for children to respond to because they are led by the teacher. The teacher chants a phrase and the children chant it back. Echo chants are popular among young children because they have to remember only one short line or simple phrase.

Fingerplays and other action songs can relate to curriculum development and can be used to enhance a young child's understanding of concepts. For example, the action chant "Let's Go on a Bear Hunt" reinforces the concepts of under, over, around, and through. At the same time, fingerplays and action songs that directly relate to the children can provide personal, concrete experiences that are relevant and meaningful to the young child. "Where Is Thumbkin?" is an all-time favorite of young children. It is their fingers and arms that are the center of attention and the stars of the play.

Fingerplays and songs that encourage full body movement are also helpful when it comes to transition times. "Teddy Bear, Teddy Bear, Turn Around" can be used to redirect children's energies when they need help to calm them down during transitions. The movement is fun, and children pick up cues from the words and move through transitions with ease and pleasure. The process is so much gentler to young children than ringing a bell or switching the lights off and on.

The traditional song "Come Follow Me in a Line, in a Line" is a delightful little tune that can also be used to assist children through transition periods. The

Children's abilities to learn the actions and words of fingerplay vary with age and experience.

teacher moves through a group of children while singing or chanting the verse in Pied Piper fashion and, one by one, touches the head of each child. As the children are touched, they join one hand and follow the teacher until they are all in a long, connected line. This is especially effective for moving children into a circle or to a different area of the classroom. This calm process of forming a line and moving to a repetitive song allows you and your children to gather together or form a circle without the confusion that this request often causes! Appendixes 2 and 3 include words and musical notations for these action songs and fingerplays, along with many others for you to use with young children.

It is very important that we not limit the use of fingerplays and action songs to very young children. Children's abilities to elaborate and expand their movements, actions, and singing abilities increase with age and experience. Three-year-olds may sing or chant short melodic songs informally as they move through an activity. These young children may not remember all the words or even understand the exact meaning of some words, but they often remember the feeling or affect they experienced during a song or fingerplay.

For the older child, fingerplays and songs offer great potential for learning new words, rhyming, and alliteration; developing language and verbal skills; and forming concepts. Teachers can also use songs and fingerplays to expand children's awareness of tempo, accent, rhythmic patterns, and intensity, all of which are part of the language and reading process.

Before using fingerplays and action songs with young children, you must learn and practice the words and movements until they are committed to memory. Fingerplays, especially, should involve a warm, intimate exchange between you and your children. This atmosphere can be lost if you have to read or refer to written notes during the play. You must be enthusiastic about sharing fingerplays and action songs with your children and be involved both with the play and with your children. Learn and practice a few fingerplays until you are totally familiar with the words and actions. Once you are comfortable with the words and actions, you can present them with the warmth, naturalness, and spontaneity needed to give them excitement and life.

Feel free to change or revise the basic forms to create your own versions or to accommodate the different age levels of your children. Approaching action songs and fingerplays from this perspective will allow you to use your own creative abilities and should limit the potential stereotyping of having all of your children doing the exact same thing at the same time. Your children should make their "Eensy Weensy Spider" move the way they want it to move. And, if you think about it, all children shake their "Hokey Pokey" in individual and different ways!

Musical Instruments for Young Children

Making music by playing instruments can be one of the most exciting parts of the creative arts experience. Children are responsive to musical instruments, and they love to experiment with the different sounds and tone qualities of sticks, drums, cymbals, bells, and a variety of other instruments. Rhythm instruments, which are real musical instruments, provide rich and varied opportunities for young children

to focus on creative exploration. Each instrument is different, is simple to use, and can be played in many special interesting ways.

Presenting Instruments to Children Some of you may remember the chaos associated with the traditional "rhythm band." Fortunately, there is a trend away from this approach to using instruments and toward a more relaxed and personally selective use of rhythm instruments. Under this approach, children can select an individual instrument and discover what tones can be produced, what the dynamic range is, and what musical textures can be developed. They can experiment with different ways of playing the instrument and notice how different a drum sounds when they play it with a mallet and tap it with their fingers. Children can compare the duration of the bell sound when they strike a triangle that is suspended from a string or held in their hands. They can discover the music hidden in the instrument and create rhythmic patterns of their very own! The more children experiment with rhythm instruments, the more sensitive they will become to the delightful patterns, combinations, and possibilities these instruments hold for making music. Bringing a child and an instrument together with ample opportunity to explore can help eliminate the stereotypical "rhythm band" where all the instruments sound at once. Certainly, not many things can be more frustrating for a teacher and more confusing for a child than having to march to the beat of the drum as all the instruments crescendo to the maximum of their dynamic range.

Appreciating Musical Instruments While it is important for children to be free to manipulate and experiment with instruments, it is equally as important that we, their teachers, provide guidance and structure when introducing instruments. One of the first things that we must do is adopt the attitude that percussion and tuned instruments are real instruments. All major symphony orchestras use drums, triangles, bells, and many other of the same kinds of instruments we find in the traditional early childhood rhythm band sets. I cannot imagine the *1812 Overture* without the full complement of drums!

Each instrument in your commercial rhythm band set can produce a distinctive and unique sound quality. Tuned instruments, such as resonator bells, have their own particular rich and resonating tone qualities. Young children stand ready to model our behavior and take our word on things, and our treatment of instruments and our attitude toward them can have a lasting effect on the way children handle and play all instruments.

Introduce one instrument at a time. If possible, have several identical instruments so that all of your children can explore and discover what sounds the instrument can make and how to produce these sounds. Young children are not good at waiting—they want to play the instrument now! Encourage your children to play the instrument and to try different ways to produce sounds. Give them the time they need to get to know the instrument. If you have only one set of instruments, you may try placing an instrument in a music center and introduce it as a small-group activity.

By introducing instruments one at a time, you allow your children to develop a musical sensitivity to each instrument gradually. When children have experi-

Beautifully painted or decorated instruments are appealing to children. Consult the music specialists in your school to find out what unique instruments are available.

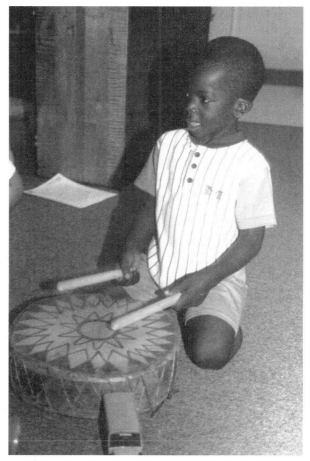

mented with several instruments, you can encourage them to make rhythmic patterns or melodies. Give your children this type of respectful introduction to musical instruments. You will be opening an avenue for them to respond to rhythm, tone, melody, and harmony—an avenue to music. Figure 4–4 illustrates and explains the rhythm instruments you might appropriately use with young children.

Although the music and movement ideas just discussed are good ways of getting you and your children started on the road to a music program, you should also consider some of the excellent recordings available. One advantage of using CDs, and/or cassette tapes you make yourself is that the songs are usually grouped and classified for specific purposes. It would be impossible to provide you with a complete list of what is suitable and available for use in the early childhood classroom, but I will include some of my favorites in hopes you might find some individual records and recording artists that will be helpful.

Give children music made all around the world as a way of beginning a lifetime of discovery of other cultures and countries from the reggae of Jamaica to the

FIGURE 4–4 Instruments for Young Children

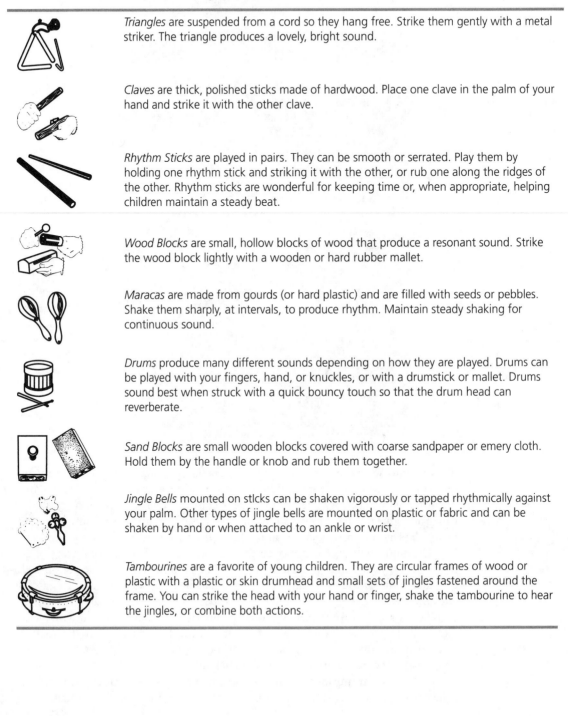

Triangles are suspended from a cord so they hang free. Strike them gently with a metal striker. The triangle produces a lovely, bright sound.

Claves are thick, polished sticks made of hardwood. Place one clave in the palm of your hand and strike it with the other clave.

Rhythm Sticks are played in pairs. They can be smooth or serrated. Play them by holding one rhythm stick and striking it with the other, or rub one along the ridges of the other. Rhythm sticks are wonderful for keeping time or, when appropriate, helping children maintain a steady beat.

Wood Blocks are small, hollow blocks of wood that produce a resonant sound. Strike the wood block lightly with a wooden or hard rubber mallet.

Maracas are made from gourds (or hard plastic) and are filled with seeds or pebbles. Shake them sharply, at intervals, to produce rhythm. Maintain steady shaking for continuous sound.

Drums produce many different sounds depending on how they are played. Drums can be played with your fingers, hand, or knuckles, or with a drumstick or mallet. Drums sound best when struck with a quick bouncy touch so that the drum head can reverberate.

Sand Blocks are small wooden blocks covered with coarse sandpaper or emery cloth. Hold them by the handle or knob and rub them together.

Jingle Bells mounted on sticks can be shaken vigorously or tapped rhythmically against your palm. Other types of jingle bells are mounted on plastic or fabric and can be shaken by hand or when attached to an ankle or wrist.

Tambourines are a favorite of young children. They are circular frames of wood or plastic with a plastic or skin drumhead and small sets of jingles fastened around the frame. You can strike the head with your hand or finger, shake the tambourine to hear the jingles, or combine both actions.

FIGURE 4–4 (continued)

Finger Cymbals produce delightfully delicate sounds. Put one on a finger of each hand and bring them together to lightly chime the finger cymbals. You can also put one finger cymbal on your thumb and another on your middle finger of the same hand and strike them together.

Cymbals are usually made of brass and have handles or straps. Cymbals produce their best tone when they are struck while being moved in a vertical motion. Hold one cymbal slightly higher than the other, bring it down, and let it strike the lower one. You may want to practice playing cymbals and master the technique of producing a pleasant sounding ring before you introduce cymbals to children. If your children can hear the lovely tone cymbals can make, they may be more inclined to respect them as a real musical instrument.

Resonator Bells are played with a mallet and can provide children with experiences in pitch, melody, and harmony. Because resonator bells are tuned, children can experiment with an accurately pitched instrument while working out patterns and melodies.

Orff Instruments were originally designed by German composer Carl Orff. Although these instruments are expensive, they are a wonderful addition to an early childhood environment. They are very high quality and produce beautiful, pure tones. The lowest pitched instrument, the metallophone, produces rich alto and bass tones. The bars are made of thick metal. The bars of the xylophone are made of hardwood. They are removable and can be taken apart and changed for different tonal patterns. The glockenspiel is the highest pitched instrument. The bars are also removable metal, and they produce a bright, soprano tone. Very young children may have difficulty playing the glockenspiel because of the small size, but four- and five-year-olds, as well as older children, will enjoy striking the bars and hearing the crisp, clear tones.

Autoharps can be valuable if you consider yourself to be a nonmusical teacher. You don't need special musical training to play an autoharp. It is a stringed instrument that can be played either by holding it flat on your lap on in an upright position. You strum the autoharp while pressing the buttons. Each button has a letter, or musical notation, that corresponds to the chords you are playing. Most music includes chord notation in the form of letters above the music bar. Follow the letter notation as you press the corresponding button while strumming the autoharp. Your children can learn to play the autoharp, too, so don't be afraid to let them explore all the chords, sounds, and sensory impressions the autoharp provides.

jigs and reels of Ireland to the zydeco of Louisiana. A wide variety of music and movement from across the globe can be a springboard for children's introduction to multicultural education in the classroom. Later in this chapter you will be introduced to two music and movement activities from cultures on opposite sides of the globe.

Classical Music and Children

Musical experiences for young children *must* include classical music in addition to the music we usually associate with the early childhood classroom. Some children in your classroom may be growing up in homes where classical music is played and appreciated. These children are indeed fortunate. For those children who are listening to only one genre, be it jazz, rock, or oldies, you may be the only resource for extending their musical experiences and the appreciation that comes from exposure to classical music. Research indicates that early association with classical music can increase children's enjoyment of music as an art form and increase children's aesthetic awareness (Cecil & Lauritzen, 1994).

Emile Jaques-Dalcroze (1865–1950), a Swiss composer and harmony professor at the Geneva Conservatory at the turn of the century, thought of movement as a way of using the body as a "musical instrument" and that body movement was a counterpart to musical expression. He further believed that early musical intelligence could be encouraged by using one's body in conjunction with musical responsiveness. This understanding can be facilitated by drawing upon the "universal language" of classical music:

> Music is significant for us as human beings principally because it embodies movement of a specifically human type that goes to the roots of our being and takes shape in the inner gestures which embody our deepest and most intimate responses. (Jaques-Dalcroze, 1921, p. 129)

Classical music can be naturally infused into the early childhood classroom in a variety of ways, from playing Bach's Preludes during quiet activities to marching around the room to the "March of the Toys" from Herbert's *Babes in Toyland*. Figure 4–5 is an overview of classical music selections that seem to naturally invite children to move their bodies in certain rhythmic patterns.

Classical music comes in all forms, shapes, and sizes, and I want to mention a few of the different styles available to you and your children. In addition to the symphony, there are sonatas, string quartets, concertos, concertinas, trios, and dances; and let's not forget opera. Opera has increased in popularity through the years, probably because the combination of music, movement, and speech is inseparably presented in ways that seem to touch our humanness. When I mention opera to my own students, I can sense the fear that seems to creep, very much like a London fog, into our classroom atmosphere. I am not suggesting that you become an opera fan or that you introduce opera to your children in any formal way. I would, however, like to give you a gentle nudge and ask you not to discount the idea of playing opera as quiet background music in your classroom. Children may not even

"Talking with Children About Music." Interview a group of first-grade students. Ask them to tell you about their favorite music and to describe why they like it more than other types of music.

FIGURE 4–5 Classical
Music and Movement
Exploration

Walking	Kabalevsky: "Pantomime" from *The Comedians* Prokofiev: "Departure" from *Winter Holiday*
Marching	Vaughan Williams: "March Past of the Kitchen Utensils" from *The Wasps* Grieg: "Norwegian Rustic March" from *Lyric Suite*
Hopping	Mussorgsky: "Ballet of the Unhatched Chicks" from *Pictures at an Exhibition* Bach: "Gigue" from *Suite No. 3*
Swaying, Rocking	Offenbach: "Barcarolle" from *The Tales of Hoffman* Saint-Saens: "The Swan" from *Carnival of the Animals*
Sliding, Gliding	Khachaturian: "Waltz" from *Masquerade Suite* Tchaikovsky: "Waltz" from *Sleeping Beauty*

notice that you have included a different type of music into your musical selections. Nevertheless, you will have broadened their exposure to yet another classical form. Many years ago, after I had played selections from *Madame Butterfly* on several occasions during quiet time, one of my five-year-olds came up to me and told me that the lady's voice made her sleepy! What more could a kindergarten teacher ask for during quiet time?

Figure 4–6, which lists some of my favorite instrumental classical music recordings, may be useful as you begin to build your own musical library, for both your personal enjoyment and the listening pleasure of your children. I found all of these recordings on budget label compact discs, and the sound quality is exceptionally good. These are not listed in any particular priority, so when you approach the classical section of your local music store, select the titles that suggest your own sensitivity to the possibilities these recordings may hold for you.

Classical music must be played in early childhood classrooms right along with Raffi and Ella Jenkins. As McGirr tells us, "Too often, early childhood programs use only children's music, nursery rhymes, fingerplays and light, short humorous pieces, all played mainly on popular instruments. Young children are capable of much more sophisticated listening" (McGirr, 1995, p. 75). Exposure to classical music affords children unique opportunities to enjoy a whole complement of musical experiences and puts them in touch with a wide range of musical expression. Research indicates that early association with classical music can increase children's enjoyment of music as an art form and increase children's aesthetic awareness (Cecil & Lauritzen, 1994). Without exposure to the great classical composers and their music, we cannot expect children to develop an appreciation for *all* music. Furthermore, without this opportunity, some children may not find out that classical music exists until they are young adults and find themselves in a college-level music appreciation class. We must encourage even the youngest children to listen to a variety of music, including classical, if we want them to develop musical appreciation in the broadest context.

Inventory your own music collection. Make notes to indicate which variety of music you seem to have the most of, and then write a paragraph about why this particular section of your collection is larger than others.

FIGURE 4–6 Your Classical Music Collection: Suggested Recordings

Wolfgang Amadeus Mozart. *Symphony no. 39 in E flat* and *Symphony no. 41 in C. No. 39 in E flat,* the first of Mozart's greatest trilogy, is dated June 26, 1788. Within the space of only six weeks, Mozart composed his last three symphonies, and *no. 39* is the only one of the three to take full advantage of clarinets. It is composed of an "Adagio," "Allegro," "Andante," "Menuetto," and "Finale." *No. 41 in C* is dated August 10, 1788. It is believed that Mozart knew this was to be his last symphony. The last movement seems to express with absolute finality all that Mozart could wish to say through the medium of the full orchestra.

Frederic Chopin. *Sonata no. 3, op. 58.* This sonata is for those of us who love piano music. Robert Schumann wrote about Chopin's *Sonata no. 3, op. 58,* saying: "The idea of calling it a sonata is a caprice, if not a jest, for he has simply bound together four of his most reckless children . . ." (Van Cliburn, 1992). However, George Sand said: "The self-sufficing coherence he achieved in this work marks him as a master who knew precisely what he was doing" (Van Cliburn, 1992). There is intense beauty and power in this piece that accumulates fantastic momentum and rushes to the crowning point with immense boldness and brilliance. The coda fulfills the work with a fiery conclusion!

Ludwig van Beethoven. *String Quartet no. 3 in D major* and *String Quartet no. 4 in C minor.* The string quartet has four parts so a composer has enough lines to fashion a full musical form; there is not much to spare for "padding." Beethoven was a long-term planner and follower-through of highly organized musical composition, and his string quartets, as his sketchbooks show, are filled with almost superhuman laboriousness. In the life work that came from four decades of compositional toil, he completed 16 string quartets.

Johann Sebastian Bach. *Brandenburg Concertos no. 1–6.* Bach was a composer of the Baroque period. At the head of an orchestra, he was a dominating figure and score reader. His hearing was so fine that he was able to detect even the slightest error in a large orchestra: "While conducting, he would sing, play his own part, keep the rhythm steady, and cue everybody in, the one with a nod, another by tapping with his feet, the third with a warning finger, holding everybody together, taking precautions everywhere and repairing any unsteadiness, full of rhythm in every part of his body." His vision was the greatest, his technique unparalleled, his harmonic sense frightening in its power, expression, and ingenuity. The *Brandenburg Concertos* are pronounced in the qualities of who Bach was as a person. They are filled with mysticism, exuberance, complexity, decoration, allegory, distortion, and exploitation of the grandiose (Schonberg, 1981). If you don't already own a recording of the *Brandenburg Concertos,* you should consider discovering how all these descriptors of his work are represented in his music.

Processes for Music and Movement

One of your primary responsibilities as a teacher of children is to establish a warm and safe environment of trust, freedom, and communication where positive and pleasurable music and movement experiences happen. Enjoyment of expression is the prime value of music and movement. We must be very careful that we do not demand perfection of form as children move through space or experiment with time and force. "Children move because movement gives them a tremendous lift, a sense of freedom, exhilaration akin to flying high above the waters, above the clouds, above the earth, and into the sky . . . " (Logan & Logan, 1967, p. 39). Our job is to create an atmosphere that welcomes this freedom.

How will you structure this atmosphere? How will music and movement thrive in your classroom? Involvement is more likely in an atmosphere in which children feel and are assured of the following conditions:

◆ It is safe to try.
◆ I can deal with events.
◆ My teacher encourages me to make the attempt.
◆ I am fulfilled for having done so.

When children find themselves in a safe, supportive, and encouraging environment, they are free to explore, experiment, and respond with unlimited creative expression. Now that you have established an environment in which children feel safe to try out new and different ways of expressing themselves, the next question you may be asking is: "How do I begin?" Good teachers always begin with a plan, and the following sections can be translated into lesson plans as you prepare to begin this journey with your children.

Introducing Movement and Dance

Assure that your children know that they have their own space and that their space belongs to them and only them. You can help your children identify their personal space by guiding them through an imagery process of finding their own imaginary space bubble.

1. Walk among the children and point out all the space in the room. Show them the empty spaces between tables and chairs and wave your hand in the space between children. Ask the children to look up and see the space between them and the ceiling.

2. Have children find a space on the floor where they can stand, sit, or lie down without touching anyone else. Ask the children to move their hands and arms around, filling up as much space as they can.

3. Encourage children to move their legs and stretch them as far as they can, seeing how much space they can fill with just their legs.

4. Tell children to stand and move their arms through their own space, reaching as far as they can without moving their feet. Ask them to explore their own space with their feet and legs.

5. Ask your children to imagine that they are inside a big space bubble that is theirs and that no one else can come into their bubble or into their space unless they invite someone. They can move inside their imaginary space bubble in many different ways. They can also carry their space bubble with them as they move around the room.

Exploring Space, Time, and Force

As you continue exploring space, time, and force with your children, you can develop activities based on the suggestions presented in this section. These ideas are

offered to assist you in your planning and to help you get started in developing your own music and movement activities. Extend the experiences by adding recorded music or other rhythmic accompaniment. The pages that follow offer many, many suggestions for engaging children in movement and dance opportunities. However, I do not recommend that you initiate these all at one time or on a day that is designated as "movement day." Group the ideas as they seem to fit into the natural progression of your plans, *or* use them one at a time on a daily basis as a way of introducing your children to the different ways they can move their bodies in creative and uniquely different ways. I also hope that you will use your own ideas to change or revise these suggestions when planning music and movement experiences for the very special group of children in your classroom; there is *no* copyright on children's creative movement. You will be reading a lot of "starter" ideas; the extension and stretching of these ideas is left up to your own creativity.

Space

1. What is space? (Begin by describing space or ask your children to tell you their definitions of space.)
2. Can you find a space on the floor where you will not touch anyone and it will be your very own?
3. How tall can you make yourself?
4. See how many different directions you can reach by stretching different parts of your body.
5. Can you make a long, low bridge using only two parts of your body?
6. Can you move forward in your space? Backward? Sideward? In a circle? Can you change your level from upward to downward?
7. Lying on the floor, can you make a round shape in your space? Straight? Crooked? Twisted?

Time

1. How fast can you move about without bumping into anyone? How slow?
2. Can you move about, changing your speed from fast to slow?
3. Can you move very fast without leaving your space?
4. Can you move one part of you very fast and another very slow?
5. Can you combine a kick, catch, and throw in a smooth motion?

Force

1. How quietly can you walk? How heavily?
2. How would you walk against a strong wind?
3. Can you make your muscles feel very strong? Weak?
4. Show how you would lift a heavy object; a light object.

The ideas in Figure 4–7 represent an extension of space, time, and force for you to explore with your children. Examine the movement ideas to determine which

FIGURE 4–7 Ideas for Movement

◆ Make yourself as small as you can.

◆ See how much space you can fill by using different parts of your body.

◆ Make your body into a straight, long shape and crawl like a snake and wiggle like a worm.

◆ Make your body as tall as you can and move in and out of empty spaces.

◆ Try different ways of moving through space.

◆ Can you move straight?

◆ Can you move in a zigzag?

◆ Can you move forward and backward?

◆ Can you move sideways?

◆ Can you move upward, downward, or in a circle?

◆ Can you move very near to someone else without touching that person?

◆ Move your arms and body as high as they can go and then as low as they can go.

◆ Lie on the floor on your back and let your feet and legs fly in their space.

◆ Lie on your stomach and stretch your head back, kick your feet in the air, and wave your arms out to your sides.

◆ Move around the room as slowly as you can.

◆ Move around the room as fast as you can without touching or getting into anyone else's space.

◆ Move as fast as you can without leaving your space. Move as slowly as you can without leaving your space.

◆ Move as quietly as you can. Can you move as quietly as a mouse?

◆ Can you quietly creep and crawl like a spider?

◆ Can you dance through the air like a butterfly?

◆ How heavily can you move? Can you move like an elephant?

◆ Can you make your muscles very strong and swing and sway like a bear?

are developmentally appropriate for the age and skill of your children. When in doubt, you can always refer to the previous section that addressed the basic stages of early musical development. A word to the wise: Do not use all of these ideas together at the same time. If you think the traditional rhythm band creates chaos, you will certainly see your children transform themselves into an uncontrollable group should you decide to introduce all of these activities at once. Use your own judgment sprinkled with a good measure of common sense.

All of these ideas encourage children to create dramatic and creative movements either to imitate familiar things in their environment or to use their bodies to perform specific movements. In addition, I encourage you to add musical accompaniment such as recordings or musical instruments, both of which can add immensely to the movement and dance experience. In addition, you should find some of the following books that can provide many additional ideas for movement and dance.

- Gelsanliter, W., & Christian, F. (1998). *Dancin' in the kitchen*. New York: Putnam.
- Hopkins, L. B. (Ed.). (1997). *Song and dance: Poems*. New York: Simon & Schuster.
- Morgan, M. (1999). *Wild Rosie*. New York: Hyperion.
- Shannon, G. (2000). *Frog legs: A picture book of action verse*. New York: HarperCollins.
- Wood, A. (1992). *Silly Sally*. New York: Harcourt Brace.

Exploring Movement and Dance Through a Multicultural Context

Music is a universal language and it brings excitement, joy, and satisfaction to children of all ages. Whether in city or country, China, the Caribbean, Dallas, or Rome, children are chanting, humming, making up songs, as well as dancing, clapping, shaking, and moving to the rhythms of others and themselves. Culturally diverse music, dance, and expressive movement provide different lenses for conveying cultural traditions and ideas. Many languages have no word that translates the word *dance,* while other languages have multiple words for different dances without having a single generic term (McCarthy, 1996). For example, one of the dance activities included in this section, the hula, has many referents—the dance, the dancers, and the song or chant used. Aina (personal communication, 2003) talks to me about this same concept, which is familiar in his homeland of Nigeria. He says that in Nigeria the drum is an essential part of dance, the word *dance* also refers to drumming. The two activities that follow reflect the cultural similarities and differences among *dance* from opposite sides of the globe. The cultural traditions of Hawaii are reflected in the hula, while the chants and rhythms of the Caribbean are captured in song and movement about a little brown girl. What is true, from a global view, is that music, movement, and dance are indeed a universal language, "an embodiment of culture, a way of knowing, a way of communicating, a kinetic human history" (Frosch-Schroder, 1991, p. 62).

> *Sometimes dancing and music can describe a true image of the customs of a country better than words in a newspaper.*
>
> Gene Kelly

The Hawaiian Hula and Caribbean Ring Dances

The Hula

The children of Hawaii learn the hula at a very young age. The hula includes a variety of hand and body motions that tell a particular story. The basic steps are easy to learn and are introduced here. Figure 4–8 provides illustrations of the basic movements. All you need is a recording of Hawaiian music or ukulele music. You might consider making and giving your children flower garlands called *leis* to wear while dancing. "Pearly Shells," introduced here, is a traditional hula known and loved around the world. The dance movements are simplified here to be appropriate for young children.

A Family's Role in Developing Music and Movement at Home

Teachers should encourage caregivers to engage children in music and movement activities. Many of today's families are responding to the research that shows the relationship between intellectual development and music literacy. There are many things that parents can do to introduce music and movement to their children. Just as caregivers help children learn to read and encourage reading readiness, they can also provide children with many musical experiences that provide a base for building music literacy.

The following list provides some ideas for families and caregivers to enjoy music and movement time with children.

- Express your own enjoyment of music and movement by singing, humming, and dancing around the house.
- Interact with children and encourage them to explore different sound sources available throughout the home. For example, an upside-down pot and a long wooden spoon serve as a great drum and mallet.
- Give children an opportunity to look at instruments up close. Show them how to pluck a guitar string or strike a piano key.
- Dance with children. Hold hands or pick them up and dance along to music. Clap your hands to the rhythm of a good song.
- Make up songs about daily routines such as getting dressed, going for a ride, and blowing bubbles in the bathtub.

Basic Hula Steps

Body Movements
Hands on waist.
Step to the right and follow with the left.
 (Hands and arms lift to the right.)
Repeat.
Step to the left and follow with the right.
 (Hands and arms lift to the left.)
Repeat.
Bend knees with hands on knees and sway to the right and then to the left.
Repeat.

Hand Motions
Smile motion: hands on cheeks and smiling.
Coconut tree: put elbow on top of the other hand and sway your arms.
Ocean roll: make rolling motion with both arms in front of you.
Shining in the sun: bring both arms up above head to make a sun.
Love and heart: touch chest with hands.

FIGURE 4–8 Basic Hula Step—Kaholo

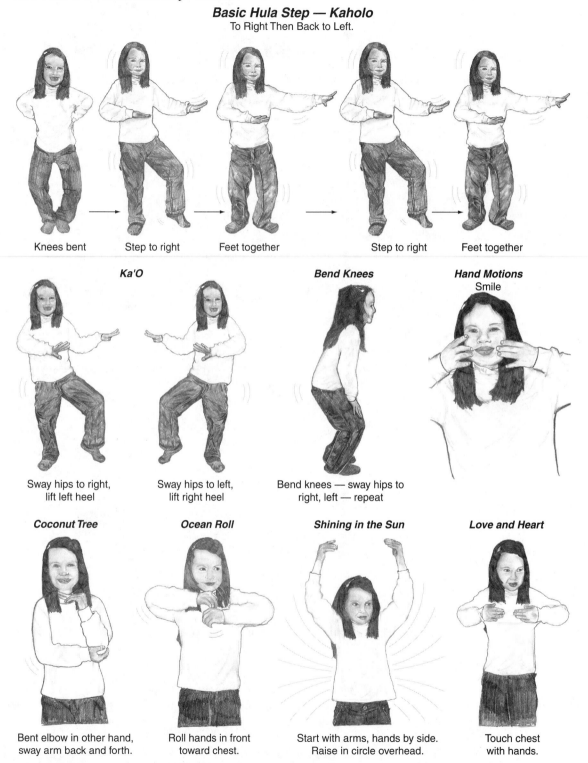

Basic Hula Step — Kaholo
To Right Then Back to Left.

| Knees bent | Step to right | Feet together | Step to right | Feet together |

Ka'O

Sway hips to right, lift left heel

Sway hips to left, lift right heel

Bend Knees

Bend knees — sway hips to right, left — repeat

Hand Motions
Smile

Coconut Tree

Bent elbow in other hand, sway arm back and forth.

Ocean Roll

Roll hands in front toward chest.

Shining in the Sun

Start with arms, hands by side. Raise in circle overhead.

Love and Heart

Touch chest with hands.

136

FIGURE 4–8 (continued)

Pearly Shells

Pearly Shells

Hands down, then hands palms up.
Both right, then left side.

From the Ocean

Roll hands in front
toward chest.

Shining in the Sun

Start with arms/hands by side.
Raise in circle to overhead.

Covering the Shores

Extend arms/hands
and move back and forth
in front.

When I See Them

Hand, palm out beside
eye. Other arm extended in
front. Repeat other side.

My Heart Tells Me

Touch chest
with hands.

That I Love You

Cross arms on
chest.

More than All Those Little Pearly Shells
Repeat first motion.

Pearly Shells (Words and hand motions can be sung or chanted.)

Pearly shells (motions indicate picking up pearly shells from the sand)
From the ocean (ocean roll)
Shining in the sun (sun motion)
Covering the shores (extend arms and hands to touch sandy shore)
When I see them (hands to eyes)

The hula is a traditional Hawaiian dance known around the world. The basic steps are easy to learn and appropriate for young children.

My heart tells me (love and heart motion)
That I love you (love and heart motion)
More than all those little pearly shells (motions to pick up shells from the sand)

An excellent resource to share with your children is a video recording titled *Hula for Children!* that shows young Hawaiian children dancing the hula. I found a copy at my local public library. If your library does not have a copy, you can purchase it through Taina Productions, Inc. at 1127 11th Avenue, Suite 204, Honolulu, Hawaii 96816, phone (808) 739-5774, or www.galaxymall.com/hawaii/hula.

Caribbean Ring Dances

The rhymes and songs of the Caribbean Islands can often be traced to their French, English, and African roots. The song "Brown Girl in the Ring" is sung as a circle game. One child stands in the middle of the ring and makes a motion that the other children mimic. See Figure 4–9. The source for this song is a collection of Afro Caribbean rhymes, games, and songs for children compiled by Grace Hallworth and illustrated by Caroline Binch (1996). Complete bibliographical information is included at the end of this book.

FIGURE 4–9 Brown
Girl in the Ring

Brown Girl in the Ring
There's a brown girl in the ring
Tra la-la-la-la.
There's a brown girl in the ring
Tra la-la-la-la.
A brown girl in the ring,
Tra la-la-la-la.
For she's sweet like a sugar
And a plum, plum, plum.
Now show me your motion,
Tra la-la-la-la.
Now show me your motion,
Tra la-la-la-la.
For she's sweet like a sugar
And a plum, plum, plum.
Now hug and kiss your partner,
Tra la-la-la-la.
Now hug and kiss your partner,
Tra la-la-la-la.
Now hug and kiss your partner,
Tra la-la-la-la.
For she's sweet like a sugar
And a plum, plum, plum.

In addition you might consider purchasing a recording by Marley and Booker of reggae and calypso songs for children. I highly recommend the following: Marley-Booker (1992), *Smilin' Island of Songs: Reggae and Calypso Music for Children*. Redway, CA: Little People Music.

Creative Movement

The next group of ideas, presented in Figure 4–10, is more open-ended. They are designed for freedom of expression, which may differ from child to child. They suggest that children move beyond exploring the basic elements of space, time, and force, and begin to add drama and their own creative interpretation and imagination to their movement experiences. For example, you might ask your children to move as if they were pushing a heavy wagon. Some of your children may have some knowledge of how to move a heavy wagon, while others may represent their understanding of wagons from what they have seen on television. As another example, you might ask children to pretend they are popping popcorn. How would they move as the kernels start to sizzle and then explode into fluffy, delicious popcorn? (See Figure 4–11.) Whatever the case, when children express what they know about walking in the rain or how a jack-in-the-box actually pops forward, their interpretation must be honored. Most significantly, your children are moving their bodies in ways that represent what they know (or do not know) about the workings of their world. Figure 4–10 presents ways to encourage creative, dramatic movement.

Materials for Creative Movement

The use of materials and props can also encourage and stimulate children to express themselves through movement. The following materials are especially enjoyable to young children.

FIGURE 4–10 Dramatizing Movement

- ◆ Move in a happy way.
- ◆ Move in an angry way.
- ◆ Move as if you are sad.
- ◆ See how gently (roughly) you can move.
- ◆ Dance like a rag doll.
- ◆ Pretend you are a tree and the wind is blowing you around.
- ◆ Gallop around the room like a horse.
- ◆ Hop around the room like a rabbit.
- ◆ Move as if you are carrying something very heavy.
- ◆ Swing and sway your body and arms like a monkey.
- ◆ Pretend you are swimming. How would your body, arms, and legs move?
- ◆ Pretend that you are a jack-in-the-box.
- ◆ Make yourself into a flat balloon and slowly blow yourself up.
- ◆ Pretend that you are a puppet with strings and someone else is making you move.
- ◆ How would you move if you were looking for something you have lost?
- ◆ Move as if you are walking in very deep snow, through a deep river, in hot sand, on cold ice.

FIGURE 4–11 Use your own imagination to think of ways to invite children to move creatively.

Scarves

Give your children lightweight, colorful scarves and encourage them to let each scarf flow up and down and all around as they move through space. Scarves can be magically transformed into capes for flying, wings for soaring, or umbrellas for dancing in the rain.

Streamers

Children can use long streamers to make interesting, flowing designs as they move and sway in a group movement activity. When placed on the floor, streamers can define a space or become a bridge across which little billy goats can tramp.

Hoops

You can place several hoops on the floor and let the children explore different ways of moving inside the hoop, in and out of the hoop, and outside the hoop.

It is easy and inexpensive to make streamer for children. One yard of colorful material will yield about twenty streamers.

FIGURE 4–12
Balancing a beanbag can be challenging, but it can also be fun.

Encourage your children to experiment with putting some parts of the body inside the hoop and other body parts outside. For example, ask the children, "Can you put both feet in the hoop and let your hands walk around the outside of the hoop?" They also can use the hoops as they would a single jump rope to practice jumping skills.

Beanbags

Play the beanbag game (see Figure 4–12). Give each child a beanbag (have a variety of colors available). The leader (either the teacher or another child) suggests movements for the other children to follow: Put your beanbag on your head and

walk around the room without letting it fall off. Put the beanbag on your shoulder, your arm, your elbow, your foot. Put it on your back and crawl around the room. Put it on the floor and jump over it. Sit on your beanbag. Roll over your beanbag. Toss it into the air and catch it with both hands. Combine the beanbag activities with the hoops or streamers.

Parachutes

Parachutes with sewn-in fabric handles should *not* be used with young children. Children have a tendency to put their little wrists through the handles, and this makes it difficult for them to turn loose when the parachute is filled with air. If your parachute does have these sewn-in fabric handles, I suggest that you CUT THEM OFF. When the force of an air-filled parachute gets too strong for children to hold on, they should be in a position to easily let go so that they are not pulled in any uncomfortable position. Encourage your children to move the parachute up and down. Help them move it in a circular pattern, or put a lightweight ball in the middle and let them bounce the ball around. You and your children (with the help of a few extra adults) can make a momentary tent out of your parachute, and the colors from underneath are beautiful. It is an easy process and one that I hope you will try. The directions are simple: Position your children and several adults at close intervals around the parachute. Raise it high in the air until it is full of air, run under it, and quickly sit on the edges. The parachute will balloon, and you and your children will delight in the magical quality it creates!

This chapter introduced a variety of ways to involve young children in music and movement activities. Remember that when you plan these experiences for young children, it is imperative to keep in mind their growth and development patterns. Too often, children are asked to engage in activities that are beyond their abilities. As you continue to think about the importance of children's patterns and stages of growth, you should consider the National Standards for Arts Education. The following sections review the music and dance standards for grades K–4 and provide guidelines to keep in mind when planning these types of activities for young children.

NATIONAL STANDARDS FOR MUSIC EDUCATION K–4

The Music Educators National Conference (MENC) established standards (1994) that reflect that organization's beliefs concerning the musical learning of young children. These standards provide a framework for teachers who work with young children and should assist teachers in planning a curriculum that is developmentally appropriate. Its mission statement is as follows:

> The National Association for Music Education is to advance music education by encouraging the study and making of music by all.

Content Standard 1: Singing, alone and with others, a varied repertoire of music. *What this looks like in practice:* Students sing expressively with appropriate dynamics, phrasing, and interpretation.

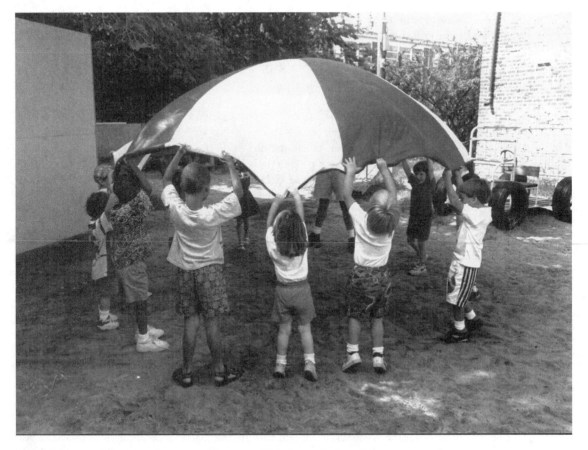

When you get a new parachute, you must cut off the sewn-in handles.

Content Standard 2: Performing on instruments, alone and with others, a varied repertoire of music.
What this looks like in practice: Students echo short rhythms and melodic patterns.

Content Standard 3: Improvising melodies, variations, and accompaniments.
What this looks like in practice: Students improvise simple rhythmic variations and melodic embellishments on familiar melodies.

Content Standard 4: Composing and arranging music with specified guidelines.
What this looks like in practice: Students use a variety of sound sources when composing.

Content Standard 5: Reading and notating music.
What this looks like in practice: Students identify symbols and traditional terms relating to dynamics, tempo, and interpret them correctly when performing.

Content Standard 6: Listening to, analyzing, and describing music.
What this looks like in practice: Students respond through movement (e.g., swaying, skipping, dramatic play) to selected music characteristics or specific music events while listening to music.

Content Standard 7: Evaluating music and music performances.
What this looks like in practice: Students use criteria for evaluating performances and competitions. Students explain, using appropriate terminology, their personal preference for specific music works and styles.

Content Standard 8: Understanding relationships between music, the other arts, and disciplines outside the arts.
What this looks like in practice: Students identify similarities and differences in the meanings of common terms (e.g., *form, line, contrast*) used in the various arts.

Content Standard 9: Understanding music in relation to history and culture.
What this looks like in practice: Students identify and describe roles of musicians (e.g., orchestra conductor, folksinger, church organist) in various music settings and cultures. A complete listing of content and achievement standards is available at www.menc.org/index.html.

 # NATIONAL STANDARDS FOR DANCE EDUCATION K–4

The National Dance Association (NDA) established its standards in 1994. The NDA standards reflect the association's belief that children in grades K–4 need to become literate in the language of dance in order to use this natural facility as a means of communication and self-expression, and as a way of responding to the expression of others. Dancing and making dances provide children with skills and knowledge necessary for all future learning in dance and give them a way to celebrate their humanity. The NDA's mission is as follows:

> The mission of the National Dance Association is to increase knowledge, improve skills, and encourage sound professional practices in dance education, while promoting and supporting creative and healthy lifestyles through high quality dance programs.

Content Standard 1: Identifying and demonstrating movement elements and skills in performing dance.
What this looks like in practice: Students accurately demonstrate eight basic locomotor movements (such as walk, run, hop, jump, leap, gallop, slide, and skip); traveling forward, backward, sideward, diagonally; and turning.

Content Standard 2: Understanding the choreographic principles, processes, and structures.
What this looks like in practice: Students improvise, create, and perform dances based on their own ideas and concepts from other sources. (Remember Lien from Chapter 1, who re-created swimming with dolphins through her dance.)

Content Standard 3: Understanding dance as a way to celebrate and communicate meaning.
What this looks like in practice: Students observe and discuss how dance is different from other forms of human movement (such as sports, everyday gestures).

Content Standard 4: Applying and demonstrating critical and creative thinking skills in dance.
What this looks like in practice: Students observe two dances and discuss how they are similar and different in terms of one of the elements of dance by observing body shape, levels, and pathways.

Content Standard 5: Demonstrating and understanding dance in various cultures and historical periods.
What this looks like in practice: Students learn and effectively do a dance from a resource in their own community; describe the cultural and/or historical context.

Content Standard 6: Making connections between dance and healthful living.
What this looks like in practice: Students explain how healthy practices (such as nutrition, safety) enhance their ability to dance.

Content Standard 7: Making connections between dance and other disciplines.
What this looks like in practice: Students create a dance project that reveals understanding of a concept or idea from another discipline (such as pattern in dance and science). A complete listing of content and achievement standards is available at www.aahperd.org/nda/template.com.

PERSONAL AND PROFESSIONAL GROWTH

Now, what about you, the teacher? How is your creative development progressing? Let's shift the focus back to you and explore some ways for you to *respond* to music and movement experiences. Some of the verbs typically associated with this second category on the continuum of affective development are *assists, performs,* and *practices.* Try your best to let go of—if just for the sake of experiential learning— some of the old trappings that may have prevented you from actively participating in music and movement activities in the past. And remember that it is our own willingness to enter into the creative process that gives us the very valuable insight into how our children experience these same types of encounters.

The Instrument Improvisation Activity

Instrument Improvisation is designed with you in my mind. It provides an opportunity for you, in your own instinctive way, to explore rhythm instruments as you work out musical "scores," or compositions that reflect your interpretation of the instrument. During the activity, you will discover the distinctive, expressive potential of the individual instruments as you and a small group of colleagues experiment with composing an original musical score. You can do all of this without excessive practice, prior instruction, or any special musical expertise. At first you may think

this will be an impossible task or too much of a challenge for you at this stage of your musical development, but allow me to assure you that my own students have had great success in creating original compositions and have been very pleased with the outcome of their efforts.

Preparing for Instrument Improvisation

You will need a variety of rhythm instruments. The following list represents the minimum that should be available: tambourines, cymbals, finger cymbals, drums with mallets, claves, wood blocks with mallets, triangles with strikers and string holders, tone blocks with mallets, maracas, rhythm sticks, jingle bells or sticks, and sand blocks. Optional instruments that add greater variety to the composition process include the autoharp, Orff instruments, resonator bells, and string instruments such as a guitar (even if no one in your class can play one!).

You will also need a tape recorder so that someone can tape your debut performance. It is difficult to play a composition and listen to it at the same time, so you will want to make sure you capture the moment on a recording.

Instrument Improvisation

To begin the Instrument Improvisation activity, place all of the instruments on the floor. Each person should experiment with the different instruments and pay attention to the variety of tones, sounds, and rhythms each instrument can produce. See if you can find new or unconventional ways of playing a familiar instrument, or combine different parts of an instrument with another. For example, what happens when you use a wooden mallet to strike a triangle? After everyone has had ample time to play all of the instruments, each person selects one instrument to use for the composition. The next steps in the process are as follows:

1. When everyone has selected an instrument, use some type of random grouping, such as counting off or grouping by the colors you are wearing, to move into groups of five people.

2. Each group should find a place where it can be alone, preferably out of the hearing distance of others. If circumstances allow, each group might choose to leave the classroom and go outside or to another room in the building.

3. Create a musical improvisation, interlude, rhythmic presentation, or other original musical composition. If you wish, add lyrics or movement and action to elaborate on the improvisation, or if you prefer, the composition can be strictly instrumental. You do not have to write a musical score; just try to keep the sequence of your improvisation in mind. Remember, though, that this is to be an original piece of music and not a takeoff on an old favorite such as "Happy Birthday." If your group is especially talented, or if you have a budding Rachmaninoff in your midst, you have permission to write a rhapsody on a classical theme. (In my experience, this has never happened, but I do not want to discourage any musical geniuses!)

4. Practice your presentation, and after about 20 minutes, return to the classroom. Stay with your group, and let your instruments rest on the floor beside you.

5. Now it is time for the performances. Each group presents its Instrument Improvisation, while an appointed sound person records each individual performance. When all the groups have played their compositions, the sound person plays back the recorded music. During the playback, each group's performance should be rewarded with applause, bravos, whistles, or other signs of appreciation.

The music and movement experiences in all of these activities can be changed and modified into developmentally appropriate practice for your children. Once you have had the personal experience of exploring the wonderful world of your own creative potential, you also should have a broader understanding of how you, as a professional, will bring similar yet age-appropriate activities to children. Your role as an early childhood teacher is to provide music and movement encounters that will bring satisfaction and enjoyment to your children. Mastery of pitch, rhythm, or melody is not the goal, and you certainly do not have to be a musical genius yourself. The goal is for young children to find pleasure and joy in the process of singing, moving, dancing, and playing instruments. Your job is to plan for these experiences, to be open and flexible in your planning, and to know the developmental levels of your children. You must search for new ideas and techniques. Even though young children love repetition, they will soon tire of songs and fingerplays if you have only three or four in your repertoire. Finally, you must enjoy and find pleasure in the creative self-expression that flows naturally and spontaneously from the child's own wellspring of creative potential.

> *Music is your own experience, your thoughts, your wisdom.*
> *If you don't live it, it won't come out your horn.*
>
> Charlie Parker

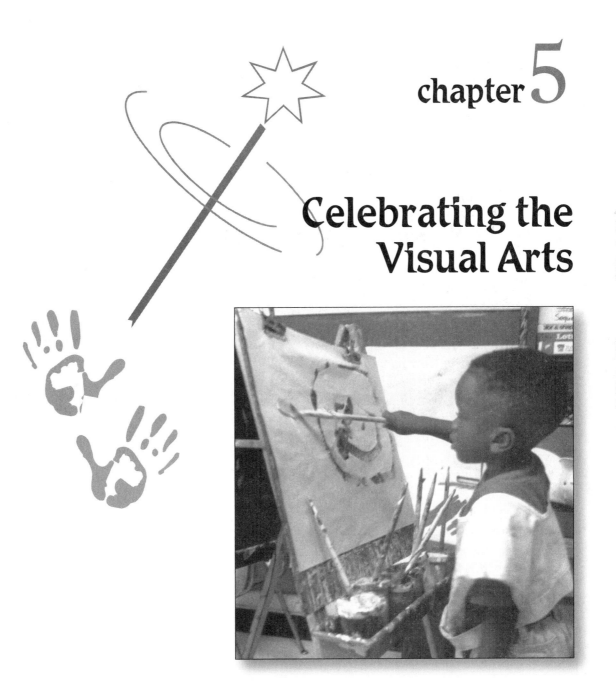

Celebrating the Visual Arts

This world is but canvas to our imaginations.

Henry David Thoreau

Imagine for a moment that tomorrow is the first day you will go to your new practicum assignment. You have been placed in a school you have heard good things about, but you spend tonight trying to figure out where the school is located and how you are going to get there in the morning. Your assignment is to observe in both a second-grade classroom and a third-grade classroom. Use your mind's eye to see the visual imagery emerge in the scenes that are about to unfold.

The second-grade teacher is introducing a unit on *Plants and Other Things That Grow.* While showing the children a red rose that she brought from her own garden, she names three of the visible parts: the green stem, the red rosebud, and the green leaves. One of her seven-year-olds, a boy named Chet, raises his hand when he recognizes the thorns on the stem and begins to recount his experiences with rosebushes. The teacher reminds him that he needs to be quiet and pay attention to what she is saying. Chet lowers his hand but still shows great interest, in nonverbal concentration, in the rose his teacher is holding. At the end of the demonstration, the teacher uses red and green markers to draw a very large rose on chart paper, and the children are then asked to draw their own pictures of the rose. The teacher approaches Chet, who has drawn a long, wide, brown line from the top of the paper to the very bottom. At this point, Chet is drawing little dots all along the sides of his brown line. When the teacher asks Chet what he is drawing, he points to the "thorns" on his rose stem and begins to tell his teacher about his experience of being pricked by the thorns on his mother's rosebush. "Here's the thorn that bit me, and this is the one that grabbed my shirt," Chet announces as he begins to talk about his drawing. His teacher gently reminds him that he needs to concentrate on drawing a rose like the one she drew on the chart paper. She then turns to you, the observer, and explains that she feels it is important to remove all of Chet's crayons except for the red and green so that he will not be so easily distracted. She says that Chet has difficulty staying on task and that too many different-colored crayons are confusing to him. "If he has only one red and one green crayon, he will be able to focus on the appropriate colors for drawing a rose." At the end of the day, Chet's drawing of a rose is not displayed with the other children's drawings. You ask the teacher why Chet's drawing is not on the bulletin board. She replies, "Chet chose not to follow the directions and then decided that he didn't want to draw a rose. I never force children to draw if they don't want to. If I did that, I would be stifling their creativity."

In the third-grade classroom down the hall, another teacher is also implementing a unit on plants. The teacher and the children spent the morning walking around the school yard, looking at all the different kinds of trees they could

see from their vantage point. As you enter the classroom, you see two or three children moving about the room collecting crayons, sheets of colored tissue paper, and glue. Several children are sitting at tables with containers of tempera paint and large sheets of drawing paper. At another table, you see a small group of children tearing paper and gluing the torn paper into patterns of colors. The teacher is walking around the room inquiring if the children need anything they do not have. Because you are a trained observer, you notice that she does not interrupt the children by asking each to tell about his or her picture, nor does she make personal judgments about the children's work by repeating the overused phrase, "I like the way you glue your pieces together." When you ask the teacher what the children are making, she replies, "They are making the trees we saw on our morning walk." When you probe further and ask her why she is not showing the children how to make trees, she responds by saying, "If I told them how to make a tree, it wouldn't be their trees, would it? Each child sees a tree in a different way. It is their collective images of a tree that represent the variety of all we saw this morning."

Hold on to the images from these early childhood classrooms while we look at the situations from an artistic and developmental perspective. It is time to examine both the activities of the children and the teachers' different approaches to the process to provide more insight into what was happening in both classrooms.

Children and the Artistic Process

In the first classroom, Chet was an artist who was unwilling to be restrained by convention. He was able to look beyond the teacher's interpretation of a rose while attempting to make an image that communicated ideas and emotions regarding his own personal experience with roses and, especially, thorns. Chet's experience with the rosebushes in his mother's garden was an important part of what he wanted to represent in his drawing. His experience was the catalyst for creating a work of art. Chet was not interested in imitating, or copying, the green stem and red bud of the rose his teacher had drawn, but he was clearly interested in creating a personal response to his unpleasant experience with roses, rosebushes, and thorns. For Chet, and other children like him, drawing is his most eloquent way of expressing himself and communicating with the rest of the world (Bleiker, 1999). In the words of Gardner, Chet was demonstrating exactly what the creative arts process is all about: "Artistic learning should grow from kids doing things: not just imitating but actually drawing . . . on their own" (Brandt, 1987, p. 32).

You already know a great deal about the process of creativity and about the processes of preparation, incubation, illumination, and verification. Hopefully, you

have been in some classrooms where these processes have been obvious. As an early childhood educator, you are developing an understanding of creative arts and that the arts, especially for young children, must be more concerned with *process* than product. You know the importance of allowing room for creative self-expression that is based on children's experiences. You also know the dangers of engaging children in trite, teacher-directed art activities. Remember how Chet responded to the robotic and stereotypical requests of his teacher? The teacher had many completed *products* to display on the bulletin board, but that is exactly what they were—15 or 20 copied projects. Unfortunately, she did not understand Chet's work, and as a result, he decided not to draw at all.

In contrast, look at the children in the third-grade classroom through the eyes of Torrance and his ideas about the four characteristics of the creative process. These third graders were provided an opportunity to freely associate their ideas and thoughts (fluency) about their nature walk and how they might capture their experiences in an art form. The variety of art materials gave them a choice of materials they could use to express the images of trees and then to actually create with their chosen materials. These children were given the needed time to experiment and explore many ways of representing trees. In other words, their teacher allowed them to be flexible when approaching the artistic process. The children chose the materials they needed and then proceeded at their own pace.

By now you can describe how this whole process, enjoyed by the third graders, allows for and encourages originality and elaboration. The only *model* present in this classroom was the image held in the mind's eye of each child. The children were free to experiment with their own ways of representing the trees they saw, and they were free to develop their own styles of representation without the threat of not making a tree just like the teacher's. All of us who work with young children have a responsibility to encourage, nourish, and support their creative and artistic endeavors. We must never artificially hasten their attempts at creative expression, nor must we control the artistic environment in order to satisfy adult ideas.

How many times have you heard a child say: "I can't draw that," or "My picture's not as good as his!" If I were to ask you to sit down and draw a self-portrait, how many of you would want to quietly disappear? The creative process must not be stifled by preconceived notions of rightness and wrongness. When any person becomes dependent on someone else's idea of what a final product should resemble, the freedom of creative self-expression becomes lost and the product is no longer a reflection of his or her own creative efforts.

Why Children Draw

Why did Chet, our second grader, draw his rose the way he did? Based on my own experiences with children and what I know about how children think, I would suggest that Chet's primary purpose was to communicate—to take his own personal experiences, ideas, and feelings about them and to express them in ways that someone else could understand. At first sight, his drawing was viewed by his teacher as a long brown line, but the essence of Chet's drawing revealed an ability to organize and communicate his experiences in a clearly communicative manner. He ex-

pressed his personal view about roses in a way that could have been experienced and understood by others. In my mind's eye, it is a profound work of art that gives great insight into the way Chet perceives, thinks about, and feels about rosebushes. In fact, his drawing could be regarded as an expression of his search for understanding the complexities of growing things and may be a clear sign of his increasing intellectual development. He is constructing his knowledge from his experiences. Chet's simple brown line with small dots tells us a great deal about the nature of his thinking and his perceptions of the world.

Often children draw because they lack the words to communicate thought and feeling, and art provides a nonverbal language for expression. They draw to experiment with new ways of doing things and to learn about the properties of crayons and paint and other materials. Drawing and painting allow very young children to feel, touch, hear, and see their world in ways that are a direct extension of themselves. They also draw because of the immediate reward of seeing beautiful colored marks on an empty piece of paper. The fun and joy for children can come from something as simple as the smell of a new box of crayons or the slippery way paint moves when they stand in front of an easel and place a paint-filled brush upon a blank sheet of paper.

A painter takes the sun and makes it into a yellow spot. An artist takes a yellow spot and makes it into a sun.

Pablo Picasso

The answer to the question "Why do children draw?" is not as important as the fact that they *do* draw, they *do* paint, and they *do* glue things together. It is up to us, their teachers, to ensure these early creative attempts are valued and nurtured so that children like Chet will not decide to stop drawing but will want to draw even more.

Children's drawings convey significant milestones in all areas of development, be it social, affective, physical, or cognitive. Their first attempts at making random marks on a piece of paper often represent an attempt to show us, the adult, just how much they know and understand about things, objects, and people in their environment. The following section delves more fully into the relationship between children, their drawings, and learning.

The Link Between Drawing and Learning

Experiences in the visual arts facilitate children's learning in a variety of areas. Art is emotionally satisfying as children express joy and happiness or fear and frustration through fluid, shiny paint. Making art becomes social when children share responsibility during art experiences. Brushes and paint containers have to be washed, paintings must be identified by artist, and materials and supplies need to be put back in their appropriate places. In the area of cognitive development, children use the visual arts to represent their thoughts and ideas. As children talk to each other about their work, they clarify concepts, develop problem-solving skills, enhance memory and observational skills, and practice language. Art is physical in the sense that children use their small muscles when attempting to control and manipulate brushes and crayons. And, finally, art is creative. Each child responds to art materials in ways unknown and unexperienced by anyone else. Children bring their own ideas and views of their world to the art experience, and in the process, they grow toward the realization of their own creative potential.

While drawing a picture about his experiences aboard a sailboat, this boy wears his sailing gloves. His gloves are an important part of this process of self-expression.

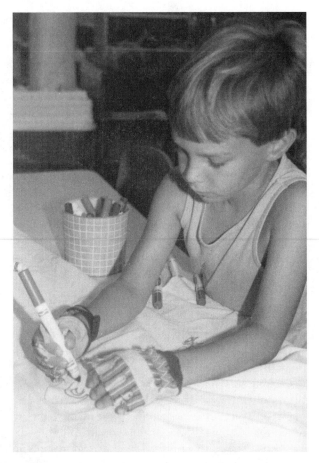

Art and Cognitive Development

One primary value of art for young children is in their construction of physical knowledge. Fox and Diffily (2001) explain that through the exploration of art materials, children build a knowledge of the physical properties of objects in their environment. It is during the schematic stage that children move out of exploration and begin to focus on symbolic representation in their artwork. It is also during this period that teachers become aware that drawing and the visual arts in general have specific benefits for cognitive development. Fox (2001) outlines some of the specific benefits for cognitive development, which are presented here:

- ◆ Drawing helps children form mental representations and fosters more freedom of thought (Lansing, 1981).
- ◆ Drawing is an avenue for conducting research, enabling children to consolidate learning from many different activities (Thompson, 1995).
- ◆ Drawing encourages flexibility in children's thinking, gives them a concrete way to express what they have learned, and sets the stage for using words to represent objects and actions in formal writing (Fox & Diffily, 2001).

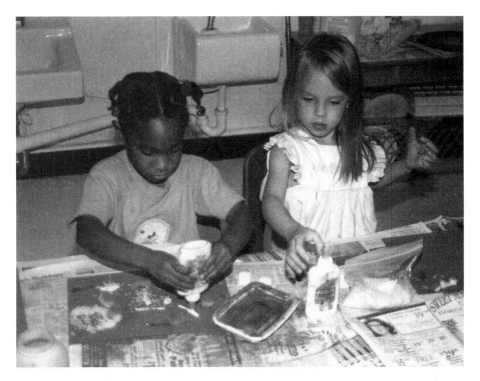

Gluing is a learned skill, and children need lots of time and practice to master this complicated process.

◆ Drawing is interrelated with writing (Koster, 1997), a relationship essential for the emergent writers as they experiment with recording their ideas on paper.
◆ Art explorations support higher-level thinking skills such as decision making, evaluation, and problem solving (p. 4).

Lowenfeld's Theory of Creative and Mental Growth

Viktor Lowenfeld has had a tremendous influence on our understanding of how children grow and learn through the artistic process. His book *Creative and Mental Growth* (Lowenfeld & Brittain, 1987) has been published in many languages and is now in its eighth edition. Lowenfeld was himself a child prodigy—a violinist, painter, and designer. He was a master at combining his talents, and this mastery was evident in the stained glass windows he designed for the concert building of the World's Fair of Paris in 1925 (Unsworth, 1992).

Lowenfeld and Brittain (1987) identified stages that children progress through as they experiment with and explore the artistic process. These stages are known as scribbling, preschematic, and schematic representation. Figure 5–1 presents a focus on these stages. As with Piaget's stages of intellectual development, remember not to interpret these stages rigidly when applying them to the children in your own classroom. Rather, use them as a guide for understanding and appreciating differences between children at different stages of artistic development.

FIGURE 5–1 Lowenfeld's Stages of Artistic Development

The Scribbling Stage (approximate ages 2–4)
Early attempts at artistic expression are usually random scribbles or uncontrolled scribbling and begin during the child's first or second year.

♦ Children at this age find pleasure in the kinesthetic process of random movements and the visual process of noticing the color left by a moving crayon.

♦ Random scribbling gradually becomes more organized as children repeat lines or begin to make circular, horizontal, or vertical patterns.

♦ During the latter part of the scribbling stage (around the age of three-and-a-half or four), children may begin naming their scribbles and telling stories about what they have drawn. This is an important step in the artistic process because children are no longer involved with just the physical movement of making lines and patterns.

♦ It is during these later stages of the scribbling period that children begin to think symbolically. This is often reflected in their drawings, and their attempts should be encouraged by teachers and other adults. These early representational drawings may appear meaningless to an adult, but they hold great value for the child who produces them.

The Preschematic Stage (approximate ages 4–7)
Young children begin to make their first representational attempts between the ages of four and seven. During the preschematic stage, children are involved in the relationship between what they see or know and making recognizable art forms.

♦ Children may draw a circle with lines for arms and legs to represent a person. Flexibility is a key word during this stage because children constantly change their representational symbols. The circle that represented a head today may be changed to an oval tomorrow.

♦ The use of color and representation is also very flexible during this stage. It is not unusual for children to color their figures with green hair or red faces. Children choose these colors because they like them and are more interested in using colors that appeal to them than in exact color representation.

♦ During this stage, as children become more aware of their environment, they begin to use a baseline. They will draw grass, flowers, houses, and trees on a baseline at the bottom of the page, and the sky will be represented by a colored strip across the top of the paper. It is of paramount importance that children in this stage of development be given the freedom to represent what they know of the world in ways that are meaningful and significant to them.

The Schematic Stage (approximate ages 7–9)
After a great deal of experimentation, children move into the schematic stage, in which they have a definite concept of human beings and the environment.

♦ During this stage, children repeat the same drawings, or symbols, of a real object, over and over again, drawing people or houses or rainbows with the same shapes, colors, and forms.

♦ Drawings are highly individualized. As children get closer to the achievement of a form concept, they gradually develop their own personal symbol for a human being or object in the environment. Each child's schema, as represented in a drawing, will be quite different from any other child's and may be considered a reflection of an individual's development.

♦ Children discover that there is order in space relationships, and they relate objects to one another. The child no longer thinks of objects as "This is a house, this is a rainbow, this is a tree," without establishing relationships between all the objects in a common space. Children will often draw pictures that show the inside and outside of an object or person at the same time.

FIGURE 5–1 (continued)

♦ During this stage, children make deviations in their drawings, and every deviation has personal meaning according to the origin of the drawing and its meaning. For example, children will exaggerate important parts, neglect or omit unimportant or suppressed parts, and change symbols for significant parts. Of course, all these characteristics refer to the way in which adults see them. Children are usually not conscious of these exaggerations; rather, they create size relationships that are "real" to them. Through the eyes of the child, the drawings represent how the child views the world and the people in it.

Age 3.0
Scribbling Stage

Age 3.5
Scribbling Stage

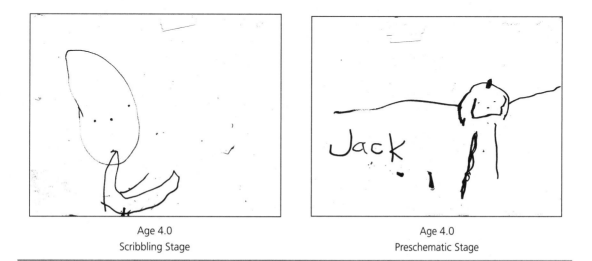

Age 4.0
Scribbling Stage

Age 4.0
Preschematic Stage

FIGURE 5–1 (continued)

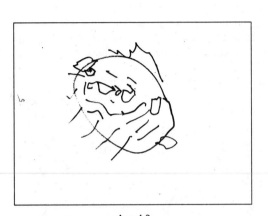

Age 4.2
Preschematic Stage

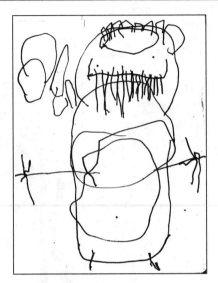

Age 4.6
Preschematic Stage

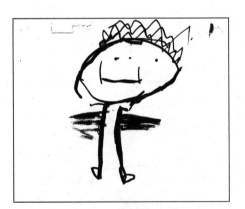

Age 4.11
Preschematic Stage

Age 5.0
Preschematic Stage

FIGURE 5–2 Kellogg's Developmental Stages

Stage I: Scribbles. Scribbles are the earliest and, according to Kellogg, the most important drawings of young children. They are simple, random markings that are made for the pleasure of doing the scribbles. When children scribble they are not yet making anything that can be considered representational art. The child is simply recognizing the ability and power to make a drawing. Children express pride in their drawings by showing their scribbles to other children and to adults.

Stage II: Lines and Shapes. As children develop more fine-motor skills, they grow more confident and their random scribbles develop into simply drawn shapes. It is during this stage that the universal symbols identified by Kellogg begin to take shape. These symbols include the mandala (circular and rectangular shapes divided into four parts by intersecting lines), suns (circles with radiating lines), ladders (parallel lines with intersecting lines), as well as spirals, wavy lines, rainbows, and many other shapes. These universal symbols found in Kellogg's collection of children's drawings from all over the world are early forms of symbolic communication. Kellogg stresses that these important forms of communication set the stage for later forms of writing and reading. Although she sees this stage as more thoughtful and organized, children still do it for the pleasure they find in the process.

Stage III: Semirepresentational. During this stage children use their experiences gained during Stage II as they begin to make true representational drawings. Sun symbols evolve into people, plants, and play objects such as balls. Ladders become houses, trucks, and cars, whereas mandalas take the form of windows and doors. It is during this stage that children move from the initial process of making lines and shapes on paper to making drawings that are semirepresentational. They describe their drawings, tell stories about them, and elaborate their drawings to expand their meaning.

Source: Adapted from Kellogg & O'Dell, 1967.

Kellogg's Developmental Stages

No conversation about drawing and learning would be complete without studies made by Rhoda Kellogg. Her research is noteworthy in that she studied over a million pieces of children's drawings that she collected from around the world. As a result, she identified several stages of development that are universal and predictable and concluded that "all children everywhere draw about the same thing in the same way at the same age" (Barnett, 1998; Kellogg & O'Dell, 1967). Figure 5–2 presents a condensed description of Kellogg's developmental stages.

How Important Is Your Role, Teacher?

Your role is a significant one, and we need to review just how important it is. Remember, there is no right or wrong in children's early representational attempts. We must be very careful not to impose adult standards on children's artwork or to evaluate their ways of artistic expression. A child's drawing is a representation of a very special and tender inner-self and must be treated with respect and dignity.

If we had a magic wand, we could revisit the third-grade classroom where we observed the children involved in many different ways of visually representing their images of trees. Each child saw the trees in a different way, and their wise teacher knew the importance of providing a variety of materials so that they could create a

drawing or painting or collage in meaningful and personally rewarding ways. This teacher understood that her children's imaginations, observations, and images provided them with the only *model* they needed to share their views of trees with her and each other.

Just like Chet and the classroom of third graders, we are all born with our own creative abilities, including those that can be classified as artistic. If you were to broaden your focus right now and were to take into consideration some of the less formal creative experiences in which you have indulged at one time or another (such as the doodles in the margins of your notebooks or the intricate designs you draw when talking on the telephone), you would see how you spontaneously experience expressive and creative activity. Occasions of this kind are familiar to all of us, and the pattern of their development usually can be traced to childhood.

Throw Out Your Old Notions: It's the Process That's Important

Consider the following challenge as you think about exploring your own creativity and designing and implementing creative arts experiences for children:

- Put away the patterns. Throw away your ditto masters and premarked papers.
- Trade your ditto paper for drawing paper from a fifth-grade teacher.
- Put the coloring books in the back of the closet or, better yet, throw them all away.
- Promise yourself that you can survive for a month without strict, rigorous, step-by-step "cookbook" art activities.
- Provide free art periods with an atmosphere in which children can create at their own pace (Rinker, 2000).
- Enjoy the freedom that basic materials provide.
- Be careful not to make a model for children to duplicate.
- Have faith in your own efforts and the creative attempts of your children.
- Acknowledge children's work, encourage the creative process, and let your children know that you value their art in its own right.
- Place the emphasis on the process and the inherent joy children feel as they create.
- Always recognize the children for being creative.
- Remember that creative expression comes from within the child.

Children's art and the drawings and paintings they share with you are important because the creative process is serious work for them. Very often final products reflect children's growth and understanding of the world around them. It is only when we pressure children to produce perfect representations, recognizable to an adult, that we may be stifling children's creative potential. Be gentle with your children and work toward instilling in them the idea that their creative efforts are diverse, important, and worthwhile.

Life is a great big canvas and you should throw all the paint you can on it!

Danny Kaye

Providing Authentic Experiences

Your role as teacher is to provide authentic experiences in the arts by giving your children challenging materials along with a great deal of encouragement. Your children will thus gain the confidence they need to express themselves through the artistic process. You are both observer and assistant. You stand by to help your children find art materials, and you assist when they have difficulty making the materials meet their needs. You show pleasure and enthusiasm in their attempts at making art, and you talk with them without passing judgment, placing value, or worse yet, making them suffer the affront of being asked to "name" their drawings. However, "encourage children to put their name on their art work because *artists* sign their work" (Rinker, 2000).

Kellogg and O'Dell (1967) capture the essence of your role when they write about the dangers of imposing evaluative criteria on children's art:

> There is in children's art no intent to create a picture in the adult sense of the word. To find a crooked house, on a crooked street, should not cause alarm. The house stands askew, inviting the rain, just as a matter of simple design. . . . Perhaps the day will come when adult and child can enjoy self-taught art together, not as cute or re-markable products of the childish mind but as the groundwork for all art. Then adults will not make stencils for children to fill in, nor will they laugh at what they do not understand. (p. 95)

Well, then, if our role is that of a facilitator and helper, what, if anything, do we say when talking with children about the process of making art?

Talking with Children About Their Art

What are appropriate comments a teacher should make when faced with a drawing and "Hey, teacher, look what I made"? Too often student teachers are quick to say, "OOOOHHHH, it's pretty," which is shallow and gives the child little more than a generic response (Paciorek, personal communication, 2004).

Remember what Hymes (1981) said about young children being beginners? Because these children are just beginning to discover the world of visual arts, you should avoid a number of responses when a child comes to you, drawing in hand. First of all, never ask a child, "What is it?" (Thompson, 1990, p. 221), and never ask a child to explain the reasons for making a particular drawing. Schirrmacher (1986) points out that the questions "What is it?" and "What is that supposed to be?" are abrupt and often difficult for a child to answer. More often than not, a child's art is very private and may reflect more of the child's pleasure at moving paint across a page than it does the child's attempt to make representational art. Schirrmacher (1986) tells us that a somewhat "less forward and abrasive than questioning" technique is the probing approach in which we ask children to "Please tell me about your picture" (p. 4). Although the probing approach encourages children to talk about their

Tatiana's Dilemma.
Discuss what is wrong with the following situation: Her kindergarten teacher stops to look at Tatiana's drawing and shows it to the other children. The teacher says, "Tatiana has made a lovely drawing today. She has colored all the leaves on her tree a beautiful green and the apples are so red they look real!" Then the teacher quietly whispers to Tatiana, "Your apples are much nicer and more real looking than the blue ones you drew yesterday."

art, Schirrmacher tells a story about a first grader who told his classmates to hide their artwork from a student teacher because "She will make you tell a real long story about it and then you have to wait while she writes it across your picture" (p. 5). The guidelines presented in Figure 5–3 describe more effective approaches to talking with children about their art. The figure serves as a frame of reference that may be helpful as you begin to engage children in dialogue regarding the very personal expressions they convey through their art. Figure 5–4 presents a succinct and definitive list of suggestions for how *not* to talk to children about their art.

Because young children are excited about their ability to represent what they know and what is meaningful to them, every art experience should provide children an opportunity to be involved in the process of creating. Another consideration is

FIGURE 5–3 Appropriate Approaches for Talking About Art

Experience	Example
Give your children the freedom and time they need to discover the properties of paint, glue, paper, and other art materials without comparing their work, correcting their "mistakes," or placing a value judgment on the process they go through or the outcome that is represented in a product.	The parent volunteer in Helen's class was showing the children how to draw a chicken. There were a series of circles to copy to draw the body as well as other examples of how to finish the drawing. When Helen became frustrated trying to follow the directions, and after she had used up all of her eraser trying to correct her mistakes, she folded her drawing and put it in the trash can. When the volunteer realized that Helen was having trouble, he drew a chicken for Helen, asked her to put her name on the drawing, and proudly hung it on the bulletin board. Needless to say, this is not only *inappropriate* but also meaningless.
When talking to children about their art, focus on the artistic elements. Hardiman and Zernich (1981) suggest that it is appropriate to talk with young children about color, line, pattern, shape or form, space, and texture.	As an *appropriate* approach to engaging children in conversation about their art, you might say to a child, "Look at how you have drawn a long brown line all the way from the top of your paper right down to the bottom," or "You used a lot of colors to draw those prickly thorns on your rose," or "You spent a lot of time making your drawing."
When a child feels unsuccessful, you should provide assistance with difficulties he or she may be experiencing.	If a child tries to paint round circles and the paint runs on the paper, you might say: "I know it is frustrating to have your paint run down the paper like that. Let's mix some new paint together and make it thicker so that your circles will stay where you want them."
Finally, when discussing representation art, you might respond with more specific comments.	For example, you could say: "It looks like your balloons are floating high in the sky. You have drawn your clouds to show how really high the balloons have floated." If it is clear that the child has drawn balloons and clouds, it would be somewhat condescending to make comments about colorful round circles!

Sources: Adapted from Hardiman & Zernich, 1981; Schirrmacher, 1986; and Smith, 1980.

Painting allows the young child to represent feelings, experiences, and sensory impressions through the artistic process.

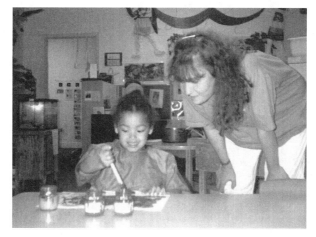

FIGURE 5–4 Inappropriate Approaches for Talking About Art

♦ Do not ask children in advance what they are planning to create—very young children rarely plan in advance what their finished products will look like.

♦ Don't quiz children on the colors they are using.

♦ Don't identify what you think it is.

♦ Do not focus on neatness during the art experience or in the finished product—such comments inhibit creativity.

Source: Rinker, 2000, p. 75.

that all experiences in the arts enhance the development of intellectual potential. The sensitively aware teacher knows that our understanding of child development is as significant as the process children experience when they are actually creating art. The visual arts provide the opportunity for growth in several important areas and especially the opportunity for the development of spatial intelligence.

Gardner's Theory of Multiple Intelligences: Spatial Intelligence

Spatial intelligence involves the capacity to perceive the visual-spatial world accurately and to perform transformations on one's initial perceptions—in other words, to perceive and create tension, balance, and composition in a visual or spatial display. This intelligence includes being sensitive to color, line, shape, form, space, and the relationship between them. Navigators, sculptors, architects, engineers, and painters all exemplify the components of spatial intelligence. Pablo Picasso, Georgia O'Keeffe, Frank Lloyd Wright, I. M. Pei, Michelangelo, James Watson, and Francis Crick (who ferreted out the structure of the DNA molecule) are just a few

A Family's Role in Developing Visual Arts Experiences at Home

Families must be kept informed of art activities taking place in the classroom in order to maintain the artistic efforts of their child. At-home artistic activities stimulate children to talk about classroom experiences at home and encourage parent participation in their learning. How can families support children's emerging creativity?

- ◆ Give children extended, unhurried time to explore and do their best work. Creativity does not follow the clock.
- ◆ Provide a place for children to leave unfinished work to continue the next day and a space that inspires them to do their best work.
- ◆ Organize a collection of resource materials, including bought materials, found materials, and recycled materials such as buttons, stones, shells, beads, play dough.
- ◆ Caregivers must give themselves permission to try out artistic activities—even when they have not had formal art lessons. It is through encouragement, risk taking, and acceptance of mistakes that parents can gain confidence in their own artistic self-expression. Your attitude, as a family member, will impact the artistic attitude of the children (Edward & Springate, 1995).

people who come to mind as truly exceptional individuals with significant measures of spatial intelligence.

Gardner (1983) shares the belief that right-hemisphere involvement in spatial tasks seems to be well established, and that the role of the right hemisphere in the processing of spatial information is well documented. Spatial intelligence is particularly evident in the visual arts:

> The enterprises of painting and sculpture involve an exquisite sensitivity to the visual and spatial world as well as an ability to recreate it in fashioning a work of art. Certain other intellectual competencies, such as facility in the control of fine motor movement, contribute as well; but the *sine qua non* of graphic artistry inheres in the spatial realm. (p. 196)

Though some of us will become master painters or sculptors, most of us will simply enjoy the pleasure that mixing colors or molding a piece of clay can bring. We can look at art, we can enjoy art, we can learn about the different styles of the painting masters, *and* we can immerse our children in a daily program of artistic expression. The children in your classroom are already artists. All you have to do is provide the materials and the time for children to explore them, and honor and respect their artistic endeavors.

Supporting Spatial Intelligence

Your attitude toward the arts and the encouragement you give your children when they are involved in the arts set the stage for giving the visual arts a prominent place in your classroom. As you prepare to support the development of spatial intelligence, consider the following suggestions:

◆ Offer children a variety of media (paint, crayons, markers, and chalk) for drawing and painting.

◆ Provide opportunities for cutting, tearing, and pasting by giving children lots of colored paper and good-quality scissors. Give children paper that is easy to tear, such as newspapers, old magazines, and phone books.

◆ Introduce different types of glue, such as glue sticks, school paste, and water-soluble commercial glue.

◆ Offer children materials for printmaking, such as stamp pads and colored markers for making fingerprints, and objects and gadgets such as small blocks, corks, erasers, and jar lids for making print designs.

◆ Fill your room with posters of great paintings, changing them regularly so that your children are exposed to great works of art.

Materials and Processes for the Visual Arts

When using art materials with children, we must be sure that the material fits the developmental levels of our children. We must think of art materials as primarily providing children the opportunity for self-expression, exploring a range of colors

Children's Literature and the Visual Arts

Lucy's Picture by N. Moon, Dial Books for Young Readers, 1995.

A young girl creates a special picture that her grandfather, who is blind, can "see" with his hands.

Visiting the Museum by Laurene Krasny Brown and Marc Brown, Penguin Group Publishing, 1986.

A family wanders through an art museum and sees examples of various art styles from primitive to 20th-century pop art.

Matthew's Dream by Leo Lionni, Scholastic Inc., 1991.

Although his parents want him to become a doctor, after a trip to the art museum, Matthew dreams of becoming a painter.

and textures, developing visual-motor skills, and providing an emotional outlet and a truly artistic experience (Lowenfeld & Brittain, 1987).

Art Materials

During the scribbling stage, children need to practice holding art materials such as crayons so that they can experience the sensory and motor sensations that come from moving a crayon across a piece of paper. On the other hand, watercolors are inappropriate for children during this stage of development because each has to manage a container of water in addition to holding a small brush. In addition, watercolors tend to run together and are difficult to control.

Large, unwrapped crayons lend themselves to the needs and fine-motor skills of young children. Crayons are an excellent art material and are easily obtained by early childhood teachers. Large markers are also excellent because they are easy to hold and the colors flow smoothly and easily.

White and colored unwrapped chalk provide for free expression with few technical difficulties. Chalk is a wonderful medium for drawing outside on sidewalks or paved surfaces, and the colors fade with the first good rain shower. Crayons and chalk facilitate expression because they are easy to use and most young children can control the kinesthetic motions required for using them.

Tempera paint is an appropriate medium if it is mixed to a thick consistency so that it does not run down a child's paper. When I was teaching kindergarten, one of my children was using tempera paint while painting at the easel. I noticed that she had a brush in each hand; one had paint on it and the other was a clean brush she had taken from the brush drawer. When I asked her why she was using two brushes, she told me that she had to have the clean brush to keep the colors in her circles from running down the paper! This was a valuable lesson for me in how to mix paint. For children in the schematic stage, watercolors provide a welcome change from the simpler materials and can often serve to inspire children to explore new avenues of painting.

Children use art materials in an effort to bring order to their experiences and to represent their knowledge in tangible form. The materials we provide must give children a sense of mastery and control, and we must not sacrifice these experiences, regardless of how much we, as adults, want to expose children to all the materials we see in brochures and catalogs.

The Reality of Art in Classrooms. Visit an early childhood classroom and make a list of all the materials available for the children to express themselves. Make another list of additional items that could be used but are not present in the environment.

Paste and glue are also popular in preschools and kindergarten. Occasionally, teachers plan art activities that involve pasting or cutting, but these are usually designed for an end product, such as snowmen, projects for holidays, or Mother's Day cards. These types of activities must never be planned for scribbling children. They are usually completed by the teacher and are meaningless when it comes to promoting any creative expression.

Pasting and gluing can be a difficult and frustrating process for very young children. They may not understand the properties of pasting; as a result, they may treat paste and glue in much the same way as they treat finger paint. Children get great pleasure from the sensory and tac-

tile experience of smearing paste, feeling its sticky properties, sticking their fingers together, smelling it, or watching it form pools on the paper. They put paste directly on the picture to be pasted and only realize they have made a mistake when the back of the picture appears on their paper. They use too much paste for large, lightweight objects and not enough paste for smaller, heavier objects.

Be patient with these young learners, and provide them with simple, unstructured pasting experiences until they have acquired the skill to successfully use glue and paste. Give them large pieces of construction paper, along with smaller pieces to simply practice the art of gluing. Encourage them to tear pieces of colored construction paper, and then glue them onto large pieces of mat board or tagboard. Use care to ensure that your children have many opportunities for practicing the skill of gluing and pasting before you even think about asking them to make a representational object, such as the mouse cup you read about in chapter 1.

Older children—those in the preschematic and schematic stages—can use colored paper, collage materials, paste, and scissors to explore texture, color, and form in a variety of ways. Remember that if you have to give more than introductory suggestions for using these materials, your idea is probably inappropriate for the skills your children need to handle the material. Select art materials because they are closely related to the children's level of development, and certainly not for the purpose of making cute, stereotypical products to be displayed with 20 or more others that look very much the same.

Processes and Activities

I am always hesitant to give my students ideas that can be mistaken for art "activities," or prescribed lessons that teachers can simply follow without gaining the necessary skill to encourage creative growth in young children. However, I have come to realize that, with a strong theoretical base coupled with research, my students *do* move beyond the recipe approach while encouraging the "child as artist" to emerge.

Using food as an art material, especially vegetables, is often a popular activity in many preschools, but I do not recommend using any type of food in activities we designate as art. Many children live at the poverty level, and for them food is a prized commodity. When we use food as an art material, we give children the message that we do not value food for its precious nutritional value. In addition, children deserve to be given real art material and should not be put in a position of confusing art materials used to make art with things we eat. If you are still finger painting with chocolate pudding, please consider an alternative. While it may not taste as good as chocolate pudding, it will be regarded by your children as an art material that is used for the sole purpose of creating art.

Following are some ideas emphasizing process that will get you started on the path of fostering creative growth through the visual arts. I encourage you not to rely on these ideas but to move toward a more secure sense of your own ability to engage children in the process of creating art. For the child, the value in an art experience is in the process.

The following ideas are all open-ended, and the products, whether they be paintings, constructions, or drawings, will be different for each child and must be

legitimate for you, the teacher. If our purpose is to give children support for their artistic expressions and to fully engage children in the process of discovering the visual arts, then we must appreciate the significance of each child's work as an event that has great significance for him or her.

Using Crayons

Texture Rubbing Lay newsprint on top of a flat item that has a definite texture (sandpaper, leaves, coins) and rub the flat side of the crayon over the object. Children also enjoy making texture rubbings of different surfaces in the room or on the playground. Encourage children to rub over cracks in the walls or sidewalk, the floor, wooden blocks, carpet or tile, puzzle shapes, or anything else they can find.

Etching Select light-colored crayons and color the surface of a tagboard or other heavy paper with the crayons. Color over the light colors with black, dark blue, or another dark color. Polish the dark surface with a tissue until it shines. Use a craft stick or other blunt utensil (a fork or a spoon handle) to scratch through the dark crayon to the bright colors underneath.

Crayon Resist Use crayons to draw a design or a picture. Be sure to press down heavily and cover the colored area well. Leave some areas and background uncolored. When the drawing is complete, brush a thin coat of tempera over the entire surface of the paper. The areas covered heavily with crayon will resist the tempera.

Brick walls are ideal for making texture rubbings.

Craypas® Craypas are an oil-based combination of crayons and pastels. They are usually flat on one side and come in a variety of brilliant colors. Children enjoy working with the Craypas as an alternative to crayons, especially when they discover that Craypas work better when they take off the paper wrapping! Craypas can also be used in an interesting way with older children. When a picture is complete, use paint thinner to liquify the Craypas. The paint thinner transforms the colors into an oil-like substance that gives the effect of an oil painting. Use small brushes to apply paint thinner to pictures. *One caution: The use of paint thinner is not appropriate for young children, so save it for the older children you may teach in the future.*

Using Colored Chalk

Chalk and Sandpaper Paint the surface of the sandpaper with a clean brush and water. Use colored chalk to draw pictures or designs on the moist sandpaper. The moist paper brings out greater richness of color. Once the drawing is complete and dry, it must be sprayed with a fixative to preserve it.

Chalk and Liquid Starch Paint the surface of the paper with a coat of liquid starch or dip the chalk into liquid starch before drawing. When the paper is dry, the colored chalk will adhere to the paper and will have a glossy look. An alternative is to draw with the colored chalk first and then wash the entire surface with the liquid starch.

Using Paints

Tempera You can purchase tempera in liquid or dry powder form. When planning painting activities for children, be sure that colors are bright and rich and the paint is thick. When children are painting with tempera, they should not have to worry that their paint will drip or run off the paper. Small amounts of paint should be mixed daily to ensure freshness and to eliminate wasting due to drying. On days when it is impossible to mix new paint, add a drop of oil of wintergreen to each container to prevent molding.

Tempera spreads easily, and children can use brushes, sponges, or rollers to create drawings. Paintings can be done at the easel, on the floor, or on tabletops. Because painting with tempera can be a messy experience, provide children with smocks. When children are painting at the easel, it is a good idea to cover the floor to protect it from dripping or spilled paint. Keep containers of clear water near the painting area for washing brushes.

Straw Painting Use finger-paint paper or other paper that has a slick, shiny finish. Let children use straws or eyedroppers to put small amounts of different-colored paint on the paper. They can then use the straws to blow the paint around so that the colors mix and create new color combinations.

Dry Tempera Lay paper on a flat surface and wet it with a sponge and water. Sprinkle different colors of dry tempera from a flour sifter or scatter the dry tempera by turning the handle and "sifting" the dry paint onto the paper. Children can also use

Remember to use paper that has a slick surface if your children plan to move the paint around on the paper.

a dry brush to mix and blend the colors to produce interesting effects. Spray the paintings with hairspray to seal the tempera.

Spatter Painting Spatter painting will be easier for children if you provide them with a spatter painting stand. The stand is simple to make and gives them a sturdy base from which to work. Make a square wooden frame approximately 12 inches by 12 inches. Purchase a piece of window screen (meshed wire) and cut it slightly larger than the wooden frame. Turn under the edges of the wire and cover with several layers of tape. This protects the children from being stuck or scratched by the rough edges of the wire. Staple or nail the screen to the frame. This becomes the top of the spatter painting stand. Make four wooden legs and use a commercial wood glue to glue them to the underside of the frame. If woodworking and frame making are not among your strong points, ask someone who is skilled in this art to make a stand for you. You will be rewarded when you see how much children delight in this somewhat mysterious process of making a picture (see Figure 5–5).

Provide children with precut paper in different shapes, or provide various items from nature, such as leaves, fern leaves, small branches, or precut stencils. Cover the spatter painting area with several layers of newspaper. Place a piece of drawing pa-

FIGURE 5–5 A spatter painting stand provides numerous opportunities for children to experiment with paint.

per on the newspaper and lay the object on the drawing paper. Use thumbtacks or small pieces of tape to hold the object in place. Place the spatter painting stand over the drawing paper. Dip and old toothbrush into the paint and shake off any excess. Rub the brush back and forth across the screen. Carefully remove the object and enjoy the image that has been produced. Experiment by using dark construction paper and light paint colors or use several different colors for one painting. When the activity is complete, throughtly wash the spatter painting stand by scrubbing it with a clean toothbrush. Dry tempera will clog up the tiny holes in the screen.

Mural Painting Mural painting is an excellent outdoor activity, and a readily available material at your school is the outside wall of the building. Give your children buckets of water and real paintbrushes, and let them create. Or tape sheets of mural paper to the outside wall of the building or to any wall in your play yard. Fasten the paper so that the bottom edge touches or nearly touches the ground or sidewalk. Dripping paint will end up on the ground or sidewalk and not on the building wall! Give children a container of liquid tempera and a large brush, and let them paint. There may or may not be a central theme. Some children will paint in their own space, while others will engage in more of a group activity. How they approach the mural is not as important as the process of working and creating together. Leave the mural as a collective painting, or cut it into smaller pieces so that children can keep their own particular sections.

Finger Painting Finger painting lends itself to motion and sensory exploration. Children use fingers, hands, arms, fingernails, and even elbows to create a picture or design. The picture can be erased and a new picture created. Finger painting should be a pleasurable experience, and children should be encouraged to experiment with several colors and different movements to create a variety of effects. Because finger painting is usually not a clean and neat experience, it is helpful to the children if there are several large sponges, buckets of water, and plenty of paper towels near the finger-painting table. Smocks will help keep clothing clean.

To facilitate use of these paints, wet finger-paint paper on both sides and place it on a smooth, flat surface. Put two tablespoons of finger paint on the wet paper, or if you are using several colors, put a heaping teaspoon of each color on the paper. Too much paint will crack or chip off when the painting is dry. Encourage children to spread the paint, and suggest different body parts that they might use to create their designs. When paintings are completely dry, carefully lift them by the corners and lay them flat on newspaper to dry.

Printing

Sponge Printing Cut sponges into several small shapes and sizes. Each child should have several containers of different-colored paint and an equal number of sponge shapes. Watercolor paper is best for sponge printing because of its absorbency. Children create designs by dipping the sponge into the paint and then pressing the sponge on the paper.

The children spent hours painting and repainting this wall with water, racing against the drying warmth of the day's sunshine.

Object Printing Provide children with a variety of objects that can be used for making prints, such as empty spools, corks, jar lids, plastic cookie cutters, and wooden blocks (see Figure 5–6). Children dip the different objects into thick tempera and overlap prints and colors to create designs. Children can also experiment with different objects by twisting them or rotating them when printing. Very often children will experiment with new ways of placing or moving the printing object. This is all part of the process of creating, so be sure that you provide them with this freedom.

Transfer Prints

An Art Portfolio.
Collect samples of artwork from one child for several months. Note any changes or similarities in style, subject matter, form, or methods the child uses as a means of expression.

Give the children a variety of leaves—ferns or ivy or large interestingly shaped leaves such as maple or oak. Cover the leaf with paint and then place a piece of paper on top of the painted leaf. The paint will transfer onto the paper, showing the leaf shape and its lines, ridges, and edges. You might try to print a feather, a piece of wood, or a seashell. Any non-food item you find around your school has unlimited possibilities for making transfer prints.

Paste and Glue

Collage

Collage is a process of creating designs and pictures by pasting different types of materials onto a surface. As an art form, it is a favorite of young children and older children alike. This may be due, in part, to the fact that there is no right or wrong way to make a collage, and the resulting product is often nonrepresentational and abstract in form. Collage materials should be stored in separate containers, with

FIGURE 5–6 Keep a wide variety of objects available for children to use for making prints.

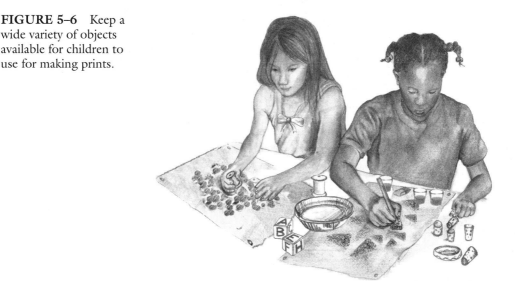

each container holding a similar collection of material. Children can keep their own collage materials in a "collage-making box" and can add to it as they find new and appealing objects.

A beginning collection of items could include scraps of cloth and material, carpet scraps, buttons, bottle caps, shells, seeds, toothpicks, small pieces of wood, sand and pebbles, rickrack, glitter, matchboxes, different-colored straws, dried leaves, flowers, and twigs. Children enjoy collecting their own objects or bringing in materials from home or outdoors. A short walk around the play yard or an excursion to someone's backyard will usually result in a large and assorted collection of interesting materials.

In making collages, children arrange their objects into a design or pattern. They can select from one container holding a similar collection of objects if they have a theme or subject ideas in mind, or they can use a combination of objects and materials from different containers. As children look for objects and make selections, they are already involved in the creative process: deciding what to use is the beginning of a collage. When children have experimented with different objects

Handling large containers of glue is frustrating for small children. As an alternative, pour a puddle of glue onto paper plates and let them use their fingers to apply the glue.

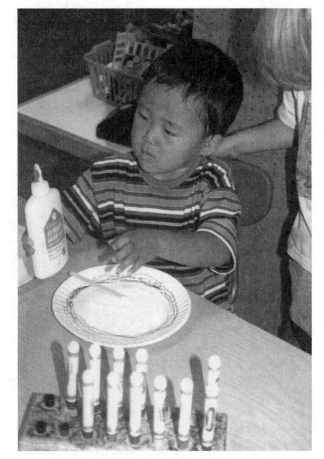

and designs, they paste or glue them on heavy paper or cardboard. Make sure the background paper is sturdy and strong enough to support heavy objects. Thin paper is difficult to handle when covered with pebbles and sand. Children should also be given the option of painting or coloring the background or adding details to their collage.

Mosaic A mosaic is a surface decoration, picture, or design made by inlaying small pieces of colored paper, stone, seeds, beads, or other material. A picture or design made in mosaic can be a long and tedious process. It also requires children to focus on a design and concentrate on maintaining this focus over a long period of time. When introducing children at the schematic stage to mosaic, make sure the designs are simple, and the material is easy to handle.

Children can use felt-tipped pens to draw a simple design on construction paper or cardboard. Then they spread glue on the design and press material into place. Older children might want to experiment with different arrangements, designs, and materials before actually gluing the objects to the paper. Other children may enjoy the process of applying glue to one piece of material at a time and then placing it on the paper. This part of the process depends on the skill and manipulative ability of the children.

The National Standards for Arts Education define what children should know and be able to do in the visual arts. One of the content standards for grades K–4 refers to the visual arts in relation to history and cultures (Consortium of National Arts Education Associations, 1994). In this chapter, you will be introduced to ways to explore the visual arts through multicultural context. When you are in the process of making African masks or Inuit sculptures, you will have an opportunity to delve more deeply into the importance of art and the artistic relationships among a variety of cultures. Other content areas that are also important for young children include media, art criticism, creativity, characteristics and merits of arts, and making connetcions between visual arts and other disciplines. The following section introduces the National Standards for Arts Education.

NATIONAL STANDARDS FOR ARTS EDUCATION

The Consortium of National Arts Education Associations is committed to the most important and enduring ideas, concepts, issues, and knowledge offered by the visual arts.

Visual Arts K–4

Content Standard 1: Understanding and applying media, techniques, and processes.
What this looks like in practice: Students use different media, techniques, and processes to communicate ideas, experiences, and stories.

Content Standard 2: Using knowledge of structures and functions.
What this looks like in practice: Students know the difference among visual characteristics and purposes of art in order to convey ideas.

Content Standard 3: Choosing and evaluating a range of subject matter, symbols, and ideas.
What this looks like in practice: Students explore and understand perspective content for works of art.

Content Standard 4: Understanding the visual arts in relation to history and cultures.
What this looks like in practice: Students identify specific works of art as belonging to particular cultures, times, and places.

Content Standard 5: Reflecting upon and assessing the characteristics and merits of their work and the work of others.
What this looks like in practice: Students understand that there are different responses to different artworks.

Content Standard 6: Making connections between visual arts and other disciplines.
What this looks like in practice: Students identify connections between the visual arts and other disciplines (social studies, language arts, science, mathematics) in the curriculum.

Exploring the Visual Arts Through a Multicultural Context
African and Eskimo Masks and Sculptures

African masks and sculpture readily come to mind when we think of African art. This vast continent with many different nations and ethnic groups is rich in traditional art forms that are an integral part of life.

On the other side of the world, not far from the North Pole on the frozen shores of the Arctic Ocean, live a group of people we call Eskimos or *Inuit*, which means "the people." The Inuit also make and use masks and sculpture as a way of preserving the ancient, cultural forms of Eskimo art.

The activities in this section are designed to show cultural similarities among the art forms of culturally diverse people.

ACTIVITY 5–1
Decorating Masks and Sculpting Animal Figures

Art is to society as dreams are to a person.

Laliberte and Kehl

African and Eskimo masks are created for a particular purpose, most often for a religious or magical rite. Many Africans and Eskimos believe that every animal has a spirit and when a dancer puts on a mask, he becomes the spirit he is portraying. An ancient hunter may have worn an animal mask to honor the animals he has caught. Some mask ceremonies are an attempt to influence the forces of nature, such as bringing good weather.

In both cultures, sculptures also have significant meaning. For example, the Ashanti women of Ghana carry small sculptures resembling dolls to ensure the

birth of healthy children. The Eskimo artist believes that the shape he will carve is already in the stone. He holds the stone in his hand, talks to it, hums a song, and waits for it to reveal its shape to him. He cuts away the parts of the stone that hide the shape waiting inside.

You and your children can make masks that can be worn and enjoyed. Use paper plates and glue a tongue depressor on the back surface to serve as a handle (see Figure 5–7), or make your own mask from cardboard. You will also need some paint and a collection of other materials for decoration. First decide what shape you want the mask to be and cut it out. Then make your eyeholes. Round eyeholes can make your mask look surprised. Eyeholes that slant downward can make it look sad. Holes slanting upward can seem angry. You can cut out holes for the children's mouth and nose, or you can paint them. You can even give the children different items to make a mouth and nose. Glue on materials such as shells, seeds, beads, or scraps of cloth. Use yarn to suggest hair, and paint geometric designs with earth and vegetable colors. Long straw or raffia fringes are frequently attached around the base of traditional African masks to hide the identity of the person wearing it. Although hiding the identity of the children in your classroom may be an unreasonable goal, it is still fun for the children to "become" the character of the mask!

Eskimo masks often represent animals. These masks are also painted and are decorated with feathers and fur. A bird mask can be decorated with artificial feathers you purchase at a local craft store. In contrast, a bear mask can be embellished with fake fur, or children can simply glue cutout pictures of animals on their masks to represent their own imaginative animals. Figure 5–8 is an example of how your masks might look. There is an ancient Inuit story that tells of a girl named Kannakapfaluk (sometimes called Sedna or Niviarsiang). This story describes her peril

FIGURE 5–7 Paper Plate Mask

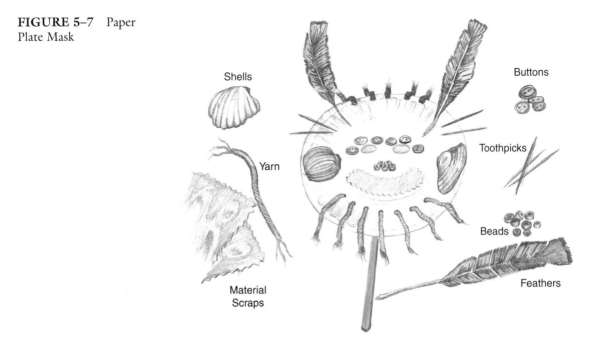

Shells

Buttons

Yarn

Toothpicks

Beads

Material Scraps

Feathers

FIGURE 5–8 Animal
Mask

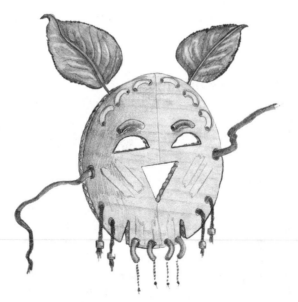

for being a stubborn young woman. The story goes like this. Kannakapfaluk was married to a dog as a punishment for her stubborn refusal to choose a suitor. Her new husband took her to his island, where they had many puppies. For revenge, one day Kannakapfaluk put the children in her boots and set them out to sea. One boot landed not far away, and the children became the ancestors of the Indians. They were at least said to look human, although they had their father's heart. The other boot drifted across the ocean, and the puppies in it became the ancestors of the Qublunaq, the White men, who one day returned to the Arctic in their sailing ships. With their hairy bodies and their bearded faces, they resembled their dog father even in outward appearance.

Children can create forms that were traditionally carved out of ivory or soapstone by using a bar of soap and water. Simply put a bar of soap in a resealable plastic bag and add water until the soap is covered. After soaking for a few hours, the soap will be soft enough to mold and sculpt. Children can squeeze the soap and mold it into shapes or figures, or they can use wooden craft sticks to cut away the parts of the soap that hide the shape waiting inside to be found (see Figure 5–9). You never know what shapes await inside a piece of soap! Poke a small hole through the sculpture, lace it with a piece of string, and hang it to dry.

No matter what approach we take to introducing children to mask making and sculpture, we must ensure that children are engaged in the art process and are not merely copying a "craft" idea from us. Our goal should be to help children understand that there are cultural similarities and differences in art to be recognized and valued.

Two excellent resources about African and Eskimo masks and sculpture are *The Art of the Eskimo* by Shirley Glubok (Harper & Row, LC 64-16637), and *Masks and the Art of Expression,* edited by John Mack (Harry N. Abrams, ISBN 0-8109-3641-0).

FIGURE 5–9 Inuit
Soap Carving

DEVELOPMENTALLY APPROPRIATE PRACTICE

In many instances, a child's response to the visual arts depends on her developmental stage and disposition, the availability of materials, and a supportive, noncritical adult. These factors determine a child's future explorations in self-expression through the arts and her positive feelings about herself and her abilities. Figure 5–10 presents a review of developmentally appropriate practice and implications for instruction in the visual arts.

The Special Children in Your Classroom

All children have the ability to create and express themselves through creative arts experiences. Children with disabilities can enjoy the pleasures of painting, coloring, printing, and all other art experiences. There are a number of ways that you can provide art activities for your children with disabilities or impairments so that they can participate right along with their peers. The process of making art is also a learning process and one that can enrich all the children in your classroom. The

FIGURE 5–10 Developmentally Appropriate Practice

◆ The environment has contrasts in color and design, and bright colors are used to create patterns throughout the classroom.

◆ Rooms are decorated at children's eye level with pictures of people's faces, friendly animals, familiar objects, and pictorial materials that depict a variety of ages and ethnic groups in a positive way.

◆ Children are given *appropriate* art media. Teachers and other adults encourage children to explore and manipulate art materials and do *not* expect them to produce a finished art product.

◆ Art activities are designed to develop children's self-esteem, sense of competence, and positive feelings toward learning about materials in the process of creating.

◆ Children have daily opportunities for aesthetic expression and appreciation through the visual arts. A variety of art media is available for creative expression.

◆ Art ideas that are relevant to children's lives are integrated throughout each day for children to express themselves aesthetically and to express ideas and feelings.

following suggestions have been gleaned from an excellent publication written and edited by Belinda Broughton titled *An Arts Curriculum for Young Children— Including Those with Special Needs* (1986).[1]

Children with Physical Disabilities

Use lap trays to provide a steady surface for gluing, painting, or coloring. If children with physical disabilities can move their toes, put paper on the floor in front of them and let them paint with their toes. Use braces and walkers to assist children in foot printing and foot painting. For children who have limited grasping ability, allow them to use both hands to hold their paintbrush or crayon. When using glue during collage activities or other tactile design production, tape the glue bottle to the table or lap tray to stabilize it. When a child has limited fine-motor skills, let her use markers instead of crayons or paint, because these tools make a heavy line with less force. Provide precut shapes for collage making or relief printing for the children who have difficulty using scissors. When selecting items for printing, use large objects, which are easier to grasp for children with limited grasping skills.

Children with Hearing Impairments

When explaining the process of making art to children with hearing impairments, use hand signals *and* words. Show children a variety of ways to approach a particular project so that they can see alternatives for interacting with the materials. Pair the child with a hearing impairment with a fully hearing child so that they can work side-by-side; the child with a hearing impairment may take clues from the partner. Encourage children to repeat hand signals as an indication that they understand the

[1] Published by the Chapel Hill Training Outreach Project, this book is a very good resource for those of you with an interest in correlating creative experiences with the Learning Accomplishment Profile (LAP). For additional information on obtaining this resource, write to the Chapel Hill Training Outreach Project, Lincoln Center, Chapel Hill, NC 27514.

process they are about to enter. Make sure that the child who is hearing impaired is sitting somewhere that maximizes a clear path for seeing you during demonstrations or when giving instructions. When involved in group activities such as mural painting, make sure the child who is hearing impaired is near you or other children and can see how the process evolves. Always face this child and repeat hand signals when necessary. Young children may be just beginning to learn sign language, and it is your responsibility to make sure they understand an art procedure. Prepare visual cue cards that demonstrate the steps involved in making a collage or a transfer print. Encourage children who are hearing impaired to use these same cue cards to visually tell you about what they have done. Remember that children with hearing impairments deserve the same *process* approach to creating art as do all children. It may be easier to limit their experiences to copying "cookbook" art, but this is an unacceptable practice in the early childhood classroom.

Children with Visual Disabilities

Provide tracing patterns for children with visual disabilities so that they can outline the objects they want to draw or paint. When offering glue to these children, add a little fine sand to the glue mixture to create a tactile road map of where the glue is placed on their paper. Mark the edges of drawing paper with masking tape so they will know the boundaries of the painting or drawing surface. Texture the different colors of paint with sand, rice, salt, sawdust, or glitter so that the children can tactilely determine which colors they are using. Arrange paint containers in a predictable sequence of colors (red, blue, green, and yellow), and tape them to the table so that they do not tip over as children dip their brushes in and out.

When you present objects for printing or gluing to children with visual disabilities, tell them what they are holding. I once observed a teacher who made her children with visual disabilities "guess" what object they were holding *before* she allowed them to glue them onto a piece of cardboard. By the time one little boy had guessed all of the objects, he had lost interest in using the objects to create a work of art. The guessing took at least five minutes, and by the time it was over, he was both tired and disinterested in the whole project. When talking to children about a particular object that is the focus of an art project, make that object available for them to touch, feel, smell, and generally explore before they enter the process of drawing or painting. Provide children with a variety of art materials that have definite texture, such as embossed wallpaper, sandpaper, waxed paper, or corrugated paper. Give children precut shapes, rather than asking them to cut out shapes before making shape pictures. Use guided imagery so that each child with visual disabilities can see pictures in her mind's eye.

Image Awareness Art Ideas for Children

Imagery and sensory experiences are very important to young children. The visual arts provide the opportunity for children to increase their awareness of sensory perception and expand the images that are part of their own experiences and

thinking. When we combine imagery and sensory perception with the visual arts, each drawing or painting becomes a natural means of a child's extending his or her own creative growth.

The following section presents some ideas for using sensory perception and imagery in the visual arts process. As with all the ideas in this book, I encourage you to extend, shorten, or redesign these activities to meet the needs and developmental levels of the children in your own classroom.

Pattern Peep

You will need the following materials for this experience:

- ◆ white construction paper (one piece for each child)
- ◆ crayons, Craypas, colored chalk, and/or colored markers
- ◆ a hat or basket to hold small strips of paper

Procedure

1. Ask the children to look at their clothing and think of some words to describe their clothes. Ask some of the following questions:

 - Are your clothes all one color?
 - What shapes can you see?
 - Can you find some stripes?
 - Does anyone have polka dots?
 - Can you find stripes going in different directions?

2. Give children large pieces of white construction paper, crayons, and other markers, and ask them to use the colors to make designs that remind them of the patterns they see.
3. When the children have finished making their designs, display them at children's eye level.
4. Invite the children to look at the designs and guess which design matches certain children's clothing.
5. If you are working with older children, you might ask them to write their names on strips of paper, and put the strips into a hat or basket. Pass the hat around and let each child select a name. The children then look at the designs and try to match the name with the different color designs.

An Imaginary Trip with Frederick the Mouse

You will need the following materials for this activity:

- ◆ the book *Frederick* by Leo Lionni (Pantheon Books, 1967)
- ◆ one large piece of white paper for each child
- ◆ heavy-gauge paper or large pieces of cardboard
- ◆ a variety of colored tissue and colored construction paper
- ◆ small pieces of colored paper cut into random shapes

- glue, paste, or a water-glue mixture
- objects for collage, such as dried flowers, small sticks, sand, seashells, blades of grass, or leaves

Procedure

1. Read the story of *Frederick*. Discuss what kind of mouse Frederick was:

- Was he cooperative?
- Did he help?
- How did he help?

Ask other open-ended questions related to the story. Encourage responses by asking the children if they have ever daydreamed, which dreams they would have liked to have kept, whether they would like to share their dreams, and whether they would like to go on an imaginary trip.

2. Ask the children to get ready for a special imaginary journey. Encourage the children to find a place on the floor or in a chair where they can be still and comfortable. Begin the imaginary journey by saying the following:

> Let's be very still, close our eyes, and pretend we're little mice. Snuggle up with another friendly mouse. Keep your shiny eyes closed and feel your soft, soft fur keeping you warm. Tuck your tiny pink feet closely under you. Gather in the golden sun to save for a rainy day. Scoop up colors from the flowers and place them gently in a beautiful basket. Gather in the smell of popcorn. Feel the silky touch of little mice ears. Watch fluffy, white clouds float through the sky, and listen to the songs that the birds sing.

3. At the end of the imaginary journey, prompt various children to respond about their images and tell about the things they would like to gather and save. Be sure to use each child's name when asking questions such as "Lindy, what did you daydream about and what will you save?"

4. When each child who wishes has responded, whisper softly that the mice may "sneak over" to the table and use the art materials to make a design, picture, drawing, or collage of the images they want to keep from their imaginary journey.

The Shape of You

You will need the following materials for this activity:

- mural paper
- crayons, markers, and tempera paint for older children
- scissors

Procedure

1. Facilitate a discussion about the special attributes of each child. Highlight such attributes as funny, helpful, busy, silly, playful, and lively.

2. Following this discussion, ask children to choose a partner. Give each pair two large pieces of mural paper slightly longer than the length of their bodies. One child lies down on the paper, and the partner traces around the body shape.

3. The roles are then reversed.

4. Once the drawings are complete, each child colors himself or herself as dressed at the time of the tracing. Allow ample time for children to make their drawings as detailed as they wish. This part of the experience must not be rushed. (I know a talented teacher of three-year-olds who gives her children a full week to complete their shapes.)

5. Once the drawings are complete—and dry, if the children used paint—they use scissors to cut out the drawings. If your children have not mastered the art of cutting yet, let them color their body shapes *without* cutting them out. Remember that this is the child's creation, and if you have children who cannot do it for themselves, you should not be implementing the activity in the first place!

6. When all the children have completed coloring their body shapes, display the shapes at children's eye level. This is a wonderful way for your children to take ownership of their own room.

The Continuum of Development in the Affective Domain: Valuing

Teaching and learning experiences that focus on the affective domain emphasize the development of self-awareness, insight, and self-knowledge. Because of the very nature of affective development, the process of moving toward these levels of self-understanding involves interpersonal experiences and involvement with other people. As a group exploring the creative arts process together, you have already developed some skills in communicating with each other. To become personally involved in the creative arts process, you must feel that you can trust your colleagues and express your opinions openly and without reservations. The process of valuing is concerned with the worth we attach to the creative arts. Many of you already have an increased appreciation for the role the creative arts play in the process of growing and learning. Similarly, your behavior may be beginning to demonstrate commitment to creative arts content. Valuing ranges in degree from simply accepting the value of the creative arts (creative arts are important) to assuming responsibility for the effective implementation of creative arts in educational programs. Valuing is the internalization of a set of specified values, but clues to those values are concerned with behavior that is consistent and stable enough to make the value clearly identifiable.

Remember, however, that development in the affective domain is a gradual process. You may have experienced some very positive feelings or some uneasy feelings about your participation in the creative arts experiences. If your overall response has been positive and has produced growth, I hope you will continue with even more enthusiasm. Those of you still unsure of your role should use the visual

arts as a new starting place for responding and valuing. Development in the affective domain is a continuous process of internalization; it is not a static quality.

PERSONAL AND PROFESSIONAL GROWTH

Effective communication is an essential and integral part of being an effective teacher. The activity in this section, An Awareness of Self, is designed to encourage you to communicate with each other in verbal and nonverbal ways. It will help you assess your participation in the creative arts. Throughout this encounter, the focus will be on participation, communication, sensitivity, and openness. You will talk with a partner about your level of participation, your willingness and ability to communicate, your feelings about sensitivity and openness, and your personal learning goals and their relationship to the creative arts.

An Awareness of Self

Procedure

1. Form small groups or pairs and take turns asking and answering the questions listed here. Answer only those questions you feel comfortable answering. However, you should consider taking advantage of this opportunity to assess your own participation in the creative arts activities; your opinions on communication, sensitivity, and openness; and the level of learning that may or may not have occurred.

2. There are a few ground rules to follow as you begin your discussion:

 a. All the information discussed is confidential.

 b. Each person responds to each question before continuing. If you choose not to respond to a particular question, you can pass.

 c. Answer questions in whatever depth you wish.

Participation

1. Did I participate in all of the activities?
2. In which activities did I find it the easiest to participate?
3. Which were the most difficult for me?
4. How did others participate?
5. Did I notice anyone being excluded?
6. In what ways did I feel included and encouraged?
7. Why am I satisfied or not satisfied with my level of participation?

Communication

1. Did I feel free to talk or was I inhibited? Why?
2. What evidence do I have to indicate that others listened to me?

3. What evidence do I have to indicate that I listened to others?
4. Did my instructor attend to what I was saying? Cite an example.
5. Did I attend and respond to my instructor? In what ways?

Sensitivity and Openness

1. How were others sensitive or insensitive to my needs?
2. In what ways was I sensitive to others and their experiences?
3. What feelings and thoughts have I shared with others?
4. How difficult or easy was it to be open to the ideas and feelings of others?
5. How did I handle positive and negative feelings?

Learning

1. What did I learn from other people?
2. What have I learned about the creative arts or affective development?
3. What do I know now about the process of creative development that I did not know before?
4. How did I contribute to the learning of others?
5. Have any of my own personal learning goals been achieved?
6. What will I do with my learning?
7. How could I demonstrate my current attitude toward creative arts education?

I would like to leave you with one final thought as we prepare to move from painting, drawing, and printing. The thought is actually a question, and an important one: "All children paint like geniuses. What do we do to them that so quickly dulls this ability?" (Pablo Picasso). I hope you will ponder this question long after you have finished reading this chapter.

Inside you there's an artist you don't know about.
Say yes quickly, if you know you've known it from before
the beginning of the universe.

Rumi

chapter 6

Encouraging Play and Creative Drama in the Classroom

I think play is an expression of our creativity; and creativity, I believe, is at the very root of our ability to learn, to cope, and to become whatever we may be. To me, play is the process of finding new combinations for known things—combinations that may yield new forms of expression, new inventions, new discoveries, and new situations.

Mr. Rogers, 1993

magine for the next few minutes that you are an observer in Ms.
Carmen's classroom and watch how her children redesign her lesson
plan to meet their own play needs. As an observer of the class, you talk
with Ms. Carmen before she begins her lesson, and the two of you review
her plans for the morning's activities. Some of the procedures in her lesson plan
include a trip through the building to collect objects that are represented in
"Goldilocks and the Three Bears." Ms. Carmen tells you that she has read this story
many times over the past several weeks and that the children are thoroughly
familiar with the dialogue, plot, conflict, theme, and climax of the story. She and
the children find different-sized chairs, spoons, beds, and bowls. They also find a
doll that the children decide can be Goldilocks, and the center director empties a
box of oatmeal so that the children will have a container to hold their imaginary
porridge. The housekeeping center is transformed into the home of the three bears,
and the children place all the found objects in the center. Once the center is
equipped with the props, Ms. Carmen begins the next part of her lesson. She plans to
assume the role of script reader, and as her children listen to the story, her intent is
to have the children respond to the dialogue of the story characters while they are
seated on the floor in the story circle.

Ms. Carmen starts reading the story, pauses where there is dialogue, and asks
the children, "What did Papa Bear say?" She expects the children to stay seated
while responding to her question. In other words, she thinks they will know what to
do. However, when she asks the question about what Papa Bear said, all the
children get up and walk to the housekeeping center. On the way to the center, they
do respond by using the words and voices of the Papa Bear, and a dialogue between
Mama Bear and Papa Bear starts to unfold. At this point, the children assume the
different roles of the characters in the story and begin to construct their own world
of the bears' experiences without any further direction or intervention from their
teacher. As Ms. Carmen watches their play, she observes some children trying to fit
their small bodies into an even smaller chair. Other children complain that the beds
were broken, when in fact the beds were not broken. One child is busy mixing
porridge in the oatmeal box while remarking that they should take a walk in the
woods because the porridge is too hot to eat. Because a real walk in the woods is not
possible at the moment, the child starts describing all the things he sees, and he
proceeds to take an imaginary woods-walk around the perimeter of the
housekeeping center. Three children talk about how Goldilocks has made a mess of
their house, while at the same time, rearranging the furniture and other props in
ways that return some semblance of order to their play environment.

During what ended up being a full morning of enactment of a familiar story, the children assumed many different roles and added dialogue of their own free will. They invented new turns and twists in the plot by expressing displeasure and pleasure as the theme evolved, and they used the props and their own imaginations to resolve the dilemmas that both the three bears and Goldilocks faced at the climax. Ms. Carmen followed the lead of her children and did not impose her own ideas about how her children *should* interpret the story or about how they should play.

At the conclusion of this wonderful and eloquently articulated period of sociodramatic play, an observing practicum student seems to be extremely frustrated and not at all pleased with the morning's activities. She conveys her negative feelings to Ms. Carmen when she remarks: "Oh, how terrible. Your whole story time fell apart." In Ms. Carmen's wisdom as a sensitive and knowledgeable early childhood teacher, she points out to the practicum student that story time had not fallen apart—the children had simply taken the story and made it their own. In addition, the children had assumed responsibility for enacting the story and, more importantly, they were definitely in charge of their own learning.

> *Creative children look twice, listen for smells, dig deeper, build dream castles, get from behind locked doors, have a ball, play in the sun, get into and out of deep water, sing in their own key.*
>
> Paul Torrance

The Play's the Thing

The children in Ms. Carmen's classroom were enjoying the full advantage of a teacher who understands the value of play and who is capable of reinventing a lesson plan to accommodate the needs and interests of her children. I often tell my own students that if we pay attention to our children, they will either show us or tell us how they want to enter into a play activity, and they will develop their own responses that, in many cases, will be more helpful to them than all the careful planning we have done prior to the experience.

Children's play is the primary vehicle that enables children to learn about themselves and others and about the world in which they live, and to progress along the developmental sequence from infancy to middle childhood. The sections that follow focus on social play, sociodramatic play, and creative drama. I think it is important to clarify relationships between these three concepts. The discussions and examples should help you put social play, sociodramatic play, and creative drama in a framework that will be useful as you add new knowledge and understanding to what you already know (see Figure 6–1).

Social Play

Social play is the "umbrella" of all play experiences, encompassing several different levels of social interactions. Young children engage in all types of social play, such as when they are playing chase, or sitting side-by-side working on puzzles, or involved in spontaneous play such as playing "heroes" while running around the playground. There may or may not be definite roles; nevertheless, these social interactions provide children opportunities to practice and learn self-related and interpersonally related social skills (Taylor, 1995).

FIGURE 6–1 Social play encompasses all other areas of play.

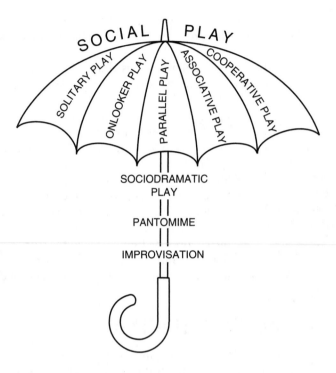

Caplan and Caplan (1973) write about social play and the broad repertoire of play behaviors that contribute to social development. They remind us that "social development can be measured in terms of a child's mobility, communication ability, self-care, self-directed activity and social attitudes and behavior" (p. 75). They also provide insight into the value of social play for children attempting to master the complex social skills necessary for working together with others. They conclude the following:

> Play helps a child try out his social skills. Children have a strong need to get and give love. In their play, young children also find outlets for such wishes as a desire to dominate, destroy, display their prowess, make noise, or make a mess. The child who in real life finds it difficult to construct, to repair damage, to help, or to give of himself to others, can find many opportunities to do so in make-believe play, as well as in reality through cooperative play with others. There is really nothing mysterious about the power of play. Play is basic to all normal, healthy children. It provides pleasure and learning and a minimum of risks and penalties for mistakes. Because it enables them to escape from the restraints and frustrations of the real world, play provides children with greater opportunity to experiment and care and more possibilities for the full exercise of the imagination. (p. 75)

As you observe children's social play, you will see some children playing alone, others playing independently with the same materials, or groups of children playing cooperatively in an organized play episode. These types of social play are described by Parten (1932) in what is recognized as a classic study in play. Parten describes social play in early childhood as a series of levels or styles of play that oc-

FIGURE 6–2 Levels of Social Play

Type or Styles of Play	Play Behaviors
Solitary Play	Children play alone with their own toys and appear to be oblivious to what others around them are doing. For example, a child may be rocking a doll while surrounded by an active block-building activity, totally absorbed in the doll as her only, and primary, play object.
Onlooker Play	A child may talk to other children, or even ask questions about the play of other children, but does not enter into the play of others. She may position herself in close proximity to other children so as to observe and hear, but continues to play in her own individual ways.
Parallel Play	Children may play with the same or similar materials, but each child is playing independently. They don't share toys, and what each child does is independent of what others are doing. Putting puzzles together or building with small blocks are good examples of parallel play.
Associative Play	Children play together, but their play is loosely organized. They may use each other's toys, ask questions, or assume different roles, but the activity is not organized into specific situations or games. For example, some children might decide to play "tag" and begin by chasing each other around the playground. Because there are no specified roles, the play can continue even if some of the children decide not to participate in the chase activity.
Cooperative Play	This level of play involves both organization and shared goals. Each child assumes a specific role and the play of the group is dependent on the cooperation of each member. Children organize their play for a purpose, and there is a division of responsibilities within the overall organization. For example, if children are playing "hospital," some children must assume the role of doctor, while others are patients or nurses. The cooperation of each child is necessary for the dramatization to occur.

Source: Based on Parten, 1932.

cur during the early childhood years. As you expand your knowledge of Parten's ideas, you will be able to design classroom settings that offer opportunities for play experiences that are appropriate for children at different levels of development. Although the following descriptions of social play may be viewed as a continuum that moves from solitary play to cooperative play, young children may engage in any of the levels at different times, depending on their personal experiences and their level of affective, intellectual, physical, and social skills. Figure 6–2 presents an overview of Parten's levels of social play.

As early childhood educators, we know that play is one of the most important things children do. All play activity optimizes children's abilities to acquire and develop new skills, to use symbols, to learn ways of representing what they know about things and events in their environment, and to further their use of language. In addition, a growing body of research is emerging that suggests that children learn most effectively through play-oriented activities (Bruner, 1986; Gabriel, 2000; Green, 2002; Morris, 2002; Smilansky & Shefatya, 1990; Stotter, 2000; Zeece & Graul, 1990). For those of you who have a particular interest in learning

more about play and its relationship to skill acquisition in some of the other content areas, I highly recommend these sources for your further study.

Because play is such a natural activity for children, and we know that play can occur in many forms and dimensions, we must find ways to extend play experiences that encourage children to reach their peak of play involvement. One way to do this is to plan for sociodramatic play experiences.

Sociodramatic Play

There are many definitions of sociodramatic play. For our purpose, *sociodramatic play* is defined as "play in which children assume roles and act out episodes" (Brewer, 2003, p. 142). Sociodramatic play is also described as play that involves social role-playing with others and refers to children's pretend play when two or more children assume related roles and interact with each other (Levy, Wolfgang, & Koorland, 1992; Morris, 2002; Smilansky, 1971).

Sociodramatic play is a highly developed form of social play. For example, a group of children is constructing an airport in the block center (cooperative play). As they work, they pretend or imagine that the blocks are airplanes, runways, or luggage. The children use words, gestures, movement, and social nuances to assume the roles of pilot, copilot, flight attendants, or passengers while engaging in make-believe in regard to objects, actions, and the situation (sociodramatic play). This complex play activity provides a wealth of opportunities for cognitive, affective, physical, and social development. Vygotsky (1978) suggested that sociodramatic play provides a meaningful way in which young children develop abstract logical thought. With all of this in mind, let's take a closer look at how children use sociodramatic play and why it is so basic to an early childhood curriculum.

During sociodramatic play, children use actions and language to respond to play themes that may imitate real-life experiences, stories from books, or ideas that evolve from movies or television programs. Sociodramatic play is a natural activity for young children and one that is especially important for the development of creativity. This type of play also correlates highly with Torrance's characteristics of the creative process (fluency, flexibility, originality, and elaboration). During sociodramatic play, children engage in a free flow of ideas and associations related to a common theme. They explore different ways of solving problems or finding solutions. Children can put a new stamp on a story reenactment to elaborate and extend their thoughts and ideas.

For example, think back to the description of Ms. Carmen's classroom of three-year-olds, their spontaneous exit from the story circle, and their entrance into the housekeeping center. In the process of leaving the story circle, they immediately assumed the roles of the characters in the story. They complained about the beds, chairs, and porridge, added dialogue, and invented new ways to resolve the conflict. And, more importantly, this sociodramatic play occurred without any intervention from their teacher. The teacher had set the stage by providing furniture, simple props, dress-up clothes, and other collected materials beforehand, thus giving the children exactly what they needed to help them carry out their own ideas. Their activity evolved into a classic example of sustained and extended sociodramatic play.

Social play and sociodramatic play are improvised by the child and guided by the imagination.

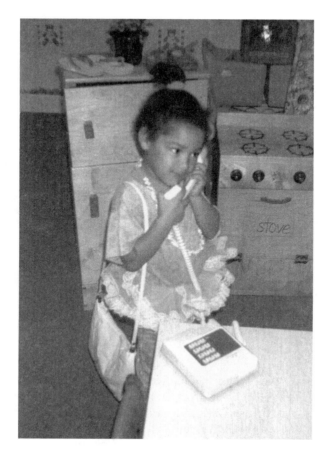

Sociodramatic play and creativity enjoy a common thread because both processes are dependent upon a child's ability to use symbols and must be viewed and honored as a rich and complex process that facilitates the development of a child's creative potential. In other words, sociodramatic play is basic to an early childhood curriculum and, as teachers, we must plan for long periods of sociodramatic play that allow children to develop their ideas in ways that are meaningful and significant to them.

Christie and Wardle (1992) and Chaille and Silvern (1996) found that during long periods of sociodramatic play, children engaged in more total play activity, group play, constructive play, and group-dramatic play than those of children in shorter play periods. In addition, they found that extra playtime did not cause children to become bored; rather, it "prompted them to engage in more complex, productive play activities" (p. 30). Do you remember what Hymes (1981) said about young children being beginners? Because our understanding of young children supports Hymes's ideas, we can assume that beginners do need time, and usually a lot of time, to become fully involved in sociodramatic play experiences that permit them to construct their play from many different points of view. Think about what would have happened to her children's play if Ms. Carmen had rung the "time to change centers bell" *before* her children had made the transition from repeating the

In many play episodes, the interaction is nonverbal. In these cases, communication occurs through movements and/or imitative action.

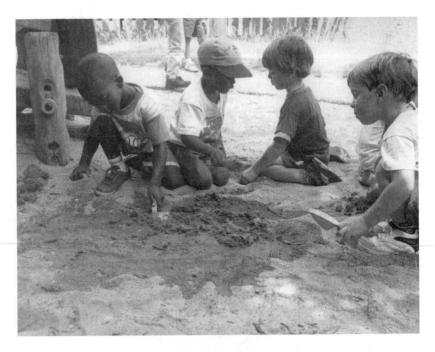

story's dialogue while sitting in the story circle to what eventually became a highly developed and sophisticated form of sociodramatic play.

To further assist your understanding of sociodramatic play, let's open another window on Ms. Carmen's classroom of three-year-olds and look at the children's behavior through six elements or criteria for sociodramatic play. Smilansky (1971) proposes that sociodramatic play includes the following:

- imitative role-play
- make-believe in regard to objects
- make-believe in regard to actions and situations
- persistence
- interaction
- verbal communication

When applying these criteria to the play of the three-year-olds and their spontaneous assumptions of the different roles involved in the play activity, we must engage in a systematic observation of their play.

The children undertook the different roles of the story characters and expressed their ideas in both imitative actions and reactions *and* through language (imitative role-play). They engaged in pretend or make-believe play as they substituted "play" beds and chairs from the housekeeping center for the beds and chairs belonging to Mama Bear, Papa Bear, and Baby Bear (make-believe in regard to objects). They also transformed an oatmeal box into a pot for mixing porridge. One child suggested that they take a walk in the woods to allow time for the porridge to cool down while, at the same time, describing the walk with words rather than going outside to take a real walk around the playground (make-believe in regard to action and situations).

The children were *persistent*. Their play lasted the entire morning, and as Ms. Carmen later told me, the story line continued to evolve and change for several days after the initial play began. The children were definitely *interacting* with each other. They fussed about Goldilocks's intrusion; they discussed options for dealing with her and their beds, chairs, and porridge. They *communicated* with each other as they related their own experiences and ideas for straightening out the situation, climax, and resolution of the play episode.

Visit a local day-care center or early childhood classroom. Record the times and occasions that are devoted to creative drama. Observe the teacher and make notes on the techniques used to involve children in creative drama.

As you think of ways to provide opportunities for sociodramatic play, remember that play involving role-taking and themes will occur in your classroom with or *without* your planning. However, you can provide the seed ideas to get children started and suggest roles or themes to initiate play activities. You must be willing to be flexible in your planning, to observe and listen to your children, and to take your cues from them, rather than being in a hurry to move into more teacher-directed and structured activities. As long as I have been in this profession, whether as a kindergarten teacher or as a college professor, I have been continually perplexed and bewildered when I have encountered teachers who still believe that they have to sit little children down and "tell" them things before learning can occur. Children construct knowledge from *within*, and play does more to facilitate this process than all the teacher talk heard on this planet.

Educators have known for a long time that sociodramatic play holds great value for children. It is through sociodramatic play that children re-create what they know about themselves, others, and the environment, *and* they do so by their own volition and according to their own ideas. Figure 6–3 provides a readily available

FIGURE 6–3 The Value of Sociodramatic Play in the Curriculum

Sociodramatic play

1. Values children's imagination; respects the individual creative expression of each child; and offers a child-centered world in which young children can develop critical thinking skills as they construct meaning from imaginary, abstract, and/or real-life situations

2. Enables children to become fluent and inventive users of movement, sound, and language to represent or symbolize the people, events, and objects that make up their world

3. Provides opportunities for social and emotional growth, the development of interpersonal skills, and heightened respect for others' feelings and desires

4. Develops and expands skills for collaboration and individual and group problem solving, and fosters an appreciation of the differences among individuals, ideas, and opinions

5. Is a spontaneous and natural activity that is an integral part of the serious business of being a child

6. Creates a learning environment in which children can demonstrate, or convey, a sequence of events

7. Allows children to organize and express their ideas clearly

8. Has a primary role in enabling children to learn through bodily kinesthetic actions

9. Encourages children to escape to the land of enchantment and adventure

Sources: Based on Edwards & Nabors (1994); Green (2002); McCaslin (2000); Rogers & Sharapan (1993); South Carolina State Board of Education (1993); and Stotter (2000).

reference that you should find useful when talking to parents and others about the value of sociodramatic play.

When encouraged and valued by a wise and well-educated teacher, the need to play can become a "continuing way of learning, a medium of expression, and eventually a creative art" (McCaslin, 2000 p. 38). I am confident that most of you now realize the importance of play and the contribution sociodramatic play makes to children's overall development. With that in mind, I'd like to move a few steps beyond spontaneous, sociodramatic play and talk about creative drama as an art form.

Creative Drama

I will begin this section by introducing you to an expert in creative drama, Nellie McCaslin. We will use her definition of creative drama, because I believe her work sets the standard for creative drama in early childhood education. Creative drama is more structured than sociodramatic play, and as the name implies, it moves beyond sociodramatic play in scope and purpose.

> It may make use of a story with a beginning, middle and an end. It is, however, always improvised drama. Dialogue is created by the players, whether the content is taken from a well-known story or is an original plot. Lines are not written down or memorized. With each playing, the story becomes more detailed and better organized, but it remains extemporaneous in nature and is at no time designed for an audience. (McCaslin, 2000, p. 6)

When children are involved in creative drama, they interpret suggestions, stories, or events using their own actions and dialogue. Formal costumes and scenery are inappropriate for creative drama, although simple props, such as hats, scarves, or other items already in your classroom, can be useful for enhancing imaginative expression and action. When these are used, they should never limit the creative impulses of the child, nor should they suggest any kind of formal production.

The goal of creative drama is not to perform for an audience; rather, it is to enhance children's creative expressiveness through artistic, intellectual, and socially shared experiences. Creative drama is a means of self-expression that encourages movement, gesture, and verbal and nonverbal communication.

Teachers can plan experiences to encourage creative drama. For example, after returning from a trip to a farm, a bakery, or the grocery store, children will often act out the people and events they encountered along the way. You can encourage them to assume the roles and activities of the people they met by providing a supportive environment for them to reenact what they have seen and heard. You can use literature to incorporate creative drama into your classroom activities. After reading a favorite story, guide your children into a creative experience in which they can act out the characters and story line.

Plan creative drama activities for some of the movement and music ideas presented in chapter 4. For example, encourage them to use words and actions to describe the process of growing, being in the rain, and almost touching the clouds. If your children are exploring space and force, ask them to pretend they are pushing a heavy wagon filled with something special and are on their way to an adventure.

Encourage them to describe and act out their adventure as it unfolds. Invite your children to give dramatic representations of stories while changing the ending, the characters, or the plot. Plan drama experiences in which your children act out familiar everyday experiences such as getting up in the morning, eating breakfast, brushing their teeth, getting ready for school, and going to school.

Other guided creative drama experiences can extend children's imaginations. Suggest to the children that they are holding an imaginary box. Inside the box is a kitten with very soft fur. Ask the children to handle the kitten, look at it, tell what they would like to do with the kitten, and then pass it on to another child. Children can pretend to be toys in a toy shop. When the store owner leaves, they all come alive and talk to each other about who they are and why they are so much fun to play with.

Remember that creative drama comes from *within* the child, is *created* by the child, is based on the *child's* experience and understanding, and is always improvised drama. Before you start thinking of ways to involve children in creative drama, you should know that McCaslin, an expert in creative drama, has delineated a sequence in the process of introducing young children to creative drama. While I doubt that she would ask us to follow this sequence in a regimented fashion, I think that her rationale for developing such a sequence is important enough for us to attend to at this point in our understanding of the process. Figure 6–4 presents an overview of ways in which creative drama can be introduced to young children.

FIGURE 6–4 Introducing Children to Creative Drama

Process	Characteristics
Imagination and Creativity	In creative drama, children use their imaginations when they dress up and pretend to be someone else or when they construct a world in which they invent elaborate rituals and adventures around familiar stories, real situations, or imagined situations.
Pantomime	Pantomime is often described in terms of what it does not have: no words and no sounds. It is the silent language of the body through which children use gestures to convey meaning to themselves and others.
Improvisation	In improvisation, the characters speak. Children add their own dialogue as they express feelings and ideas in words. For very young children, dialogue is most likely brief at first but begins to flow more rapidly once the children have had opportunities to discover the process. During the "takeover" of Ms. Carmen's lesson on "Goldilocks and the Three Bears," her children became active participants in improvision. Through their sociodramatic play, they improvised the story by using their own words and actions rather than those that were written in the book. They took a very simple story and made it their own.
Children's Theatre	In children's theatre, the play comes to life on a stage. While it may be beneficial for children around the age of 11 or 12, early childhood educators know that there is little value in formal productions for young children, so wait until you are teaching fifth grade to introduce children's theatre into your curriculum.

Imagination and Creativity

When children imagine (and they are always doing this, with or without our permission), they move into a private place comprised of their own comfort or discomfort, their own personal attempts at communication with an imagined person or object, and a rich and complex state of consciousness that only the child and the imagination of that child are privileged to enter.

Children who create imaginative play with other children make their own important discoveries. Teachers who are aware of the value of play can create an atmosphere that inspires children to be creative. For example, in fantasy play children assume roles when playing alone or with other children. Children will improvise and live within a role, a person, an animal, or even an object. Morris (2002) discusses an innovative framework for teacher-led dramatic play activities called the *Teacher in Role* strategy. One of the main components of this framework focuses on types of "teacher-led dramatic play that, regardless of the subject matter, stimulates spontaneous and playful contributions from the children involved" (p. 38). Within the context of creative drama, the adult facilitates the experiences, using a sophisticated story line that has a beginning, middle, and end. Children explore these components of the story through unstructured, imaginative dialogue and problem solving. Children act in a dream world, within which it is possible to move in and out, according to their own needs. When taking on roles in this way, children can deal with unsolved problems even when they do not fully understand the situation from an adult perspective. The play is a safe way to try out feelings and solutions or make-believe actions (Balke, 1997; Gardner, 1991).

The Imagination Station was developed by Morris in 2002. This approach is based on the development, implementation, and evaluation of an early childhood drama curriculum for young children. The aim of the curriculum is to foster children's emerging literacy, develop children's oral and kinesthetic languages, and aid, through problem solving within the context of guided drama, children's social and moral development. A wonderful example from The Imagination Station is Journey into Story. The facilitator takes the students on an imaginative journey into the story's setting. Movement is used in conjunction with music and slight narration. "*Magic Dust, Traveling caps, swimming,* or *group bike rides* are examples of ways we actively travel into the story settings" (Morris, 2002, p. 42). If you are interested in learning more about The Imagination Station, read the Morris article in *Youth Theatre Journal*, volume 16, 2002.

It is during concentrated moments of imaginative thinking that a teacher can invite children to experiment with the process of capturing the images in a dramatic form. One example of a teacher encouraging a child to both concentrate on an image and then do something in order to deal with the image occurred in a first-grade classroom that I was recently observing.

Six-year-old Anthony was getting ready to move with his family to a neighboring city about 20 miles away. During the three days it would take his family to move all of their household possessions, his best friend Katya and Katya's dad would be feeding and walking Anthony's new puppy. In his imagination, Anthony was concerned that Katya would forget the trick of how to unlock the gate to the

When children play, they are thinking, organizing, planning, and interacting with the environment in meaningful and purposeful ways.

backyard and not be able to feed or pet his puppy. When hearing about his fears, Anthony's teacher suggested a playacting experience in which one child became Anthony and another child assumed the role of Katya. Anthony liked the idea, and he and several other children used the blocks, boards, and construction sets and tools in the block center to construct his backyard and the tricky gate latch. The play began with Anthony explaining to Katya exactly how to open the gate. He also showed Katya where the water hose was attached to the house and where he kept the puppy's food. Other children soon joined in the play, and it was not long before there were many imaginary animals in the backyard. The play evolved from being Anthony's backyard into a fully equipped zoo with a variety of exotic animals. The dialogue still centered on feeding and walking animals, but the children were now pretending to feed elephants and trying to figure out how to get a leash around a giraffe's long neck! The imaginations and creativity of the children were soaring.

What began as an attempt to ease the fears of one child had evolved into a wonderful period of creative and imaginative play. Your experience as a teacher may, indeed, cause you to pause and consider the tender feelings and emotions your children experience in their day-to-day lives. When this happens in your classroom, you can use the valuable tool of creative drama as a way of guiding children into a safer realm of reality, whatever their ages or their experiences. What is required of you is to pay attention to your children. I have talked a lot about children and creativity, children and drama, children and play, children and the arts, but I have not talked very much about the importance of your role as a facilitator of the creative arts experience for young children. The next section in this chapter will provide you with some basic guidelines to ensure that *you* benefit as much as your children do from creative drama.

Teachers and Creative Drama: Are You Comfortable?

As artists, actors, musicians, and dancers, we as teachers often find ourselves in the same predicament as our children when it comes to being open to the creative process. You have read in this book and I am sure countless other books required for your teacher education program about the importance of helping children to build positive self-esteem and the role that the creative arts can take in this endeavor. Based on our own life experiences (or lack of experiences), some teachers will be ready to jump in and experience the creative arts, and other teachers will stand before a group of children, hands sweating, knees trembling, while wondering if they will ever be successful in getting through the drama part of the curriculum.

Not to worry. Creative dramatics in early childhood does not require the skill needed to succeed in a Broadway play, nor does it require the minimal effort needed to act out "blowing out candles on a birthday cake." *Teachers should always start where they are comfortable.* This can range from taking a leading role in the creative dramatic play of children, being a facilitator who keeps the play moving along, or being a background person who has limited visibility. Even *you* can blend into the background. Another thing to consider is introducing creative drama activities that require you to take the least amount of risk. You can encourage children through their involvement in creative drama, or play, or art for that matter, from the sidelines. You do not always have to be front and center when sharing drama with children.

Call on a Friend If you are not sure of what you are doing or if you wonder if you are doing it right, call on a friend to be your security blanket. This person could be a colleague, teacher's aid, parent, volunteer, or can come in the form of a puppet or a magic wand. You can hide a lot of discomfort behind a puppet, and you may use a magic wand to take the focus off of you and put all of the focus into the wand. *Practice makes perfect.* Use the privacy of your own home, maybe your bedroom or kitchen. Try singing in the shower. Practice singing along with the radio or a CD; make up silly songs about your day or about the traffic. When no one is there to watch or judge you, allow yourself to be silly; after all there is no one looking at you. If this is too risky for you, drive down the road singing *If you're happy and you know it.* Change the words to match your mood, such as If you're *angry* and you know it, If you're *hungry* and you know it, If you're *tired* and you know it. I am not saying that it is an easy thing to transfer from the privacy of your home into the very public classroom space you share with your children, but it can make a difference if you do a little private rehearsing (Edwards, 2002; Edwards & Nabors, 1994; Leithold, 2000).

The next section focuses on pantomime. This is usually a pretty safe activity for both adults and children because you do not have to remember any *words.*

Pantomime

Pantomime encompasses our ability to use our bodies to convey what we would have otherwise said in words. We all have seen six-year-olds shrug their shoulders,

we have observed four-year-olds roll their eyes, and we certainly have come face-to-face with the second grader who, nonverbally and with clearly understandable body language, announces to the whole school that the playground is where she intends to stay and that she has no intention of coming back into the classroom. These children do not need words to convey their messages; they are masters at pantomime and do not even know it! They are also exhibiting their talent for communicating without words.

When introducing very young children to pantomime, you might begin by encouraging them to explore familiar images and moods. For example, begin by asking the children to walk around the room as you play a steady drumbeat. Encourage children to express themselves by saying, "Now it's beginning to rain. Lift up your arms and feel the rain on your hands. Look up and feel the rain on your face. There is a big rain puddle ahead. Show how you would get across the puddle. Now it's beginning to snow. Use your body to pretend that you are very cold. The snow is getting a little deeper and you are having a lot of fun playing with the falling snowflakes. Use your body to show how you would move through the snow." Children will have individual responses to walking in the rain or playing in the snow. They will represent their experiences through their own interpretation and will decide for themselves what actions are meaningful to them. Ask children to move their bodies like falling leaves or trees being blown in the wind.

Think about and be sensitive to the particular experiences of your children and engage them in pantomime activities to which they can relate on a concrete level. These types of simple, imaginative experiences allow young children to participate in pantomime as a form of creative drama without having to use words. For young children especially, the request to use expressive language can often get in the way of the experience. Your leadership and awareness of the needs and skills of your children can lead them from simple pantomime activities to improvised creative drama in which they use oral language to discover the possibilities for dialogue and dramatizations. (You will find some ideas for introducing pantomime into your creative drama curriculum later in this chapter.)

Improvisation

Improvisation refers to creative drama in which sounds and expressive language are added. Children may use some of the original dialogue from a story or may enact a familiar situation by using a block to represent a telephone while pretending to place an order for take-out pizza. Once children become accustomed to the process, they will begin to add dialogue and actions that reflect what they want to express.

When children create, they are making sense of the world.
Robert Alexander

Nursery rhymes, poems, and songs are excellent material for introducing improvisation. Children as young as two years old enjoy dramatizing the familiar poem "Teddy Bear, Teddy Bear, Turn Around." Nursery rhymes such as "Hey! Diddle, Diddle" can be acted out and extended through the use of imaginative thinking and verbal communication. Through improvisation children can decide whether they want to be the cat, the fiddle, the cow, the moon, the dog, the dish, or the spoon, and they can also decide how to portray each imaginary part! Or the

children can act it out together as they jump over the moon, laugh, and run away. This is an instance in which a simple prop may be useful. A small block placed on the floor can be transformed into an imaginary moon over which your children can jump.

Simple nursery rhymes such as "Humpty Dumpty" or "Jack and Jill Went Up the Hill" give young children many opportunities to explore familiar roles and to identify with different characters. Children want to "be" Humpty Dumpty, the king's men, or the horses. If encouraged, and when you provide a positive classroom environment in which children feel safe to express themselves, this form of creative drama becomes a very powerful mode of learning. It is through these experiences that young children can engage in dialogue and express emotion, while using their bodies to perform or act out what they know about their real and imaginary worlds.

Well-known stories can provide wonderful creative drama experiences. You, the teacher, can read the story and pace the timing to match the children's movements and actions, or, as children become thoroughly familiar with the story line, sequence, and plot, as our three-year-olds had with the story of "Goldilocks and the Three Bears," they may improvise their own dialogue and actions without your guidance. Remember that the actions, movements, and dialogue are created by the children. There are no "correct" lines to be memorized and spoken or directions to be rigorously followed in the process of self-expression, and children should be under no pressure to create a "product" for an audience. "Caps for Sale," "Swimmy," "Ask Mr. Bear," "The Three Little Pigs," and "The Three Billy Goats Gruff" are just a few good stories that lend themselves well to creative drama.

Children love sound effects and these inanimate objects can provide barrels of laughter during improvisational activities. There are some sound effects that children can create on their own and others with which they might need some teacher assistance. The following ideas are gleaned from Stotter (2000) and can easily be incorporated into many dramatic situations.

Sound Effects

DOOR SLAM
Ordinary door in a house.
Try a door slam for a mouse house.
Try a door slam for a large castle.
Add a lock after you close the door.
ZOOMING CARS AND HORNS
"Zooom" "Zooom" while turning your head.
"Beeep" "Beeep" in nasal voice.
ANIMAL DRINKING WATER
BIRDS SINGING IN A FOREST

Try a series of three bird-like sounds . . . rotate them a few times so that we clearly hear three different kinds of birds.

BIRDS FLYING BY
Start softly, get louder, then softer.
WAVES CRASHING ON THE BEACH

DUCK FAMILY
Father duck. Mother duck. Baby duck.
NORTH WIND
STARS
Create a sound for each little star popping in the night sky.
PIANO
Pink-a-pink-a-pink, pink-pink or whatever you can come up with (Stotter, 2000, p. 54).

Here are a couple of book selections that work beautifully with some of these sounds. Read *If You Give a Mouse a Cookie* by Lana Numeroff (Harper & Row, 1985). You will have many opportunities to make all kind of mouse sounds. Instead of making the sound for a mouse drinking water, your children can make the sounds for a mouse "eating a cookie." *Make Way for Ducklings* by Robert Mc-Closkey (Viking, 1969) is a delightful story about Mr. and Mrs. Mallard and their adventures rearing the family of ducklings. *Owl Moon* by Jane Yolen, illustrated by John Schoenherr (Philomel, 1987), is a story of a young child and her father who go owling. The trees stand still as statues while the father calls, "Whoo-whoo-whoo." You and your children can have fun calling "Whoo-whoo-whoo for the owls." You can find many more story books that lend themselves to sound effects.

Children's theatre, a term often used interchangeably with *formal dramatics*, is very different from creative drama. Children's theatre is audience-centered and has public performance as its goal. Children's theatre refers to formal productions rehearsed for an audience; it is directed, dialogue is memorized, and props, costumes, and scenery are important to the production. It is the script, whether written by a

Using the methods and materials suggested in this chapter, design a creative drama experience for young children. Implement your plan with a small group of children and evaluate the outcome. Note the children who participated and those who did not. Make a list of ways you might include more children and ways you can improve the activity.

When children engage in imitative role-play, they assume a make-believe role and express it through action, gesture, expression, and language. Here we see examples of the troll and two Billy Goats Gruff.

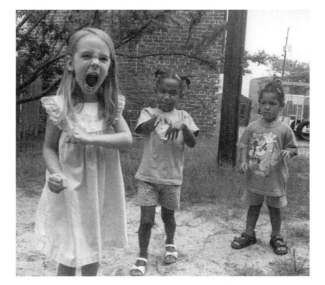

teacher or the children, and equipment and materials used in production that distinguish children's theatre from creative drama.

As early childhood educators, we must confine our efforts to encouraging creative drama experiences for our children, and we must leave children's theatre to our colleagues and children in the upper elementary grades. Children's theatre and/or formal dramatics are inappropriate for the early childhood curriculum.

Creative drama also opens another door for us as teachers. We can use what we know about creative drama to further our understanding of Gardner's theory of multiple intelligences, especially *intrapersonal* and *interpersonal* intelligence. His ideas have much to offer as we look at the relationship between creative drama and the development of intellectual growth in young children.

Gardner's Theory of Multiple Intelligences: Intrapersonal and Interpersonal

Gardner's theory is significant to early childhood educators because it gives support to teachers who plan activities and experiences that focus on each child's unique abilities. He also challenges us to recognize the different intelligences in children and to celebrate the fact that each child possesses a combination of intelligences that must be nurtured and honored. Creative drama promotes the development of intrapersonal and interpersonal intelligence.

Intrapersonal Intelligence

Intrapersonal intelligence refers to our ability to access our own feelings—the range of emotions and affective states we experience on a day-to-day basis—and to draw upon them as a means of understanding and guiding our behavior. Gardner suggests that at the most advanced level, intrapersonal knowledge "allows one to detect and to symbolize complex and highly differentiated sets of feelings" (Gardner, 1983, p. 239).

This personal intelligence involves the ability to know oneself and to have access to one's own feeling life, and it involves the capacity to discriminate among one's desires, needs, wishes, fears, and skills. It also includes knowledge of one's own strengths and weaknesses and the ability to draw upon feelings. Intrapersonal intelligence includes knowledge of our other intelligences. We see highly developed forms of intrapersonal intelligence in individuals engaged in the helping professions and in skilled teachers and parents. I am sure all of us have our own examples of people in our lives who have shown us this level of self-knowledge and self-understanding.

Creative drama has tremendous potential for promoting rich and meaningful dialogue that allows children to reflect upon and explore their own feelings. It also provides for the healthy release of feelings through appropriate and acceptable channels. Through all areas of creative drama, young children can experiment with ways of interpreting strong feelings by assuming roles that lie outside of their per-

sonal, affective states. For example, when Anthony's teacher realized that Anthony was experiencing a great deal of fear around the care and feeding of his new puppy, he addressed Anthony's anxiety by creating a safe situation in which he could express his fears in a more comfortable and controlled situation. The teacher took a "real" event and transformed it into a symbolically portrayed improvisation. By doing this, the teacher not only enabled Anthony to be more aware of how he was feeling but also provided an arena in which he could release his fears and anxieties in a concrete and deeply involved process. Anthony learned a valuable lesson in how to draw upon his feelings and personal experiences to guide his own behavior. He gained a further understanding of his own problem, wishes, and anxieties, and ultimately resolved each of these through creative drama.

Interpersonal Intelligence

Interpersonal intelligence turns outward, to other people. It is our capacity to discern and respond appropriately to the moods, temperaments, motivations, and desires of other people. Gardner sees interpersonal intelligence as our ability to read the intentions and desires of other people, and to act upon this knowledge as a way of effectively relating to others (Gardner, 1983). Counselors, salespeople, teachers, and politicians are individuals who should have highly developed interpersonal intelligence. Carl Rogers, Abraham Maslow, Mother Teresa, Mahatma Gandhi, and political leaders who serve as ambassadors and diplomatic representatives exhibit characteristics of people who have high degrees of interpersonal intelligence. For young children, interpersonal intelligence "entails the capacity of the young child to discriminate among the individuals around him and to detect their various moods" (p. 239).

In the art of creative drama, we move outward as we communicate by sending and receiving messages through dialogue, actions, and nonverbal communication. Creative drama is concerned with receiving a message and a willingness to understand another person's point of view or way of looking at a situation. It also requires sensitivity to the needs, level of comprehension, and receptivity of the receiver.

When we engage in *pantomime,* the message and ideas conveyed are nonverbal, and we listen as much to the nonverbal responses of others as we do to the silent words that are going on inside of our own heads. As a result, we become more and more aware of the receptivity of our actions and the mood of others' reactions. As we begin to add words through *improvisation,* we develop the ability to discern the temperaments, motivations, and desires of other people.

Let's look again at Anthony's experience in creative drama for an example of interpersonal intelligence at work. As Anthony and his playmates became involved in the playmaking, he began to realize that Katya's motivation and desire was, in fact, to take excellent care of his puppy. Through his participation in the creative drama episode, Anthony exhibited the ability to notice Katya's mood and, in particular, to detect her intentions to attend to the needs of his new pet.

Through creative drama, children develop the capacity to look inward (intrapersonal intelligence) and outward (interpersonal intelligence). Through this process of speaking, pretending, role-playing, and even silent communication,

children develop a deeper self-awareness as well as more positive and appropriate relationships with others.

The role of the teacher in creative drama and in the development of the personal intelligences is very important. You must be an encourager, an observer, a designer, and a resource. As you reflect on what you have learned so far about the personal intelligences, let's take a look at some ideas you may consider as you think of ways to support the development of intrapersonal and interpersonal intelligence in young children.

Supporting the Personal Intelligences

Acceptance, tolerance, patience, and a willingness to attend and respond to children's experiences are the essential requirements for supporting the development of intrapersonal and interpersonal intelligence. Young children are inherently social and are always looking for ways to play out their ideas with others. The following ideas should begin to answer the question "Where do I start?"

Encourage the Use of the Imagination by Designing Activities That Facilitate Freedom and Originality of Expression Ask your children to think of a special friend. If they cannot think of a real one, ask them to make up a friend. "Now pretend that you and your friend are going on a walk to a very special place. How do you get there? Do you walk? Does someone in your family take you to this special place? Now that you have arrived at this special place, what do you and your friend do? Pretend that you are doing things together, and use your imagination to tell each other what you are doing. Let your friend know what you would like to do, and tell your friend why you want to do it."

Design Creative Drama Activities That Facilitate an Awareness of Self Invite your children to make noises using parts of their bodies other than their voices. Suggest that they click their tongues, breathe loudly, clap their hands, stamp their feet, or tap parts of their bodies. Allow the children to respond in as many ways as they can think of, and then choose a sound they would like to make and go to a space in the room where they can make this sound without being bothered by the sounds others make. You might consider tape recording the sounds and playing them back to your children so that they can hear the "orchestra" of sounds they can make without using words.

Explore Moods and Feelings Through Body Movement and Dialogue After hearing a familiar story, ask the children to convey, through their actions and words, their own interpretation of the feelings and experiences of the different characters. Or tell your children that they cannot use words to talk to each other and that they will have to talk with their hands. Their hands are just like words and cannot touch each other. "How will you say, 'Hello'? Imagine that you are angry. How would you show that by using your hands and not your voices? Imagine that you are shy

or nervous. Imagine that you are happy. How would you show that with your hands? Choose a partner and talk to your friend by just using your hands."

Suggest an Imaginary Situation in Which Children Communicate Verbally, Interact with Others in Their Own Characteristic Way, and Speak in the Character of Another Person Create a dialogue for a family, and let each child portray an identifiable family member as everyone responds to each other in character within the given situation. The situation could range from something as simple as a family cookout or picnic to making sure all the windows and doors are locked before going to bed.

Encourage Your Children to Work Together, Through an Imaginary Situation, to Begin Understanding and Responding to the Emotions of Others Set up a scene in which your children must respond to a situation involving the various types of buildings in which children live. The book *Amazing Grace* by Mary Hoffman, illustrated by Caroline Binch, is an excellent source for getting children to understand what it's like to live in a high-rise apartment building. Each child can assume a character role as they talk together, express feelings, and come to a resolution that is acceptable to everyone.

Seize the Opportunity to Use the Real-Life Challenges of Your Children to Help Them Access Their Own Feelings Ask children to think of something in school that they would like to change and then name all the reasons they cannot change it. Then ask the children to pretend what would happen if their wish to change something really did come true. Observe your children and notice problems or joys that may be resolved or heightened through a creative drama experience. Reenact a special occasion such as a birthday party, or give imaginary presents to the child who has just received a new sibling. Most of the material for developing interpersonal and intrapersonal intelligence through creative drama comes to school each morning as your children walk through the door.

Give Yourself Permission to Stand Back and Be a Facilitator You are the one who can plant the seeds for creative drama. You are also in charge of preparing the classroom environment to welcome children into the process, and you can assume the role for processing activities if you see a need for furthering resolutions to imaginary situations. Just be sure that you do not fall into the role of "producer and director." Creative drama is one activity in which less intervention from you is better than more!

The quality of a creative drama curriculum may be affected by many factors. It is the degree to which our program is developmentally appropriate that determines whether the interactive process enables children to progress in their willingness to become involved. With that in mind, we must consider what the National Association for the Education of Young Children (NAEYC) has to offer in terms of developmentally appropriate practices in creative drama.

A Family's Role in Developing Creative Drama at Home

Family and environmental factors contribute to the development and nurturance of creative drama in young children. Caregivers should provide a less restrictive home play environment in order to encourage creative drama in the home. It is important to include equipment, toys, and materials that stimulate creative, make-believe play. The following toys and materials are considered to be especially useful when engaging in creative drama at home.

- Blocks of various shapes, sizes, and colors
- Culturally accurate dolls and equipment needed to play with during role-play
- Water and sand tables
- Variety of costumes, appropriate for both boys and girls without being stereotypical
- Puppets and homemade puppet stages
- Areas in the home where children can play with real objects, such as hammers and pegs, screwdrivers and screws, cash registers and real money, chalk and chalkboards
- Art supplies including paints, clay, homemade clay, paper, scissors, markers, glue, crayons, glitter
- Real musical instruments

All of the toys listed promote creativity when children are encouraged to explore and discover the properties of these toys for themselves. Children can use the materials included in the list in a variety of ways related to creative drama (Ellermeyer, 1993).

DEVELOPMENTALLY APPROPRIATE PRACTICE

While affirming the importance of creative drama for young children, NAEYC proposes that child-initiated, child-centered, teacher-supported play is an essential component of developmentally appropriate practice (Bredekamp, 1987). Figure 6–5 reflects guidelines for implementing developmentally appropriate experiences and activities in creative drama.

The Special Children in Your Classroom

Can the special children in your classroom participate in and benefit from creative drama? The answer is, of course, yes. Drama is all-inclusive, and every child can de-

FIGURE 6–5 Developmentally Appropriate Practice

◆ Teachers and other adults play with toddlers reciprocally, modeling how to play imaginatively with baby dolls and accessories. For example, when you play tea party, you should pretend to drink from a cup and use facial expressions and language to exclaim how good it tastes. This provides very young children the opportunity to model an adult.

◆ Teachers support children's play activities so that children stay interested in the play experience, moving gradually from simple exploration of objects to more complicated play, such as pretending. Adults recognize that sociodramatic play and creative drama provide opportunities to develop self-awareness and social skills (awareness of others) such as cooperating, helping, negotiating, and talking with the other people involved to solve problems.

◆ Children are provided concrete learning activities with materials, simple props, and objects relevant to their own life experiences. Teachers prepare the environment so that it is easy for children to participate in creative drama and other play situations requiring communication and cooperation.

velop self-awareness and awareness of others through personal involvement in the creative drama process. Doctoroff (1996) found that using creative drama to encourage social interaction improves the attitudes of non–special needs children toward children with disabilities. "Portray people with disabilities in active leadership positions, rather than passive roles" (Haugen, 2000, p. 57). When we think about diversity, self-awareness, and awareness of others who share the world with us, we must create opportunities for creative dramatics in all programs, especially those programs accommodating children with disabilities. When you plan creative drama experiences for *all* of your children, consider the following guidelines in your planning:

◆ Select themes that reflect a shared background of experiences. If you have a child who lives in a high-rise apartment building and a child who is visually impaired who has never seen an apartment building, the raw material for your drama-related activities should center on what they know rather than what they do not know. For example, invite the apartment-dwelling child to stack blocks, one on top of another, while describing the concept of a high-rise building to a child who is visually impaired.

◆ Use children's shared experiences to suggest theme-related activities that introduce fantasy and imagery into the action and dialogue. For example, invite all of your children, including the child in a wheelchair, to imagine how it would feel to soar like an eagle above mountains and valleys or to roll in the wetness of morning dew on the grass at sunrise.

◆ Outline imaginary situations that set up boundaries, including the safety nets I discussed in chapter 3, which also leave room for imaginary exploration, inventive actions, and personal dialogue. For example, if you ask your children to pretend to be firefighters, you must provide visual clues for the child who is hearing impaired so that he or she can participate fully and with confidence.

◆ Make sure the props you introduce are childproof and physically safe. This does not mean that you cannot provide a number of easily found classroom props, but you should check each prop to ensure that there are no sharp edges, that the weight of the prop is manageable for your children, and that

Children's Literature and Creative Drama

Aunt Nina's Visit by Franz Brandenberg, Greenwillow Press, 1984.

While Aunt Nina is giving a puppet show for her nieces and nephews, her six little kittens have fun disrupting the production.

Ms. MacDonald Has a Class by Jan Ormerod, Houghton Mifflin, 2001.

After visiting the farm, the children in Ms. MacDonald's class learn to move, look, and sound different while preparing to present the performance of a lifetime.

Sarah's Story by Bill Harley, illustrated by Eve Aldrigde, Ten Speed Press, 1999.

Sarah cannot think of a story to tell in class for her homework assignment, but on her way to school, she gets help from some unexpected sources.

it can be easily recognized by the child who is visually impaired or held (and manipulated) by children with cerebral palsy.

♦ Never force a young child with special needs, or any child in your class, to participate in creative drama. This is not to say that you should not encourage children to participate, but this must be done with a gentle nudge. Shy children, children with disabilities, or children who are unsure of their physical abilities may not believe you when you say: "Oh, girls and boys, this is sooooo much fun!"

♦ Provide some time at the end of a creative drama experience for processing. This gives children a sense of closure and allows them to unwind. For example, in the firefighting activity the closure could be having all of the firefighters return to the station house for a nice dinner and a good night's sleep.

♦ Help children with visual impairments know when, where, and how to participate by giving hands-on narrated tours of objects in the environment beforehand, and provide an ongoing commentary during the activities (Haugen, 2000, p. 56).

Read chapter 15, "Creative Drama for the Special Child" in Creative Drama in the Classroom *by Nellie McCaslin. Select several activities from this chapter to introduce to a group of special children, and evaluate the outcome according to McCaslin's criteria.*

Haugen recounts a conversation between two children in her kindergarten class, one of whom uses a wheelchair and cannot speak: "Learn from your children. I once overheard a kindergartener say, 'Hey, Jen, I'll push your wheelchair if you carry my library books'" (p. 57).

Processes and Materials for Encouraging Creative Drama

Creative drama as an art form enables children to draw upon their own personal experiences and feelings as a source of content that allows the imagination to take wing (Eisner, 1987). In addition to giving children wings to explore creativity and imaginative playacting, creative drama also taps the roots of children's knowledge of the world and provides an avenue through which they can create situations and journeys through spontaneous and improvised sound, movement, and expression.

Children come to us bringing all the "equipment" they need. There is no body of information or technique that children must master, and there is no need to rely on knowledge that is outside their realm of understanding. Movement and sound, pantomime, improvisation, and gesture enable children to act upon creative impulses in a personal, exciting way. Your role as a teacher is to liberate yourself from the "cookbook" approaches to creative drama and to focus your energy on your children's experiences, knowledge, feelings, and perceptions. Remember that creative drama springs from your children's inner resources; they provide all the essential materials.

Each of the following ideas should be introduced as a single experience. As you read through them, you may be tempted to take your children on a marathon drama experience. This is *not* the intent. Each idea represents a seed for a beginning activity. Integrate the ideas carefully into your overall lesson plans as single units of drama. If you simply run through the list and ask your children to participate in these activities one after the other, you will be robbing them of the opportunity to expand on these seed ideas. The marathon approach may also result in meaningless performances in which your children will soon grow tired and bored. Use the activities wisely and add your own ideas for making the suggestions relevant to the experiences and skills of your children.

Ideas for Pantomime

- ◆ Pantomime the growth of a seed into a tall, strong tree. Begin by snuggling deep in the soft earth. Feel the sun making you warm. Feel the gentle rain that helps you to grow. Slowly peek out of the ground and grow and stretch into a tall, strong tree. Stir up a little breeze, and let your tree twist and turn. How do your branches move? How do you move during a rainstorm? On a quiet sunny afternoon? Show how your leaves fall to the ground. Show what happens when a strong wind blows.
- ◆ Turn all your children into busy little spiders. Tell them that they have to fill the whole room with spider webs. Get all the corners; do not forget the chair legs and all the places between the centers. Show how you would shoot your spider web all the way up to the ceiling. When the children have completed their imaginary spider webs, ask them to find a place where they can sit quietly and wait for a fly to come along.

◆ Play an imaginary piano, a violin, a drum, a guitar. Show how you have to hold them differently and what you have to do to make music. Play some fast songs, some slow songs, some loud songs, and some soft songs.

◆ Bounce like a ball across the playground. Roll like a ball down the street. Catch an imaginary ball when someone throws it to you. Look at it and then throw it to someone else. Roll the ball to another person. Pick up the ball and show how big (small, heavy, light) it is. Bounce your ball to a friend. Take the ball and put it someplace where it cannot roll around.

◆ Move like a giant. Fly like a butterfly. Crawl like a snake. Tiptoe like a little mouse. Children love to pretend to be animals, even animals that they have never seen. Some favorites of young children are cats, horses, rabbits, monkeys, frogs, birds, and snakes. You can expand this type of dramatization by asking the children to select one animal and move in as many ways as they can think of. Let children choose a variety of animals that jump, crawl, gallop, or pounce, and let them demonstrate these similar movements.

◆ Go fishing. Throw your line in the water and wait for a fish to bite. Show how you feel when the fish bites your hook. Show how strong your fish is. Reel in your fish and cook it up for dinner.

◆ We are going on a journey. Everyone pack a suitcase and lunchbox and meet me over here at the station (train, bus, and airport). Everyone get a ticket and climb onto the train (bus, airplane). (A small chair for each child is a useful prop.) Show how you feel about going on a journey. You hear an announcement that the train cannot leave. Show how that makes you feel. Look behind you and see the engineer (driver, pilot) coming. She says, "We're all ready to go now!" Show how you feel now.

Ideas for Improvisation: Characters Speak!

In improvisation children make up their own dialogue, movements, actions, and expressions. There are no lines to memorize or "correct" responses; children react and interact from their personal perspectives and experiences. Each child's method of self-expression has value. Include all the children who want to participate, and be gentle with the children who are inhibited or reluctant to take part. These children need your support and encouragement as much as the active children. The timid child may be afraid of making a mistake or may feel inadequate in communicating thoughts and feelings. Offer these children the opportunity to participate in a small, nonthreatening way and give them the time they need to move into the process. *Never* force children to participate in creative drama until they are both willing and ready.

Improvisation can be slow to develop at first, understandably, because dialogue is dependent on the language skills of your children. No matter what the age of your children, you must *expect the unexpected* and encourage unexpected responses. It is the unexpected that gives originality to improvisation, and the unexpected leads to self-discovery, self-expression, and appreciation of others in terms of a child's own experiences. With that in mind, I invite you to implement some of the following ideas with the children in your own classroom:

1. Ask your children to talk in gibberish, making sounds that have no meaning. Suggest situations in which they can talk to each other in gibberish, such as asking for more juice, asking if they can go out to play, asking a friend if they can borrow a toy, scolding an imaginary puppy who is running around the classroom, or getting angry at a tricycle that goes too fast. Encourage dialogue and suggest that children add movement, expression, and action to their play.

2. Set up situations in which children can take on different roles and can interpret the suggestions through improvisation. For example, suggest the following:

- "You and your friends are playing on the playground. You hear a strange noise, and when you look up, you see a spaceship from outer space come down and land in our school yard. What would you say to each other, and what would you say to the space creatures? Can you use your bodies to show how you would feel when you decide to take a ride on the spaceship?"
- "You come home from school and find a leprechaun sitting on your porch. What do you say to the leprechaun? What do you give him to eat or drink? What do you say to your parent when asked why you brought a leprechaun home from school? How do you explain what you are going to do with the leprechaun?"
- "You are a group of children who live near a haunted house. One afternoon, you decide to sneak inside of the haunted house to see what you can find. How will you get inside? What do you find as you walk through all the rooms? All of a sudden, you hear a strange noise coming from the attic. What do you do? What do you say to each other once you are safely back outside?"
- "Pretend that you are riding on a magic carpet. You can stop anywhere you would like along the way. Let's stop at the zoo and pretend to be the animals. Now you are feeling hungry. Land your magic carpet at a grocery store and go shopping for something to eat for lunch. What do you buy and how does it taste? On your way home, you stop at a toy store to buy something to take home with you. Choose a toy and then pretend to be that toy. How does your toy move, and what does it say? When you get back home, tell everyone all about what you saw on your magic carpet ride."

3. Encourage your children to exchange dialogue and actions as they express

- how to catch or ride a whale,
- how to drive a car,
- how to talk to a dinosaur, or
- how to climb to the moon.

4. Put an object in the center of a circle and ask the children to tell a story about it. How did it get in the circle? What does it want and why is it in the classroom? What does the object make you think about?

Providing props and open-ended materials is the teacher's responsibility. The availability of a variety of materials allows children to make choices.

Prop Boxes

Another way to encourage creative drama in your classroom is through the use of prop boxes. Prop boxes can be placed throughout the centers for children to use during unstructured play time. These boxes contain materials that suggest specific topics for dramatic play, and they may be used by your children as they experiment with a variety of situations and roles.

Karen Paciorek (personal communication, 2002) offers some thoughtful suggestions for using prop boxes in an early childhood curriculum. Her ideas deserve your consideration and are presented in Figure 6–6.

When I introduce the idea of prop boxes to my own college students, the most frequently asked question is "Where do I get all these props?" Begin by deciding what props will be of interest to your children and which props relate to their own personal experiences. The next step involves making phone calls to local stores; surveying the other teachers in your school; and going straight to the source, such as a fast-food restaurant where you can collect paper containers, plastic forks and spoons, napkins, and straws, and, if you are lucky, an apron or two that have the fast-food logo imprinted on the front. When you send out your parent newsletter, let your parents know that you are collecting used items for a particular prop box and ask them to send in items with their children. One of my students surveyed the

FIGURE 6–6 Guidelines for Using Prop Boxes

- ◆ Provide props that are in good repair and easily reached.
- ◆ Introduce children to new roles and ideas that might suggest possible themes for dramatic play.
- ◆ Provide a full-length mirror.
- ◆ Allow sufficient time for play to develop.
- ◆ Guide children unobtrusively.
- ◆ Suggest a relevant supporting role for a child who is having difficulty entering a dramatic play situation.
- ◆ Listen to conversations to learn about interests, feelings, experiences, and concerns.
- ◆ Set up areas that provide equipment for dramatic play to take place out on the playground.
- ◆ Allow children to make props of their own for dramatic play.
- ◆ Rotate the props frequently.
- ◆ Add items as the theme continues to encourage children to return to the areas and extend their play.
- ◆ Add some surprises every so often: fresh flowers on the table in the family living area, a cooking project available during choice time that takes place in the kitchen area, a book on construction (bridges or buildings) in the block area. All of these will encourage play in those particular areas.

Source: Paciorek (personal communication, 2002). Used with permission.

women on her dorm floor and came up with a variety of items related to living in a dorm: a sign-in sheet, a whole box of old keys, pillows, and three discarded stuffed animals. When word got around the dorm that she was collecting things for children, the resident manager gave her an old guitar that had been in the common room's closet for more than a year!

Think of your search for prop box items as a search to add pleasure to children's school experiences. The themes represented in Figure 6–7 should be enough to get you started on your quest to make prop boxes for your children.

There are a few generic props that you will want to always have available to your children. They are considered to be the time-honored favorites of all children: capes and cloaks, crowns, pots and pans, hats of all sorts and sizes, dress-up clothes, and shoes that range from firefighter's boots to magic slippers. Simply use your *own* imagination coupled with what you know about the experiences of your children to put your prop boxes together—and let the drama begin (see Figure 6–8).

Field Trips

Take a field trip around the school yard or to an interesting place in your neighborhood. Ask the children to look at all the things they see and listen to all the sounds they hear. After the field trip, children will naturally improvise some of the things they saw and heard. They may construct replicas of the buildings, ask you for masking tape so they can create sidewalks, or use the cardboard brick blocks to build what they have seen.

FIGURE 6–7 Themes and Props to Enhance Creative Drama

Theme	Props	
Veterinarian	Pictures of animals	Pet brush
	Small stuffed animals	Thermometer
	Pet carriers	Rolls of cloth bandages
	Disposable gloves	Stethoscope
	Adhesive tape	Leashes/collars
	Empty vitamin bottles	Water/food dishes
	Cotton swabs	
Post Office	Hand stamps	Stickers
	Stamp pads	A big bag for carrying the mail
	Envelopes	Individual mailboxes
	Your school stationery	Pens and pencils for "writing"
Office	Typewriter	Paper
	Calculator	Keys
	Telephone	Briefcase
	Notepads	Microwave oven
Automobile Repair	Screwdrivers	Wrenches
	Hammer	Keys
	Safety glasses	An old garden hose
	A real, old tire	License plates
	Tire patches	Knobs and dials from a car panel
Ice Cream Shop	Hats	Paper cones
	Aprons	Empty jars of sprinkles
	Scoops	Play-dough cherries
	Plastic dishes	Empty ice cream containers
School	Small chalkboards	Teacher's desk
	Erasers and chalk	Stapler
	Report cards	Pencils and paper
	Handbell	Books from the upper grades
Barber Shop/ Hairdresser	Combs and brushes	Hand and table mirrors
	Empty spray bottles	Posters of hairstyles for both men and women
	Towels	Telephone
	Sheets cut into smocks	Bobby pins and hair clips
	Curlers and pins	Empty bottles of aftershave with the labels still on
	Empty shampoo bottles with the labels still on	

Stories and Poems

When children are familiar with a favorite story or poem, encourage them to expand the experience through improvisation. Stories that are good for dramatization should have a simple plot; a variety of cumulative actions; dialogue, especially between children and other children and between children and animals; and repetitive words, phrases, or sentences. The following stories make good beginning dramatizations:

FIGURE 6–8 Prop boxes are a treasure trove of ideas for children's creative drama. Keep them full!

"The Three Billy Goats Gruff"
"Goldilocks and the Three Bears"
"The Little Red Hen"
"The Elves and the Shoemaker"
"Stone Soup"
Ask Mr. Bear
"Little Red Riding Hood"
The Little Engine That Could

When selecting stories for improvisation, remember that there are often more roles than the obvious ones. The story of "The Three Little Pigs," for example, requires sticks, straw, bricks, and houses, as well as the pigs and the wolf.

Creative drama is an important process for developing self-awareness and self-expression. Through it you and your children can expand the imagination, develop skills in body movement, and practice verbal and nonverbal communication. You do not need formal training in drama or theatre to be successful in planning and implementing creative drama experiences for young children. The creative drama activities in this chapter focus on creating optimum conditions for exploration and free expression. One goal of these activities is to help you establish a foundation for building basic trust between you and your children so you and the children will feel that it is safe to try while being assured of nonjudgmental acceptance and respect.

Your participation in creative drama experiences will bring together some of the elements from guided imagery, music and movement, and the visual arts. Think of creative drama as a culminating experience through which you can assess

the value you now place on the whole notion of creative arts in early childhood education.

Creative drama allows young children to "walk a mile in another's shoes" (Pearson-Davis, 1993, p. 16) and helps them to gain an understanding and appreciation for people from other cultures and ethnic groups.

NATIONAL STANDARDS FOR THEATRE EDUCATION

Theatre and drama are primary ways that children learn about life—about actions and consequences, about customs and beliefs, and about others and themselves. The National Standards for Theatre Education (K–4) start with and have a strong emphasis on improvisation, which is the basis of social pretend play.

Theatre K–4

Content Standard 1: Script writing by planning and recording improvisations based on personal experience and heritage, imagination, literature, and history.
What this looks like in practice: Students collaborate to select interrelated characters, environments, and situations for classroom dramatization.

Content Standard 2: Acting by assuming roles and interacting in improvisations.
What this looks like in practice: Students imagine and clearly describe characters, their relationships, and their environments.

Content Standard 3: Designing by visualizing and arranging environments for classroom dramatizations.
What this looks like in practice: Students collaborate to establish playing spaces for classroom dramatizations and to select and safely organize available materials that suggest scenery, properties, lighting, sound, costumes, and makeup.

Content Standard 4: Directing by planning classroom dramatizations.
What this looks like in practice: Students collaboratively plan and prepare improvisations and demonstrate various ways of staging classroom dramatizations.

Content Standard 5: Researching by finding information to support classroom dramatizations.
What this looks like in practice: Students communicate information to peers about people, events, time, and place related to classroom dramatizations.

Content Standard 6: Comparing and connecting art forms by describing theatre, dramatic media (such as film, television, and electronic media), and other art forms.
What this looks like in practice: Students select movement, music, or visual elements to enhance the mood of classroom dramatization.

Content Standard 7: Analyzing and explaining personal preferences and constructing meanings from classroom dramatizations and from theatre, film, television, and electronic media productions.

What this looks like in practice: Students explain how the wants and needs of characters are similar to and different from their own.

Content Standard 8: Understanding context by recognizing the role of theatre, film, television, and electronic media in daily life.

What this looks like in practice: Students identify and compare similar characters and situations in stories and dramas from and about various cultures, illustrate with classroom dramatizations, and discuss how theatre reflects life.

Exploring Creative Drama Through a Multicultural Context

As old as language itself, folktales encircle the globe and have proven to be gifted travelers. They make themselves at home in culture after culture, all the while maintaining their own individuality and the essence of an idea. They have been preserved, altered, and adapted by storytellers and have outlived many generations through the simple mediums of the human voice and memory.

Folktales are easily understood, and stories about animals are especially appealing to children. They usually have fascinating patterns of repetition and incantation, and the issues are soon stated, with no unnecessary subtleties of emotion and no bewildering wavering between cause and effect. Everyone acts in character; good comes to glory, and evil is punished. Folktales have lasted because they speak of profound truths, teach us about life and right and wrong, and are vastly entertaining.

Introducing folktales through creative drama is a good way to learn about other groups of people and their cultures, languages, literature, traditions, and wisdom. Involving children in those ancient stories helps in their language development, spreads cultural literacy, provides cross-cultural awareness and understanding, and promotes a high level of dramatic quality (Gerke, 1996).

Turn back to chapter 1 of this book and reread the description of the children in the block room acting out the "The Three Billy Goats Gruff." This Norwegian folktale was published by Peter Christian Asbjornsen and Jorgen Moe in their collection of traditional tales under the title of *Norwegian Folk Tales* in 1845. The first translation of the tales into English was by Sir George Webhe Dasent in 1859. According to Lewis (1991),

> It was not surprising that Dasent was so captivated by Scandinavia. The plots of fairy tales everywhere have many likenesses; what changes them is the place where they are told—the country and the people. Wherever the landscape is wild, the winters long and bitter, and the villages small and isolated, magic and mystery thrive. Why should the folk there doubt that trolls live in the forest, as well as wolves and bears; or that animals, who share the same scene and hardships, can speak if they will, and even change into humans and back again? (Introduction)

Cumulative beast tales are almost perfectly constructed short stories. They waste no words; the action moves rapidly, and the satisfactory endings to the action are often tied off with a couplet that children love to repeat.

Children will be persistent in play episodes when given the time to explore the possibilities of materials.

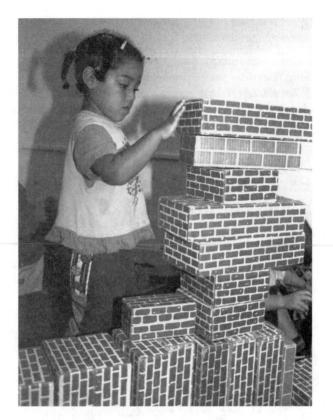

Dramatizing Folktales from Around the World

The Norwegian Folktale "The Three Billy Goats Gruff" and the British Tale of "The Three Little Pigs"

In "The Three Billy Goats Gruff" the goats want to get to the other side of the bridge in order to eat the grass in a pasture, but they quickly discover that a troll lives under the bridge. The tension increases as each goat approaches the bridge, confronts the troll, and convinces the troll to allow him to cross. This cannot go on indefinitely; the largest billy goat and the troll must settle their differences. The conflict reaches a climax when the largest billy goat knocks the troll off the bridge and crosses to the other side. The goats eat happily ever after (see Figure 6–9).

Conflicts between characters representing good and characters representing evil are typical of folktales. Other villains in folktales play adversarial roles similar to those of trolls and ogres. For example, in the British tale of "The Three Little Pigs," the little pigs must outwit a wolf. In addition to clearly defined good and bad characters, the repetitive language with its use of rhyme and onomatopoeia builds the story to a quick, dramatic climax. In "The Three Little Pigs" the wolf threatens, "I'll huff and I'll puff and I'll blow your house in," and the pig replies, "Not by the

FIGURE 6–9 Blocks make a wonderful prop for creating a bridge for "The Three Billy Goats Gruff" to tramp-tramp over to get to the grassy pasture.

hair of my chinny, chin, chin." Children accept the logical justice of the outcome, because the wolf meets an end similar to that of his victims (from *English Fairy Tales*, by Joseph Jacobs, 1892, Putnam's).

Folktales are recommended for use on all levels because different age groups will view them according to their own maturity and experience. As you prepare the environment for creative drama or build plays from stories, make sure that you are thoroughly familiar with the material to avoid pitfalls such as forgetting parts and having to refer to them out of sequence. Proceed in order, holding the climax until the end and including as many details as the children are able to handle and as are necessary to the story.

After the story has been told and all questions are answered, the children are ready to begin planning how they will act it out and make it their own. The children may play the story many times, and with each replaying children will develop greater freedom and self-confidence. Throughout the year you and your children will experience delightful results through the world of creative drama and play-making. Just remember that creative drama is not intended for public performance: It is just for the sheer pleasure of having fun! The rewards for your children will be found in communicating, expressing emotions, portraying characters through body movement, interacting with others, speaking in the character of another, and creating settings and characters to build a story line with a beginning, rising actions, and a climax.

ACTIVITY 6–1

Getting Ready to Dramatize Other Folktales

The following list includes some general guidelines for encouraging and motivating children to dramatize folktales:

- Suggest that everyone be an animal, then take a walk in the forest and find something to eat.
- Try several animals, including the way they walk, sounds they make, and feelings they have.
- Review important ideas of the plot.
- Have children choose partners to play different roles.
- Keep an atmosphere of fun; this is not rehearsal for a "play."
- Have children speak in different body positions.
- Illustrate various sounds and let children make them.
- Pass a basket and ask children to describe the sensory attributes of objects (hard, soft, round).
- Pretend to be another person.
- Playact real-life situations, such as picnics, getting dressed, or shopping.
- Show pictures of people involved in a variety of actions to evoke a discussion of how people and animals might feel in each situation—happy, sad, angry, and surprised.
- Experiment with games by saying your name in a different way; for example, make machine noises or mimic sounds in nature.

As you create an atmosphere for drama and playmaking, remember the most important person in the process: the child.

- Treat each child as someone who has something special to contribute.
- Encourage each child to express ideas and feelings about the story being dramatized.
- Ask each child to imagine and show what someone else might think, feel, and do.
- Help each child to maintain his or her particular ideas, and integrate the ideas with the play of the group.
- Develop and appreciate that individuality is basic to the affective, intellectual, social, and physical growth of children, because it underlies positive self-concept, creative thinking, and the ability to perceive and interact successfully with others.

Every folktale is rooted deep within a particular culture, and the world of culture is limitless (Wolkstein, 1992). The vast reservoir of folktales lies within the great oral traditions of our world's cultures. The following is a brief list of folktales from around the globe that you might use in creative drama activities:

Africa:	Hen and Frog
Denmark:	The Talking Pot

England:	Jack and the Beanstalk
Finland:	The Bear Says North
France:	Little Red Riding Hood
Germany:	The Bremen Town Musicians
India:	Numskull and the Rabbit
Ireland:	The Bee, the Harp, the Mouse and the Bum-Clock
Italy:	The Silver Nose
Japan:	The Tongue-Cut Sparrow
Jewish Folktales:	The Devil's Trick
Mexico:	Why the Burro Lives with the Man
Norway:	East O' the Sun West O' the Moon
Poland:	The Jolly Tailor Who Became King
Russia:	Mr. Samson Cast
Scotland:	Upright John
South America:	The Tale of the Lazy People
Spain:	The Flea
Vietnam:	In the Land of Small Dragons
The West Indies:	The Magic Change Tree

Now it is time to switch gears and return to the discussion of a recurring theme of this book—affective development.

The Continuum of Development in the Affective Domain: Organization

In order to guide ourselves in the process of either becoming a teacher or learning to be a more effective teacher, we must first know where we are and where we want to go. Because we are both the creator and the created, we also must think about our present level of development and must generate some specific data about our personal and professional selves. I would like to pause for just a few minutes and review the steps on the continuum of affective development that we have addressed to this point in our learning. Part of this discussion involves a measure of self-disclosure, but I think it is relevant to the overall process we engage in when taking a serious look at our development in the affective domain. The subject is affective ways of knowing and learning; the messenger is Kierkegaard.

Kierkegaard and Time

Some of you may think that a lesson from the philosopher Kierkegaard is a strange way to look at affective development. As I was thinking about some of the things he wrote, I remembered a point he made about *time,* and how my memory of his ideas about time has impacted my personal perspective of the continuum of affective development.

Kierkegaard's notions of time present an encouraging analogy to my own process of affective development. He suggested that there are those who believe that time is like a *circle*. If we do not do something when the time comes around, we will have another chance. He also suggested that there are those who believe that time is like a *river*. If we do not do something when the opportunity passes our way, the opportunity will pass us by, never to return. Now, what does this have to do with the *continuum* of affective development?

To this point in your reading, I have invited you to *receive* and attend to certain phenomena. In some cases, you were encouraged to attend to creative arts content, and in others the content was directly related to your personal and professional growth as a teacher. In the discussions that followed, I nudged you to *respond* by becoming an active participant in activities and to react by taking part in group experiences. Your involvement in the An Awareness of Self activity presented in chapter 5 provided an opportunity for you to develop some insight into behaviors that suggest that you *value* the arts enough to willingly become involved in the process. I know that some of us view these opportunities as a circle; that is, if we decided not to become involved in the internalization process of attending, responding, and valuing during the time the invitation was extended, we knew we would have the opportunity at a later time. On the other hand, some of us believe that we must seize opportunity when it knocks, because, like the river, the time may pass us by, and we would have missed the opportunity.

Now, what does all this have to do with Kierkegaard? Remember that the continuum of affective development is arranged as a process of internalization— that is, a gradual process that may occur at different levels and at different times for different people. If, for example, you know that you are attending to the creative arts but are finding difficulty responding to the suggested activities, you should think of the continuum as similar to Kierkegaard's circle. If you are not yet responding at the level you would really like to, you will have many more opportunities, as the invitation to respond will continue throughout this book. As far as Kierkegaard's river is concerned, as it relates to the creative arts and your own personal and professional growth, the river and circle of your participation in the creative arts will continue to flow long after you have read this book and completed this course.

On the continuum of affective development, the process of *organization* is concerned with bringing together different values, resolving conflicts, and beginning to build an internally consistent value system. One way to think about all the different parts of us that contribute to our being teachers is to understand and accept our own strengths, limitations, and weaknesses. The emphasis in this process will focus on accepting responsibility for utilizing our strengths and developing a plan to eliminate weaknesses or deficiencies. In the section that follows, Personal and Professional Growth, a series of activities will help you gather information from yourself (and others) about your strengths at this very moment. Then you will be able to describe your own level of organization with greater clarity and accuracy.

PERSONAL AND PROFESSIONAL GROWTH

It is almost impossible to dig for strengths and competencies without an increased awareness of where our weaknesses are. We are often too hard on ourselves and spend more energy focusing on our weaknesses than on the very real strengths that have brought us to this point in our journey. Some of us have a harder time than others acknowledging or talking about our strengths and accomplishments. The old notion of modesty creeps into our view of self and causes us to downplay those strengths we know we possess. Talking with friends is reassuring; the very act of self-disclosure and sharing can help us understand the congruence between personal and professional strengths. Sharing also shows that weaknesses are only deficiencies that can and will be corrected; courses not taken, lack of experience in working with children or other adults, or skills that are not fully developed can all be remedied. Just as the children we teach are continually developing, so should we as teachers continue to grow and develop both personally and professionally.

As you work through the activities, focus on your strengths, using creative expression to communicate them to others. These activities allow for a great deal of flexibility and originality in your own creative responses. As you participate in an environment that is supportive and personally secure, you will learn more of the ingredients for establishing this same kind of trusting atmosphere in your classroom, which will in turn enable you to encourage your children to continue their journey into the creative process.

Steps Toward Integration: The Personal "Me" and the Professional "Me"[1]

You will need the following materials before beginning this activity:

- Two large envelopes for each group, one labeled Strengths and one labeled Weaknesses
- Ten small slips of paper for each participant
- One piece of notebook paper for each participant

Procedure

1. Form small groups of three or four people and sit together in a circle on the floor.

2. Take a few minutes and think of five personal or professional strengths you already possess that will be useful in your teaching career. These strengths may consist of skills, areas of knowledge, traits, experiences, values, and so forth.

[1] Adapted with permission from McCarty, F. H. (1976). Teaching-learning goals: Steps toward achievement. In L. Thayer (Ed.), *Affective education: 50 Strategies for experiential learning*. Saline, MI: L. T. Resources.

For example, you might have a talent for preparing nutritious party hors d'oeuvres, a skill that you can certainly use for preparing balanced snacks for your kindergarten children. Or you may know a great deal about children's literature and be in a position to select appropriate stories for children of different ages. When you have thought of five strengths, list them on your piece of notebook paper. This will be your master list. Then transfer this list of strengths to five of your small slips of paper, writing one strength on each slip. Do not put your name on the small slips of paper, just your strengths.

3. When each person has completed a master list and has transferred this list to the small slips of paper, each one of you should put the five small slips of paper (your strengths) into the large envelope labeled Strengths. Keep the master list for yourself.

4. Next, take a few minutes and identify five professional weaknesses or deficiencies that are possible to correct, such as courses not yet taken, books not read, activities that have not been experienced, or desirable skills not yet mastered. For example, you may feel that you do not know enough about social studies, but you have not yet taken the course. Or, you may feel that you are not ready for student teaching and realize that you have had only one practicum assignment and have two more practicum placements to complete before student teaching. Write these weaknesses on your master list and then write them on the small slips of paper.

5. Following the same procedure you did with your strengths, put any of the small slips of paper you wish to into the large envelope labeled Weaknesses. You do not have to disclose your weaknesses list if it makes you uncomfortable.

6. Choose one person in your group to be the reporter. Your group reporter then opens the large envelope and reads the small slips of paper to the rest of you, starting with the Weaknesses envelope. Focusing on one weakness at a time or a group of weaknesses that seem to fit together, each of you can make suggestions or present alternatives that could eliminate these weaknesses. Pay attention to the deficiencies to be worked on, and do not spend your time trying to figure out who wrote them!

7. The reporter then reads the slips of paper from the Strengths envelope. As each strength is read, the person to whom the strength belongs acknowledges ownership of the strength by using an *I* statement. For example, when one of your strengths, such as patience, is read aloud, you respond by saying: "I am patient with children."

8. When all the strengths have been read, each group should spend a few minutes processing the activity and sharing your feelings about disclosing your strengths to the group.

9. Keep your master lists. The list of weaknesses can be useful when selecting courses or deciding on practicum experiences. The strengths list can be an excellent reference when you feel discouraged or professionally insecure.

Your Gunnysack

Teachers are continually bombarded with stimuli, all of which have an impact on our abilities to be creative. Often the influences of these "then and there" personal

experiences hinder our ability to be totally present in the "here and now" of the creative arts experience. Spontaneous responding to the creative arts means being free, or at least temporarily released, from the pressures and anxieties that we all encounter in day-to-day living in the outside world.

One of the first things you explored in this book was guided imagery. Remember the feelings you had when imagining that you were a tiny green seedling reaching toward the sun as you pushed your slender blades of green through the warm, moist earth? That imaginary journey was grounded in your imagination. The next activity is designed to be grounded in reality. It was written to help increase your awareness of what is going on inside of you in the here and now of the creative arts classroom. This includes an awareness of inner tensions, physical sensations and experiences, and events and people that you have dealt with throughout the day. The following guided imagery experience should help you observe, and then eliminate, some of the events that may produce stumbling blocks that stand between you and free, creative expression.

Sit in a comfortable position or lie down on the floor and let your body become comfortable. Focus your awareness on your place of centering, and let your mind's eye wander through your body until it finds just the right centering place. Allow yourself to begin to relax . . . relax with awareness. Take a couple of deep breaths . . . letting all the tension flow out of your body and into the surface that supports you. Your body becomes quiet. . . . Your mind is at attention and stretched forward in anticipation. Take a few more minutes to make sure you are centered . . . relaxed . . . and comfortable.

Much of the time we are not aware of how our everyday encounters with others and experiences in our environment affect our behavior. Take a few minutes to re-create an image of where you were when you first woke up this morning. Who was there? . . . What was happening? . . . What feelings did you have? . . . What were your thoughts about today? As these images begin to shift in your mind's eye, allow your mind's eye to follow the events of your day that led you to this place and time. Where did you go? . . . Who did you see? . . . What did you do? Take a few more minutes to reconstruct your day until you arrive in this here and now moment. I will pause for a few minutes to give you time to follow your day.

Now direct your attention to the events of the day that troubled or bothered you. These events might have involved another person . . . many people . . . or some event that was out of your control. You may have had a disagreement with someone . . . maybe you missed lunch . . . or had car trouble . . . a bad class . . . or any number of other experiences that left you feeling unsure . . . upset . . . unsafe . . . tired . . . or out of control. Use your mind's eye to hold onto the day's unpleasantness while we look for a place to put them.

Imagine a very large sack lying on the floor near you. . . . This is a gunnysack, and it has a very important purpose. It is especially designed to hold all of the experiences . . . events . . . or people that have disrupted your day today. This gunnysack is a safe place to keep those things, and once they are safely tucked away, only you can decide if and when you want to get them out again. Take all of the troubling elements of your day . . . and one by one . . . pick them up and tuck them away in your gunnysack. They will be very safe. You can get them out again anytime you wish . . . but for right now . . . put them away and free yourself from their influence. Be gentle . . . and handle them with care. . . . Use your mind's eye to watch yourself as you fill up your gunnysack. Listen to what is going on inside your mind. . . . This will help you get in touch with their influence.

When your sack is full, use your mind's eye to pick it up. It may be heavy or light, but even if it is heavy you can carry it. I have asked a very wise and trustworthy companion to watch over your gunnysack while we spend some time exploring our creativity. Use your imagination as you carry your gunnysack out through the door of this classroom and leave it outside this room in the watchful care of my companion. When you feel sure that your gunnysack and all the things it contains are safe . . . use your imagination to walk back into this room . . . free of the troubles and unpleasant events of the day. As long as you know where your sack is, you will have more control over what to do with it.

Begin to move your fingers and toes a little. Open your eyes slowly and let the sight of this room come into your field of vision. When your eyes are fully open, stretch your limbs, shake off any remaining tension, and return to the here and now of this room.

Of all areas of study, creative drama offers one of the richest opportunities for creative growth; and of all the arts, creative drama encompasses perhaps the greatest variety of experiences because it deals with thought, feeling, imagination, movement, vocalization and words, and the opportunity for self-understanding and our understanding of others.

The ideas in this chapter are a guide, allowing for adaptation and expansion of the suggestions as individual circumstances require, and hopefully inspiring you to build details into the ideas for your own group of children.

Play is the exultation of the possible.

Martin Buber

chapter 7

Experimenting with Three-Dimensional Art

Sculpture is like a journey. You have a different view as you return. The three-dimensional world is full of surprises in a way that a two-dimensional world can never be.

Henry Moore, British sculptor, 1982

O nce upon a time there was a little lump of clay that lived at the bottom of an old wooden clay bin. This little lump of clay was very soft and malleable and longed to be touched, kneaded, stretched, and squeezed. The little lump of clay knew that he had many shapes inside just waiting to take form. But he also knew that before he could become a shape, someone would have to take him into her hands and mold a shape that would transform him into something more than the squashed lump he had become. He was tired of living in the old clay bin, and he dreamed of becoming a beautiful pot, a cup for tea, an animal, or even a mythical creature with a fantastic shape.

Imagine that you are holding this little round lump of clay in your hands. Close your eyes and imagine the weight of the clay. Use your imagination and allow your fingers to explore the physical and tactile qualities of the clay—the hardness and softness, heaviness and lightness, and smoothness and roughness. Now, look into your mind's eye and watch your fingers slowly dig into the clay as you begin to move the clay into a new shape. Fold the clay over and start kneading and stretching it as you pull out shapes that have not existed before. Allow a shape to emerge from within the clay as it changes forms almost intuitively. Continue working the shape in your mind's eye until you imagine a subtle transition of one shape as it changes into another. When the clay has become a shape that is pleasing to both you and the clay, use your mind's eye to see what you and the clay have created.

Clay is unique because its sensitive plasticity is exquisitely impressionable as it responds to the human touch. Many adults and children enjoy working with clay because it provides the direct experience of thinking with our hands. We can change it into forms in space as we use it to make connections between ideas and sensations. Like the ancient shipboard carver of nautical folklore who said he did not know what he was making because it was still in the ivory tusk, the shapes contained within a lump of clay emerge from our own tactile inspiration through the *process* of kneading, stretching, squeezing, and rolling the clay. This comes about through the direct sensory contact of "knowing" with our hands.

Clay and other forms of three-dimensional art provide experiences for children to explore form, depth, space, and texture. Unlike two-dimensional art, which requires children to transform their awareness and experiences of three-dimensional objects in space onto a flat surface, three-dimensional art allows children to represent their knowledge of the world by communicating shape through its surface and edges, while its mass tells of the physical properties such as weight and density. What happens when young beginners work with clay and other three-dimensional art forms? Let's take a look at some of the things children experience as they become involved in the process of exploring three-dimensional art.

Young Children and Three-Dimensional Art

The young child's creative exploration of and experimentation in the three-dimensional arts is also often invisible to the eye. Children express themselves in their own unique ways, and the material reflection of this creative process may be visible only through the heart of the child, the creator. This is especially true when children begin to sculpt, build, or randomly glue pieces of art materials together to form shapes that are pleasing and satisfying.

Three-dimensional art provides children with a multitude of possibilities for making complex shapes from a main body of materials. Unlike painting, which is only seen, three-dimensional art can be touched, felt, and viewed from a variety of perspectives. At a very early age, children begin to experiment with three-dimensional form. They stack blocks and transform them into cars and trains, and they dig holes in sand and discover the magic of inverting a container of moist sand to create a sand castle. Children build elaborate structures with Legos® and Tinkertoys®, and they push and pull clay into free forms in space. All of these play activities provide opportunities for children to organize sculptural form to convey their own ideas about what they know and how they see what they know. The following sections take a closer look at some of the particulars of three-dimensional art that are appropriate for the young children in your classroom. For those who have never worked with three-dimensional art, it may

Young children enjoy pushing and spreading a lump of clay into flat "pancakes" or even "cookies."

present more of a challenge than creating with paper and paint, but take some time to try out some of the activities for yourself. And remember that when you are involved in these processes, you are not making a craft project; you are *creating* a design that has never been created before! Think of what Sir Henry Moore said about the surprises three-dimensional art holds, and get ready for discovering ways of entering the creative arts process that you may not have encountered before. Your children's experiences, as well as your own, will surely be filled with surprises as you watch a lovely work of art emerge through the three-dimensional art process.

Molding and Sculpting with Clay

As you and your children will discover, clay seems to provide the ultimate relationship between sight and touch. It can be flattened, poked, and rolled into abstract representations, or it can be molded into shapes and forms that are recognizable and useful.

Children Ages Two to Four

Clay is an excellent material for children between the ages of two and four. When they handle this three-dimensional material, children use their fingers and muscles to beat and pound the clay without any visible purpose. They get a great deal of satisfaction from patting it, poking it with other objects, or smearing it across a tabletop. Children this age may also give names to a lump of clay, such as calling it a motorcycle, with accompanying "zoom, zoom, zoom" noises, and saying, "This is a motorcycle." Because these children often lack the dexterity required to form clay into objects, the clay should be of the proper consistency so that children can easily roll or pinch it as they explore and manipulate it. The lump of clay should be large enough to be held with both hands so that children can subtract bits and pieces of clay to change its shape or form.

This process provides immediate sensory (tactile and visual) pleasure to the child. It is through this exploratory activity that the very young child discovers the properties and potential that clay holds. Because it is an exploratory process, you should not let the clay harden or even consider firing their creations.

Children Ages Four to Seven

Between the ages of four and seven, children become more particular in their modeling and creating and may, in fact, seek to make representations of objects and themselves. The process of molding and creating may begin with an image the child has in mind, or an object may emerge as the child explores the clay and gives it shapes and new meanings. The images or ideas often go through many transformations before the child is finally satisfied or gets tired of stretching and squeezing the clay.

Some children will start with a lump of clay and will pull out smaller pieces from the whole lump before beginning their attempts at representation. Others will start with many small pieces of clay and will put these together to construct their ideas

in a tangible form. As you observe your children, you will see both methods being used, and either is appropriate as long as it is a natural process for a child. These objects also become part of children's play as they decorate their forms with toothpicks, pipe cleaners, or craft sticks.

Children Ages Seven to Nine

The plasticity of clay makes it advantageous to use with children aged seven to nine. Lowenfeld and Brittain (1987) remind us that

> The very nature of the material will necessitate the flexible use of concepts. Whereas a drawing demands a simultaneous concept of one event, the process of modeling with clay permits a constant and continual changing of form. Figures can be added or taken away or changed in their position and shape. Therefore, action can be included in any motivation and should be related directly to the child's experience. (p. 185)

You will notice a continuation of the two different approaches children use to work with clay. Using the *synthetic* method of modeling, children put single pieces (symbols) of clay together into a whole. Using the *analytic* method of modeling, children pull single parts out from the whole form. Both of these methods represent a child's way of thinking and perceiving, and it would be inappropriate to ask children to deviate from the method that is most comfortable and natural for them (Lowenfeld & Brittain, 1987).

Boxes, Wood, and Sand

Clay is certainly not the only material that can be manipulated to form three-dimensional art. Young children can learn to use glue, tape, and boxes to construct three-dimensional designs, stabiles, and mobiles. Several small cardboard boxes can be transformed into three-dimensional forms that have personal meaning to children, such as cars, trains, planes, or even people and animals. When provided with large boxes, such as those used for shipping appliances, young children can design and create a variety of imaginative structures that can be painted and decorated. Once your children have mastered the techniques of using paste, glue, and tape, they will need only your encouragement and gentle guidance to enter the process.

Small pieces of wood, which can be purchased commercially or collected from a local lumberyard, appeal to children because they offer a variety of possibilities for combining three-dimensional shapes. When I introduced the woodworking center to my kindergartners, they constructed, glued, and painted the small pieces of wood into elaborate and quite sophisticated three-dimensional objects. These small pieces of wood offered unending possibilities in design and construction for my five-year-olds and provided them with a new way to explore form, depth, spatial relations, height, width, and texture (see Figure 7–1).

Sand castings are another form of three-dimensional art that older children enjoy. In sand casting, the artist uses clean sand and a disposable casting mold made from a small box. Small quantities of plaster of paris are mixed and then gently poured into the mold. The purpose is to reproduce a design in a permanent material. Children love to play in sand and usually welcome the chance to

FIGURE 7–1 Small pieces of discarded wood make ideal materials for children to construct their own three-dimensional sculpture.

make lines or drawings in moist sand or to arrange objects such as pebbles, shells, or sticks in special designs. Children delight in the process because the relief sculpture is the reverse of the mold. When sand casting with very young children, you must mix and pour the plaster of paris into the children's containers. But older children can complete the process with little assistance from you. They can arrange their designs and objects in the sand and can mix and pour the plaster themselves.

In most three-dimensional art activities, the focus is on the sensory elements of touching, seeing, and feeling because the artists *feel* the movement of the material as they use their hands to mold it into objects that have meaning. When children experiment with three-dimensional art, they use their fingers to discover textural qualities. They use their imaginations and knowledge of the world to create patterns and designs. With each experience they develop an increasing ability to "see" objects emerge and unfold in the artistic process.

The creative arts activities in this chapter are designed to help you and your children *see and feel* the process of creating. I hope that as you explore and experiment with three-dimensional art in a process that is not product-oriented, you will begin to develop a deeper sensitivity to the sensory explorations of children and the value these experiences hold for them.

Conditions That Encourage Creative Expression

Your attitude, room arrangement, availability of materials, and classroom atmosphere can all have an effect on how readily your children respond to three-dimensional art experiences. Of utmost importance is your attitude toward your children's efforts and the development of good rapport. In three-dimensional art, as well as in other cre-

It is the teacher's responsibility to arrange the classroom in ways that facilitate and encourage three-dimensional art exploration.

ative arts forms, your children must know that their individual expressions are unique, even in the simplest forms, and that you do not expect perfect representations. One way to ensure such an attitude is to make open-ended suggestions and to allow your children to think, work, and experiment with different ways of manipulating materials as a means of self-expression. When children create, they are often entering an unknown realm of self-expression. They will be more willing to try and to accept their own attempts if they feel secure in their relationship with you.

It is important that you set the stage for children to be successful as they experiment with concrete materials to express their thoughts, feelings, and ideas. Remember that children's expressions are based solely on their experiences and their personal knowledge of the world. It is vitally important that we remember that they have not yet had the time to accumulate the knowledge and information that we adults have. They will represent their world according to adult standards *when they become adults.*

Every child is an artist. The problem is how to remain an artist once he grows up.

Pablo Picasso

As adults and caregivers, we do have a role in helping children further their development of three-dimensional art. Helping parents understand the complexities of three-dimensional art is part of our responsibility as teachers. Caregivers must understand that children are not "just playing" with sand, clay, and other 3-D art materials, but that these activities contribute significantly to the overall development of children and especially the development of spatial intelligence.

A Family's Role in Developing Three-Dimensional Art at Home

◆ Provide children with many types of clay. These can include play dough, homemade clay, salt clay, and modeling clay.

◆ Clay can be shaped, molded, and cut. Some tools for working with clay that are readily available around the home include cookie cutters, rolling pins, ice cream scoops, bottle caps, potato mashers, old scissors, toothpicks, and screws or bolts.

◆ Wood scraps can be used to make 3-D objects. Young children can glue, nail, or clamp wood scraps together to make unique structures.

◆ Large boxes are great for making structures in which children can play. For example, go to your local appliance store and ask to have a refrigerator box saved for you. Bring the box home, cut out a door and window, and help children decorate this "house" with paints and fabrics.

◆ Aluminum foil can also be used to make sculptures. Children can crinkle it to make three-dimensional shapes and designs.

◆ Look around the home and collect things that can be used to create a "theme" collage. As you walk around the yard, pick up sticks, leaves, pebbles, straw, bark, and sand to glue onto a piece of cardboard to make a collage.

◆ Your children can also make prints by using kitchen utensils. They can dip the utensils, such as a potato masher, into water-soluble paint and then make their own designs on a piece of paper.

Gardner's Theory of Multiple Intelligences: Naturalist Intelligence

A decade after Howard Gardner formulated the theory of multiple intelligences he revisited his theory and found another ability that deserved to be called an intelligence: naturalist intelligence.

The naturalist intelligence refers to the ability to recognize and classify plants, minerals, and animals, including rocks and grass and all varieties of flora and fauna. The ability to recognize cultural artifacts such as cars or sneakers may also depend on naturalist intelligence. Gardner explains that naturalist intelligence is an ability we need to survive as human beings. We need, for example, to know which animals to hunt and which to avoid. Other animals need to have a naturalist intelligence to survive. Finally, he says that the big selling point is that brain evidence supports the existence of the naturalist intelligence. There are certain parts of the brain particularly dedicated to the recognition and the naming of what are called "natural"

things (Checkley, 1997; Kimmelman, 1999). Darwin is probably the most famous example of a naturalist because he saw deeply into the nature of living things.

Children possessing this type of intelligence may have a strong affinity to the outside world or to animals. They may enjoy topics, games, shows, and stories that deal with animals or natural phenomena. Or when they enter elementary school they may show an unusual interest in subject areas such as biology, zoology, botany, geology, meteorology, paleontology, or astronomy. As young children they enjoy collecting, classifying, or reading about items from nature, such as rocks, fossils, butterflies, feathers, and shells.

Supporting Naturalist Intelligence

The following suggestions can help you to support naturalist intelligence in the children in your classroom:

- ◆ Encourage children to see patterns in nature.
- ◆ Explore the sensory elements in nature such as sounds, smells, taste, and feel.
- ◆ Take nature walks or provide gardening activities to observe nature and natural phenomena.
- ◆ Bring animals into your classroom and teach your children how to care for them.
- ◆ Create, help children create, or have collections of natural objects in your classroom.
- ◆ Provide your children with videos and books about nature, science, and animals.
- ◆ Introduce your children to endangered species and tell them why certain species are threatened or endangered.

Many of the materials introduced in this chapter support the development of naturalist intelligence. Earth clay is a natural material and changes easily as children mold it into shapes. Burlap comes from cotton, another natural material that still shows the fine cotton strands as it is woven and unwoven. The sand for sand casting comes from the earth as do the small wooden pieces used in wood sculpture. The earth and all the natural things and animals on it offer you and your children an endless array of opportunities to develop skills in the area of naturalist intelligence. You and your children will find many of these things right in your own school yard.

DEVELOPMENTALLY APPROPRIATE PRACTICE

One way to allow children to be successful is to give careful attention to room arrangement and placement of materials. Figure 7–2 provides information for assuring the activities you plan for three-dimensional art are developmentally appropriate.

Young children need to manipulate, explore, and experiment with many different types of three-dimensional art materials to discover their properties. All of

FIGURE 7–2 Developmentally Appropriate Practice with Three-Dimensional Art

◆ Place clay tables and materials near a sink and provide containers of water for each child.

◆ Place smocks, hand towels, and materials for embellishment or decoration within easy reach of the children.

◆ Before initiating a large box sculpture, arrange the room so that the children have the needed space to experiment and enlarge their designs.

◆ During a sand casting activity, the focus must be on playing in the sand and making designs rather than on the outcome of the final product.

◆ Make sure all the small pieces of wood offered to children for construction have smooth edges and are free from splinters and wood fragments that could puncture children's fingers.

◆ Give your children the freedom to create, the materials and tools they need, and time to become involved in the creative process.

these processes take time. To hurry children through an activity in search of a product denies them the practice and exploration needed to fully understand the potential of an art material. Children will learn these properties slowly and at their own pace, just as they learn to walk or button their coats. Skills such as making a pinch pot have no value until children need them. More often than not, teaching skills will confuse and frustrate children rather than encourage individuality and originality. In creative expression, the outcomes are always unpredictable!

The combination of art and special needs children creates an exceptionally rich and positive learning environment (Herberholz & Hanson, 1995). "The fact that art experiences discourage copying actually promotes improved self-image. In art, originality rather than copying correctly is rewarded. Therefore, concern about the correctness of the final product need not frustrate or hamper the potential creative urges of children with disabilities" (p. 146).

The Special Children in Your Classroom

When we think of three-dimensional art, we tend to think of sculpture, wood carvings, weavings, or puppets and masks that are made to represent something familiar—something we can recognize and something with a pleasing appearance. Therein lies the challenge for us, as teachers: to provide children with three-dimensional art materials that give them the freedom and flexibility to create artworks of their own choosing. This is especially true when planning activities for your special needs children. One of the great strengths of the art experience for special needs children is that children with disabilities are able to set their own pace in the process and have control over their own environment. This, in turn, leads to the development of self-confidence and self-discovery.

As you begin to plan three-dimensional art activities for the special children in your class, it is important to include elements of both repetition and variety. Your special needs children may need opportunities to repeat and practice squeezing clay or applying glue. Repetition can be very satisfying, and it allows children to overcome some of the obstacles they may encounter when first introduced to clay (see

FIGURE 7–3 Your children with special needs will enjoy repeated opportunities to experiment with a variety of materials.

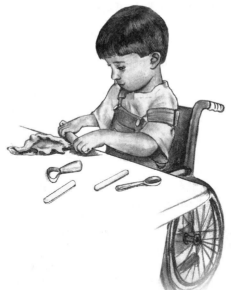

Figure 7–3). By providing a variety of activities, your children can use existing skills to transfer what they know from one art experience to another. They can also participate in two or three different art activities that require similar skills.

You may need to adapt the three-dimensional art activities included in this chapter to meet the developmental needs of your particular children. In previous chapters I suggested specific procedures for your special needs children so that you and your children could have ideas readily available to explore. There are no such suggestions in this chapter. Rather, I have included some guidelines for adapting all creative art ideas to the children in your care. To use Bruner's term, I see this process as a way of *scaffolding,* or gradually providing you with the information you will need to adapt materials, equipment, and procedures for most activities, regardless of the strengths or limitations of your special needs children. However, one of your roles as a facilitator of the creative process is to never underestimate the creative abilities of all of your students, especially those of your special needs children. It is during these moments of free self-expression, experimentation, and exploration that children with special needs can make unique and personal statements about their own creative potential. Figure 7–4 summarizes the teacher's role in working with special needs children.

All three-dimensional art activities involve learning based on action and learning through doing. Because it is impossible to predict how the special needs children in your class will respond to the materials you offer, you must find a balance between activities that present obstacles to your children and those that can be adapted to their needs while reducing frustration and increasing the children's potential for success. With success comes confidence, and with confidence, your special needs children will gain the sense of accomplishment necessary to make the most of the creative process.

FIGURE 7–4 Special Needs Children and the Role of a Teacher

◆ *Simplify.* Make sure the skills required to manipulate art materials meet the developmental levels of your children. For example, if you plan to use plasticine, and you know that your children lack the physical strength to handle this rather stiff material, use a softer and more pliable material such as earth clay or play dough.

◆ *Repeat directions.* Each child develops an understanding of the art process at a different rate and through different directions. Don't expect two children to follow the same set of directions in the same way to any art process. For example, verbal directions may be appropriate for some of your children, but you will need to provide verbal *and* visual directions for the child with a hearing impairment. Your role is to watch, listen, and be patient and gentle with children who need guidance, even if it means repeating yourself many times using a variety of methods.

◆ *Demonstrate.* In most situations, we want to limit how much we demonstrate the final outcome of an art activity. However, with special needs children, it may be necessary, at times, to allow your children to be familiar with a final product, and the steps involved that link the process between raw material and artistic creations. For example, a child who is visually impaired may need to touch and feel a clay sculpture before making her own connection between images and sculpted objects.

◆ *Divide the art activity into manageable stages.* Each stage in the artistic process has its own value and must be experienced before moving on to the next stage. When we allow children the time they need to move from one stage to another, we are showing them that the process is both natural and gradual. For example, children may need to squeeze, squash, pinch, and prod clay before moving from this purely tactile experience into the stage of rolling the clay into a ball or other object. This is a tremendously important stage of the artistic process, one that contributes greatly to a child's learning about the properties of clay as an art material. Although the end result of this exploration stage may not be readily apparent, it lays the foundation and provides technical hints that will be useful when children add their own special magic to shapes that evolve from the clay.

Source: Based on Herberholz & Hanson, 1995.

Processes and Materials for Three-Dimensional Art

The following ideas are appropriate for children who are familiar with how art materials work and for children who have had many opportunities to manipulate and explore a variety of media. Until the time and moment are just right, and you are sure that your children can benefit from additional information, these methods must remain your closely guarded secret. Do not use these activities as a means of introducing children to previously unencountered art materials. If you listen to your children, observe them, and remain sensitive to their needs, you will know when they are ready for the more complex skills needed for three-dimensional art production. And, please, when you and your children are in the process of exploring representational symbols, restrain yourself from falling into the bad habit of asking a child the sometimes impossible question to answer: "What is this?" Instead, take the process approach. A simple "Look how you have squeezed and rolled your clay!" is usually all you need to say to encourage children to begin talking about what they are creating.

Children's Literature and Three-Dimensional Art

The Pottery Place by Gail Gibbons, Harcourt Brace Jovanovich, New York, 1987.

> Visit behind the scenes and learn about all the special tools and skills needed for pottery making.

Lucy's Picture by Nicola Moon, illustrated by Alex Ayliffe, Puffin Pied Piper Books, New York, 1994.

> Lucy's grandfather is coming to visit and she wants to surprise him with a picture. Lucy makes something very different, something her grandfather can appreciate, even though he is blind. All it takes is a little imagination.

The Little Lump of Clay by Diana Engle, Morrow Junior Books, New York, 1989.

> This story is about a lump of clay that is forgotten. He ends up in the potter's bin and longs for someone to pick his or her way to the bottom and shape him into something beautiful.

The information about equipment, terminology, and health and safety in this section will help you develop your own skills so you can meet the needs of your children when the moment arises. Proceed carefully when demonstrating skills to ensure against the "do it like me" approach. The teacher-centered method sends a clear message to children that their ideas and creative attempts are not acceptable or valued. College students, beginning teachers, and parents often ask children what it is they have just made. This product-centered approach perpetuates the idea that only a recognizable finished product is good enough to go home or be displayed in an "art exhibit" in the hall.

Earth Clay

Earth clay is a natural material. Depending upon where you live, it may be possible to take a bucket and shovel and dig some up from the ground! It must be kept in airtight buckets with lids. Moisten the clay regularly or cover it with a damp cloth to keep it soft and pliable. When your clay starts to dry out, use a blunt tool (pencil eraser or small wooden block) to make indentations, and then fill them with water. Seal the container tightly and allow the clay to sit overnight or longer if needed. If the clay becomes dry and hard, put it into a thick plastic bag and pound the clay into a powder. Then mix it with water. Clay can be purchased in a variety of colors,

FIGURE 7–5 ECDC Cooked Clay

1 cup flour

½ cup salt

2 tablespoons cooking oil

1 teaspoon cream of tarter

1 cup water

Optional: food coloring or flavor extract such as peppermint or almond

Combine all ingredients in a cooking pot. Cook over medium heat, stirring constantly, until the mixture thickens and loosens from the sides of the pot. Turn out onto a flat surface and let cool. When it is cool enough to touch, knead the clay until it is smooth. Store in plastic bags or airtight containers. This recipe may be doubled or tripled.

Source: Humphreys, personal communication, 1995. Used with permission.

but a good supply of red earthenware or white clay is all you need for children to enjoy the sensory experience.

Two types of clay commonly used in early childhood settings are earth or potter's clay and oil-based clay. Earth clay is water-based and will harden; it can be painted and fired in a kiln. It can be purchased at your local ceramic product supply store. Oil-based clay, which remains pliable and can be used over and over again, is available from a school supply catalog in a variety of colors and block sizes.

An alternative clay that is very suitable for young children is salt-based, homemade clay that you can mix up in your classroom. Teachers at the Early Childhood Development Center use an easy recipe for making cooked clay that will last for several months, even when used daily. Figure 7–5 provides the recipe and directions for mixing, cooking, and cooling.

After your children have had many opportunities to manipulate different types of clay, they may enjoy a more challenging process with a specific purpose in mind. As your children move from the experimental level to more sophisticated levels of representation, the basic information in the section Techniques for Working with Earth Clay will help you know what to do when a child comes up to you with two pieces of clay and asks, "How can I make these stick together?" Until your children ask you or you observe that they are ready for more information, you should carefully avoid demonstrations or the "Wait and I will show you how" approach. We must constantly remind ourselves that the child's experiences in molding and sculpting are primarily a touching and exploratory process. Any products that emerge should be the result of the process and should not be predetermined by an art lesson contrived by the teacher.

Whatever the age of your children, the process of exploring clay should never be hurried. Requiring children to produce a final product—be it a dinosaur, a dragon, or a motorcycle—can inhibit the creative efforts of your children. Provide helpful guidance and give your children the freedom to represent their own experiences with this exciting, artistic medium.

Make arrangements to visit and observe a classroom for young children and another classroom for older children. Take notes on ways young children and older children approach and manipulate clay. Analyze your findings and make comparisons between the two age groups.

Health and Safety

Remind your children not to put clay materials in their mouths. Clay dust can create some problems, so I recommend that you and your children sponge everything clean after using clay, and wear an apron to keep dust from your clothes. Wipe up all the dust when you have finished working with the clay, and if anyone drops clay on the floor, pick it up before anyone slips on it.

Equipment

Clay, sponges, smocks, flat surfaces or linoleum floor squares (standard 12-inch squares), sheets of heavy plastic on which children can place their clay, bowls for water, and airtight containers for storing clay will provide the basics for getting your children started in their clay experiences. You should also use steady tables that provide a big enough work surface and that give children enough room to spread out their clay.

Children enjoy using a variety of tools when working with clay. These materials should be *available* to children who become interested in creating and designing specific objects or projects rather than just exploring and manipulating the clay itself. Never force children to use tools; the key word here is *available*. Too many instructions or tools for refining the product can restrict the creative nature of the clay experience.

A beginning collection of available tools, such as those shown in Figure 7–6, might include rollers (round, wooden cylinders from the block center), rolling pins, craft sticks for cutting, cookie cutters, spoons, toothpicks, brushes, and scissors (scissors that are old or too blunt to cut paper anymore). Tempera paint can be used to decorate hardened projects that children want to keep.

Techniques for Working with Earth Clay

Wedging

Wedging is the process of stretching and kneading clay to remove air bubbles. If you are fortunate enough to have access to a kiln, clay should be thoroughly

FIGURE 7–6 Provide children with a variety of tools for working with clay.

wedged if the final product is to be fired. Air bubbles left in clay that has not been properly wedged will cause the product to explode when exposed to the intense heat in a kiln.

Scoring

Children score clay when they join pieces of clay together by making grooves in the clay before pressing them together. Use scissors to roughen the surfaces and then press the pieces firmly together. Children can use wet fingers to smooth over the joint and make it practically invisible.

Slip

Slip is clay mixed with water until it resembles the consistency of cream. Use the slip as glue to adhere pieces or surfaces of clay together. It can be placed on scored surfaces to ensure better bonding of pieces.

Pinch-Pot Method

This is the process of turning a lump of clay into a bowl-like object. Place your thumbs in the center of a ball of clay and turn the clay around and around while pushing downward with the thumbs to form a well. Using the fingers, gently pull up the clay to form the wall of the bowl. To make a flat bottom, simply press the clay firmly onto a flat surface.

Coil-Pot Method

Use the pinch-pot method to make a base for the pot. Roll out a strip of clay (commonly known to children as a "snake"), press it on top of the pinch-pot base, and coil it around. Add more coils, pressing each one onto the last coil until the wall of the pot reaches the desired height. If the clay does not join together easily, score the base and each added strip or join them together with slip. Once the layering is complete, children can use wet fingers to create a smooth surface.

Slab Method

Place two wooden sticks (ordinary rulers will work nicely) parallel to each other on a linoleum square. Place a ball of clay between the sticks and use a round wooden cylinder or rolling pin to roll out the clay to a flat slab. The thickness of the slab will be determined by the thickness of the wooden sticks. Use a pencil to draw a design or pattern on the slab, and use scissors or a craft stick to cut out the design. Then gently remove the background clay and allow the design to dry. If the design is to be fired, a 1/8-inch thickness is ideal. When fired, clay that is too thin will crack, and clay that is too thick will explode.

Cleanup and Saving Children's Work

When your children are just beginning to create designs and objects from clay, many of them will want to save what they have made. When they make this request, let them keep their creations. After a few experiences in working with clay, however, most of your children will be content to roll their shapes back into balls to go into the clay bucket or bin. As long as they know the clay will be available on a regular basis, and that they can help seal it in a place where it will be kept damp, they will be reassured that they can repeat the process and make even more creations. If children really want to save the shapes, you can coat them with regular, commercial floor wax so that they won't crumble when dry. This is a simple process. Put the created form aside (in a safe place) where it can dry for a few days. When most of the moisture has evaporated, dip the art piece into a bucket of liquid floor wax and let it dry. Over a period of two or three days, repeat the process. The wax will form a surface bond around the clay, giving it more stability.

Every genuine work of art has as much reason for being as the Earth and the Sun.
Ralph Waldo Emerson

Creative and Imaginative Ideas for Children

The ideas in this section provide children the opportunity for a variety of experiences and imaginative expression through three-dimensional art. Each child's own creative effort must be accepted regardless of how meager a product may appear. Your role is primarily that of encourager, facilitator, and resource.

Clay

An Imaginary Lump of Clay

To help get your children's attention, before starting this activity, read one of the books listed in the Children's Literature and Three-Dimensional Art box.

Procedure
1. Read a story about clay to your children.
2. Talk to your children about what it might feel like to be clay. Discussion can center on how clay feels, what you can do with clay, what makes clay get hard and dry, and what happens when you add water to clay. Encourage your children to add their own ideas and comments about the properties and uses of clay.
3. Tell your children that they are going to pretend to be little lumps of clay and to imagine that they can roll themselves into a big ball. The following script is a guide to this process:

You are all wet, lumpy balls of clay. Imagine what shape you would like to become, and then move your bodies in ways that help you make yourself into your own special shape. When you have created just the shape you want, try to be real still for just a few minutes so you can pretend to let your clay start to dry and get a little harder. Now, look around the room at all the shapes we have. In just a minute it will be time to be lumps of clay again. Pretend that

someone is pouring imaginary water on you so that you will become nice and soft again.

4. Follow up the activity with conversations about what it felt like to pretend to be clay. Were there any shapes that could have had names? Was it hard to be still long enough to dry? If the "shapes" could have been placed somewhere in the room for others to see, where would they like to have been placed?

Clay Impressions

For this activity, you and your children will need a variety of objects for making impressions in soft, malleable clay. Some objects you will want to collect include

- old keys of different sizes and shapes
- toothbrushes, combs, clothespins, and objects from nature, such as pinecones, shells, rocks, and sticks
- blocks of different shapes, forks and spoons, and other "found" objects that the children think hold possibilities for making clay impressions

Procedure Encourage your children to select different objects and experiment with what happens when they press the object into the clay. Have a variety of objects available for the children to create designs of their choice in their own lump of clay. Point out to your children that they can change the shape of their clay to fit their ideas of different ways of making impressions.

Fabric and Fiber

Fabric is an excellent material for children to see, touch, and handle. It comes in many colors and textures and can be glued, stitched, woven, or unwoven as children create designs or patterns. Burlap, as a loosely woven fabric, is especially suited to the skills of young children.

Burlap Unweaving

Weaving is basically a method of interlacing strands of yarn, strips of cloth, thread, paper, or other material to combine them into a whole texture, fabric, or design. Although six- and seven-year-olds can understand and manipulate the over-and-under, back-and-forth technique involved in weaving, most four- and five-year-old children lack the dexterity, eye-hand coordination, and patience to complete a weaving project.

Unweaving is the opposite of weaving. Beginning with a whole, separate materials are removed to create a design. It is a simple activity that requires minimal fine-motor control, and it is rewarding because children are *taking something apart* rather than having to put something together in a predetermined pattern. Because there is no loom to fill, weavers can stop when the design seems complete or when they get tired.

Older children and adults can reweave the fabric with different-colored threads or strands of yarn to create new color combinations, textures, and patterns.

You will need the following materials for this activity:

- precut burlap squares (approximately 12 inches by 12 inches) in a variety of colors
- ordinary classroom scissors
- glue

Procedure

1. Show children how they can use a toothpick to lift a thread from the burlap. Demonstrate how threads can be pulled from the burlap by catching a thread from the frayed edge of the cloth.
2. Encourage children to create random or patterned designs by unweaving, fraying, raveling, or reweaving the fabric with different colors.
3. Use white, clear-drying glue to secure the designs once the process is completed. If the edges of the burlap have been frayed, rub a thin layer of glue along the edge where the fraying begins. If the edges are not frayed, apply glue to the burlap where fraying could occur as a result of handling.

Boxes and Cartons

Three-dimensional art provides children with many ways to discover form and shape, texture and pattern. "Box sculpture" is a wonderful process for allowing children to combine different sizes and shapes to create interesting and imaginative three-dimensional art forms.

You will need the following materials for making box sculptures:

- Find boxes of many shapes, sizes, and types ranging from small matchboxes to the large boxes used for shipping refrigerators and other large appliances. Other cardboard forms that you and your children can collect include cereal boxes, salt boxes, tissue boxes, mailing tubes, paper towel tubes, and other containers you might find around your school or at the grocery store.
- An assortment of materials that can be used to accent shape and design include recyclable packaging pieces, string, toothpicks, pipe cleaners, spools, and small pieces of scrap lumber and wooden sticks or dowels.
- You will also need glue, a roll of masking tape for each child, and paint and brushes, in case they decide to add color to their sculpture.

Procedure

Box sculpture can be a group activity in which children share ideas and interpretations about construction, or it can be an individual activity in which children develop a sculpture on their own. The process gives each child, as artist, an opportunity to manipulate, design, and construct interesting and imaginative shapes and structures. For this reason, directions should consist of an "invitation"

Use glue or tape to arrange a variety of small boxes into a box sculpture. Pay attention to the processes you experience while making your sculpture. When completed, reflect on the experience and make notes about how the process evolved.

to sculpt rather than step-by-step instructions of how to create the sculpture. When the sculpture is complete, children can paint it and embellish it with accent materials. Tempera will not adhere to waxed surfaces such as milk cartons, so add a little liquid glue to the paint before painting these surfaces.

Sand

I doubt there are many among us who do not already know how much young children love to play with sand. Sand *casting* is based on the same principles involved in making mud pies, sand castles, and frog houses; it simply takes the process one step further. Sand casting is most suitable for children ages seven and older. Younger children will be content just playing in the sand, adding water, and making mud!

Sand Casting

Sand casting is the process of capturing a design that has been sculpted in wet sand into a permanent plaster-of-paris work of art. The pleasure of making a sand casting comes from playing in the sand *before* the actual cast is poured. Although the adult in the room is in charge of mixing the plaster and pouring it into the mold, your children can spend as much time as they want making designs in the sand, changing the design, and adding all the objects they need to make their design into something that they would like to have cast into a sculpture. The "designing in the sand" period of time is the best part of this activity, and thus should be allotted the most time. Once the mold has been cast, the process is over.

You will need the following materials for sand casting:

- clean sand
- a container of water for each child
- a small box for each child (small shoe boxes are ideal)
- dry plaster of paris
- objects to make impressions or to leave in the design
- throwaway containers for mixing the plaster of paris
- paper towels and newspaper for cleanup

If your school is located on a plot of land that offers a yard filled with sand, you and your children could take containers and scoops outside to collect your own sand for the activity. For most children, collecting the sand is almost as much fun as using sticks to make designs in their molds.

Procedure

1. Fill the small box slightly over half full with sand. Moisten the sand with water until the sand will hold a shape when pressed with an object.

2. Designs can be scooped out of the sand to form a concave depression or objects can be pressed into the sand to create designs. Little fingers are excellent

at poking round holes to make personal finger art! Shells, pebbles, and other objects can be added to enhance the design.

3. You or another adult should mix the plaster of paris with water until it is thoroughly wet. Stir the plaster mixture until it begins to thicken to the consistency of white liquid glue. Pour the plaster mixture gently into the shoe box sand mold or use a cup to dip the plaster mixture into the mold. Pour slowly so that the plaster mixture does not splash or break the design in the sand.

4. Immediately begin cleaning up objects and buckets after pouring plaster over the sand. Empty the buckets onto newspaper or outside. The plaster-of-paris mixture will harden very quickly. Never clean plaster buckets at the sink. The plaster will harden and clog drains.

5. When the plaster of paris has hardened, usually after about an hour, carefully lift the sand-cast sculpture from the mold. Wash off excess sand in a plastic tub filled with water or with an outside water hose.

Give your children the material, and then give them the nicest gift of all—the freedom to make choices about how to use it. Given the opportunity, they will make the choices that are important to them, they will have fun playing in the sand, they will find ways of entering the process, and they will create!

All of these ideas emphasize that children need time to imagine and create. Another aspect of understanding the importance of time is our own personal involvement in more complex, adult-oriented, three-dimensional art endeavors. Such experiences are important, because they may reveal an awareness of how timing allows us to become knowledgeable of how certain art materials work; an awareness of our own approach and process; and an awareness of how we create an environment in which we take risks and extend ourselves into uncharted waters. Each of these time-related concepts (knowledge, awareness, and environment) is illustrated in the following art form that arrived in Japan from China many centuries ago: the Zen garden.

Exploring Three-Dimensional Art Through a Multicultural Context
Gardens from China to Japan

Zen gardens, first designed during the Kamakura period, from 1185 to 1333, were designed for contemplation and meditation. The gardens use stones to represent mountains or islands and raked sand to suggest flowing, moving water. Early Japanese gardens were created where one could enter and walk around and were much larger in scale than the gardens we see today. Around the 11th century, Zen priests adopted the dry landscape or "Karensansui" style and began building gardens in their monasteries. They were used as an aid to create a deeper understanding of Zen concepts. Not only was the viewing intended to aid in meditation, but the entire creation of the garden also was intended to trigger contemplation.

Today it has become popular to take this type of gardening indoors. Miniature Karensansui gardens can be placed in classrooms and homes to provide a retreat

The outdoor classroom is an ideal location for making sand castings.

from the often hectic world for their designers. Figure 7–7 is an illustration of a child's Zen garden.

You and your children can create your own Zen gardens. The Zen garden is extremely simple, and the simpler your garden is, the better. When completed, gardens should be placed in an area of your classroom where you and your children can go to have a quiet moment to look at the garden and think about what you see. All you will need to make Zen gardens is a shoe box lid for each child, clean sand, hand-chosen rocks or stones, and plastic forks.

ACTIVITY 7–1

Zen Gardens

- ◆ Each child places some sand in the shoe box lid.
- ◆ The children select three or four rocks that form the framework for the garden.
- ◆ Place the rocks in the sand.
- ◆ Use a plastic fork to rake a circular series of lines around the rocks to create designs that look like ripples. This is reminiscent of a pebble being thrown into a pond.
- ◆ Rake the rest of the open area so that the sand looks like flowing, moving water.
- ◆ The garden can be changed as often as the children like to create new designs or simply to tidy up the sand with a fresh raking with the plastic fork.

FIGURE 7–7 Zen Garden

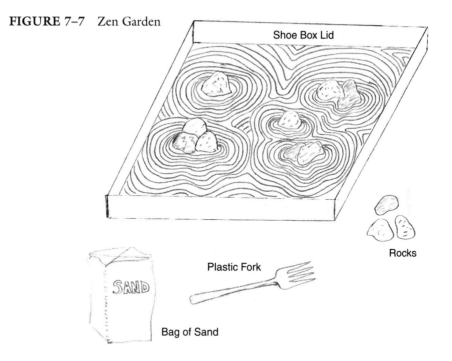

- Place the gardens in a special place, on a table, in a quiet area of the room, or a window ledge, and enjoy.

Pueblo Pottery Painting

Native Americans have lived in North America for thousands and thousands of years, although scholars debate exactly when the ancestors of today's Native Americans arrived in the Americas. Archaeologists believe that they were hunter-gatherers who developed technologies and practices suited to hunting and fishing. Their histories, like all histories, reveal the widest array of human attributes. All Native American traditions are specific to particular places and people, and have been passed down from generation to generation. They tell of how animals, humans, and the natural world were created, and they offer important instructions and lessons for living.

When Clay Sings, by Byrd Baylor (1987), illustrated by Bahti, is a story about the daily life and customs of prehistoric Southwest Indian tribes. Their stories are retraced from the designs on the remains of their pottery. The Indians treat the broken pots with great respect: "Every piece of clay is a piece of someone's life," they say. Clay has its own small voice and sings. Its song has lasted thousands of years. Baylor's prose-poem, as simple and powerful as the clay pots, sings too.

ACTIVITY 7–2

Painting Pottery

◆ Talk to the children about how the Pueblo people used plants and paint rock to make paints for decorating their pottery.
◆ Children mix water with many colors of tempera powder paint.
◆ Make the "pottery" by covering cans of various shapes and sizes with pre-cut poster board. Use glue or tape to hold the poster board in place.
◆ Children use the paint they made to paint their "pottery" and use other found items in the art center to decorate their pottery.

Three-Dimensional Art for Teachers

Creative expression, awareness of the process, knowledge of materials, time, and a sense of safety and trust are required for the three-dimensional art ideas presented in this section. Attempts to implement these ideas without all of these needs being addressed will serve only to frustrate the artist and to interrupt the creative process.

Pariscraft Face Masks

Pariscraft is a heavyweight fabric embedded with plaster of paris that can be easily manipulated when wet and that dries hard into a permanent shape. If you decide to paint your mask, you will need to apply a fixative before you add paint. Water-based paint will cause the mask to soften and lose its shape if it is not sealed beforehand. Pariscraft also forms well over cardboard, newspaper shapes, ballons, bottles, and other objects with interesting shapes and designs.

The process of making Pariscraft face masks involves a high level of trust. It is a good idea to read through the entire section before actually entering into the process.

Although this activity is primarily for older children and adults, I have observed early childhood teachers making face masks with children as young as four years old. As a matter of fact, the next little girl you are about to meet, a four-year-old named Kenya, wanted her teacher to make a face mask of her every day. When we finally asked her why, she said, "It helps me get to sleep."

Remember, you must *never* cover children's eyes or mouths. Most of my adult students prefer to have their faces covered with plastic wrap (commercial brands used for food storage are ideal), and use several large straws cut into short lengths to breathe through. There are some, however, that want to use petroleum jelly and use the plastic wrap only on their eyes for protection. When working with children, use a petroleum jelly, such as Vaseline®, to rub on their foreheads and cheeks instead of using plastic wrap. After you have experienced the sensory and tactile sensations it evokes, you will understand why you should be sure your children want to participate before you issue the invitation. In other words, experience the process yourself before you decide to invite others to be models for a Pariscraft face mask.

Making Pariscraft Face Masks

This process involves both physical touching and physical presence. You will be working with a partner and talking while your facial features are being captured in a durable and lasting art form. Because your entire face will be covered, including your eyes, for about five minutes, anyone who has real fears or phobias should ask to be a mask maker and not volunteer as a model. If at any time you feel uncomfortable during the process, you can stop by simply lifting the mask from your face.

You will need the following materials for this activity:

- Pariscraft cut into six-inch lengths—one 20-pound box for a group of 20 participants (Pariscraft, also called plastercraft, can be purchased from school supply companies or your local arts and craft supply stores.)
- large plastic straws
- plastic containers for water (one container for each pair)
- plastic wrap (commercial brands used for food storage are ideal)
- a small rug or a towel for each participant
- large jars of petroleum jelly

Procedure

1. A mask maker and a model should demonstrate the entire process before the activity begins.

2. The model lies on the floor, face up, resting his or her head on a rug or towel.

3. Using several long pieces of plastic wrap, the sculptor covers the model's face, hair, and upper clothing. The model uses a plastic straw to punch a hole in the plastic wrap and then breathes through several small lengths of the straw, which are inserted into the mouth. If you are using petroleum jelly, cover the face completely and then use the plastic wrap to cover the eyes.

4. The sculptor talks to the model throughout the process.

5. The sculptor softens the Pariscraft by dipping it in water, one piece at a time, and removes excess water by squeezing it through two fingers. Still using one strip at a time, the sculptor starts to cover the model's face, beginning at the forehead. The eyes are the last facial feature to be covered, so the sculptor then moves to the chin after covering the nose.

6. The sculptor then adds strips vertically from the jawbone to the temples on both sides of the face.

7. The sculptor adds another layer using the same steps to give the mask extra strength. As each strip is placed on the model's face, the sculptor tells the model what is happening and checks often to see whether the model is comfortable and can breathe well. It is important to attend to the model throughout.

8. When two layers of Pariscraft have been applied, the sculptor must tell the model that the eyes will be covered next.

9. After covering the eyes, the sculptor can use very light finger pressure to mold, shape, and accent the features of the model.

10. When the Pariscraft begins to harden, the sculptor stops touching the mask, sits down next to the model, and makes physical contact in another way—touching the model's arm or head, holding hands, and so on.

Kenya relaxes as her teacher smooths petroleum jelly on her face.

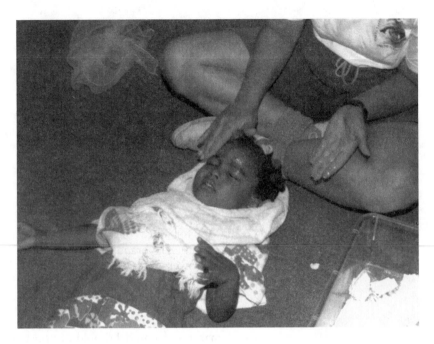

Small pieces of moistened Pariscraft are carefully applied to Kenya's forehead.

When the mask is complete, her teacher gently lifts it from Kenya's face.

Charlie admires Kenya's mask and decides that he wants to be next for the mask-making experience.

11. The sculptor talks quietly with the model or tells the model a story until the Pariscraft has hardened enough to be lifted from the face without collapsing, usually 15 minutes from the start of the process.

Once the demonstration has been completed, participants form pairs and proceed to make their masks. Participants can put names on their masks with a pencil and then let them dry and harden. When the masks are completely dry, they can be sprayed with a fixative and then painted, or they can be left in their natural state.

Remember, it is not the product of the mask that is important to this process. The mask simply becomes an outgrowth of the experience. The primary reason for the experience is the process of exploring the tactile and sensory impressions Pariscraft provides. If you hear yourself saying, "It doesn't look like me," you may want to repeat the activity so that you can pay closer attention to experiencing the process instead of the product.

When you clean up, do *not* pour the leftover plaster water down the drain. It will harden!

A Self-Sculpture in Clay

This process integrates the use of guided imagery and exploration in clay, which will help you become more aware of all the special characteristics that make you uniquely you. Throughout the activity, you will be creating an image of yourself out of clay—what you are like, how you feel, and how you imagine yourself to look and be. Your self-sculpture may evolve realistically and end up resembling a human form, or it may emerge as an abstract representation of some aspect of your own reflective awareness. Some may take no shape at all and simply remain the round lump of clay with which you began. Whatever the clay decides to do, your sculpture need only have meaning to you. The actual sensory contact with the clay and your awareness of yourself form the heart of the process. As in making Pariscraft face masks, it is the process and not the end product that has meaning.

You will need the following materials for this activity:

◆ two large handfuls of earth clay for each individual
◆ a large square of heavy plastic for each individual
◆ a flat, smooth working space such as a table or the floor where each person can have his or her own area of space

Procedure

Make sure you have enough clay. Work your clay into a ball until it is about half the size of a basketball. Take a few minutes to explore the tactile properties of the clay, and then attend to the reading of the following guided imagery:

> Take a few minutes to get acquainted with the clay. . . . Feel its texture and weight. . . . Feel the way it changes shape as you explore it with your fingers. . . . Try different ways of shaping it . . . squeezing, patting, rolling, pulling, pushing, stroking, punching. . . . Discover what this clay is like and how it is capable of being formed.

Now that you have explored your clay, shape it into a fairly round ball and set it gently on the plastic in front of you. Make sure you are sitting in a comfortable position, and close your eyes. Focus your awareness on your hands and fingers and pay attention to how they feel. . . . Can you still feel some residue of clay on your palms and the tips of your fingers? While your ball of clay rests on the floor (or table) in front of you, turn inward and let your awareness center on the different areas of your body. Become aware of what you feel in each different part of your body. . . . Give yourself permission to relax with awareness. . . . Take a deep breath, and as you release it let all of the tension flow into the space in this room.

Now, use your mind's eye to see an image of your round ball of clay. Imagine that it will slowly change and shape itself into an image of yourself. Imagine how your hands and fingers are moving this imaginary ball of clay, and let it change itself slowly into some representation of yourself. . . . You might see several changes in your image or perhaps just two or three images of how your imaginary clay is evolving into a shape. Whatever images you see in your mind's eye, just be aware of how your clay develops and changes inside your imagination.

Now, keep your eyes closed and reach out to the real ball of clay in front of you. . . . Hold it gently in your hands for a few minutes. Focus your attention on your fingers and hands, and let them begin to move and get reacquainted with the clay. Slowly allow your hands and fingers to begin moving the clay as you explore the process of creating a self-image out of this lump of clay. Focus on all of the details of the process of shaping the clay . . . how the clay feels, how your fingers move . . . and the images that come to you as the clay changes shape. As much as you can, let the clay and your fingers lead you in this shaping. See what develops out of this process of shaping and creating a self-portrait in clay. You will have about 10 minutes to do this.

(Pause for 10 minutes.)

Now slowly open your eyes and look at what you have made out of the clay. Continue to work on it a little if you wish, but do not make any major changes in it. Look at it carefully and be aware of what it is like . . . all of its properties and characteristics. . . . Does it represent who you are in this time and place? Now that you can see what you have created, what are some thoughts that come into your mind? How would you describe the process?

At the end of the activity, each person should have an opportunity to process the whole experience. This, of course, is by invitation only, but because you have been together for almost a full semester, processing and discussion should come easier than it has before. As you enter into the processing stage of this activity, speak in the first person and in present tense.

Group Sculpture

This activity provides an opportunity to build on the ideas of others to create a form or design out of a large piece of clay. Sculptors work as a group to transform the clay into a group sculpture. The form that evolves is a reflection of the group process.

You will need the following materials for making a group sculpture:

- Each group of four or five people will need a large ball of clay (at least as big as a basketball).
- Each group needs a large piece of plastic on which to place the clay.
- A container of water should be provided for each person.

Procedure

1. Form small groups of four or five people, and place the large ball of clay in the middle of the circle. This is a silent activity, so the verbal exchange of ideas is not permitted.
2. As you sit in your circle, observe the ball of clay resting in front of you.
3. When you have an idea or simply an urge to start molding the clay, place your hands and fingers on the clay and begin to sculpt. Remember to do this without verbalizing your idea to the others.
4. As each of you has an image or an idea about how to mold the clay, begin to work together simultaneously. The clay does not have to "become" anything. Its evolving shape is simply a reflection of the group process.
5. When the group feels that the sculpture is complete, stop working and spend a few minutes looking at what you have created.
6. As each group completes the process, stand up, move around the room, and look at the work other groups have created.

The following questions will be helpful as you begin to process this activity. You should narrow or extend these processing questions to meet the needs of your own particular group. What is important here is to get everyone to spend a few minutes talking about the process.

- What did you do during the sculpting experience?
- How would you describe the group sculpting process?
- What similarities or differences did you notice in the way the people in your group approached the sculpting activity?
- Is there anything you would like to tell us about your sculpture?

One of the underlying—yet central—themes of this book is how we as teachers grow and develop affectively. We have all moved from *attending* to the arts and their role in the education of all people to *organizing* our thoughts and ideas about the arts into every facet of our work as teachers. This process of internalization is of critical importance as we prepare to live joyous, humane, and meaningful professional lives. Our affective development, and our awareness of it, also helps us to grow in personal ways into creative and interesting people.

The Continuum of Development in the Affective Domain: Characterization by a Value or Value Complex

The last major category of the taxonomy of educational objectives in the affective domain is *characterization by a value or value complex*. At this level of affective development, our value system has a major influence on our overall lifestyle. In our personal and professional roles as educators, lifestyle involves our own consistent and predictable behaviors in relation to the creative arts and creative arts education.

Development in the affective domain is an ongoing, lifelong process. It would be unreasonable to think that, as a result of the few limited experiences in this book, we have reached this highest level of affective development. What we can be sure of, however, is that we have "tuned in to" the realm of our own affective domain and can now make choices about ways of introducing the creative arts based on our clarified values.

Let's take a few minutes to reflect on the continuum of affective development in terms of how we think about the nature of the affective domain. The following section gives us a chance to pause and think about some of the things we have learned, thoughts we have had, and feelings we have experienced.

Reflective Awareness and the Continuum of Affective Development

An important aspect of reflective awareness is "knowledge of, awareness of, and control of the feelings that accompany certain situations" (Barell, 1995, p. 247). As a process for gaining greater awareness of our own affective development, the following questions focus on our experiences before, during, and after the Personal and Professional Growth activities throughout this book. This process is offered as a means of looking back at ourselves to remember our experiences, to question, and to think about our own thinking.

Receiving

Receiving involves attending with awareness and being receptive to certain things in our environment.

- What were your first thoughts when you were reading about guided imagery?
- How willing were you to become an "imaginer" and use your mind's eye to create images of the yellow sun or the cool darkness under the blanket of the Earth's surface?
- When scanning your years in school and looking for a favorite teacher, what other images came into your mind's eye?
- What images did you capture in an art form, in written notes, or through conversations with others?
- Have you thought about any of the images since you first experienced them?

Responding

Responding refers to active participation on the part of the learner. We respond when we move beyond attending to a particular situation and react by doing something and becoming actively involved.

- What were you thinking when you realized you would be expected to move to music through dance?

- How did you feel as you worked with others to create a musical improvisation?
- How would you assess your level of participation? Were some activities easier, or more difficult, in which to participate?
- Are you satisfied with your level of involvement? Should another opportunity arise, would you participate more than you did initially?
- What are some of the things you learned about yourself and other people?

Valuing

Valuing is concerned with the worth we attach to the content of events, situations, and experiences, and in this case, the creative arts.

After reading the section Reflective Awareness and the Continuum of Affective Development, write down your answers to all of the questions. Use your written responses to develop a one-page narrative that describes your growth in the affective domain.

- In what ways did your attitude toward the creative process convey the value of working with another person?
- What ideas do you have for assuming a position of responsibility for the effective implementation of creative arts programs for young children?
- How do your behavior and actions indicate a new level of awareness regarding the importance of creative and artistic development in all people—adults as well as children?

Organization

Organization is concerned with bringing together different values, resolving conflicts, and building an internally consistent value system.

- What was your level of awareness of your strengths and weaknesses *before* you actually wrote them down in a list?
- How did you organize your thinking when deciding on strategies to correct deficiencies or weaknesses relating to professional skills?
- What are the most important things you need to remember about the creative arts as a process and your own role in offering this process to children?
- How have the "here and now" experiences in the arts contributed to the overall value you place on the role of the arts in education?
- How consciously are you monitoring and evaluating your thinking before, in the middle of, and after responding to this question, and all of the preceding questions?

Characterization by a Value or Value Complex

Characterization by a value or value complex means that we have a value system that has controlled our behavior for a sufficiently long time. Thus, the behavior is pervasive throughout our lifestyle.

- When you make plans for personal, free time activities, do your plans include the arts?

◆ How often do you listen to music, dance for pleasure, or paint or color with crayons or other visual arts material?

◆ Do you have friends or acquaintances who are professional musicians, actors, or artists?

◆ Have you thought about learning to play an instrument, taking dance lessons, or attending an acting class?

◆ Has this class influenced your attitudes and behaviors toward the arts?

You have been encouraged to develop an awareness of the value of creative arts education and the role you play in this process. Now it is time to come full circle; you are not ending a journey, but beginning a new adventure with greater appreciation of your own role as a creative teacher who can facilitate the creative and artistic process in children. With this in mind, let's take a look at the connections among our attitudes, beliefs, and behaviors as they relate to the arts.

PERSONAL AND PROFESSIONAL GROWTH

You are an intelligent, capable, and creative person. These are universal traits of all successful teaching professionals. Accordingly, this approach to creative arts has been structured to encourage a supportive learning environment in which you enter into the creative process in personally meaningful ways. This is the basic foundation for creative arts exploration. Your willingness to trust and try, combined with the freedom to choose your own unique ways of expression, will pay high dividends as you continue to learn ways to encourage children to develop their special modes of self-expression.

The question "What is your philosophy of creative arts education?" can often produce anxiety and apprehension in preservice, or even experienced, teachers. Defining a philosophy of education is difficult enough, and now someone is asking you about a philosophy of *creative arts* edcuation! Was Tolstoy (1963) right when he called the arts a manifestation of emotion, or was Collard (personal communication, 1981) right when she said that the arts (music) are disciplined passion? Do not let these questions frighten you. At this point in your journey, I would hope that your philosophy is still in the developmental stage. However, it is not too early to begin thinking about your own views and beliefs about the creative arts and teaching.

The activity Teaching: Attitudes, Beliefs, and Behaviors will give you some time to ask yourself questions about the teaching field and your role as a teacher of the creative arts. In this nonevaluative setting, you will have the opportunity to talk about your feelings and ideas about teaching, specifically teaching the creative arts, with another person. The dyadic encounter can be a first step in defining your beliefs about creative arts education, clarifying your role as a teacher in relation to these beliefs, and developing your own philosophy of creative arts education.

As you continue to read, you may begin to think about what your responses will be during the activity. A word of caution: What you decide to say as you read ahead right now might change moments before you enter the encounter. If that happens, it is a positive sign: It means that you are still giving your philosophy a chance to evolve, develop, and grow!

Teaching: Attitudes, Beliefs, and Behaviors

Each one of you will have an opportunity to share feelings and ideas about the field of creative arts education with another person. Pair up with another participant. If there are teachers and preservice teachers in your group, you should consider forming dyads together.

Begin the dyadic encounter by reading the following text silently and then responding to the questions or statements. When you have finished reading the introductory paragraph and have completed the encounter, return to the large group and talk about the experience, examining additional questions you might have about the arts in early childhood education.

Sharing ideas successfully with one another involves some basic skills and a positive attitude. The fundamental dimensions of a shared encounter are self-awareness, self-disclosure, trust, risk taking, empathic understanding, nonpossessive caring, acceptance, and feedback. In an understanding, professional, and nonevaluative atmosphere, we can confide significant information about ourselves to someone else, who reciprocates when the roles are reversed. This "stretching" results in a greater feeling of trust, understanding, and acceptance, and the personal and professional relationship becomes closer, allowing more significant self-disclosure and greater risk taking. As you continue to share your ideas and experiences authentically, you should come to know and trust each other in ways that may enable you to become good resources for each other.

Note the ground rules for this experience:

1. You should be comfortably seated, directly facing your partner, in a location that is free from distractions. If your environment does not meet these conditions, find another setting before proceeding any further.
2. Remember what you were thinking when you first read this section.
3. All the information discussed is strictly confidential.
4. Each partner responds to each statement before continuing.
5. Complete the statements in the order in which they appear. Do not skip items.
6. The discussion items are open-ended statements and can be completed in whatever depth you wish. You may decline to answer any question simply by telling your partner that you choose not to respond.
7. Either partner can stop the exchange if he or she becomes obviously uncomfortable or anxious.

Look up. If your partner has finished reading, begin your dialogue:

- The name I like to go by is . . .
- My teaching experience includes . . .
- I want to teach because . . .
- My primary objectives as a teacher are . . .
- As a teacher, I know that the creative arts are important because . . .
- Some creative arts methods I plan to use with children are . . .
- The reasons I use these methods are . . .

Look at your partner while you respond to this item. (Also, try to use your partner's name occasionally when responding.)

- Right now I am feeling . . .
- As a prospective teacher, I believe that I can be (very) (reasonably) (not very) successful in facilitating children's creative expression . . .
- Some evidence of my success (or lack of success) includes . . .
- Arts methods that I would like to learn more about are . . .
- Creative arts methods that I would be unhappy using are . . .
- I think the difference between art and crafts . . .

Checkup: Have a two- or three-minute discussion about this experience so far. Maintain eye contact as much as you can and do a little self-check by silently responding to the following questions:

- How well am I listening?
- How open and honest am I being?
- How eager am I to continue this interchange?
- Do I believe that I am learning something about myself?
- Some educational ideas about the creative arts that I would like to know more about are . . .
- Ways in which I could more effectively bring creative arts experiences to children are . . .
- Some of my real strengths as a creative arts teacher are . . .
- Some of my real weaknesses as a creative arts teacher are . . .
- I am (fulfilled/frustrated) in my ability to experience the creative arts in this class because . . .
- So far, my philosophy of creative arts education is . . .
- To become more creative and involved in the creative arts and a more creatively oriented teacher, I have to work on (circle those that apply or add other things you need to work on):
 - my overall philosophy or beliefs regarding . . .
 - skills such as . . .
 - letting go and being uninhibited about . . .
 - accepting my creative potential, especially in the areas of . . .
 - recognizing the creative abilities and efforts of children and how I will incorporate these into my teaching . . .
 - learning more about multiple intelligences theory and . . .
 - other things such as . . .
- Ideas of yours that have really interested me are . . .
- I wonder if you would talk a little more about . . .
- What can we share with the large group about our discussion . . .
- Some things I would change about these questions are . . .

In the preceding chapters we have encountered many examples of how we grow and learn in the affective domain. We have also made decisions relating to our personal and professional development as we have reflected on our actions,

thoughts, and feelings. The greater our awareness of the affective domain and the more time and attention we give to this integral part of who we are, the more open we will be to our own creativity and the creative potential of our children.

I will leave you with an ancient proverb, one that Robert Valett (1977) expanded on, placing emphasis on the development of affective skills and abilities with a greater awareness on the importance these play in the total education program.

I hear—and I attend
I see—and I remember
I feel—and I wonder
I care—and I aspire
I speak—and I relate
I reflect—and I understand
I love—and I transcend
I experience—and I act
And so do I become.

chapter 8

Planning for Literature

*I like books that remain faithful to the very essence of art. Namely; those
that offer to children an intuitive and direct way of knowledge, a
simple beauty capable of being perceived immediately, arousing in their
souls a vibration which will endure all their lives.*

Paul Hazard, distinguished scholar from the Sorbonne, 1944

> **L**evi *walked up to me, put the book firmly in my hand, and said, "Read this to me." I took the book and began to read Faith Ringgold's* Tar Beach. *I read, and Levi listened. At the end of the story, Levi looked at me and asked what I thought was a most appropriate question: "Can boys fly like that girl . . . how did she do all that flying stuff?" I was really caught off guard, and since I did not know what else to say, I said, "Yes, boys like you can fly in their imaginations." Levi had many more questions about how that little girl flew over buildings and why they were having supper on top of the house. By this time a small crowd had gathered, and some of the other children had questions of their own.*

I knew that neither my words nor my explanation satisfied Levi's need to know about flying. He needed some firsthand experience in allowing his imagination to soar so that he *could* imagine what it would be like to fly over buildings and bridges. So I consulted a friend and colleague, Linda Kauffman, and together we wrote an interdisciplinary unit entitled Imagination. We based the unit on *Tar Beach* and other books about children using their imaginations.

Using children's literature as the focal point, we designed the unit so that it integrated literature, the visual arts, drama, and music and movement. (Our unit, complete with the web we developed, is included later in this chapter.) There were several surprises and rewarding "aha" moments that occurred during the *process* of designing the unit. The process taught even these two seasoned schoolteachers a new thing or two! As you read about our exercise in creative planning, you should begin getting some ideas about how the visual and performing arts can be fostered and encouraged through the use of children's literature. For now, though, let's turn our attention to the special magic that literature offers our children and examine how books, stories, and poems are clearly recognized as potent forces for learning.

The Literature Environment

> With a poem in your pocket and a song in your head, you will never be alone at night, when you go to bed.
>
> Marjorie Farmer, 1973

I have read countless poems to young children to keep in their pockets for rainy days or especially dark nights. Just the idea of having access to poems and other forms of literature can be soothing and comforting to a child. Poetry, books, and stories serve as a mirror for children, and literature can help them take a look at the outside world in relation to their own inner, imaginary world and their unique

Visit an early childhood classroom. Observe the activities that occur in the center, and record ways that children utilize the materials. Visit the other centers in the classroom, and make note of the types of books you find in each.

feelings. Excellent children's literature often reveals to children that their imaginative and affective states are not unlike those of other people (especially "grown-ups") and that their feelings and imaginary worlds must be important because someone has actually written about them!

Hundreds of children's books are published each year, and it seems that there is a special book for each child and each child's experiences. Children must be introduced to a variety of literature, including picture books, Mother Goose, poetry, and concept books. Picture books, one of children's favorites, can be divided into two major categories: wordless picture books, which do not have a written text, and picture books, which use words and illustrations to tell the story. Your children can interpret the illustrations of wordless picture books to make up their own story as they follow the sequence. Even when there is a written narrative, young children often use illustrations to understand the story. Illustrations add life and richness to the story experience and increase children's enjoyment of literature.

Literature for children can be categorized into many different genres. Traditional literature includes folktales, fairy tales, fables, beast tales, magic and wonder, Mother Goose, and jingles. Fantasies are stories that are rooted in places and things that could not really happen. Other important genres of children's literature include realistic fiction, poetry, picture books, concept books, and fiction and nonfiction. Table 8–1 presents an overview of these different genres, descriptions, and examples of books for children.

The examples offered in Table 8–1 do not begin to make a ripple in the wellspring of beloved and memorable literature for children. There are literally thousands of excellent books currently available on the market. It is up to you and the resourcefulness of your school librarian or the children's librarian at your city and/or country library to find appropriate books for children. Remember to surround your children with print, pictures, and illustrated books that combine the visual elements of line, color, shape, and texture into pleasing and aesthetic compositions. Children depend on you to open the doors for them to explore endless hours of literary adventures. It is through your "search and find" efforts to select quality literature that you will offer your children the gift of enjoying and finding pleasure in the process of discovering literature.

The coveted Caldecott Medal, named for English illustrator Randolph Caldecott, is awarded each year to an outstanding picture book. If you spend some time looking at the illustrations in these award-winning books, you will discover that illustrators use a variety of techniques and media to create truly beautiful and appealing works of art. Your own experiences with Robert McCloskey's *Make Way for Ducklings* (Viking, 1941), or John Schoenherr's illustrations in Jane Yolen's *Owl Moon* (Philomel, 1987) will help you learn to appreciate the importance of art in children's books. (A list of Caldecott Medal books is included for you in appendix 1.)

TABLE 8–1 Literary Elements and Examples

Genre	Description	Example
Traditional Literature	Folktales	"Little Red Riding Hood"
	Fairy Tales	"The Elves and the Shoemaker"
	Fables	"The Hare and the Tortoise"
	Beast Tales	"The Three Billy Goats Gruff"
	Magic and Wonder	"Beauty and the Beast"
	Mother Goose	"Little Miss Muffet"
	Jingles	"One, Two, Buckle My Shoe"
Fantasy	Animal Fantasy	*Frederick* (Leon Lionni, Pantheon, 1967)
	Humorous Tales	"Mr. and Mrs. Vinegar," an English Folktale
Realistic Fiction	Family Life	*Alexander and the Terrible, Horrible, No Good, Very Bad Day* (Judith Viorst, Atheneum, 1977)
Poetry	Rhyme	"Poem to Mud" (Z. Snyder, in *Today Is Saturday,* Atheneum, 1969)
	Repetition	"Beautiful Soup" (Lewis Carroll, in *Alice's Adventures in Wonderland,* 1865)
	Imagery	*Where the Sidewalk Ends* (Shel Silverstein, Harper & Row, 1974)
Picture Books	Short Stories	*Where the Wild Things Are* (Maurice Sendak, Harper & Row, 1963)
	Retold Stories	*The Sleeping Beauty* (David Walker, translator and illustrator, Croswell, 1976)
	Wordless Picture	*Frog Goes to Dinner* (Mercer Mayer, Dial, 1974)
Concept Books	Information	*My Puppy Is Born* (Joanna Cole, William Morrow, 1991)
Nonfiction	Biography	*Will You Sign Here, John Hancock?* (Jean Fritz, Coward, McCann, 1976)

Arranging Your Room for Literature

Locate books and space for browsing and reading in an area of the room that is quiet and away from the more active centers. If you have the resources, carpet the area or place small rugs on the floor. The book area must be a comfortable, attractive, and inviting place for your children. Always display the books at the child's eye level. Observe your children to determine which books seem to be favorites, and let these books form your basic book collection. These favorite books can reside in the area indefinitely while new additions, such as concept books, books that relate to the needs of individual children, or books chosen in response to or to encourage new enthusiasms can circulate on a regular basis.

Be sure that you read each book before placing it in the active collection. It is very important that you be thoroughly familiar with each book you present to your children and that you know the story line well enough in advance to read it at a moment's notice. Arrange your schedule so that you can spend some time in the book center each day. Sit with your children, read to them, and talk informally with them about the books in which they are interested, the books you read together, and the books about which they want to know more.

A comfortable overstuffed chair with large pillows is a nice place to curl up with a good book.

Choosing Excellent Literature for Children

Selecting books for children and preparing for the presentation of a new book are two of your most important responsibilities. Books for young children should have most of the following elements:

- A simple, definite plot. Children should have some idea about the outcome of the story. Stories should be short, and there should be few printed words in relation to the number of pictures.
- Repetition of words, rhymes, or happenings with which children can quickly become familiar or enjoy chanting or saying the repetition after they have heard it several times.
- Direct conversation between story characters.
- Language and vocabulary that children can understand and that is appropriate for their age level, interests, and level of understanding.
- Stories that present familiar and interesting situations and incidents, such as stories about animals, people, and other children.
- A climax that leaves the children feeling resolved and satisfied.

A Family's Role in Developing Literacy at Home

Families share in the responsibility to help children become literate. Caregivers need to remember that if they want their children to be readers and writers, then it is important that they make reading and writing a priority in the family. Even when caregivers feel that their own reading and writing skills are not fully developed, they can still tell their children stories and can demonstrate by their actions that literacy is very important to them. The most important single thing family members can do to help children become literate is to *read to them*. Research study after study has shown that children who have had many stories read to them are successful in literacy programs in the schools. The following tips are helpful to families and caregivers as they work to nurture children in facilitating their literacy development.

- Establish a routine for reading to children and try to read to them at the same time every day.
- Select books that are not only interesting for children, but that you enjoy as well.
- Be patient when children want to assist you in reading. They enjoy helping turn pages and pointing to pictures that they recognize.
- When a child attempts to name objects in the illustrations or verbalize about the story, remember that these small steps are steps in the right direction toward literacy.
- Don't be afraid to change the quality of your voice to match the characters and/or the story line. You can make your voice exciting, you can sound surprised, and you can even sound sad when it reflects the emotions of the characters. Use your voice as a literacy tool.
- Watch for visual cues that will let you know when the child has had enough or is tired of being read to. When the child stops paying attention it is time to put the book down and do something else (Kupetz, 1993).

- Accurate and realistic information in concept books.
- Accurate presentation of ethnic, cultural, and racial information. Stories should not portray sexual, cultural, racial, or ethnic stereotypes.
- A limited number of main characters.

The teacher who knows how to encourage language and literacy skills in young children is also knowledgeable about the child's capacity to learn language. These teachers seem to possess a high degree of understanding about the development of

linguistic intelligence *and* how to nurture this intelligence in children. Gardner's idea of linguistic intelligence is the last one discussed in this book. Remember that Gardner proposed that there may be many more intelligences waiting to be identified, but this book focuses on the areas of intelligence that seem to fit most appropriately to the creative arts.

Gardner's Theory of Multiple Intelligences: Linguistic Intelligence

At this point in your reading, you are beginning to fully understand the importance of the relationship between Gardner's ideas of multiple intelligences and the arts and the implications his theory has for how we view the artistic and creative processes of young children. As educators, it is incumbent upon us to fully understand that young children express themselves through all the intelligences, and by now you should have an intuitive grasp of the multitude of ways through which young children learn and express what they know. With that in mind, let's take a closer look at what Gardner has to say about *linguistic* intelligence.

Storytellers, poets, journalists, orators, and other people who have the ability to use language (whether orally or in writing) have a large amount of linguistic intelligence. This intelligence includes a person's sensitivity to the sounds, rhythms, and meanings of words and sensitivity to the different functions of language. Some of these include auditory decoding (listening for meaning), visual decoding (reading), semantics (examination of meaning), syntax (the ordering of words and their inflection), and pragmatics (how language can be used).

Gardner tells us that we can look at the "end states" of intelligences in the lives of individuals to see the intelligences working at their maximum. He offers a wonderful example to illustrate this kind of intelligence by describing the rapidity and skill with which a young Jean-Paul Sartre found his identity in writing. Gardner (1983) quotes Sartre as saying,

> By writing I was existing. . . . My pen raced away so fast that often my wrist ached. I would throw the filled notebooks on the floor, I would eventually forget about them, they would disappear. . . . I wrote in order to write. I don't regret it; had I been read, I would have tried to please (as he did in his earlier oral performances). I would have become a wonder again. Being clandestine I was true [at age 9]. (p. 81)

Other individuals in whom we can see linguistic intelligence at work include Charles Dickens, Pat Conroy, and the great poets Robert Frost, Gwendolyn Brooks, Sojourner Truth, Maya Angelou, and Langston Hughes.

Any discussion about linguistic intelligence must stress the role of the teacher in nurturing and expanding this intelligence in young children. Understanding how we can help children develop their linguistic potential is useful for all of us who work with children. With this in mind, let's consider how we can support the development of linguistic intelligence and the ways in which we can use literature to support this important area of intellectual development.

Supporting Linguistic Intelligence

One of our most important responsibilities as teachers is to read to children. When we read to children, we tap into their past experiences and present interests, while opening a window for them to interpret and respond to literature in ways that are meaningful to them. Taylor (2000) says:

> If students are going to connect with school and school culture, they need to locate themselves, their life and learning experiences, cultures, values, language, and physical characteristics within the books they are exposed to at school. (p. 24)

As children respond to the books and stories we read, they are becoming literate. When they talk about stories they are developing oral literacy and the ability to express themselves in spoken language. Visual literacy is heightened as children pay attention to illustrations and use them to make a story come alive and have meaning. Children demonstrate their oral and visual literacy as they retell stories, scribble drawings and letters of the alphabet, and make up stories related to those read aloud to them. Literacy is a process that begins very early in young children, and its roots are deeply implanted in hearing stories and books read aloud. The development of literacy and linguistic intelligence is no longer viewed as a process that begins when children enter kindergarten; this process begins with the verbal and nonverbal interactions we have with infants. It continues through, and beyond, the moment we pick up that first book and read it aloud to a child.

Reading stories to children is an important activity and meaningful experience that must occur throughout the day.

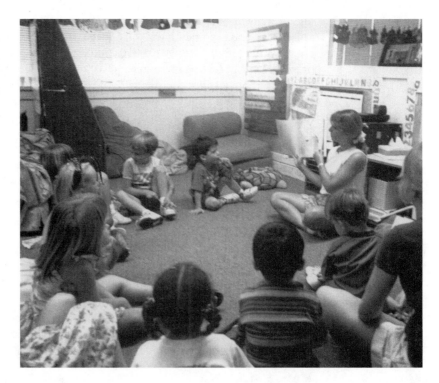

Arrange your classroom so that it is print-rich by filling every available space with all kinds of books. Put a Frank Lloyd Wright "coffee table" book in the block center, and place illustrated cookbooks and books about interior decorating in the house-keeping center. Buy yourself a copy of the *Anthology of Children's Literature* 4th edition (Johnson, Sickels, & Sayers, 1970), one of the best-known and most respected volumes that include both stories and poetry for children, and read from it daily. Provide many opportunities for children to talk about stories by establishing a comfortable area in your room where children can relax with books while reading and having conversations about what they read (see Figure 8–1). Vary your approach to story-telling by using flip charts, flannelboard stories, movie-box stories, chalk-talk stories, and story starters to encourage your children to make up their own stories. When you fill your classroom with books and give your children many opportunities to listen to stories and to talk with you and each other about the ideas, information, and concepts they are discovering, linguistic intelligence and the acquisition of literacy will emerge.

Linguistic intelligence grows out of using language. Do not allow your classroom to gain the reputation of being the quietest room on the hall. Strive to earn the reputation of being the room in which children are always talking, reading, interacting, and expressing ideas through words. If another teacher says to you, "Your children talk more than anyone else's on the hall," respond with a smile and a delightfully lilting "Thank you!" Figure 8–2 gives some specific ideas for turning your classroom into a space that promotes the development of linguistic intelligence.

FIGURE 8–1 Creating a cozy place for children to relax with books encourages them to explore and enjoy literature.

FIGURE 8–2 Creating a Literacy Environment

◆ Include print in every part of the room where children play. Fill your room with magazines, books, maps, phone books, newspapers, and notepads.

◆ Create post offices, grocery stores, restaurants, and travel agencies, and have all the printed materials available that your children would find in these "real" places.

◆ Change the printed material often, while selecting new printed matter based on the daily lives and interests of your children.

◆ Label your classroom. Always put the labels at child's-eye level and make them large enough for the children to see across the room. For example, label the containers that hold Legos®, puzzles, blocks, crayons, and dress-up clothes so that your children can begin to connect the names of things with the length, configuration, and spelling of the objects.

◆ Set up a library center. Make this center as cozy as possible by adding beanbag chairs and rocking chairs that are child-sized.

◆ Teach your children how to handle books. You will have some children in your class who have never been shown how to treat a book. When you model respect for books and show your children how to handle them, they will quickly learn the rules of book handling. A simple lesson on taking care of books can instill in your children the idea that books are valuable and, more importantly, that you trust your children to handle books carefully.

Throughout this book we have focused on developmentally appropriate practice and methods of teaching based on our knowledge of how young children learn. The degree to which teaching strategies and curricula are developmentally appropriate is also a major determinant in the quality of our literacy program. For children to fully understand and remember what they are learning, the language and literacy experiences must be relevant to the child in the context of the child's experiences and development.

DEVELOPMENTALLY APPROPRIATE PRACTICE

Children acquire linguistic skills through hearing and using language. Literacy skills grow out of a child's desire to use language to solve problems and to express needs, insights, ideas, and excitement. Children do not develop linguistic skills by being quiet and listening to an adult lecture about a particular concept.

Another important influence on children's emergent literacy is how they learn to read and write. Children want to tell and write stories, and they demonstrate this quest for literacy when they become involved with literacy materials. One concept of literacy, as viewed through a child's early writing, is reflected in children's invented spellings. As young children begin to write, they create their own unique spellings based on how they hear and perceive words. They will use letter words such as *U* for *you* and *R* for *are*. These spellings may appear strange to adults, but they are based on the phonetic relationships constructed by the child, usually without much assistance from an adult. These imaginative and quite ingenious attempts at transferring the spoken word onto paper in written form are a definite component of early literacy development and should be accepted and encouraged by teachers and other adults.

A classic example of a child using invented spelling is found in a story written by a very good friend of mine, Anya Mae Davidson, when she was four. She wrote the story when she and her family traveled from Maine to Pennsylvania for a holiday week. The word placement on the page, uppercase and lowercase letters, and punctuation are exactly as Anya Mae wrote them. As you will see, she knew exactly what she wanted to say, *and* she found a way to say it that is clear and understandable to anyone who reads her story.

Wan we Got to Philab Phia it was a 11 a clok
Ora Room in the hotal was on the
22 flor The nacs day we wat to the pool.
I swam in the pool a lidl wth yol. Wan
I was don and in the pool I wat into the hottob.

Anya Mae Davidson. Used with permission.

When Anya Mae read her story to me, she put her finger under each word and read, with beautiful phrasing, inflection, and pauses, her story: "When we got to Philadelphia, it was eleven o'clock. Our room in the hotel was on the 22nd floor. The next day we went to the pool. I swam in the pool a little with Yona [her brother]. When I was done and in the pool, I went into the hot tub." Anya Mae was writing about a joyful event, and it is appropriate that she used invented spelling to tell her story. Older children should also feel free to use invented spelling when writing stories. Figure 8–3 shows how Anya Mae's older, six-year-old brother Yashi used invented spelling to write a very detailed story about an imaginary adventure.

The National Association for the Education of Young Children's concept of developmental appropriateness for the teaching of language and literacy development during the early childhood years is invaluable to those planning curricula for young children. Figure 8–4 summarizes developmentally appropriate ways to introduce literature to young children.

I hope you will view these examples of how children capture their ideas in writing as a reminder of the importance of letting our children enter into the writing process in ways that encourage, rather than discourage, their early writing attempts.

The goals of a language and literacy program are for young children to expand their ability to communicate orally and through reading and writing and to *enjoy* these activities. The special children in your classroom are certainly no exception to this approach to language and literacy. Development in all the language arts is essential for your special needs children.

From the following list of book categories that relate to all of us, select the one about which you know the least: racial and ethnic diversity, elderly people, family structures; or children's concerns, such as violence, child abuse, foster care, death, homelessness, and attitudes toward school. Develop an annotated bibliography to add to your literature resource file.

The Special Children in Your Classroom

It is an unusual classroom in which most children are at the same level of development. In fact, you should consider yourself very fortunate indeed if there is a *great deal* of diversity among the children in your care. Every child's development is individual, and just as all the children in your classroom do, children with special needs are likely to show differences in skill development.

wanch upon a time
there lived a boy
he asked his mother
if he cud go on a long
Jrny his mother sed yes
so he paked some food
and we nt uot side
he came to a big casl
garding it were two
snakse in side the casl
were 500 gostse and goo
goblinds it was luky becos
he brange a nife he cild ol of them
and he starfed off agen soon
he came to nother casl garding
that casl were gards thay were
suprisd becos meny peple tride
to get to that casl thay were sup.
but he was not ded thay invit ic
him in the king was thay suprisd
too the king invitid eat them
to live with them he napd ever after
cold up and thay lived his mother

FIGURE 8–3 Yashi Davidson's Composition Using Invented Spelling
Source: Yashi Davidson. Used with permission.

◆ Teachers read frequently to children or tell stories using flannelboards or magnetic boards, and they encourage children to manipulate and place figures on boards.

◆ Teachers provide picture books that depict a variety of ages and ethnic groups in a positive way.

◆ Teachers encourage children's language development by speaking clearly and frequently to individual children and *listening* to their responses.

◆ Children are provided many opportunities to see how reading and writing are useful before they are instructed in basic skills, such as letter names, sounds, and word identification. Some types of ideas that facilitate the development of language and literacy include

 ◆ listening to and reading stories and poems

 ◆ dictating stories

 ◆ seeing a variety of print material in use

 ◆ experimenting with writing by drawing, copying, and inventing their own spelling

 ◆ accepting the wonderful ways in which children spell their words, and teaching formal literacy skills only when the child is ready

FIGURE 8–4 Language, Literacy, and Developmentally Appropriate Practice

For example, you may have children in your classroom who face different challenges to their literacy development. You may observe a language delay in a child who uses language that is noticeably deficient for his age. Other causes of language delay include physical problems such as a hearing impairment or structural problems in the speech-producing organs (Brewer, 2003). The presence of a visual impairment or emotional problems can affect the language development of a young child and children who use English as a second language. In any case, it is your responsibility as a teaching professional to design both the physical *and* childhood environment of your classroom so that no children will be left out of the language and literacy experiences. Adopt an *inclusionary philosophy* through which you make a professional commitment to the inclusion of your children with special needs into every aspect of your literature environment. When you do this, all your children will benefit. The following ideas for your classroom should be useful as you begin to plan ways for *all* your children to develop their language abilities.

Including All Children: Listening

To encourage the development of listening skills in children with language delays, Heward and Orlansky (1996) suggest the following:

◆ Provide adequate seating for the child with language delays. Let children sit where they can hear best, which is usually close to the teacher, or in front of the group during story time or large-group listening activities.

◆ Keep background noise to a minimum, both inside and outside the room. For example, when you plan to use background music during an activity, make sure the children understand the nature of the activity before you begin playing the music.

Literacy begins in children's early years as they imitate adult reading behaviors.

◆ Do not talk to children when your back is turned. Make sure that your children can see your full face so they can clearly see your natural mouth movements.

◆ Encourage your children to ask questions. You might ask them to signal you when they cannot understand or hear what is being said.

Including All Children: Looking

When you are selecting books, keep in mind that there will be children in your classroom with visual impairments. We must strategically find ways for these children to be able not only to see the illustrations in this book, but to see the text as well. Stanley (2000) suggests the following ideas for meeting the needs of your children with visual impairments:

◆ Use oversized big books, holding them at child's eye level. This may mean you have to get out of your rocking chair and sit on the floor with the children.

◆ Consult your school librarian to locate sources for ordering books with large print or special visual cues.

◆ Scan illustrations in some of the favorite books onto transparencies so that you can project them on a large screen in the classroom.

◆ Explore the Internet for appropriate picture books that you can show through a TV viewer.

◆ Include "touching" books that have tactile representations of the illustrations of photographs. If these books are beyond your budget, bring in supplementary materials to provide children a means for touching (Stanley, 2002, p. 2).

Including All Children: Speaking

Follow the lead of your children by establishing dialogue and planning activities that reflect the children's interests. The development of language skills is best facilitated when it is used for a real purpose *and* when language is an integral part of all the activities in your classroom. Tompkins and Hoskisson (2005) recommend the following strategies for enhancing language development in all children:

◆ Include all children in conversations. Conversations have social as well as instructional purposes, and as children engage in conversation, they build a sense of community and a climate of trust.

◆ Use smaller groups. Some of your children may be more comfortable talking in small groups and more successful in small-group conversations. For example, they might be more articulate when talking about a book or a poem to a small group rather than to the whole class.

◆ Use manipulatives. Many children find it much easier to talk when they are talking about an object they are holding.

◆ Use drama projects. Encourage children to use puppets to tell stories or to carry on conversations between puppet characters. Involve your children in learning fingerplays and other dramatic activities such as role-playing and improvisation.

◆ Always speak naturally to children with language delays and make sure neither you nor any other child in the classroom talks down to them.

◆ Encourage your children who speak English as a second language to share their native languages through songs, stories, or books that reflect their heritage and culture.

◆ Plan for activities that pair an English-speaking child with an English as a second language (ESL) child. Hester (1987) tells us that this is one of the best strategies for helping ESL children learn English. More often than not, children can understand each other long before their teachers and other adults can. This should be easy for you to arrange, and it also will help you to move away from teacher-directed conversations.

Of course, everything that happens in your classroom will facilitate the development of language if you provide an accepting environment in which children feel free to talk. Provide them with many opportunities to talk about interesting things, and make sure that there is active involvement on both your part and the part of your children. The section that follows provides additional guidelines for establishing a language-rich environment for all of the children in your classroom.

Children's Literature and Storytelling

Tell Me a Tale: A Book About Storytelling by J. Bruchac, Harcourt Children's Books, 1997.

Twelve stories from around the world, including excellent sources of stories from the Native American tradition.

From Sea to Shining Sea: A Treasury of American Folklore and Folk Songs by A. Cohn, Scholastic, 1993.

Songs and stories reflecting America's diverse cultures within the context of the history of America. Includes work by 15 Caldecott Award–winning artists.

Wonder Tales from Around the World by H. Forest, August House, 1995.

A collection of 27 time-honored tales from every continent, lacing them with lively prose, rhyming refrains, and useful source notes.

Processes and Materials for Using Literature with Children

Young children are constantly responding to language in oral form through conversations, dramatic play, singing, and stories. They are also learning about language in its written form as they encounter signs, labels, and magazines in a print-rich environment, and as they watch while listening to adults read stories or use books to find answers to children's many questions. In the early stages of literacy development, children need teachers who can make stories, poems, and books come alive with excitement and pleasure. We must invite children to respond to literature by becoming active participants in using literature in a variety of ways. This section introduces some ideas for using literature that allow children to hear and respond to the literacy environment you create in your classroom.

Storytelling with the Flannelboard

Storytelling is truly an art form—an enthusiastic teacher telling good stories with facial expressions, gestures, words, and eye contact can have children almost spellbound as they listen intently. As a beginning storyteller, you may not yet have the confidence to sit before a group of children and tell a story without the usual props or books, so it is perfectly legitimate for you to develop the expressive art of storytelling at a place that will be enjoyable for your children and rewarding for you. Flannelboard storytelling seems to fall about midpoint on the continuum between

A child-size sofa or couch allows children to sit comfortably when reading.

reading a book to children and the intimate, personal, and direct quality of story-telling. When good stories come to life on the flannelboard, children receive immediate sensory impressions and use their own imaginations to make the story their own. A good story, accompanied by flannelboard figures, easily captures the attention of children. Children will shift positions and move around until they have a perfect view of the flannelboard. All the while, they will be using their own imaginative power to interpret and understand the story. And you will be practicing the art of storytelling and developing confidence in your own potential for becoming a master storyteller.

Constructing Flannelboards

Story characters and props for flannelboard storytelling can be made in a variety of ways. Medium-weight interfacing is especially useful because you can lay the interfacing over a book illustration and see the illustration through the transparent fabric. Use a pencil to trace the outline of the characters and props. Once you have the outline, use crayons or nontoxic markers to add color and dimension to your pieces. Flannelboard pieces made with interfacing are strong, and they do not tear like paper figures. They will adhere to almost any fabric or cloth surface. When I tell a flannelboard story to a group of children, I often place the flannelboard characters and props on the children's clothes. They become very involved in the story, and before it is over, the children have "become" the character or prop I placed on the board!

Another ideas that works well with young children is to use small magnet strips that can be cut and used on paper or cardboard pieces and then attached to a metal cookie sheet. Use small cake pans or pizza pans as individual magnet boards or as

theme-specific magnet boards in individual learning centers (Paciorek, personal communication, 1995). Children can make their own characters and can retell stories, too. Encourage them to draw and cut out their pieces and stick a small piece of the magnet strip to the back of each piece to tell their own story. Keep the cut-out figures in a flat box or folder, and let the children use them for their own storytelling experiences.

Interfacing, paper, and cardboard are not the only materials that can be used to make flannelboard activities. Felt in a variety of colors is also durable. You can trace characters and props from coloring books (one of the few good uses for coloring books) onto the felt and then cut them out. These drawings are usually line drawings that are easily traced and colored. For embellishment, you can add pieces of other material, glitter, yarn, or contrasting fabric. Remember, though, that the more you add to your flannelboard cut-outs, the heavier they will be. Heavy figures fall off the flannelboard and disrupt the flow of the story. It can be very frustrating to both you and your children when the flannelboard characters keep falling off the board!

There are some general guidelines to follow when preparing a story for children. Let's look at these guidelines from two perspectives: the art of storytelling and procedures for using the flannelboard. Once you have selected your story, consider the qualities of good storytelling. Figure 8–5 covers the basics of storytelling with the flannelboard.

Besides being aware of how to tell a story well, you must also consider how best to handle a flannelboard. Make sure the flannelboard is located in a stable position. If the board is placed on a table, bump the table or shake it slightly to make sure that the flannelboard cannot fall or tip over. Check to make sure that you have all of the characters and props. Place them on a flat surface out of the children's view and in the order you will place them on the flannelboard. Practice telling the story

FIGURE 8–5 Using a Flannelboard to Share Stories

- Read the story several times until you are thoroughly familiar with the sequence, the main ideas, and the characters in the story.
- Practice telling the story aloud. You don't have to know the story word for word, but you must know key words or phrases that are important to the story line.
- Practice telling the story in front of a mirror and be aware of your facial expressions, gestures, and voice intonation. See if you can maintain eye contact with yourself throughout the storytelling process.
- Record yourself on a tape recorder as you tell the story. Try different voices for different characters, and change the intensity and pace of your words as you move from one part of the story to another.
- Encourage the children to become involved in the story when there are repetitions or when the story calls for actions.
- Before you start telling the story, make sure that all of the children have room to sit and that they can all see and hear you.
- If the children are clearly not interested in the story, end it very quickly and move to another activity. This last step seems to be the hardest for some teachers, especially after they have worked so long on making the flannelboard figures. You may find it difficult to believe that your children do not like or appreciate all the effort you put into preparing for the story, but you can put the story away and present it at a later time or to a different group of children.

as you place the characters and props on the flannelboard. Pay particular attention to placement, available space, and location of specific figures.

Quiz Cards

Quiz cards are easy-to-make visual aids that allow a story to continue long after it has been read. In addition to being a type of literary puzzle appropriate for young children, quiz cards can also be used to encourage children to use their imaginations. Quiz cards can be used by the children in a learning center or in teacher/child interactions. My own kindergarten children used to anticipate quiz-card riddles and looked forward to guessing the answer to a question.

You can make quiz cards for many of the books you read to children. If you make just one quiz card every few weeks, at the end of the year you will have prepared some very special materials that can be used by the children in your classroom for many years to come.

You will need the following materials for making quiz cards:

- tagboard
- books with illustrations large enough to trace
- pencil carbon paper
- colored markers (nontoxic, water based) or crayons
- laminating film or clear Contact® paper
- scissors

Learning to read begins in a print-rich environment long before children can decode words.

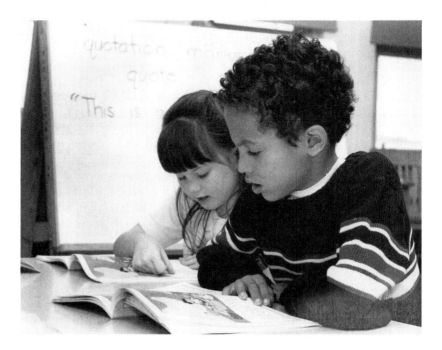

Procedure

1. Cut tagboard into a 14-inch by 7-inch sheet. Then fold the sheet so there is a 6-inch long overlay and a 2-inch margin on the underlay.

2. Select an illustration from the book you plan to read. Place a piece of pencil carbon paper on the tagboard underlay, and place the illustration you want to trace on top of the carbon paper. Carefully align the illustration so that when the quiz card is closed, part of the illustration will be visible on the right side of the underlay. This is especially important for nonreaders, as these children will use the picture clue to guess the title of the book or the answers to other questions you might decide to ask. Use a pointed tool, such as a cap from a ballpoint pen, to make an invisible tracing over the outline of the book illustration. Be sure to press down firmly. When you have traced over the outline of the book illustration, remove the pencil carbon paper. You now have the outline of the illustration on the underlay of the quiz card.

3. Use felt-tipped markers or crayons to color in the outline and make it more representational and similar to the book illustration.

4. On the front of the card, write a simple question that you can ask your children or that they can ask each other. You might ask them to "guess" the name of the book, the identity of the characters, or other questions. When the quiz card is closed, your children will use the part of the illustration that is visible to decide the answer (see Figure 8–6). For example, "Who were the Bremen Town Musicians?" would be a very simple question for very young children. A small part of the illustration representing the answer shows on the underlay. In this case, the part of the illustration that your children see would be the legs, ears, tail, or other body parts of one or several of the animal characters described in the story.

5. When you have finished the illustration and have written the question on the front of the quiz card, cover the card with clear Contact® paper. Laminating also adds durability to the cards, but laminated material will crack or come apart after a few years.

I still have the original quiz cards that I made years ago. Hundreds of children and college students have enjoyed them, and they are in the same condition as they were when I made them. As the year progresses and more of your children are reading and thinking at higher levels, you can prepare quiz cards in which the illustration is not visible when the card is closed. You can also design higher-level questions that address more than memory and recall. And let's not forget your creative children. Place the materials for making quiz cards in a center, and wait and see what new ideas your children come up with for making their own cards.

After you introduce quiz cards with the stories to which they refer, place them in centers for children to use just for fun. The following stories seem to lend themselves very well to quiz cards: "The Three Little Pigs," "The Elves and the Shoemaker," "The Bremen Town Musicians," "The Fisherman and His Wife," "Rapunzel," "Rumpelstiltskin," "Little Red Riding Hood," "Jack and the Beanstalk," "Peter and the Wolf," "The Three Billy Goats Gruff," "The Ugly Duckling," and "Hansel and Gretel."

FIGURE 8–6 Quiz cards challenge children to interact with literature and extend their experiences with the stories you share.

Poetry

> Poetry ennobles the heart and the eyes, and unveils the meaning of all things upon which the heart and the eyes dwell. It discovers the secret rays of the universe, and keeps us immovably centered.
>
> Dame Edith Sitwell, British poet, 1887–1964

The sharing of poetry, whether with children or other adults, is intrinsic to the development of the imagination and the celebration of our humanness. When we listen to poetry, through the sensuous use of language, we experience the illusion of being in the presence of the event about which the poem is written. The reader of a poem is made aware that the experience of every event by every individual is a unique occasion in the universe and that at the same time this uniqueness is the universal mode of experiencing all events.

When reading poetry to children, you should read the poem as though it were the most important piece of literature in the universe. Collom and Noethe (1994) suggest that we use poetry as a force to pull children's imaginations into the world of words and ideas. Something rare and wonderful happens when we read poetry to children; they settle into a "dreamy concentration [as they] daydream and let their minds fill with the images that the poet gives them" (p. 1). Approach the reading and writing of poetry with the same interest and sensitivity as you approach reading stories and storytelling. Your job is to build bridges between the ways children play with words, invent words, and experiment with rhyme and the wealth of poetry that is available to young children.

There are more poets writing for children today than ever before, and good poetry books are available for children of all ages. In a classic study of highly circulated volumes of poetry for children, Kutiper and Wilson (1993) found that Prelutsky's *The New Kid on the Block* (Greenwillow, 1984) and Silverstein's *Where the Sidewalk Ends* (Harper and Row, 1974) and *A Light in the Attic* (Harper and Row, 1981) were the dominant titles circulated in each of the schools in their study. The power of these two poets to write about familiar, everyday occurrences with a perfect measure of humor, combined with the effective use of rhyme, rhythm, and visual imagery, appeals to children, and they love these poems. Is there anyone among us who has not thought about all the reasons for staying home from school that Silverstein's character recites in "Sick?" When we read Prelutsky's "Oh, Teddy Bear" from *The New Kid on the Block*, are we not transformed back to our childhood and the memories of our beloved teddy bear? It is during these poetry moments that adults and children can put the world on hold for a while and pay attention to the intimacy of our inner life by letting the words of the poet come inside.

Children seem to have a natural affinity with poetry, and we can make poetry reading and writing arduous or self-enriching for young children. Because we want the poetry experience to touch children in imaginative and poignant ways, we must *plan* for poetry. The guidelines presented in Figures 8–7 and 8–8 are recommended as a way to help you gain confidence in your ability to present poetry to children.

If you do not already have one, get a library card from the public library and check out various poetry books by Shel Silverstein, Sandra Martz, Maya Angelou, Robert Frost, Robert Louis Stevenson, and Langston Hughes. Select a few of the poems that seem to touch a chord in your life, and bring them to class for a poetry reading.

FIGURE 8–7 Reading Poetry to Children

◆ Read poetry aloud every day to help you and your children enjoy the sounds and rhythms of the poetic form. All poems should be good enough to stand up under repeated readings.

◆ Select poetry that presents sharply cut visual images and contains words that are used in fresh, novel ways.

◆ Select poetry that can stand alone and doesn't require extensive explanations. The poems you select should not have been written down to children's supposed level.

◆ Write poems on charts and hang them around your room.

◆ Design a unit on poetry and read a collection of poems. Encourage your children to respond to the poems by talking informally with you and with each other.

◆ Poetry should encourage children to interpret, to feel, and to put themselves in the experiences of the poet. The subject should say something to children, "strike happy recollections, or tickle their funny bones" (Norton, 2002, p. 317).

◆ Use art, drama, and music activities to extend your children's interpretations of a favorite poem, but remember to keep the focus on the poem. Art, music, and drama should support the poem, not take the place of it.

Sources: Based on Norton, 2002; Tompkins & Hoskisson, 2005; and Webre, 1993.

FIGURE 8–8 Writing Poetry with Children

◆ Before inviting children to write poetry, you must give them many opportunities to listen to poetry. Children need time to hear poetry so that they can remember, imagine, and experience a wide variety of poetic forms and poets' styles.

◆ There are no poetry rules that children must follow, and no poem is a failure. Poetry does not have to rhyme, and while you should not forbid your children to write rhyming poems, rhyme must never be imposed as a criterion for writing poetry.

◆ Poems can take any shape and be written anywhere, and with anything, on a page of paper. Poems can also be about anything; they can be serious or silly. Topics should originate in the feelings and experiences of your children.

◆ Children can write collaborative poems in which each child contributes a line for a small-group collaboration. You can record the poem by writing their ideas on chart paper, much in the same way you would record a language experience approach to story writing.

◆ Individual compositions usually follow a collaborative effort. It is, however, crucial to remember that children become motivated to write poetry only when they have had many opportunities to develop their awareness and to stimulate their senses and imaginations. Take your children for a walk outdoors, smell the air in fall, listen to the city sounds of cars and buses, touch trees and the earth, and feel the heat as it radiates off hot asphalt or sand, and then allow them to use words to describe what they see, hear, and feel. Sometimes they will become inspired by what other children say about their experiences, and in the process, they may want to borrow someone else's thoughts, ideas, and words. When this happens, you should celebrate this sharing and borrowing, as it is perfectly appropriate.

Sources: Based on Cecil & Lauritzen, 1994; Norton, 2002; Tompkins & Hoskisson, 2005; and Webre (1993).

In my own experiences as a poet, I have come to realize that there is a lot of room for individual styles and that we all write in the only way a poet can write—from the heart. When we censor our attempts at creating poetry, we are not being true to what we imagine in the "here and now" of the poem's message.

The following poetic forms are presented as a type of poetic scaffold, or a formula for your children to see images, words, and combinations of ideas to create poetry. Do not interpret these suggestions too rigidly. "Some forms may seem more like sentences than poems, but the dividing line between poetry and prose is a blurry one, and these poetry experiences help children move toward poetic expression" (Norton, 2002, p. 433).

In their book that is rapidly becoming a classic in the study of language arts, *Language Arts: Content and Teaching Strategies* (2005), Tompkins and Hoskisson expand on the ideas of poet Kenneth Koch by describing how he developed simple formulas to make it easier for young children to become poets. I am including some of those formulas here for you to consider using with your own group of budding poets. (For additional information on helping your own group of children become successful poets, I recommend that you consult some of the authors mentioned in this section, whose works are referenced in appendix 1. They are all respected experts.)

"I Wish . . ." Poems

A simple-formula poem idea is to have children begin each line with "I wish" and complete the line with a wish. In the Men Rev Elementary School, Jane Schuler's six-year-olds composed an "I wish" poem that reflects their thoughts and feelings about being in first grade.

> *I Wish*
> I wish we had more blocks.
> I wish that it was my birthday.
> I wish I could go to the beach and play.
> I wish I could fly like a sea gull.
> I wish I could paint all day.
> I wish Mrs. Schuler would come tell me a story.
> I wish I had my own cubby.

Color Poems

When using this poem idea, children select a color and either begin each line of their poems with that color or choose a different color for each line. They can also use words to describe what a particular color means to them. In Jane Schuler's first-grade classroom, her children wrote about the color black and created the following poem:

> *Black*
> Black is like my puppy
> except he is mostly white.
> Black is the sky
> when the moon hides behind clouds.
> Black is on my shirt

and there's red and yellow too.
Black is the same name as Mr. Black,
he takes care of me and my sister after school.
Black is the color of my room at night
before my mom opens the door.

"If I Were . . ." Poems

In "If I were . . ." poems, young children imagine what it would be like to be something or someone else—a sailboat, a penny, or a star. Each line of the poem begins with "If I were" and tells what it would be like to be that object or person. The following poem was written by a neighbor of mine. Seven-year-old Gabrielle describes what she would do if she were a paintbrush.

> *If I Were a Paintbrush*
> I would paint the world
> With pink and yellow and blue.
> And I would sail around in my balloon,
> And all the world would be a
> Rainbow.

You can introduce all of these ideas for poetic scaffolds as ways of ensuring that your children gain immediate success in poetry writing. Of course, for your children who have not mastered the art of writing, you will have to capture their poems in written form or on a tape recorder. The important thing to remember is that poetry is what happens when we loosen our spirits and let go with words. Eleanor Farjeon (1956) said it most eloquently when she penned the following words:

> What is poetry? Who knows?
> Not a rose, but the scent of the rose.
> Not the sky, but the light in the sky.
> Not the fly, but the gleam of the fly.
> Not the sea, but the sound of the sea.
> Not myself, but what makes me
> See, hear, and feel something that prose
> Cannot: and what it is, who knows?
> This, my fellow learners, is how poetry is born.

Exploring Literature Through a Multicultural Context

Multicultural literature includes literature that addresses cultural themes and characters from many groups of people. It also includes religious and regional themes. Multicultural literature focuses on people whose identities, contributions, and histories "have been omitted, distorted, and undervalued in society and school curriculm" (Bishop, 1997, p. 3).

It is very important that all students see reflections of themselves and their lives not only in school settings, but in the curriculum as well. Literature contributes to

the children's understanding of how they see themselves and how other people see, view, and value them. "Literature is recognized as a key tool for increasing cultural awareness; it must be carefully selected to reflect accurate customs and values of specific culturally diverse groups" (Norton, 2005).

In thinking about children's literature and the importance of sharing oral, written, and visual stories from around the world, I immediately thought about all the richness and beauty of the many languages, both written and spoken, that we see and hear all over the planet. Knowledgeable teachers understand the importance of surrounding children with a variety of language experiences to promote literacy. We should also provide opportunities for children to hear and see languages that differ from their own. Exposing children to many languages encourages them to think about other cultures and to gain an understanding of the differences and similarities among the world's people. Books are ideal for introducing children to stories about other children who may seem different on the outside, but who have similar feelings on the inside. Children who see evidence of their life and learning experiences mirrored in the books they read gain an affirmation of themselves and their identities (Taylor, 2000). The next section addresses two different types of "languages" that can provide knowledge and information about children in Egypt and children of Native American decent.

Egyptian Hieroglyphics

This section introduces Egyptian hieroglyphics as a way of exposing children to an ancient form of writing that can promote children's delight in discovering a new way to use the letters of an alphabet.

About 5,000 years ago the people of Egypt began drawing simple pictures to represent the objects around them and the sounds that they heard. This was one of the very first forms of writing, which was written on papyrus scrolls using colored inks and pens. There were about 750 different hieroglyphics, mostly representing people, animals, plants, and other objects.

Although hieroglyphics were mainly used to tell stories and communicate ideas, they also present an interesting art form. The colors that the Egyptians used also made the writing look like an art form rather than just a form of communication. Reds, blues, greens, and browns were used, all of which came from the soil or ground up minerals. They also used gold dust!

The manner in which you use hieroglyphics with your children depends on the ages of the children and their understanding and knowledge of the alphabet. Children who have mastered the alphabet can have fun writing their names or the names of their friends in this ancient language. The process involved in this activity borrows from the movable alphabet we see in most Montessori classrooms.

ACTIVITY 8–1

Writing Your Name with Ancient Egyptian Symbols

Trace (or draw freehand) each individual symbol of the Egyptian hieroglyphic alphabet on a card. Make sure you have at least 10 cards of each letter. When children work with these in centers they will need enough cards of all the symbols to

FIGURE 8–9 Alphabet
Cards

F and V are the same
U and W are the same

FIGURE 8–9 (continued)

Alphabet Cards

Example of Name

"write" their names. Next, on the back of each card write the corresponding letter of the English alphabet. For example, write the letter *D* on the back of the card that shows the hieroglyphic hand symbol.

Introduce the process to the children by showing them how to arrange the cards to spell out their names using the English alphabet. Then the children can turn the cards over to see how their names are spelled in Egyptian hieroglyphics. Put all the cards in a box or other container along with a photocopy of the full Egyptian hieroglyphic alphabet (see Figure 8–9) and add it to your language experience center. Older children might want to actually copy the symbols on paper so have colored chalk and markers available. It is inappropriate, however, to ask young children to reproduce exact copies of these symbols because it is too rigid and too tedious and requires a skill level too high for their age level. My belief is that only rarely should an art form be literally copied.

Native American Picture Symbols

Native Americans have a rich and celebrated culture to share. Their values, languages, foods, clothing, music, art, and recreation have been well documented over the past 200 years. Using multicultural books to support the study of Native American culture is essential when helping young children "learn that beneath surface differences of color, culture or ethnicity, all people experience universal feelings of love, sadness, self worth, justice and kindness" (Wilms, 1991, p. 4). A myriad of books written by Native Americans provide valuable insight into the various native cultures in ways that young children will find interesting. The following books are only a few of the

many culturally correct works that teachers can use to accurately reflect, affirm, and legitimize native cultures, while bridging literature-based reading experiences with other content areas (McMahon, Saunders, & Bardwell, 1996–1997).

Native American Books and Extended Activities

dePaola, T. (1978). *The Popcorn Book*. New York: Holiday House. Popcorn was discovered by native people many years ago and provides a natural connection to American Indian culture and children of all ages. This book reveals interesting facts about the popular snack and includes two recipes for making popcorn.

Clark, A. N. (1991). *In My Mother's House*. Illustrated by V. Herrara. New York: Viking Press. This is a collection of stories and poems created by American Indian children. The illustrations are beautifully rendered in both color and black and white. Tewa of Tesuque Pueblo describes his people's homes, customs, and work habits along with their strong communal spirit.

Harrell, B. (1995). *How Thunder and Lightening Came to Be: A Choctaw Legend*. Collages by S. L. Roth. New York: Dial. This is the story of two birds, Heloha and Melatha, who accidentally create thunder and lightening as a way to warn their people of rainstorms.

There are many ways to create rain and thunder and lightening in the classroom; however, one of the best and most fun ways to create this magic is to use your fingers and the children's fingers to "make rain."

Making Rain

Begin by asking the children to sit in a circle and tell them that you will look at them when it is time to make a sound (with their fingers or hands) and you will look at them again when it is time to change the sound. Start making the sound that comes from brushing your hands lightly together. Once all the children are making the same sound, look at a child and change your sound and motion to a snapping sound (snap your fingers together) and keep these sounds going on around the circle of children. Next, tap your hands to your knees to make the sounds of beginning thunder. Keep this up until all the children are making "thunder." Finally, slap or beat an object (books, bells, cymbals) or the floor to make the loud sound of lightening. Once you have created "rain" reverse the process until the rain stops and the room is quiet once again! If your children are old enough to handle a flashlight, give one to a couple of the children to create lightening by flashing them off and on. This truly creates a room full of rain and thunder and lightening!

The next section will introduce you to the process of writing messages using Native American picture symbols. You and your children can use these symbols in much the same way as you used the Egyptian hieroglyphics, or you might want to be more creative and design and implement your own ideas for using Native American picture symbols in the classroom.

Native Americans use symbols in their language to write and to express themselves. They paint symbols on many things, such as their clothing, shelters, pottery, and even their bodies. Colors mean certain things to Native Americans, and they make colored paints from charcoal, berries, roots, clay, moss, and other things in nature.

ACTIVITY 8–2

Writing Stories with Native American Picture Symbols

Introduce the Native American picture symbols to the children by showing them the symbols in Figure 8–10. These symbols should be enlarged and displayed at child eye level. It is a good idea to put each symbol on a separate card or piece of paper so that the children can arrange them in the same way that they would arrange words for constructing a sentence. Encourage the children to play around with the symbols by arranging and rearranging them so that they begin to form a story. For example, place the picture symbol for walking first, then place the symbol for mountain to the right. Next, use the symbol for sleeping, and as the last symbol in the story add the symbol for horse. Then read the story to the children; it goes like this: "The little boy walked over the mountain for a long time. He got so tired that when he came down from the mountain, he went to sleep. The next time he went mountain climbing he took his horse with him so he would not have to walk." See how many stories you can write before you ask your children to do the same. You might even show one of your stories to the children as you read it and point to each symbol. Remember that symbols are placed left to right, just likes words in a sentence.

Native American picture symbols can be used by children who have not yet learned the alphabet or who do not know many words. You can be as creative as you want to be when using these symbols; just remember that children invent their own stories based on their own experiences, so do not make them invent stories based on yours.

FIGURE 8–10 Native American Picture Symbols

Now let's get back to Levi, his question about flying girls, and unit development. What follows is a brief description of the process we went through when designing a literature-based unit integrating literature, the visual arts, music and movement, and drama. Specific examples include brainstorming association, webbing, compiling resources, and planning activities. You already know, of course, that a unit must also include goals and objectives, lesson plans, and methods for evaluation. (Because this section is not about the how-to's of unit development, but rather is an example of integrating the arts and literature, there are no goals, lesson plans, or evaluations included in the discussion.)

Linking the Arts Through Literature: An Interdisciplinary Unit

Our sample unit, entitled Imagination, links the disciplines of music and movement, the visual arts, and drama through children's literature. It represents the collaborative planning of two teachers to connect ideas that exist among the artistic forms presented in this book. The unit is designed as a *framework* within which children can express and communicate a variety of thoughts, ideas, and feelings through their own interpretation of the visual and performing arts. We like to use the word *framework* because it suggests that although it is the teacher who usually begins the development of unit design, there should be equally as much input given by the children. Also, remember that there are as many methods for developing units as there are topics to be covered. We chose the process that seemed to work best for us. Although we describe the method of planning that we used, we encourage you to change it, modify it, or use an entirely different process if you already have one that works well for you.

Selecting a Theme

This was an easy task, because Levi and his classmates had shown great interest in *Tar Beach* and the illustrations that so vividly paint a picture of a little girl who can fly. We also knew that she was using her *imagination* to accomplish these amazing feats of flight, so we decided to look for other books that related to young children using their imaginations. We selected the following books to form the focal point of the unit:

◆ *Amazing Grace* by Mary Hoffman, illustrated by Caroline Binch, Dial Books for Young Readers, 1991. A young girl imagines that she is Joan of Arc, Anansi the Spider, a pirate sailing the seven seas, and other whimsical and historical characters. When she decides to try out for the part of Peter Pan in a school play, she has her first encounter with race and gender stereotyping.
◆ *Wilfrid Gordon McDonald Partridge* by Mem Fox, illustrated by Julie Vivas, Kane/Miller Book Publishers, 1984. Wilfrid spends his days visiting people who live in an old people's home that is right next door to his house. He

uses his imagination to gather objects to give to the old people so that they can once again have the memories they have lost.

♦ *Ben's Trumpet* by Rachel Isadora, Mulberry Books, 1979. Ben loves to hear the Zig Zag Jazz Club musicians play, filling the air with the sounds and rhythms of jazz. When he hears it, he plays along on a trumpet that nobody else can see. When some of the neighborhood children laugh at him and say things like "Man, you're crazy! You got no trumpet!" the trumpeter from the club invites Ben to come to the club and opens the door to his dream.

♦ *My Head Is Full of Colors* by Catherine Friend, illustrated by Kiki Oberstenfeld de Suarez, Hyperion Books for Children, 1994. Maria awakes one morning and imagines that her normally spiky brown hair has been replaced by all the colors in the rainbow. Her head is full of colors, and on this day she draws and paints like never before. The following morning, she imagines that her head is full of books. They tell her about faraway places, creepy spiders, and rockets that fly to the moon. Before long, her head is full of animals and then people. One day Maria awakes to find her head is full of everything wonderful that is just her.

♦ *And Shira Imagined* by Giora Carmi, The Jewish Publication Society, 1988. Shira and her parents visit Israel. They go first to Tel Aviv. "Imagine, this city appeared like a miracle out of the sand," her mother says. And Shira imagines. All the stuffed animals from her bedroom back home in America join her in her imagination, appearing with buckets, ready to build castles in the sand. Wherever the family goes, Shira imagines. And when she imagines, her animal friends are with her.

♦ *Tar Beach* by Faith Ringgold, Crown Publishers, 1991. Cassie Louise Lightfoot has a dream: to be free to go wherever she wants for the rest of her life. One night, up on "tar beach"—the rooftop of her family's Harlem apartment building—her dream comes true. As Cassie learns, anyone can fly: "All you need is somewhere to go you can't get to any other way. The next thing you know, you're flying among the stars."

We chose these particular books because of their enchanting stories and illustrations, *and* because they represent diversity in ethnicity, environments, settings, gender, race, and age.

Brainstorming Associations

During an evening spent reading these books, we found ourselves being tickled and delighted with the imaginary powers of the story characters. We knew that if we did not find the books to be pleasing, the children would not either! After we read each book, we had a free-association, brainstorming session, during which we listed every thought and idea that came into our minds. Figures 8–11 and 8–12 represent the end result of our brainstorming sessions on *Tar Beach* and *Ben's Trumpet*, respectively.

FIGURE 8–11 Words and Ideas Associated with *Tar Beach*

Personal Dreams
Blankets
Stars
Food
Bridges
Tar
Buildings
Girders
Families
Tables
Watermelon
Jobs
Neighbors

Siblings
Flying
Quilts
Clotheslines
Cities
Boats
Diamonds
Soaring
Flights
Sleeping
Factories
Gifts
Playing Cards

Floodlights
Skyscrapers
Construction
Jobs and employment
Indian
Ice Cream
Chicken
Peanuts
Rooftops
Nighttime
Beds
Mattresses
Parties

Webbing as a Creative Process

The *process* of developing a unit, and especially the time spent in designing the web, is the heart and soul of planning. It is also the process that gives insight into how you and your colleagues can design units that are different from, and better than, the traditional compartmentalization of content areas that I see so often in the units of beginning or inexperienced teachers.

A process approach to unit design and webbing is not unlike the creative process that occurs when we engage in *any* creative endeavor. *Preparation* involves gathering information; in this case, Levi and his classmates wanted to know about imaginary flying. Once we identified the purpose and nature of the unit, we selected books that focused on the imagination and began brainstorming associations between the story and illustrations of the books and our topic, Imagination. You can see from our lists that we had plenty of information to begin tackling the task. *Incubation,* letting ideas develop or letting go of direct concentration on the task at hand, occurred when we became so absorbed in the story line and characters in the books that we found ourselves talking about the talent and sensitivity of the authors and illustrators. That, in turn, led to a lively discussion about what kind of children's book we would like to write. Our energy moved, if only momentarily, from the task of designing a unit to admiring the beauty and wonder of such masterful writing and painting and whether or not we had the talent and skill to write similarly excellent books! We experienced *illumination* a few days later, when we realized that all of the elements were coming together and that we were being true to our own beliefs that support children's rights to make choices about

FIGURE 8–12 Words and Ideas Associated with *Ben's Trumpet*

Jazz
Trumpets
Rhythm
Zig Zag
Beat
Blues
City
Nighttime
Dreams
Wishes
Jazz Clubs
School
Piano

Practice
Sax
Trombone
Drums
Movement
Cat's Meow
Sounds
Families
Grandmothers
Siblings/Brother
Playing Cards
Playing instruments
Stoops

Patterns
Buildings
Peer Pressure
Imagination
Sadness
Dancing
Listening
Adults
Children
Musicians
Friends
Teaching
Outlines/Contours
Black and White

entering into activities that are appropriate for them as individuals. We had discovered a way for children to *choose* from a variety of activities, their own ways of exploring imagination. This "aha" moment was exciting and challenging because we had come full circle in realizing that Imagination could be presented in many ways and through many avenues. Our efforts were finally paying off, and our ideas were making a great deal of sense. The process of *verification* will occur in the future, after the unit has been implemented and evaluated by the kindergarten teacher at the Early Childhood Development Center. We might have to rethink, refine, redo, and rewrite (Balkin, 1990), but for teachers of young children, that comes naturally with the territory!

Review the web in Figure 8–15, and select one of the books represented. Look at the ideas listed under music and movement, three-dimensional art, drama, and literature, and for each category design an activity that is process-oriented and developmentally appropriate for a group of six-year-olds.

Webbing as a Way of Planning

As we looked at our brainstorming lists on *Tar Beach* and *Ben's Trumpet*, we continued the process by grouping the items into the categories of visual arts, drama, and music and movement. We also noticed that other categories—ones that we had not thought of initially—were emerging that could be classified as subcategories, such as families, role models, travel, and affect. The possibilities for this unit seemed to be limitless. However, we wanted to stay true to our goal, so we took note of these categories (so we would not forget them) to incorporate

FIGURE 8–13 Ideas from *Tar Beach* Categorized into Content Areas

Personal Dreams- ART/AFFECT
Blankets- DRAMA
Stars- ART
Food- DRAMA
Bridges- ART
Tar- ART
Buildings- ART
Girders- ART
Families- DRAMA
Tables- DRAMA
Watermelon - ART/DRAMA
Jobs- DRAMA
~~Neighbors- AFFECT~~
~~Siblings - AFFECT~~
Flying- MUSIC/MOVEMENT
Quilts- ART
Clothes lines- DRAMA
Cities- ART
Boats- MUSIC/MOVEMENT
Diamonds- ART

Soaring- MUSIC/MOVEMENT
Flights- MUSIC/MOVEMENT
~~Sleeping~~
Factories - DRAMA
~~Gifts- AFFECT~~
Playing Cards- DRAMA
Floodlights- DRAMA
Skyscrapers- ART
Construction- ART
Jobs- DRAMA
~~Indian - AFFECT~~
Ice Cream- DRAMA
Chicken - DRAMA
~~Peanuts~~
Roof tops- ART
~~Night time - AFFECT~~
Beds- DRAMA
Mattresses- DRAMA
Parties - DRAMA

into units we might plan for later in the year. After all, we were responding to a very specific question from an inquisitive five-year-old named Levi!

Figures 8–13 and 8–14 are replicas of our original brainstorming list of words. They show how we categorized the words according to content areas. There were some words and ideas that simply did not seem to relate to literature, music and movement, the visual arts, or drama, so we crossed them off. There is no need to try and force every idea to fit into a category. When this happens to you, just omit those ideas that do not naturally fall into place and let them go.

At this point, the first steps in the process were completed: We had selected a theme, chosen the books, brainstormed associations, and grouped the words on the list into categories. Eventually, a preliminary web took shape, which finally evolved into the more complex web shown in Figure 8–15.

FIGURE 8–14 Ideas
from *Ben's Trumpet*
Categorized into Content
Areas

Jazz- MUSIC/MOVEMENT
Trumpets - MUSIC
Rhythm- MUSIC/MOVEMENT
Zig Zag- MOVEMENT
Beat - MUSIC/MOVEMENT
Blues- MUSIC
City - ART
Night time- ART
~~Dreams- AFFECT~~
~~Wishes- AFFECT~~
Jazz Clubs- MUSIC/MOVEMENT
School- DRAMA
Piano - MUSIC/MOVEMENT
Practice- DRAMA
Sax- MUSIC/MOVEMENT
Trombone- MUSIC/MOVEMENT
Drums- MUSIC/MOVEMENT
Movement- MOVEMENT
Cat's Meow - DRAMA/MUSIC
Sounds- MUSIC/DRAMA

~~Families- AFFECT~~
~~Grandmother - AFFECT~~
Siblings/Brother- DRAMA
Playing Cards- DRAMA
Playing Instruments- DRAMA
~~Stoops~~
Patterns- ART
Buildings- ART
~~Peer Pressure - AFFECT~~
Imagination - DRAMA
Sadness- DRAMA
Dancing- MUSIC/MOVEMENT
~~Listening~~
Adults- DRAMA
Children- DRAMA
Musicians- MUSIC/MOVEMENT
Friends- DRAMA
Teaching- DRAMA
Outlines/Contours- ART
Black and White- ART

Compiling Resources for Learning Experiences

We knew that we wanted to provide children with a wide range of experiences in music and movement, drama, and the visual arts. We looked at each book and decided that it would be appropriate to design activities related to each individual book so that children would have a variety of choices when deciding which art form was most appealing to them. By designing the unit in this way, we knew we could give children hands-on experiences through self-selected activities. In other words, some children could explore their imaginations through music and movement, while others could choose painting or sculpture or dramatization as a way of focusing and exploring their imaginative powers.

We also knew that not all activities would appeal to or, in fact, be appropriate for all of the children, and that we must remain focused on the topic of our theme, Imagination, and use the activities to support the theme. So often when we become so absorbed in the planning process and think of hundreds of things for children to do, the activities take on a life of their own, and we lose sight of why we developed the unit in the first place! We were determined not to let this happen to us.

As you read over the web, note that we have not included any actual activities or the steps involved in implementing a series of activities. In textbooks such as this it is not wise to present a cookbook approach by defining specific activities that suggest the author knows the developmental levels and needs of the children in your particular age group or classroom environment. Therefore, what the web does provide is a framework to get you thinking about how you can take the ideas and use them to design learning experiences that are both relevant and appropriate to the knowledge base of the children with whom you are involved.

Planning Integrated Experiences

As you plan thematic units integrating the arts and literature, include materials and equipment for both individual and group experiences. Give your children a variety of boxes, in many shapes and sizes, to use to create a box sculpture of a tar beach, or have a lump of pliable, moist potter's clay available on a table for the making of tiny bird's eggs like the ones Wilfrid gave to Miss Nancy. Play a lively jazz recording of the great Louis Armstrong and stand back and watch your own musicians at the Zig Zag Jazz Club as they play their imaginary instruments. Read *Anansi the Spider* stories, and invite your children to spin webs; or tell the story of Aladdin, and let your children create their own magic genie. Bring in large, empty ice cream cartons, place them in the block center, and invite your children to build an ice cream factory; or collect the materials your children would need to have a picnic on an imaginary tar beach.

Invite someone from the fine arts department to bring a harp to your classroom, and encourage your children to strum and pluck the strings. Shira heard the harp in her imagination—your children may need to see one before they can imagine what beautiful sounds come from a classical harp. Transform an area of your room into the Big-Sea-Water; use blocks to build canoes and boats, and see whether there is a Hiawatha in your midst. Build sand castles in the sand table and pretend they are being built by your children's favorite stuffed animals, or take an imaginary ride on a tramway to the top of a mountain. Have available many colors of crayons and large sheets of drawing paper. Put the book *My Head Is Full of Colors* on the table next to the art materials, and watch the creative energy of your children begin to bloom and flourish.

Play the soundtrack from *Romeo and Juliet,* and tell your children the name and composer of the music. Grace became Juliet after seeing the ballet with her Nana. There is a strong possibility that you have a Juliet and a Romeo in your classroom! Take your children on a memory hunt around your classroom and find imaginary things that they might want to give to someone who is special in their lives. Imagine warm things, and scary things, things that make children laugh, and things

FIGURE 8–15 Imagination Unit Web

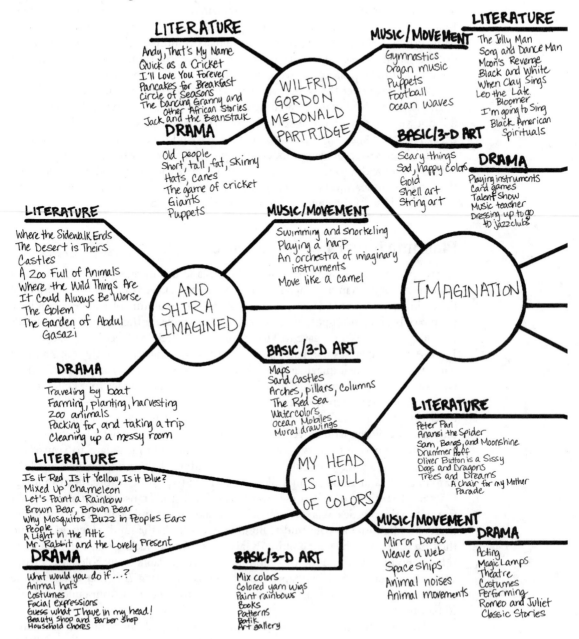

LITERATURE
Andy, That's My Name
Quick as a Cricket
I'll Love You Forever
Pancakes for Breakfast
Circle of Seasons
The Dancing Granny and
 other African Stories
Jack and the Beanstalk

DRAMA
Old people
Short, tall, fat, skinny
Hats, canes
The game of cricket
Giants
Puppets

WILFRID GORDON McDONALD PARTRIDGE

MUSIC/MOVEMENT
Gymnastics
organ music
Puppets
Football
Ocean Waves

LITERATURE
The Jelly Man
Song and Dance Man
Moon's Revenge
Black and White
When Clay Sings
Leo the Late
 Bloomer
I'm going to Sing
Black American
 Spirituals

BASIC/3-D ART
Scary things
Sad, happy colors
Gold
Shell art
String art

DRAMA
Playing instruments
Card games
Talent show
Music teacher
Dressing up to go
 to jazz clubs

LITERATURE
Where the Sidewalk Ends
The Desert is Theirs
Castles
A Zoo Full of Animals
Where the Wild Things Are
It Could Always Be Worse
The Golem
The Garden of Abdul
 Gasazi

DRAMA
Traveling by boat
Farming, planting, harvesting
zoo animals
Packing for, and taking a trip
Cleaning up a messy room

AND SHIRA IMAGINED

MUSIC/MOVEMENT
Swimming and snorkeling
Playing a harp
An orchestra of imaginary
 instruments
Move like a camel

BASIC/3-D ART
Maps
Sand Castles
Arches, pillars, columns
The Red Sea
Watercolors
Ocean Mobiles
Mural drawings

IMAGINATION

LITERATURE
Peter Pan
Anansi the Spider
Sam, Bangs, and Moonshine
Drummer Hoff
Oliver Button is a Sissy
Dogs and Dragons
Trees and Dreams
 A chair for my Mother
 Parade

LITERATURE
Is it Red, Is it Yellow, Is it Blue?
Mixed Up Chameleon
Let's Paint a Rainbow
Brown Bear, Brown Bear
Why Mosquitos Buzz in Peoples Ears
People
A Light in the Attic
Mr. Rabbit and the Lovely Present

DRAMA
What would you do if...?
Animal hats
Costumes
Facial expressions
Guess what I have in my head!
Beauty Shop and Barber Shop
Household chores

MY HEAD IS FULL OF COLORS

BASIC/3-D ART
Mix colors
Colored yarn wigs
Paint rainbows
Books
Patterns
Batik
Art gallery

MUSIC/MOVEMENT
Mirror Dance
Weave a Web
Space ships
Animal noises
Animal movements

DRAMA
Acting
Magic Lamps
Theatre
Costumes
Performing
Romeo and Juliet
Classic Stories

FIGURE 8–15 (continued)

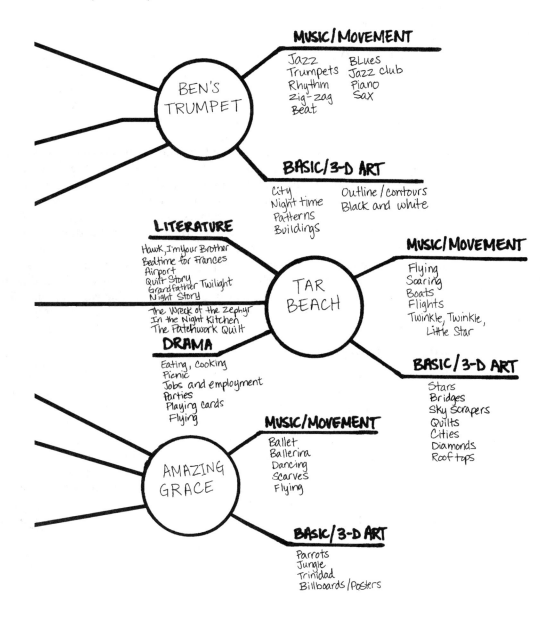

BEN'S TRUMPET

MUSIC/MOVEMENT
Jazz Blues
Trumpets Jazz club
Rhythm Piano
zig-zag Sax
Beat

BASIC/3-D ART
City Outline/contours
Night time Black and white
Patterns
Buildings

TAR BEACH

LITERATURE
Hawk, I'm Your Brother
Bedtime for Frances
Airport
Quilt Story
Grandfather Twilight
Night Story
The Wreck of the Zephyr
In the Night Kitchen
The Patchwork Quilt

DRAMA
Eating, cooking
Picnic
Jobs and employment
Parties
Playing cards
Flying

MUSIC/MOVEMENT
Flying
Soaring
Boats
Flights
Twinkle, Twinkle,
 Little Star

BASIC/3-D ART
Stars
Bridges
Sky Scrapers
Quilts
Cities
Diamonds
Roof tops

AMAZING GRACE

MUSIC/MOVEMENT
Ballet
Ballerina
Dancing
Scarves
Flying

BASIC/3-D ART
Parrots
Jungle
Trinidad
Billboards/Posters

that make them cry. Pretend to be Mr. Drysdale who has a voice like a giant. Imagine what it would feel like to have a head full of animals! What would you talk about if your head were full of books? What do you see when you fly through the shining stars? Play musical recordings from a variety of cultural and ethnic groups. Construct the George Washington Bridge out of Legos® and Tinkertoys®. Make puppets and flannelboard stories to put in your centers.

When collecting materials and planning activities, you *must* make sure they serve as springboards for your children to express *their own* personal ideas about the magic and wonder that grow from their imaginations. You are the facilitator of learning. Your goal is to empower your children by creating a classroom environment in which children have choices and can choose their own path when exploring their imaginations. You want to allow children to use the activities in ways that are personally meaningful and relevant to them. If you require all of the children to participate in all of the activities, you and your children will be missing the many exciting learning experiences that can be created through an arts and literature unit. There are many roles to be played, many drawings waiting to unfold, and many imaginations waiting to be tapped. Look at your children as individuals. Remember the importance of the creative process by planning activities that do not rely on products as evidence of success, and keep Gardner's theory of multiple intelligences in mind every time you plan units for young children.

Implementing the Unit

Read the storybooks we used to plan this unit, and then reconsider, replace, reprocess, and reconceptualize (Balkin, 1990) our ideas so that they are developmentally appropriate for the children in your practicum placement or the children in the classroom in which you are now teaching. Allow a free-association of ideas related to those presented here, and prove to yourself that you are a *fluid* thinker. Explore a variety of ways to change our unit by looking at the needs and developmental levels of your children from many different perspectives. When you do this, you will know you are a flexible thinker. Put a new stamp on what we have written and make it your own—be an original thinker. And, finally, add embellishment and detail to this open window for ideas, and elaborate on the unit in ways that seem to fit your own teaching style.

Once again, it is time to shift the focus and turn inward as we continue to develop those personal and professional skills that are such an integral part of who we are as teachers. I am inviting you to try your hand at writing poetry. The next section encourages you, the adult learner, to become a poet.

PERSONAL AND PROFESSIONAL GROWTH

Imagery is a primary source from which poetry is born. Poetic imagery opens our minds to new ways of looking at the world, and it allows us to ascend to levels of consciousness that we might not otherwise visualize.

Poetry for Teachers

From the hundreds of poetic forms available, I have selected the cinquain, haiku, and cumulative forms to introduce you to your own poetic potential. The *cinquain* (SIN-cane) is governed by specific literary principles that serve as a basis for expressing thoughts and feelings. *Haiku* (high-KOO) is the beloved poetry of the Japanese culture and consists of three lines that contain five, seven, and five syllables, respectively. *Cumulative poetry* is written collectively by a small group of people and has a very simple style and few rules. Once you discover that you are indeed a poet and feel comfortable with your own poetry, you can use cinquain and cumulative poetry with your children.

As you practice writing poetry and become more secure in the knowledge that there are poems inside you just waiting for your voice, you will have begun the process of making poetry writing a regular part of your classroom activities.

Writing a Cinquain

- A cinquain consists of five lines, usually unrhymed, that refer to a particular idea, observation, event, or feeling.
- A cinquain does not make broad, sweeping statements about a particular subject; rather, it describes one idea, one feeling, or one thing seen or observed in the poet's own experience.
- A modified variation that simplifies the cinquain is particularly helpful for beginning poets. The modified principles for writing a cinquain are as follows:
 - First line: one word that names the topic or identifies the title
 - Second line: two words that describe the topic or title
 - Third line: three words expressing action related to the topic or title
 - Fourth line: four words that express a feeling statement about the topic or title
 - Fifth line: one word that summarizes or serves as a synonym for the topic or title

Guided Imagery for Cinquain Find a place in the room where you can sit comfortably or where you can lie down. Keep this book open to the page describing the principles for writing a cinquain, and have pen and paper nearby. When everyone is comfortable and quiet, a volunteer should read the following guided imagery.

> You have found a place in the room where you can lie down or sit comfortably without touching anyone else. . . . Let your body move around a bit until each part finds a comfortable place, then let it settle down on that spot. . . . Close your eyes and turn your attention inward. . . . Be aware of whatever thoughts, words, or images are going through your mind and let them pass.
>
> When your mind and body are quiet and peaceful, imagine yourself moving into a wonderful, safe place. . . . Use your mind's eye to watch this place unfold before you . . . a place that gives you a strong feeling of warm, comfortable, peaceful, relaxed safety. Get a sense of what the area is like. Take time to allow all the details of this place to pass through your mind. . . . See the shapes, spaces, forms, sounds, and presence of your place. When

you have noted the details of this inner sanctuary of your mind, allow your awareness to move from the here and now of this room to the here and now of your own special place.

As you come closer and closer, you recognize something or someone familiar. It could be a person, an object, an animal, a leaf. Whatever it is at this moment, you are the only one who is aware of its identity. Let your awareness be in touch with the feelings you are having and take a few minutes to experience these feelings.

Now stand back and capture this image in your mind's eye. In a moment I will ask you to open your eyes and come back to the here and now of this room. When you are ready, gently open your eyes and, while still holding on to your image, take your pen in hand and re-create this moment in cinquain.

The following cinquains were composed by some students in my graduate creative arts class:

Cat
Grey, white
Purring, looking, listening
She comes to attention
Sentry.

Grass
Brown, dry
Waving, sighing, rustling
Animals snuggle together there
Home.

Friend
Handsome, brilliant
Caring, protecting, nurturing
Delta bring him home
Companion

Cinquains can also be humorous, so do not dismiss an idea or event as the subject of your cinquain just because it reflects your sense of humor:

Exams
Cumulative, difficult
Reading, studying, planning
I am so stressed
Torture.

Write several cinquains and then read them to someone sitting near you. When you have read your cinquain to one person, consider reading it to the whole group. Reading aloud is voluntary, however, and you may choose not to read your poems.

Writing Haiku

Haiku is a poetic form that contains a reference to nature or to something happening in the present experience of the poet. The experience may be part of some-

thing going on around the poet or may relate to an internal emotion or feeling. Haiku *is* a feeling. It is an affective moment found in our common everyday lives, in the small dramas that we experience each day. Ann Atwood (1971), a modern poet and writer of haiku, tells us that haiku is "both simple and profound, constructive and expansive, meticulously descriptive yet wholly suggestive." Haiku is poetry to be savored. When I read haiku, I imagine that I am slowly and with gentle care leaning into the heart and mind of the poet.

A haiku is an unrhymed poem with three lines and a total of seventeen syllables: five in the first line, seven in the second, and five in the third. For example, here is a haiku by the 18th-century Japanese poet Issa.

> If things were better
> For me, flies; I'd invite you
> to share my supper.
> Issa (1763–1827)

Read the following haiku verses contributed by several of my students (who requested that they remain anonymous). These poems illustrate how they use this ancient poetic form to express feelings and experiences with just the right images.

> Seth shares Spring with me
> Eager, smiling, outstretched hand
> Holding a flower.

> Under a blue sky
> Cool grass beneath where I sit
> I'm watching for you.

> Riding through New York
> Flower vendors' colors burst
> Through the bus windows.

As a poetic form, haiku can be very abstract for young children. They will find the restrictive literary principles of writing haiku difficult and frustrating. There have been many well-meaning teachers who have introduced haiku to young children only to discover that instead of encouraging children to capture an emotion through a poetic form, they have directed the children's emotions (usually negatively) toward the process of trying to write a haiku! I have seen young children who did not even know the meaning of the word *syllable* trying their best when their only goal was to please the teacher. Even though you and I may find the haiku to be an exciting and stimulating poetic form, we will all be well advised to leave the writing of haiku to older children and to use the cinquain and other simple poetic forms when introducing poetry writing to young children. We must, however, read haiku to young children. Figure 8–16 serves as an easy reference for you to find books of haiku for further reading.

FIGURE 8–16 Recommended Books on Haiku

Reading haiku to young children can enrich and expand their experiences while providing a source of pleasure and aesthetic awareness. In preparation for reading haiku to your children, read and come to understand and appreciate the beauty and essence of this poetry form for itself. There are four wonderful books that will introduce you to the truth and wisdom found in haiku:

◆ *A Few Flies and I: Haiku by Issa,* selected by Jean Merrill and Ronnie Solbert, from translations by R. H. Blyth and Nobuyuki Yuasa, illustrated by Ronnie Solbert. Pantheon Books, New York, 1969.

◆ *Cricket Songs,* Japanese haiku translated by Harry Behn, Harcourt, Brace and World, 1964.

◆ *Haiku: The Mood of the Earth,* by Ann Atwood. Scribner's Sons, 1971.

◆ *Of This World: A Poet's Life in Poetry,* by Richard Lewis, photographs by Helen Butterfield. Dial Press, 1968.

Writing Cumulative Poetry

Cumulative poetry is a poetic form that allows a small group of people to compose a single poem. The process is easy, and the results often reflect the "collective unconscious" of the poets. I use the process of writing cumulative poetry with children as young as four years old (they dictate the lines as I write them on chart paper) as well as with older children and adults. Cumulative poetry does not have to rhyme; there are no prescribed literary rules to follow; and each poet, in turn, can determine the direction or nature of the poem. The following are guidelines for writing cumulative poetry:

1. Form small groups of six to eight people. Sit close together in a circle.

2. Each person in the group should try to think of an opening line for the poem. When one of you thinks of a beginning line, write it on the paper. Then pass the paper to the person sitting next to you. The second person reads the first line, thinks of a second line, and writes it below the first sentence. When the second person has written the second line, that person should fold the paper so that only the second line, and not the first line, can be read.

3. The second person then passes the folded paper to someone else in the group. That person reads the second line, adds a third line, and folds the paper so that only the third line can be read. Pass the paper to another person and follow the same procedure. Each poet has only one line of the poem on which to base a contribution. When the poem is complete and everyone has added a line, one member of the group should read the poem aloud.

The following cumulative poems were written by preservice and professional teachers who are, like you, discovering their own poetic potential. When I read them, I am always amazed that each poem was written by a group. The poems express thoughts and feelings that one would envision being written by a single poet. As you read these poems, remember that the poets could read only one line, the

one preceding their own, before adding their own thoughts and ideas to the emerging thoughts of others.

> Bright, shining spiral
> Winds an everlasting path
> Toward me.
> The children come running, laughing,
> Singing, chanting all around,
> I'm lost in the loveliness of the sound
> And the joyful sight.
> The children will smile and be carefree
> Like waves upon the sand.

Now try writing your own cumulative poems. Let your thoughts flow and be free with your imagination. Poetry stretches our imaginations in fresh and unexpected ways, and my ardent hope is that you will go out and find poetry for yourselves and for your children. It must be included as an everyday occurrence in a joyous and energetic literature program. Should you choose to do this, I know you and your children will be amazed with the results.

In this chapter I have written about some of the processes and materials for introducing young children to a language and literacy environment. I have emphasized the importance of our role, as teachers, in planning literary experiences that promote the development of linguistic intelligence, and child-centered teaching and learning. Your role has been presented as one of a facilitator of this process through the modeling and acceptance for the thoughts and feelings of your children. I have also encouraged you to design new ways of helping children move into language, literacy, and literature through an interdisciplinary approach to the arts. Through such means, *you* are the primary person who will help children come to appreciate the role literature plays in the total educational program that will help children to learn more effectively and with meaning and that will benefit each child who looks to you for guidance. Your challenge is to learn how to arrange the literature environment, while sharing the magic with your children. I conclude this chapter with some advice:

> Make friends with poetry. Look forward to stories. Cry during plays. Cultivate affect. Believe in the magic of words. Have a vivid imagination. Look forward to dreams. Giggle with children. Handle books with care. Laugh a lot. Celebrate creativity. Sit under a tree and read poetry. Write love poems. Be a teacher.

If we, as educators, can remember to take time to engage in just a few of these things, we will be better prepared to allow creativity to be the guiding force in all we do for children.

Imagination is more important than knowledge.

Albert Einstein

chapter

Beginning a
New Adventure

*The end of all our travels will be there again
at the beginning of our journey.*

T. S. Eliot, 1948

*L*ien, our five-year-old from chapter 1 who dances with dolphins, was a kindergartner when she discovered how to transform clay into ocean waters. Isabella was in first grade when she used her fingers and the power of her imagination to create a hopping rabbit. When Anthony, another six-year-old, expressed concern about whether or not his friend Katya would remember how to take care of his new puppy, he accepted an invitation to improvise a creative drama experience. Levi, the emergent reader with the imposing question about flying girls and late afternoon suppers on a rooftop, expanded his imagination even further by reading many more books about imaginary travels.

With each of these children and situations, the insight and knowledge of a sensitive and observant teacher provided a "stage" for each child to journey into a new unfolding of himself or herself. Talented and creative teachers reached out to Lien, Isabella, Anthony, Katya, and Levi, touching their lives with gentle brushings and overflowing understanding. Then each teacher offered insightful ways for the children to grow in their own personal and creative ways.

But let's not forget Chet, the unconventional artist who refused to copy the green stem and red rosebud his teacher had drawn. He quickly learned that in order to be successful in artistic endeavors, he must stop drawing roses from his own point of view and, instead, follow the directions for imitating and reproducing a rose drawn by someone else. Chet's experience reminds me of a similar situation involving Saint Exupery's The Little Prince (1971).

The Little Prince made one drawing of a boa constrictor swallowing its prey whole and another drawing of a boa constrictor digesting an elephant. Upon showing his drawings to many grown-ups, the Little Prince always received the same response: "That is a hat." He was also advised to put aside his drawings of boa constrictors and, instead, devote himself to serious subjects such as history, arithmetic, and grammar. He then tells us

> That is why, at the age of six, I gave up what might have been a magnificent career as a painter. I had been disheartened by the failure of my Drawing Number One and my Drawing Number Two. Grown-ups never understand anything by themselves, and it is tiresome for children to be always and forever explaining things to them. Whenever I met one of them who seemed to me at all clear-sighted, I tried the experiment of showing him my Drawing Number One, which I have always kept. I would try to find out, so, if this was a person of true understanding. But, whoever it was, he, or she, would always say: "That is a hat." Then I would never talk to that person about boa constrictors, or primeval forests, or stars. I would bring myself down to his level. I would talk to him about bridge, and golf, and politics, and neckties. And the grown-up would be greatly pleased to have met such a sensible man. (pp. 4–5)

Like the grown-ups in *The Little Prince*, Chet's teacher not only denied him the opportunity to express his own understanding of the world, but she also took away all the vital elements necessary for nurturing his creative and artistic potential.

Teachers can plan, design, and implement activities, but the process of creating must contain the essential spirit, warmth, and support to nurture the child as a creative human being. To do anything less is simply not acceptable.

The processes and materials suggested in this book have focused your attention on experimenting with your imagination and discovering your own creative potential while exploring the arts with children. I have also nudged you to become self-aware and more self-understanding as you prepare for a career in education.

Building a Bridge Between Self-Understanding and Creativity

The bridge that leads to understanding the connection between children as creative individuals, the arts, and our role as teachers is an important one. When we teachers look at the heart and soul of the person responsible for opening a window through which children may enter into creative and artistic experiences, we must consider the core of self that maintains and motivates us, as adults, to look even closer into who we are as ordinary people, and especially who we are as teachers. My own experiences as an educator have provided an expanding view of the connection between a self-awareness and understanding and the propensity for creative processing. I believe that these are not only interrelated but, in my own mind's eye, may in actuality be the same thing.

My view of this connectedness has evolved as a result of reading and studying the work of some of the greatest scholars of our time. Maslow (1970) and Rogers (1983) propose that some of the same types of personality characteristics described by Torrance (1962, 1979, 1984, 1995, & 2000) also describe the personality characteristics of self-actualized individuals. Both believe that a creative person and a self-actualized person share similar personality traits. If we accept this idea, and it certainly seems plausible, we must broaden our understanding of the relationship between self-understanding and our potential to be creative human beings. The next section presents an overview of Maslow's research into the characteristics of people on the journey to becoming self-actualized.

Self-Actualization and Teachers

Maslow's research (1970–1971) yielded many important and useful characteristics of self-actualizing people. Among those characteristics, there are six that especially relate to our role as educators and Figure 9–1 describes them for you. As you read through these descriptions, think about the ones that seem to describe *you*.

We need only to look as far as, or imagine, a classroom full of children to find ample support for the ideas proposed by Maslow, Rogers, and Torrance. When we take into account Gardner's theory of multiple intelligences, and the developmen-

FIGURE 9–1 Self-Actualization and Teachers

◆ *Acceptance of self, others, and nature.* Self-actualized individuals accept their human nature, with its shortcomings and flaws, in the same way they accept the elements of nature. This is not to say that they are completely self-satisfied. It simply implies that these individuals accept all of human nature the same way they accept the things in nature. They see other people and the world with an uncritical acceptance and keep a beginner's mind about all they do. "One does not complain about the water because it is wet, or about rocks because they are hard" (Maslow, 1971, p. 207).

◆ *Spontaneity.* Self-actualized people are spontaneous in their behavior. They behave with a sense of simplicity and naturalness and an awareness of their own thoughts and inner life. These individuals have no desire to hurt others or fight with others and will go to great ends to avoid either. Their actions are based on a code of ethics that enables them to "go through the ceremonies and rituals of convention with a good-humored shrug and with the best possible grace" (Maslow, 1971, p. 209).

◆ *Freshness of appreciation.* Self-actualizing people have the capacity to appreciate again and again, with the eyes of a child, the beauty of life. No matter how stale the world becomes to others, these people look at things with pleasure, freshness, and wonder. Upon hearing a great piece of music or after seeing a hundred butterflies in a single hour, each experience is just as wonderful and exciting as the first.

◆ *Identification, sympathy, and affection.* Self-actualized individuals are benevolent and have a desire to help others. They feel a kindred spirit toward all people of the world and view the human race as members of their own family. They are affectionate and forgiving of the shortcomings of others.

◆ *Philosophical, unhostile sense of humor.* Self-actualized people do not make people laugh by hurting someone else; nor do they exhibit a superior humor whereby they find it funny to laugh at another person's inferiority. Their humor often has its source rooted in parables, fables, or philosophy that elicits a smile rather than a belly laugh. Usually, their humor is spontaneous and with a change in setting or circumstances will not be repeated.

◆ *Creativeness.* They are creative in original or inventive ways. Maslow was not referring to "talent" when he talked about creativeness. He viewed the creativeness of the self-actualized person as being similar to the naive and universal creativeness of children—a fresh, simple, and direct way of looking at life. These people are less inhibited, less constricted, and more spontaneous and more natural in their view of creativity.

tal perspectives of Piaget, Erikson, Lowenfeld, and Vygotsky, the whole picture comes into view.

The creative arts provide a structure, an invisible arena of sorts, for nurturing a child's rich creative life and the development of self-awareness and understanding. Through experiences in music, dance, movement, drama, the visual arts, and literature, children are involved in the process of developing all areas of intelligence, creativity, affect, and self-knowledge through a variety of modes. At the same time, they are learning more about themselves and others.

The creative arts also provide tremendous opportunities to nurture the creative lives of teachers. As adults, our experiences in music, the visual arts, and other areas of the creative arts, open doors to our own self-knowledge and self-understanding of the importance and value of creative arts in our daily lives. As with children, the arts provide a universal arena for learning more about ourselves and about others. The next section presents some true stories about my own graduate

students' experiences in attending and participating in visual and performing arts activities, programs, and/or presentations.

College Students' Reflections on Attending Visual and Performing Arts Events

These reflections serve as validation to the importance of being open to new experiences in the arts. These personal encounters with the arts also enable us to impact the experiences of the children in our classrooms. The words you are about to read are excerpts taken from actual final exam comments by a group of students enrolled in my creativity class. The exam assignment was as follows:

> Attend a performance or production related to the creative arts (music and movement, visual arts, images, drama and theatre, 3-D art, literature, poetry). Collect a program, description, or other material related to the event. Identify five (5) concepts or ideas that are discussed in your textbook relating to what you saw or heard. Write a detailed description about how the event you attended relates to the concepts that you identified from the book. Draw a conclusion about the value of attending such events.

"Karen": My visit to the Gibbes Museum of Art provided me with a very visual experience of the arts. The Gibbes shows students that there are many ways to represent art, and even history, through examples of paintings, photography, and three-dimensional art. Many of the paintings, drawings, and photographs can be used as a visual timeline and history lesson, therefore provide[ing] students an alternative to reading from textbooks and being lectured about historical aspects of the city.

"Elizabeth": The bands that performed at the festival were Swing Soup and The East Coast Party Band. Fans danced all afternoon to swing, zydeco, bluegrass, jazz, and beach music. Looking back at my experience that day, I recognize the importance of having music and movement in the classroom. Learning dance routines that include rhythmic patterns helps to develop mathematical, spatial, and sequential thinking. Children's creative confidence develops as they explore the world of music and movement.

"Michelle": The improvisational group Mary Kay Has a Pose was a great example of creative movement. The actors used their bodies to express their personal interpretation of the scene or events taking place. Each improviser brought their own experiences to the stage, and used those experiences to create a storyline that fit together with the other storylines that were being acted out. Their freedom of expression and open-ended actions were a great display of creative movement that could be easily implemented in the classroom.

If you believe in great things, other people will too.
Oliver Wendell Holmes

"Ryan": As we have learned throughout the course of this semester, the development of the creative arts is a process that can evolve over a lifetime. I have always felt that my artistic abilities were lacking when compared to my classmates. However, by merely participating in our class activities, my overall perception of the arts has greatly improved. The jazz concert helped me consider the importance of including authentic experiences in the classroom. In retrospect, teachers who shared wonderful stories of their own personal experiences taught some of my most informative and interesting classes. While theories and concepts are crucial to a strong educational foundation, it is the additional real life stories that help students put learning into context.

As we pursue these basic human goals, it becomes more and more evident that the study of the arts provides the foundation for people to soar to the heights of their innate human potential.

The children are waiting for you. They are waiting for reassurances that there is more than one way to play a drum, that they can create magical bunnies with their hands, and that their paintings are valued even if they do not look just like all the rest. They are waiting for you to plan and then give them lots of time to bring their own personal feelings, experiences, perceptions, ways of knowing, and imaginations to the creative arts process.

The last section of this book is for you to write. I will provide the structure, but it will be up to you to weave the imagery, the music, the colors, the drama, and the stories into the fabric of *your own* development.

PERSONAL AND PROFESSIONAL GROWTH

While writing this book, I searched for a long time for just the right words I needed to convey the importance of a *process approach* to arts education to my readers. As I began writing this last chapter, I remembered something A. A. Milne's Piglet said about giving gifts:

> 'All right, then, I'll give him a balloon. I've got one left from my party. I'll go and get it now, shall I?' 'That, Piglet, is a very good idea. It is just what Eeyore wants to cheer him up. Nobody can be uncheered with a balloon.' (*Winnie-the-Pooh*, Dutton, 1954, p. 79; originally published in 1926)

My dream, and Piglet's gift, seeded the following guided imagery.

Gifts from the Wise One

Find a good spot in the room where you can lie down or sit comfortably without touching anyone else. Wiggle around a little until your place feels right for you. Close your eyes and let your mind begin to relax.

> Imagine that you are walking on a familiar trail. It is dusk, and there is a full moon rising on the horizon. You can see the trail easily, you feel safe in these surroundings, and you can see everything around you. What is this trail like? What else can you see? How do you feel as you walk along this well-worn trail? Just ahead there is a small side path that leads to a magnificent forest. Just inside the forest is the home of a very wise person; a person known to all who visit as the Wise One. The Wise One can tell you the answer to any question. . . . Notice the stones marking the path, turn toward the majestic forest, and walk toward the Wise One's home.
>
> Notice the wind singing through the trees as you move along the path, and then see a dwelling begin to appear before you. Walk toward the dwelling until you see a small campfire. Sitting in front of the small campfire is the Wise One. Approach in silence. Walk up to the fire, put some more wood on it, and sit quietly. As the fire burns more brightly, you can see the Wise One more clearly. Take some time to really become aware of how you felt while in the presence of such a wise person. Now ask the Wise One a question that is important to you. As you ask this question, see the smile that

flows from the Wise One's face, and listen in silence for your answer. The answer might come with words alone. . . . The Wise One may answer you with a gesture, or the Wise One may show you something. What kind of answer do you receive? Pay attention to the answer and the way in which it was given. . . . You will soon have to say goodbye to the Wise One. . . . Say anything else you want to say before you leave.

Just as you are about to say goodbye, the Wise One turns and searches in an old leather bag for something very special to give to you. . . . Accept the gift and hold it in your hands. Look at the gift. You are wondering if you can keep the gift and take it home. The Wise One smiles, nods an affirming yes, and bids you farewell. Now turn away and start walking back down the path, carrying your gift with you.

As you walk down the path and back to the trail, notice your surroundings so that you will remember how to find your way back to the Wise One when you want to make the journey again. Keep your eyes closed and bring your gift with you as you return to the here and now of this space and this room. . . . Take some time to see your gift in more detail. What did the Wise One give you? When you are ready, put this gift away carefully and safely in your memory . . . and say goodbye to your journey for now.

When the imaginary journey is over, turn to someone near you and spend a few minutes talking about your journey, your gift, and your experience.

Good Words

You will need the following materials for this activity:

* one large sheet of construction paper for each person
* markers or felt-tipped pens
* masking tape

Procedure

1. Tape a sheet of paper to everyone's back.
2. Move around the room and write positive comments or good words on each other's sheet of paper. Just write what you feel without signing your name.
3. When everyone has finished writing comments and good words, take off your sheet of paper and read the good words given to you.
4. Take your "good words paper" home with you. Tape it up in a place where you can see it and read the positive things other people have said about you!

Creative Arts: Carry Them On!

It is not the number of activities you design or the methods of implementation you use that are the most important elements of creative arts education. What is most important is that you provide the essence of a creative environment in which children know they can reach and explore the creative potential they bring to the classroom every day.

The creative teacher, who has a conscious interest in the processes involved in the creative arts, is one who "needs to see herself not as one who 'gives' art to stu-

dents (as tourists 'do' the Louvre), but as one who can open up windows on the world to students as well as to herself" (Dimondstein, 1974, p. 303). You have discovered firsthand what it feels like to be in an environment that encourages creativity, and you have experienced an atmosphere that gives you time to enter the creative process. Now you are faced with a choice. You must decide, from your own experiences and for your own professional and personal reasons, how you will go about the task of introducing children to the *process* of experiencing the creative arts. You must also decide if you can or will give up coloring books, dittos, and red flowers with green stems and creatively change the familiar, traditional, product-oriented approach to creative arts production.

Imagine for just a moment that you are in your classroom. You can design a creative arts curriculum that will have value and meaning for both you and your children. Beginning teachers: How will you structure the environment to give your children the time and freedom to become involved in the creative arts process? Experienced teachers: How will you break away from the old confines of having all the children draw, make, sculpt, or "create" the same things at the same time? Directors and principals: How will you help your teachers move away from the traditional toward an innovative alternative approach to creative expression? College instructors: What experiences will you design to help your aspiring teachers understand the affective nature of the creative arts and to use that understanding in the teaching/ learning process? For all of us who are charged with enhancing the quality of life for young children, how will we experience movement in dance, feel the imaginary force of the wind on our bodies, capture the rainbow's gold in painting, create a dream image in sculpture, or recall intimate moments in a cinquain? Think about these things and remember that you do not have to be innately talented to dance, sing, paint, sculpt, or orchestrate beautiful music. What you have to be is open to exploration.

FIGURE 9–2 Open the "windows to the world of the creative arts" for your children.

Give yourself and your children permission to give form to sensory perceptions, take risks with inhibitions, and respond to creative impulses. Be sensitive and aware of your creative potential and the creative efforts of your children. Joy and pleasure, for each of you, waits to be discovered.

I leave you with one final thought from A. A. Milne's *Winnie-the-Pooh* (Dutton, 1954; originally published in 1926, p. 12). There are wisdom and good gifts in this message:

> There are people who begin the Zoo at the beginning, called WAYIN, and walk as quickly as they can past every cage until they get to the one called WAYOUT, but the nicest people go straight to the animal they love most, and stay there.

You have come to the end of this book but certainly not to the end of your journey. I hope that your interaction with the creative arts has been filled with personal and professional meaning and that all of your experiences will encourage you to continue this magnificent adventure—both for your own creative growth and for the children who look to you for guidance. Acknowledge the talents and creative abilities of your children and open a pathway for them to begin their journey.

Now, promise yourself, this very moment, that you will always keep the magic and wonder of the creative process filled with joy and life!

It is a blessed thing to have an imagination.

Mark Twain

appendix 1

Literature

Caldecott Medal Award–Winning Books and Their Illustrators

The Caldecott Medal Award is presented annually to the illustrators of the most distinguished picture books published in the United States.

2005. *Kitten's First Full Moon*. Illustrated and written by Kevin Henkes. Greenwillow Books HarperCollins.

2004. *The Man Who Walked Between the Towers*. Mordicai Gerstein. Roaring Brook Press/Millbrook Press.

2003. *My Friend Rabbit*. Eric Rohmann. Roaring Book Press/Millbrook Press.

2002. *The Three Pigs*. David Wiesner. Clarion/Houghton Mifflin.

2001. *So You Want to Be President?* Judith St. George. Illustrations by David Small. Philomel.

2000. *Joseph Had a Little Overcoat*. Simms Taback. Viking.

1999. *Snowflake Bentley*. Jacqueline Briggs Martin. Illustrations by Mary Azarian. Houghton Mifflin.

1998. *Rapunzel*. Retold and illustrated by Paul O. Zelinsky. Dutton.

1997. *Golem*. Story and pictures by David Wisniewski: Photography of cut-paper illustrations by Lee Salsbery. Clarion/Houghton Mifflin.

1996. *Officer Buckle and Gloria*. Peggy Rathmann. Putnam's.

1995. *Smoky Night*. David Diaz. Harcourt Brace.

1994. *Grandfather's Journey*. Allen Say. Houghton Mifflin.

1993. *Mirette on the High Wire*. Emily McCully. Putnam's.

1992. *Tuesday*. David Wiesner. Clarion.

1991. *Black and White*. David Macaulay. Houghton Mifflin.

1990. *Lon Po Po: A Red Riding Hood Story from China*. Ed Young. Philomel.

1989. *Song and Dance Man*. Stephen Gammell. Knopf.

1988. *Owl Moon*. John Schoenherr. Philomel.

1987. *Hey Al*. Richard Egielski. Farras, Straus and Giroux.

1986. *The Polar Express*. Chris Van Allsburg. Houghton Mifflin.

1985. *Saint George and the Dragon: A Golden Legend*. Trina Schart Hyman. Little, Brown.

1984. *The Glorious Flight: Across the Channel with Louis Bleriot July 15, 1909*. Alice and Martin Provenson. Viking.

1983. *Shadow*. Marcia Brown. Scribner's.

1982. *Jumanji*. Chris Van Allsburg. Houghton Mifflin.

1981. *Fables*. Arnold Lobel. Harper & Row.

1980. *Ox-Cart Man*. Barbara Cooney Hall. Viking.

1979. *The Girl Who Loved Wild Horses*. Paul Goble. Bradbury.

1978. *Noah's Ark*. Peter Spier. Doubleday.

1977. *Ashanti to Zulu: African Traditions*. Leo and Diane Dillon. Dial.

1976. *Why Mosquitoes Buzz in People's Ears: A West African Folk Tale*. Leo and Diane Dillon. Dial.

1975. *Arrow to the Sun*. George McDermott. Viking.

1974. *Duffy and the Devil*. Margo Zemach. Farrar, Straus and Giroux.

1973. *The Funny Little Woman*. Blair Lent. Dutton.

1972. *One Fine Day*. Nonny Hogrogian. Macmillan.

1971. *A Story—A Story*. Gail E. Haley. Atheneum.

1970. *Sylvester and the Magic Pebble*. William Steig. Windmill.

1969. *The Fool of the World and the Flying Ship*. Uri Schulevitz. Farrar, Straus and Giroux.

1968. *Drummer Hoff*. Ed Emberley. Prentice Hall.

1967. *Sam, Bangs and Moonshine*. Evaline Ness. Holt.

1966. *Always Room for One More*. Nonny Hogrogian. Holt.

1965. *May I Bring a Friend?* Beni Montresor. Atheneum.

1964. *Where the Wild Things Are*. Maurice Sendak. Harper & Row.

1963. *The Snowy Day*. Ezra Jack Keats. Viking.

1962. *Once a Mouse*. Marcia Brown. Scribner's.

1961. *Babouskka and Three Kings*. Nicolas Sidjakov. Parnassus.

1960. *Nine Days to Christmas*. Marie Hall Ets. Viking.

1959. *Chanticleer and the Fox*. Barbara Cooney. Crowell.

1958. *Time of Wonder*. Robert McCloskey. Viking.

1957. *A Tree Is Nice*. Marc Simont. Harper & Row.

1956. *Frog Went A-Courtin'*. Feodor Rojankowsky. Harcourt Brace Jovanovich.

1955. *Cinderella, or the Little Glass Slipper*. Marcia Brown. Scribner's.

1954. *Madeline's Rescue*. Ludwig Bemelmans. Viking.

1953. *The Biggest Bear*. Lynd K. Ward. Houghton Mifflin.

1952. *Finders Keepers*. Nicolas Mordvinoff. Harcourt Brace Jovanovich.

1951. *The Egg Tree*. Katherine Milhous. Scribner's.

1950. *Song of Swallows*. Leo Politi. Scribner's.

1949. *The Big Snow*. Berta and Elmer Hader. Macmillan.

1948. *White Snow, Bright Snow*. Roger Duvoisin. Lothrop Lee & Shepard.

1947. *The Little Island*. Leonard Weisgard. Doubleday.

1946. *The Rooster Crows*. Maud and Miska Petersham. Macmillan.

1945. *Prayer for a Child*. Elizabeth Orton Jones. Macmillan.

1944. *Many Moons*. Louis Slobodkin. Harcourt, Brace Jovanovich.

1943. *The Little House*. Virginia Lee Burton. Houghton Mifflin.

1942. *Make Way for Ducklings*. Robert McCloskey. Viking.

1941. *They Were Strong and Good*. Robert Lawson. Viking.

1940. *Abraham Lincoln*. Ingri and Edgar Parin d'Aulaire. Doubleday.

1939. *Mei Li*. Thomas Handforth. Doubleday.

1938. *Animals of the Bible: A Picture Book*. Dorothy Lathrop. Stokes.

Folktales

Asian

Demi. (1990). *The empty pot*. New York: Holt. A tale that develops the importance of honesty.

Hong, L. T. (Reteller). (1993). *Two of everything*. Morton Grove, IL: Whitman. A Chinese folktale in which a magical pot duplicates whatever it contains.

Lang, A. (1981). *Aladdin and the wonderful lamp*. Illustrated by E. LeCain. New York: Viking. Deep color and ornamentation illustrate a tale from *The Arabian Nights*.

Laurin, A. (1981). *The perfect crane*. Illustrated by C. Mikolaycak. New York: Harper & Row. A Japanese tale about the friendship between a magician and the crane he creates from rice paper.

Levine, A. (Reteller). (1994). *The boy who drew cats: A Japanese folktale*. Illustrated by F. Clement. New York: Dial. Cats come to life to defeat a giant rat.

Mahy, M. (Reteller). (1990). *The seven Chinese brothers*. Illustrated by J. and M. Tseng. New York: Scholastic. Watercolors complement this traditional tale.

Mosel, A. (1972). *The funny little woman*. Illustrated by B. Lent. New York: Dutton. A little woman chases a rice dumpling and is captured by wicked people.

San Souci, R. D. (1992). *The Samurai's daughter: A Japanese legend*. Illustrated by S. T. Johnson. New York: Dial. The heroine of the story slays a sea monster.

Young, E. (Trans.). (1989). *Lon Po Po: A Red-Riding Hood story from China*. New York: Philomel. Girls outwit the wolf in this version of the tale.

British

Brett, J. (1987). *Goldilocks and the three bears*. Northbrook, IL: Dodd, Mead. A highly illustrated version of this folktale.

Cauley, L. B. (1982). *The cock, the mouse, and the little red hen*. New York: Putnam. Repetitious language appeals to young children.

dePaola, T. (1981). *The friendly beasts: An old English Christmas carol.* New York: Putnam's. The setting of Bethlehem is depicted in this folk song.

Galdone, P. (1985). *The little red hen.* New York: Clarion. An industrious hen won't share her cake with her lazy friends.

Galdone, P. (1985). *The three bears.* New York: Clarion. This traditional tale is illustrated with large, humorous pictures.

Kellogg, S. (1985). *Chicken Little.* New York: Morrow. A humorous, modern version of the tale, with cars, trucks, and helicopters.

Kimmell, E. (Reteller). (1993). *The gingerbread man.* Illustrated by M. Lloyd. New York: Holiday House. The cumulative tale of the runaway cookie.

MacGill-Callahan, S. (1993). *The children of Lir.* Illustrated by G. Spirin. New York: Dial. An Irish tale in which an evil stepmother changes children into swans.

Marshall, J. (1988). *Goldilocks and the three bears.* New York: Dial. A folktale that is added to by means of illustrations.

Rounds, G. (Reteller and Illustrator). (1992). *The three little pigs and the big bad wolf.* New York: Holiday House. The illustrations in this folktale focus on the antics of the wolf.

French

Perrault, C. (1954). *Cinderella.* Illustrated by M. Brown. New York: Scribner's. Fine lines suggest the mood of this fairy tale.

Perrault, C. (1981). *The glass slipper: Charles Perrault's tales of times past.* Translated by J. Bierhorst. Illustrated by M. Miller. New York: Four Winds. A new translation of *Histoires ou contes du temps passé.*

Perrault, C. (1992). *Puss in boots.* Retold by L. Kirstein. Illustrated by A. Vaes. Boston: Little, Brown. A beautifully illustrated retelling of the French folktale.

German

Galdone, P. (1982). *Hansel and Gretel.* New York: McGraw-Hill. This folktale is appropriate for younger children.

Grimm, Brothers (1980). *Hansel and Gretel.* Illustrated by S. Jeffers. New York: Dial.
Illustrations with strong lines and a magnificent gingerbread house should appeal to readers.

Hyman, T. S. (Reteller and Illustrator). (1983). *Little Red Riding Hood.* New York: Holiday House. The richly detailed borders add to this attractive version.

Jarrell, R. (Trans.). (1972). *Snow White and the seven dwarfs.* Illustrated by N. E. Burkert. New York: Farrar, Straus & Giroux. The artist carefully researched the illustrations to show the Black Forest and German heritage.

Plume, I. (Reteller and Illustrator). (1980). *The Bremen Town musicians.* New York: Doubleday. The soft color illustrations show animals going through the forest.

Rogasky, B. (Reteller). (1982). *Rapunzel: From the Brothers Grimm.* Illustrated by T. S. Hyman. New York: Holiday House. A forest setting seems right for a girl imprisoned in a high tower.

Rogers, A. (Trans.). (1977). *The wolf and the seven little kids.* Illustrated by O. S. Svend. New York: Larousse. Seven goats have a conflict with a wolf when their mother leaves the house.

Jewish

Geras, A. (1990). *My grandmother's stories: A collection of Jewish folktales.* Illustrated by J. Jordan. New York: Knopf. These stories come from a Russian Jewish heritage.

Sanfield, S. (1991). *The feather merchants and other tales of the fools of Chelm.* Illustrated by M. Magaril. New York: Orchard. Thirteen folktales from traditional Jewish culture.

Singer, I. B. (1982). *The golem.* Illustrated by U. Shulevitz. New York: Farrar, Straus & Giroux. Another version of a Jewish folktale.

Zemach, M. (1977). *It could always be worse.* New York: Farrar, Straus & Giroux. A small hut seems larger when all the animals are removed.

Norwegian

Asbjornsen, P. C. (1957). *The three billy goats gruff.* Illustrated by M. Brown. San Diego: Harcourt Brace Jovanovich. Goats prance across the pages of this favorite "telling" tale.

Asbjornsen, P. C. (1992). *East o' the sun and west o' the moon.* Translated by G. W. Dasent. Illustrated by P. J. Lynch. Cambridge, MA: Candlewich. The

Norwegian landscape is re-created in the beautiful illustrations that accompany this tale of enchantment.

Asbjornsen, P. C., & Moe, J. E. (1960). *Norwegian folk tales*. Illustrated by E. Werenskiold and T. Kittelsen. New York: Viking. A collection of 35 Norwegian folktales.

Russian

Afanasyev, A. N. (1990). *The fool and the fish: A tale from Russia*. Retold by L. Hort. Illustrated by G. Spirin. New York: Dial. With the help of enchantment, a peasant wins the tsar's daughter.

Cech, J. (1992). *First snow, magic snow*. Illustrated by S. McGinley-Nally. New York: Four Winds. A woodsman and his spouse wish for a child and become parents of a snow child.

Fonteyn, M. (1989). *Swan lake*. Illustrated by T. S. Hyman. San Diego: Harcourt Brace Jovanovich. A retelling of the ballet.

Ransome, A. (1968). *The fool of the world and the flying ship*. Illustrated by U. Shulevitz. New York: Farrar, Straus & Giroux. A simple boy overcomes obstacles to wed the czar's daughter.

Informational Books

Ammon, R. (1989). *Growing up Amish*. New York: Atheneum. Photographs, maps, and drawings depict the life of the Amish in Pennsylvania.

Anderson, J. (1984). *The first Thanksgiving feast*. Photographs by G. Ancona. Saint Louis, MO: Clarion. Photographs from the Plimoth Plantation located in Plymouth, Massachusetts, accompany this story of the first Thanksgiving.

Apfel, N. (1988). *Nebulae: The birth & death of stars*. New York: Lothrop, Lee & Shepard. Some photographs from observatories highlight this text.

Ardley, N. (1989). *Music*. New York: Knopf. A history of musical instruments, enhanced by numerous pictures.

Arnosky, J. (1982). *Drawing from nature*. New York: Lothrop, Lee & Shepard. This book gives directions for drawing water, land, plants, and animals.

Banish, R. (1988). *Let me tell you about my baby*. New York: Harper & Row. An older child tells the story of a new sibling.

Barton, B. (1982). *Airport*. New York: Crowell. Large illustrations follow people as they get ready to board a plane.

Bash, B. (1989). *Desert giant: The world of the saguaro cactus*. Boston: Sierra Club/Little, Brown. The story and illustrations are about the life cycle of the saguaro cactus.

Bash, B. (1990). *Urban roosts: Where birds nest in the city*. Boston: Little, Brown. This book investigates birds that live in the cities.

Bash, B. (1993). *Shadows of night: The hidden world of the little brown bat*. San Francisco: Sierra Club. The illustrations and text depict the life of the bat.

Berger, M. (1985). *Germs make me sick!* Illustrated by M. Hafner. New York: Crowell. A book that tells how viruses affect people.

Bergman, T. (1989). *Finding a common language: Children living with deafness*. Milwaukee, WI: Gareth Stevens.

Bergman, T. (1989). *One day at a time: Children living with leukemia*. Milwaukee, WI: Gareth Stevens.

Bergman, T. (1989). *On our own terms: Children living with physical disabilities*. Milwaukee, WI: Gareth Stevens.

Bergman, T. (1989). *Seeing in special ways: Children living with blindness*. Milwaukee, WI: Gareth Stevens.

Bergman, T. (1989). *We laugh, we love, we cry: Children living with mental retardation*. Milwaukee, WI: Gareth Stevens.

Branley, F. M. (1983). *Saturn: The spectacular planet*. Illustrated by L. Kessler. New York: Harper & Row. This book utilizes information from the *Pioneer* and *Voyager* space explorations.

Brinckloe, J. (1985). *Fireflies!* New York: Macmillan. A young boy captures, watches, and then releases fireflies.

Brown, L. K., & Brown, M. (1990). *Dinosaurs alive and well! A guide to good health*. Boston: Little, Brown. This humorous text provides rules on nutrition, exercise, and cleanliness.

Cajacob, T., & Burton, T. (1986). *Close to the wild: Siberian tigers in a zoo*. Photographs by T. Cajacob. Minneapolis, MN: Carolrhoda. The large color photographs in this book depict life in a natural-habitat zoo.

Cobb, V. (1990). *Why can't you unscramble an egg? And other not such dumb questions about matter*. Illustrated by T. Enik. New York: Lodestar.

Developed in a question-and-answer format, this text and the illustrations answer questions such as "Why does wood burn?"

Cole, J. (1982). *A cat's body*. Photographs by J. Wexler. New York: Morrow. The photographs and text show how a cat responds physically in different moods and activities.

Cole, J. (1983). *Cars and how they go*. Illustrated by G. Gibbons. New York: Harper & Row. A simplified explanation of how parts of a car function.

Cole, J. (1984). *An insect's body*. Photographs by J. Wexler & R. A. Mendez. New York: Morrow. The anatomy of a cricket is explained in the text and photographs.

Cole, J. (1987). *The magic school bus: Inside the Earth*. Illustrated by B. Degen. New York: Scholastic. This book provides a humorous approach to the study of the planet Earth.

Cole, J. (1991). *My puppy is born*. Photographs by J. Wexler. New York: Morrow. The text and photographs in this book follow puppies from birth through their first eight weeks of life.

Cole, J. (1993). *How you were born*. Photographs by M. Miller. New York: Morrow. A book about birth for young children.

Couper, H., & Henbest, N. (1992). *The space atlas: A pictorial atlas of our universe*. San Diego: Harcourt Brace Jovanovich. Using a large-book format, the authors provide many details about space.

dePaola, T. (1975). *The cloud book*. New York: Holiday House. The book presents 10 clouds and tells about their shapes and the ways in which they forecast the weather.

dePaola, T. (1978). *The popcorn book*. New York: Holiday House. The illustrations and the story present facts about popcorn.

Esbensen, B. J. (1990). *Great northern diver: The loon*. Illustrated by M. B. Brown. Boston: Little, Brown. Presented in picture-book format, the text and illustrations describe the loon's migrations, habitat, and characteristics.

Esbensen, B. J. (1991). *Tiger with wings: The great horned owl*. Illustrated by M. B. Brown. New York: Orchard. The illustrations and text depict the life of the great horned owl and how it is influenced by interactions with people.

Fischer-Nagel, H., & Fischer-Nagel, A. (1986). *Life of the honey bee*. Minneapolis, MN: Carolrhoda.

These close-up photographs show various stages in the life cycle of the honey bee.

Ford, M. T. (1992). *100 questions and answers about AIDS: A guide for young people*. Morristown, NJ: New Discovery Books.

Fritz, J. (1976). *Will you sign here, John Hancock?* New York: Coward McCann. A realistic life story of the Revolutionary War personality.

Gallant, R. A. (1986). *The Macmillan book of astronomy*. New York: Macmillan. This book explores the planets and the stars.

George, W. T. (1986). *Box turtle at Long Pond*. Illustrated by L. B. George. New York: Greenwillow. This illustrated book introduces turtles to young children.

Gibbons, G. (1990). *Beacons of light: Lighthouses*. New York: Morrow. The illustrations and the text in this book present the history of lighthouses.

Grace, E. S. (1991). *Seals*. Photographs by F. Bruemmer. Santa Fe, NM: Sierra Club/Boston: Little, Brown. This book gives details about seals, sea lions, and walruses.

Guiberson, B. (1992). *Spoonbill swamp*. Illustrated by M. Lloyd. San Diego: Holt. Through its illustrations, this book tells about the residents of the swamp, a spoonbill alligator.

Haldane, S. (1991). *Helping hands: How monkeys assist people who are disabled*. New York: Dutton. The author of the book develops a photo essay about a quadriplegic and a capuchin monkey.

Hausherr, R. (1989). *Children and the AIDS virus*. New York: Clarion. This book includes two levels of information, with large print for younger children and smaller print for older children and adults.

Hirschi, R. (1989). *Who lives in . . . the mountains?* Photographs by G. Burrell. New York: Putnam's. The photographs in the book show mountain scenes and animals.

Hirschi, R. (1989). *Who lives on . . . the prairie?* Photographs by G. Burrell. New York: Putnam. The photographs in this book provide an easy introduction to prairie life.

Hirst, R., & Hirst, S. (1990). *My place in space*. Illustrated by R. Harvey and J. Levine. New York: Orchard. These detailed drawings provide a humorous introduction to astronomy.

Hoban, T. (1990). *A children's zoo*. New York: Greenwillow. Each photograph in this book is accompanied by a list of three words that describe the animal.

Isadora, R. (1993). *Lilie at ballet*. New York: Putnam's. The text and illustrations in this book follow a young girl's experiences.

Isenberg, B., & Jaffe, M. (1984). *Albert the running bear's exercise book*. Illustrated by D. de Groat. Boston: Houghton Mifflin. Step-by-step directions for exercises.

Johnston, G., & Cutchins, J. (1988). *Scaly babies: Reptiles growing up*. New York: Morrow. The photographs and text cover baby snakes, lizards, crocodiles, and turtles.

Kerrod, R. (1988). *Primates: Insect-eaters and baleen whales*. New York: Facts on File. Photographs, illustrations, the glossary, and an index add to the discussions of monkeys, apes, bats, platypuses, and whales.

Koch, M. (1993). *World water watch*. New York: Greenwillow. A picture book that asks the readers to help save the oceans.

Kramer, S. (1992). *Lightning*. Photographs by W. Faidley. Minneapolis, MN: Carolrhoda. The author of this book discusses many aspects of lightning.

Krementz, J. (1977). *A very young rider*. New York: Knopf. The photographs and text describe the preparation of an Olympic hopeful.

Lavies, B. (1989). *Lily pad pond*. New York: Dutton. The photographs presented follow tadpoles and other pond life.

Lavies, B. (1990). *Backyard hunter: The praying mantis*. New York: Dutton. The life cycle of the praying mantis is presented in text and illustrations.

Matthews, D. (1989). *Polar bear cubs*. Photographs by D. Guravich. New York: Simon & Schuster. The photographs and text in this book follow polar bear cubs as they explore their arctic homes.

McDonald, M. (1990). *Is this a house for a hermit crab?* Illustrated by S. D. Schindler. New York: Orchard. This picture book follows as a crab looks for a new home.

McLaughlin, M. (1989). *Dragonflies*. New York: Walker. The text and photographs illustrate the life cycle of dragonflies.

McMillan, B. (1992). *Going on a whale watch*. New York: Scholastic. The photographs and illustrations in this book develop some concepts related to whales.

McPhail, D. (1985). *Farm morning*. San Diego: Harcourt Brace Jovanovich. A girl and her father explore the barnyard.

Miller, M. (1990). *Who uses this?* New York: Greenwillow. The readers of this book must turn the page to check whether they have identified the correct user of a tool.

Patent, D. H. (1988). *Appaloosa horses*. Photographs by W. Munoz. New York: Holiday House. Patent explores the origins and characteristics of Appaloosas.

Patent, D. H. (1988). *Babies*. New York: Holiday House. This book tells about infants from birth to age two.

Reid, B. (1989). *Playing with plasticine*. New York: Morrow. This book gives instructions for making plasticine sculptures.

Sattler, H. R. (1985). *Train whistles*. Illustrated by G. Maestro. New York: Lothrop, Lee & Shepard. A picture-book guide to the meaning of train whistles.

Sattler, H. R. (1989). *The book of eagles*. Illustrated by J. D. Zallinger. New York: Lothrop, Lee & Shepard. A book that presents the behavior and life cycle of eagles.

Scarry, H. (1985). *Looking into the Middle Ages*. New York: Harper & Row. This pop-up book shows castles, cathedrals, and villages.

Selsam, M. E. (1958). *How to be a nature detective*. Illustrated by E. J. Keats. New York: Harper & Row. A book that encourages children to identify animals by observing their tracks.

Selsam, M. E. (1982). *Where do they go? Insects in winter*. Illustrated by A. Wheatley. New York: Four Winds. A book that discusses flies, grasshoppers, and bees.

Selsam, M. E., & Hunt, J. (1985). *A first look at bird nests*. Illustrated by H. Springer. New York: Walker. A book that describes the nests of common American birds.

Selsam, M. E., & Hunt, J. (1987). *A first look at caterpillars*. Illustrated by H. Springer. New York: Walker. A book that tells about the life cycle and habits of the caterpillar.

Selsam, M. E., & Hunt, J. (1988). *A first look at seals, sea lions, and walruses*. Illustrated by H. Springer. New York: Walker. A book that tells characteristics of seals, sea lions, and walruses.

Selsam, M. E., & Hunt, J. (1989). *A first look at animals with horns*. Illustrated by H. Springer. New York: Walker. A book that discusses characteristics of animals with horns.

Sill, C. (1991). *About birds: A guide for children*. Illustrated by J. Sill. Atlanta, GA: Peachtree. The

large colorful illustrations and minimal text introduce various types of birds.

Simon, S. (1981). *Poisonous snakes.* Illustrated by W. R. Downey. New York: Four Winds. A book that discusses the important role of poisonous snakes, where they live, and their behavior.

Simon, S. (1985). *Soap bubble magic.* Illustrated by S. Ormai. New York: Lothrop, Lee & Shepard. A book that encourages observation of and experimentation with soap bubbles.

Simon, S. (1988). *Galaxies.* New York: Morrow. A book that examines the Milky Way and other galaxies.

Wexler, J. (1993). *Jack-in-the-pulpit.* New York: Dutton. The close-up photographs in this book provide details.

Wood, A. J. (1993). *Egg!* Illustrated by S. Stilwell. Boston: Little, Brown. This fold-out book encourages readers to predict.

Yoshida, T. (1984). *Young lions.* New York: Philomel. A book about lion cubs on an African plain.

Yoshida, T. (1991). *Rhinoceros mother.* New York: Philomel. This highly illustrated book tells about rhinoceros behavior and habits.

Zubrowski, B. (1981). *Messing around with water pumps and siphons.* Illustrated by S. Lindblom. Boston: Little, Brown. This is a children's museum activity book that encourages children to experiment.

Modern Fantasy Books

Andersen, H. C. (1974). *Hans Andersen: His classic fairy tales.* Translated by E. Haugaard. Illustrated by M. Foreman. New York: Doubleday. A collection of 18 Andersen tales.

Baker, K. (1989). *The magic fan.* San Diego: Harcourt Brace Jovanovich. A Japanese man is able to save his village when he is guided by a magic fan.

Barrie, J. (1911). *Peter Pan.* Illustrated by N. S. Unwin. New York: Scribner's. Wendy, Michael, and John accompany Peter to Never Never Land.

Bond, M. (1960). *A bear called Paddington.* Illustrated by P. Fortnum. Boston: Houghton Mifflin. The beginning of a series of books about a bear who joins a human family.

Cameron, E. (1954). *The wonderful flight to the mushroom planet.* Illustrated by R. Henneberger. Boston: Little, Brown. Two boys build and fly a spaceship.

Clearly, B. (1965). *The mouse and the motorcycle.* Illustrated by L. Darling. New York: Morrow. Ralph the mouse makes friends with a boy who owns a toy motorcycle.

Collodi, C. (1988). *The adventures of Pinocchio.* Illustrated by R. Innocent. New York: Knopf. A nicely illustrated version of the classic tale.

Erickson, R. E. (1974). *A toad for Tuesday.* Illustrated by L. DiFiori. New York: Lothrop, Lee & Shepard. An owl captures Warton, but he becomes his friend rather than his dinner.

Fleming, I. (1964). *Chitty chitty bang bang.* Illustrated by J. Burmingham. New York: Random House. This restored car has remarkable properties.

Godden, R. (1947). *The doll's house.* Illustrated by T. Tudor. New York: Viking. The three dolls in the story want a home of their own.

Grahame, K. (1908). *The wind in the willows.* Illustrated by E. H. Shepard. New York: Scribner's. Mole, Water-Rat, and Toad have a series of adventures along the river, on the open road, and in the woods.

Griffin, P. R. (1991). *A dig in time.* New York: Macmillan. Personal artifacts found in a yard let children have a time-warp experience in which they discover information about family members.

Kipling, R. (1894). *The jungle book.* New York: Doubleday. A collection of jungle stories including "Mowgli's Brothers," "Tiger-Tiger!" "Rikki-Tikki Tavi," and "Toomai of the Elephants."

Kipling, R. (1983). *The elephant's child.* Illustrated by L. B. Cauley. New York: Harcourt Brace Jovanovich. A highly illustrated version of one of the Just So Stories.

Lawson, R. (1939). *Ben and me.* Boston: Little, Brown. An autobiography of Benjamin Franklin's friend, Amos Mouse.

Leaf, M. (1936). *The story of Ferdinand.* Illustrated by R. Lawson. New York: Viking. Ferdinand would rather smell flowers than fight a matador.

LeGuin, U. K. (1988). *Catwings.* Illustrated by S. D. Schindler. New York: Franklin Watts. Four kittens with wings escape from the city slums.

LeGuin, U. K. (1992). *A ride on the red mare's back.* Illustrated by J. Downing. New York: Orchard. A toy horse comes to life and helps a girl rescue her brother from the trolls.

Lewis, C. S. (1950). *The lion, the witch and the wardrobe.* Illustrated by P. Baynes. New York: Macmillan. Four children enter the magical kingdom of Narnia by means of a wardrobe.

Lindgren, A. (1950). *Pippi Longstocking*. Illustrated by L. S. Glanzman. New York: Viking. Pippi does some very strange things, such as scrubbing the floor with brushes tied to her feet.

Lionni, L. (1963). *Swimmy*. New York: Pantheon. A small fish learns about the marvels of the sea.

Lionni, L. (1967). *Frederick*. New York: Pantheon. A little mouse teaches his friend about the value of the imagination.

Marzollo, J., & Marzollo, C. (1982). *Jed's junior space patrol: A science fiction easy-to-read*. Illustrated by D. S. Rose. New York: Dial. Robots and telepathic animals add to this space adventure.

McBratney, S. (1989). *The ghosts of Hungryhouse Lane*. Illustrated by L. Thiesing. Cambridge, MA: Holt. Some children discover that their new home has ghosts.

Milne, A. A. (1926). *Winnie-the-Pooh*. Illustrated by E. H. Shepard. New York: Dutton. Pooh has some adventures with his nursery friends and Christopher Robin.

Milne, A. A. (1928). *The house at Pooh Corner*. Illustrated by E. H. Shepard. New York: Dutton. Pooh constructs a house.

Oakley, G. (1928). *The church mice in action*. New York: Atheneum. The church mice enter Sampson into a cat show in this picture storybook.

Potter, B. (1902). *The tale of Peter Rabbit*. New York: Warne. The original tale of the mischievous rabbit.

Potter, B. (1903). *The tale of Squirrel Nutkin*. New York: Warne. The original tale of the impertinent squirrel.

Selden, G. (1981). *Chester Cricket's pigeon ride*. Illustrated by G. Williams. New York: Farrar, Straus & Giroux. Chester embarks on a night tour because he misses his country home.

Thurber, J. (1990). *Many moons*. Illustrated by M. Simont. San Diego: Harcourt Brace Jovanovich. In this recent version of Thurber's 1943 story, the court jester grants the princess's wish for the moon.

Travers, P. L. (1934). *Mary Poppins*. Illustrated by M. Shepard. San Diego: Harcourt Brace Jovanovich. A strange nanny arrives with the east wind and changes the life of the Banks family.

Van Allsburg, C. (1983). *The wreck of the Zephyr*. Boston: Houghton Mifflin. A picture storybook fantasy in which a boy tries to become a great sailor.

Williams, M. (1984). *The velveteen rabbit*. Illustrated by A. Atkinson. New York: Knopf. Another newly illustrated version of the 1922 classic.

Wolff, F. (1993). *Seven loaves of bread*. Illustrated by K. Keller. New York: Tambourine. The author of this book uses the pattern of a cumulative folktale.

Yolen, J. (1972). *The girl who loved the wind*. Illustrated by E. Young. New York: Crowell. In this book, the wind visits a girl and sings to her about life.

Multicultural Books

African American Literature

Aardema, V. (1975). *Why mosquitoes buzz in people's ears*. Illustrated by L. & D. Dillon. New York: Dial. An African folktale that explains why mosquitoes buzz.

Aardema, V. (1977). *Who's in Rabbit's house?* Illustrated by L. & D. Dillon. New York: Dial. A Masai folktale illustrated as a play and performed by villagers wearing masks.

Aardema, V. (1981). *Bringing the rain to Kapiti Plain: A Nandi tale*. Illustrated by B. Vidal. New York: Dial. A cumulative tale from Kenya.

Arkhurst, J. C. (1964). *The adventures of Spider: West African folktales*. Illustrated by J. Pinkney. Boston: Little, Brown. A collection of West African folktales.

Bryan, A. (1986). *Lion and the ostrich chicks, and other African folk tales*. New York: Atheneum. A collection of folktales.

Crews, D. (1991). *Bigmama's*. New York: Greenwillow. Some children visit Bigmama in Florida.

DeKay, J. T. (1969). *Meet Martin Luther King, Jr.* Illustrated by T. Burwell. New York: Random House. This biography stresses the magnitude of Martin Luther King's work and the reasons why he fought against injustice.

Dragonwagon, C. (1990). *Home place*. Illustrated by J. Pinkney. New York: Macmillan. The family visits an old home site.

Feelings, M. (1974). *Jambo means hello: Swahili alphabet book*. New York: Dial. This beautiful book uses the Swahili alphabet.

Ferris, J. (1988). *Go free or die: A story of Harriet Tubman*. Minneapolis, MN: Carolrhoda. This biography describes Tubman's experiences during the time of slavery and the Underground Railroad in the United States.

Flournoy, V. (1985). *The patchwork quilt*. Illustrated by J. Pinkney. New York: Dial. Making a quilt brings a family together.

Gerson, M.-J. (1992). *Why the sky is far away: A Nigerian folktale*. Illustrated by C. Golembe. Boston: Little, Brown. A *pourquoi* tale from Nigeria.

Greenfield, E. (1991). *Night on Neighborhood Street*. Illustrated by J. S. Gilchrist. New York: Dial. The text and illustrations depict activities on a street.

Grifalconi, A. (1992). *Flyaway girl*. Boston: Little, Brown. An African girl receives guidance from her ancestors's spirits.

Guy, R. (1981). *Mother Crocodile*. Illustrated by J. Steptoe. New York: Delacorte. A folktale from Senegal, West Africa, that emphasizes that elders' advice should be heeded.

Haley, G. E. (1970). *A story, a story*. New York: Atheneum. An African tale that tells about a spider man's bargain with Sky God.

Harris, J. C. (1986). *Jump! The adventure of Brer Rabbit*. Adapted by V. D. Parks. Illustrated by B. Moser. San Diego: Harcourt Brace Jovanovich. Five Brer Rabbit stories, including "The Comeuppance of Brer Wolf" and "The Moon in the Millpond."

Havill, J. (1986). *Jamaica's find*. Illustrated by A. S. O'Brien. Boston: Houghton Mifflin. A girl finds out how good it feels to return a lost possession.

Hoffman, M. (1991). *Amazing Grace*. Illustrated by C. Binch. New York: Dial. A girl proves that she can be the best Peter Pan.

Howard, E. F. (1989). *Chita's Christmas tree*. Illustrated by F. Cooper. New York: Bradbury. A family prepares for Christmas in early Baltimore.

Johnson, A. (1989). *Tell me a story, Mama*. Illustrated by D. Soman. Danbury, CT: Watts. A picture book in which a mother tells stories about her childhood.

Knutson, B. (Reteller). (1990). *How the Guinea Fowl got her spots: A Swahili tale of friendship*. Minneapolis, MN: Carolrhoda. This Swahili tale tells a story of friendship that explains a physical characteristic.

Kroll, V. (1992). *Masai and I*. Illustrated by N. Carpenter. New York: Four Winds. A girl compares her life with the life of the Masai.

McDermott, G. (1972). *Anansi the spider: A tale from the Ashanti*. Cambridge, MA: Holt, Rinehart and Winston. A colorfully illustrated folktale.

McKissack, P. (1986). *Flossie and the fox*. Illustrated by R. Isadora. New York: Dial. A tale of the rural South.

McKissack, P. (1989). *Nettie Jo's friends*. Illustrated by S. Cook. New York: Knopf. Animal friends help a girl find a needle so she can make a dress for her doll.

Mollel, T. M. (1992). *A promise to the sun: A story of Africa*. Illustrated by B. Vidal. Boston, MA: Little, Brown. A "why" tale that explains the character traits of bats.

Pinkney, A. D. (1993). *Seven candles for Kwanzaa*. Illustrated by B. Pinkney. New York: Dial. This book details the preparation for the African American holiday.

Rosen, M. J. (1992). *Elijah's angel: A story for Chanukah and Christmas*. Illustrated by A. B. L. Robinson. San Diego: Harcourt Brace Jovanovich. A Jewish boy learns about friendship by the gift of a black wood carver.

San Souci, R. D. (1992). *Sukey and the mermaid*. Illustrated by B. Pinkney. New York: Four Winds. A folktale with elements from West Africa, the Caribbean, and the Sea Islands of South Carolina.

Smalls-Hector, I. (1992). *Jonathan and his mommy*. Illustrated by M. Hays. Boston: Little, Brown. A boy and his mother take an unusual walk in their neighborhood.

Williams, K. L. (1991). *When Africa was home*. Illustrated by F. Cooper. New York: Orchard. A family moves back to Africa because they miss their friends.

Williams, V. B. (1986). *Cherries and cherry pits*. New York: Greenwillow. A girl utilizes a magic marker to tell stories about people who like cherries.

Asian American Literature

Allen, J. (1992). *Tiger*. Illustrated by T. Humphries. Cambridge, MA: Candlewick. In this book, a hunter saves a tiger by taking its picture rather than killing it.

Asian Culture Centre for UNESCO. (1976). *Folktales from Asia for children everywhere* (3 vols.). New York: Weatherhill. These folktales come from many Asian countries.

Coerr, E. (1993). *Mieko and the fifth treasure*. New York: Putnam. A young Japanese girl almost loses her gift for drawing when her hand is injured during the bombing of Nagasaki.

Conger, D. (1987). *Many lands, many stories: Asian folktales for children*. Illustrated by R. Ra. Boston: Tuttle. These 15 folktales are identified by their countries of origin.

Friedman, I. R. (1984). *How my parents learned to eat*. Illustrated by A. Say. Boston: Houghton

Mifflin. A humorous story about eating with chopsticks or knives and forks.

Garland, S. (1993). *The lotus seed*. Illustrated by T. Kluchi. San Diego: Harcourt Brace Jovanovich. A Vietnamese woman brings an important lotus seed with her when she and her family settle in America.

Hyun, P. (Ed.). (1986). *Korea's favorite tales and lyrics*. Illustrated by D. Park. Boston: Tuttle/Seoul International. A collection of folktales, poems, and stories.

Melmed, L. K. (1993). *The first song ever sung*. Illustrated by E. Young. New York: Lothrop, Lee & Shepard. Set in Japan, the illustrations and poetic text follow a boy as he poses the question "What was the first song ever sung?"

Mosel, A. (1972). *The funny little woman*. Illustrated by B. Lent. New York: Dutton. In this Japanese folktale, a woman steals a magic paddle.

Nomura, T. (1991). *Grandpa's town*. Translated by A. M. Stinchecum. Brookline, NY: Kane-Miller. The text, which is written in both Japanese and English, follows a boy and his grandfather around the grandfather's town.

Wallace, I. (1984). *Chin Chiang and the dragon's dance*. New York: Atheneum. A young boy dreams of dancing on the first day of the Year of the Dragon.

Yep, L. (1993). *The man who tricked a ghost*. Illustrated by I. Seltzer. Mahwah, NJ: Troll. Set in medieval China, this story tells about a boy who outwits a ghost.

Hispanic American Literature

Behrens, J. (1978). *Fiesta!* Photographs by S. Taylor. Chicago: Children's Press. Photographs of the Cinco de Mayo festival.

Belpre, P. (1973). *Once in Puerto Rico*. Illustrated by C. Price. New York: Warne. A collection of Puerto Rican tales.

Bierhorst, J. (Ed.). (1992). *Lightning inside you: And other Native American riddles*. Illustrated by L. Brierley. New York: Morrow. This book contains riddles from several regions, including southern Mexico and Western South America.

Brown, T. (1986). *Hello amigos!* Photographs by F. Ortiz. San Diego: Holt, Rinehart and Winston. This book's photographs follow a boy on his sixth birthday.

Dorros, A. (1993). *Radio man: A story in English and Spanish*. New York: HarperCollins. This book focuses on the migrant farm workers.

Ets, M. H., & Labastida, A. (1959). *Nine days to Christmas: A story of Mexico*. Illustrated by M. H. Ets. New York: Viking. Ceci has her first Posada with her own pinata.

Garcia, R. (1987). *My Aunt Otilia's spirits*. Illustrated by R. Cherin & R. Reyes. Chicago: Children's Press. An aunt from Puerto Rico with magical powers visits her family in the United States in this story.

Griego, M. C. (1981). *Tortillitas para Mama and other Spanish nursery rhymes*. Illustrated by B. Cooney. San Diego: Holt, Rinehart and Winston. In this book, nursery rhymes appear in Spanish and English.

Soto, G. (1993). *Too many tamales*. Illustrated by E. Martinez. New York: Putnam's. A family story set during Christmas Eve.

Native American Literature

Aliki. (1976). *Corn is maize: The gift of the Indians*. New York: Crowell. A history of corn, how it grows, and how it was first used.

Arnold, C. (1992). *The ancient cliff dwellers of Mesa Verde*. Photographs by R. Hewett. New York: Clarion. A nonfiction book about the Anasazi people.

Baylor, B. (1976). *Hawk, I'm your brother*. Illustrated by P. Parnall. New York: Scribner's. Rudy Soto would like to fly through the air like a hawk.

Begay, S. (1992). *Ma'ii and cousin horned toad: A traditional Navajo story*. New York: Scholastic. A horned toad plays tricks on Ma'ii, the coyote, until Ma'ii promises to leave him alone.

Cleaver, E. (1985). *The enchanted caribou*. New York: Atheneum. An Inuit tale of transformation.

Cohlene, T. (1990). *Turquoise boy: A Navajo legend*. Illustrated by C. Reasoner. Albertson, NY: Watermill. Folklore uncovers how a Navajo boy brought horses to his tribe.

Cohn, A. L. (Comp.). (1993). *From sea to shining sea: A treasury of American folklore and folk songs*. New York: Scholastic. This book progresses from traditional Native American folklore to that of more contemporary times.

Freedman, R. (1988). *Buffalo hunt*. New York: Holiday House. The illustrations and text of this

book show the importance of the buffalo to the Great Plains Indians.

Goble, P. (1978). *The girl who loved wild horses.* New York: Bradbury. This picture storybook tells about a Native American girl's attachment to horses.

Hoyt-Goldsmith, D. (1992). *Arctic hunter.* Photographs by L. Migdale. New York: Holiday House. This photographic essay follows the life of an Inuit boy and his family.

Joosse, B. M. (1991). *Mama, do you love me?* Illustrated by B. Lavalle. San Francisco: Chronicle. A young girl tests her mother's love.

Keegan, M. (1991). *Pueblo boy: Growing up in two worlds.* New York: Cobblehill. A photographic essay depicts the life of a contemporary boy.

Luenn, N. (1990). *Nessa's fish.* New York: Atheneum. An Inuit girl and her grandmother embark on an ice fishing expedition.

Miles, M. (1971). *Annie and the old one.* Illustrated by P. Parnall. Boston: Little, Brown. Annie's love for her Navajo grandmother causes her to stop work on a rug that she associates with the probable death of her grandmother.

Morgan, W. (1988). *Navajo coyote tales.* Santa Fe, NM: Ancient City Press. A collection of tales for young readers.

Oughton, J. (1992). *How the stars fell into the sky: A Navajo legend.* Illustrated by L. Desimini. Boston: Houghton Mifflin. Because Coyote is impatient, First Woman cannot write the laws for the people.

Prusski, J. (1988). *Bring back the deer.* Illustrated by N. Waldman. San Diego: Harcourt Brace Jovanovich. A young Native American boy discovers the values of respect, wisdom, and patience.

Roth, S. (1990). *The story of light.* New York: Morrow. A retelling of a Cherokee myth about the bringing of light.

Spencer, P. U. (1983). *Who speaks for wolf.* Illustrated by F. Howell. San Anselmo, CA: Tribe of Two Press. A Native American learning story.

Van Laan, N. (Reteller). (1993). *Buffalo dance: A Blackfoot legend.* Illustrated by B. Vidal. Boston: Little, Brown. A story about respect between humans and animals.

Picture Books

Aardema, V. (1975). *Why mosquitoes buzz in people's ears.* Illustrated by L. & D. Dillon. New York: Dial. African cumulative tale tells the humorous reason for mosquitoes' buzzing.

Ackerman, K. (1988). *Song and dance man.* Illustrated by S. Gammell. New York: Knopf. Grandpa creates the magic of vaudeville for his grandchildren.

Bemelmans, L. (1939). *Madeline.* New York: Viking. Madeline lives in Paris with 11 other girls and has an appendectomy.

Brown, L. K., and Brown, M. (1986). *Visiting the art museum.* New York: Dutton. A family tours the art museum.

Brown, M. W. (1947). *Goodnight moon.* Illustrated by C. Hurd. New York: Harper & Row. A book for young children that creates a soothing atmosphere at bedtime.

Burton, V. L. (1939). *Mike Mulligan and his steam shovel.* New York: Houghton Mifflin. Mike Mulligan and his shovel work together.

Carle, E. (1971). *Do you want to be my friend?* New York: Crowell. A mouse looks for a friend.

dePaola, T. (1974). *Watch out for the chicken feet in your soup.* Englewood Cliffs, NJ: Prentice Hall. Joey is embarrassed by his grandmother's old-fashioned ways until a friend shows great admiration.

Engel, D. (1989). *The little lump of clay.* New York: Morrow. A story about a homely lump of clay whose destiny is to be shaped into an object of lasting beauty.

Fleming, D. (1993). *In the small, small pond.* Cambridge, MA: Holt. Rich colors enrich the pond setting.

Gag, W. (1928). *Millions of cats.* New York: Coward, McCann. An old woman's desire for a beautiful cat results in a fight among trillions of cats.

Gibbons, G. (1987). *The pottery place.* New York: Harcourt Brace Jovanovich. This book invites readers to visit behind the scenes and learn about the special tools and skills needed for the traditional craft of pottery making.

Hall, D. (1979). *Ox-cart man.* Illustrated by B. Cooney. New York: Viking. Subtle illustrations provide new insights to this tale about a New England farmer in the early 1800s.

Leaf, M. (1936). *The story of Ferdinand.* Illustrated by R. Lawson. New York: Viking. Ferdinand decides that he would rather smell the flowers than fight the matador.

Lionni, L. (1969). *Alexander and the windup mouse.* New York: Pantheon. A real mouse is jealous of a loveable windup mouse.

MacLachlan, P. (1979). *The sick day*. Illustrated by W. P. Du Bois. New York: Pantheon. A father and daughter amuse each other when they get sick.

Mayer, M. (1974). *Frog goes to dinner*. New York: Dial. A boy hides a frog in his pocket and takes him along when the family dines in a fancy restaurant.

McCloskey, R. (1941). *Make way for ducklings*. New York: Viking. A city park in Boston provides a home for Mr. and Mrs. Mallard and their ducklings.

Musgrove, M. (1976). *Ashanti to Zulu: African traditions*. Illustrated by L. & D. Dillon. New York: Dial. The traditions of 26 African peoples are described in alphabetical order.

Potter, B. (1902). *The tale of Peter Rabbit*. New York: Warne. This edition includes Potter's original illustrations.

Scieszka, J. (1992). *The stinky cheese man and other fairly stupid tales*. Illustrated by L. Smith. New York: Viking. Full-page humorous illustrations and varying font sizes create a unique book.

Sendak, M. (1970). *In the night kitchen*. New York: Harper & Row. A young child's dream transports him into a night world.

Sendak, M. (1993). *Where the wild things are*. New York: HarperCollins. Max's imagination turns his bedroom into a forest inhabited by wild things.

Seuss, Dr. (1938). *The 500 hats of Bartholomew Cubbins*. Champaign, IL: Vanguard. A magic hat keeps reappearing.

Stevenson, R. L. (1990). *My shadow*. Illustrated by T. Rand. New York: Putnam. A feeling of movement is created through the shadows and the actions of the children.

Viorst, J. (1972). *Alexander and the terrible, horrible, no good, very bad day*. Illustrated by R. Cruz. New York: Atheneum. Alexander experiences unhappy emotions when he loses his best friend and does not have any dessert in his lunch box.

Walker, D. (Trans. & Illus.). (1976). *The sleeping beauty*. New York: Crowell. This beautifully illustrated book resembles the setting for an opera or ballet.

Yashima, T. (1955). *Crow boy*. New York: Viking. A lonely outcast at school finds respect and self-confidence.

Yolen, J. (1987). *Owl moon*. Illustrated by J. Schoenherr. New York: Philomel. A beautifully illustrated book that re-creates the wonders of nature.

Yorinks, A. (1986). *Hey, Al*. Illustrated by R. Egielski. New York: Farrar, Straus & Giroux. A janitor realizes that his home is better than he thinks.

Zolotow, C. (1962). *Mr. Rabbit and the lovely present*. Illustrated by M. Sendak. New York: Harper & Row. A rabbit helps a little girl search for a gift for her mother's birthday.

Poetry Books

Adoff, A. (1974). *My black me: A beginning book of black poetry*. New York: Dutton. A collection of black poetry.

Adoff, A. (1982). *All the colors of the race*. Illustrated by J. Steptoe. New York: Lothrop, Lee & Shepard. A girl with mixed-race parents reflects on tolerance.

Aesop (1988). *Aesop's fables*. Retold by T. Paxton. Illustrated by R. Rayevsky. New York: Morrow. A poetic version of the fables.

Angelou, M. (1978). *And still I rise*. New York: Random House, 1978. These new poems are powerful, distinctive, and fresh, and as always, full of the uplifting rhythm of love and understanding.

Atwood, A. (1971). *Haiku: The mood of the Earth*. New York: Scribner's. Beautiful photographs accompany these haiku nature poems.

Baylor, B. (1978). *The other way to listen*. Illustrated by P. Parnall. New York: Scribner's. You have to be patient to hear cactuses blooming and rocks whispering, but it is worth it.

Behn, H. (1964). *Cricket songs*. New York: Harcourt, Brace and World. Poems of Issa and other geniuses of the art of haiku are included in this collection.

Bierhorst, J. (Ed.). (1983). *The sacred path: Spells, prayers and power songs of the American Indians*. New York: Morrow. A collection from sources across America.

Bryan, A. (1992). *Sing to the sun*. New York: HarperCollins. African American poems that reflect the culture of the Carribean.

Carroll, L. (1973). Beautiful soup. In M. C. Livingston (Ed.), *Poems of Lewis Carroll*. New York: Crowell. Carroll uses repetition to re-create the sounds of soup being taken from a hot tureen and placed in children's mouths.

Carroll, L. (1977). *Jabberwocky*. Illustrated by J. B. Zalben. New York: Warne. A picture interpretation of Carroll's poem in watercolors.

Carson, J. (Ed.). (1989). *Stories I ain't told nobody yet*. New York: Franklin Watts. An anthology that includes a collection of poems written by people in Appalachia.

Caudill, R. (1969). *Come along!* Illustrated by E. Raskin. New York: Holt, Rinehart and Winston. The illustrations complement the author's haiku images with acrylic paint on colored rice paper.

deRegniers, B. S., Moore, E., White, M. M., & Carr, J. (1988). *Sing a song of popcorn: Every child's book of poems*. New York: Scholastic. An anthology of poems illustrated by nine Caldecott Medal artists.

Duffy, C. A. (Ed.). (1994). *I wouldn't thank you for a valentine: Poems for young feminists*. Illustrated by T. Rafferty. San Diego, CA: Holt. Poems that explore many feelings and emotions.

Ferris, H. (Ed.). (1957). *Favorite poems old and new*. New York: Doubleday. An anthology.

Field, E. (1982). *Wynken, Blynken and Nod*. Illustrated by S. Jeffers. New York: Dutton. A classic poem that appears in a newly illustrated edition.

Fisher, A. (1971). *Feathered ones and furry*. Illustrated by E. Carle. New York: Crowell. Fifty-five poems written about furry animals and feathery birds.

Frost, R. (1949). *Complete poems of Robert Frost*. New York: Holt, Rinehart and Winston. This is a collection of classic Frost poetry.

Frost, R. (1978). *Stopping by woods on a snowy evening*. Illustrated by S. Jeffers. New York: Dutton. Large pictures are used to illustrate Frost's poem.

Hood, T. (1990). *Before I go to sleep*. Illustrated by M. J. Begin-Callanan. New York: Putnam. Nighttime verse.

Hopkins, L. B. (Ed.). (1987). *Click, rumble, roar*. Photographs by A. H. Audette. New York: Crowell. This book includes 18 poems about machines.

Hughes, L. (1974). *Selected poems*. Illustrated by E. M. Kauffer. New York: Random House. This collection represents the choices Hughes himself made, shortly before his death, of the poems that he most wanted to preserve from his six published volumes.

Hughes, S. (1988). *Out and about*. New York: Lothrop, Lee & Shepard. These poems follow a child and her infant brother through the seasons.

Johnson, H. (1971). *Hello, small sparrow*. Illustrated by T. Chen. New York: Lothrop, Lee & Shepard.

A collection of poems in the form of ancient Japanese haiku.

Kemp, G. (Ed.). (1980). *Ducks and dragons: Poems for children*. Illustrated by C. Dinan. Winchester, MA: Faber & Faber. An anthology of poems about seasons, reality, animals, fantasy, fear, and old songs.

Knudson, R. R., & Swenson, M. (Eds.). (1988). *American sports poems*. New York: Franklin Watts. An anthology of poems about sports and athletes.

Koch, K. (1970). *Wishes, lies, and dreams*. New York: Vintage. Topical poems relate experiences that are common to all children.

Lear, E. (1946). *The complete nonsense book*. Northbrook, IL: Dodd, Mead. This text includes *A book of nonsense*, originally published in 1846, and *Nonsense songs and stories*, originally published in 1871.

Lear, E. (1991). *The owl and the pussycat*. Illustrated by J. Brett. New York: Franklin Putnam's. This classic poem is set in the Caribbean.

Lee, D. (1991). *The ice cream store*. Illustrated by D. McPhail. New York: HarperCollins. A collection of humorous poems.

Lewis, R. (1968). *Of this world: A poet's life in poetry*. Photographs by H. Butterfield. New York: Dial. This book includes poems by Issa and interesting information about his life.

Livingston, M. C. (Ed.). (1982). *A circle of seasons*. Illustrated by L. Everett Fisher. New York: Holiday House. These poems are about the four seasons.

Martz, S. (Ed.). (1987). *When I am an old woman, I shall wear purple: An anthology of short stories and poetry*. Manhattan Beach, CA: Papier-Mache Press. An anthology of stories and poems that paint a rich picture of women as they age.

Merrill, J., & Solbert, R. (1969). *A few flies and I: Haiku by Issa*. Translated by R. H. Blyth and N. Yuasa. Illustrated by R. Solbert. New York: Pantheon. The great Japanese poet Issa uses the ancient form of verse to express feelings and experiences.

Milne, A. A. (1954). *Winnie-the-Pooh*. Illustrated by E. H. Shepard. New York: Dutton. The classic story, with poems, about Christopher Robin's friend, Pooh.

Milne, A. A. (1958). *The world of Christopher Robin*. Illustrated by E. H. Shepard. New York: Dutton. These poems tell about a boy and his toy animal friends.

Milne, A. A. (1961). *When we were very young.* Illustrated by E. H. Shepard. New York: Dutton. Delightful poems about Winnie-the-Pooh and the hundred-acre wood.

Moore, C. (1980). *The night before Christmas.* Illustrated by T. dePaola. New York: Holiday House. Large, brightly colored illustrations appear in picture-book form.

O'Neill, M. (1961). *Hailstones and halibut bones.* Illustrated by L. Weisgard. New York: Doubleday. These poems describe the basic colors.

Prelutsky, J. (1982). *The baby uggs are hatching.* Illustrated by J. Stevenson. New York: Greenwillow. These humorous poems are about Grebles, Sneepies, and Slitchs.

Prelutsky, J. (Ed.). (1983). *The Random House book of poetry for children.* Illustrated by A. Lobel. New York: Random House. An anthology of more than 500 poems divided according to themes.

Prelutsky, J. (1984). *The new kid on the block.* New York: Greenwillow. Author uses rhyme and rhythm to write humorous narrative poems about familiar, everyday occurrences.

Prelutsky, J. (Ed.). (1986). *Read-aloud rhymes for the very young.* Illustrated by M. Brown. New York: Knopf. An attractive collection of poems that stress vivid language.

Prelutsky, J. (Ed.). (1988). *Tyrannosaurus was a beast: Dinosaur poems.* Illustrated by A. Lobel. New York: Greenwillow. Fourteen poems about characteristics of dinosaurs.

Prelutsky, J. (1993). *The dragons are singing tonight.* Illustrated by P. Sis. New York: Greenwillow. Poems about dragons.

Schwartz, A. (1992). *And the green grass grew all around: Folk poetry from everyone.* Illustrated by S. Truesdell. New York: HarperCollins. A collection of folk poetry.

Seuss, Dr. (1957). *The cat in the hat.* New York: Random House. An illustrated humorous poem.

Silverstein, S. (1974). *Where the sidewalk ends.* New York: Harper & Row. A collection of humorous poems.

Silverstein, S. (1981). *A light in the attic.* New York: Harper & Row. Humorous poems that tell about such situations as the polar bear in the Frigidaire.

Sky-Peck, K. (Ed.). (1991). *Who has seen the wind? An illustrated collection of poetry for young people.* Boston: Museum of Fine Arts, and Rizzoli. Appropriate art accompanies this collection of poems.

Snyder, Z. (1969). *Today is Saturday.* Illustrated by J. Arms. New York: Atheneum. Snyder uses end rhymes to suggest the visual and auditory elements of mud and internal rhymes to create a real tongue twister.

Starbird, K. (1979). *The covered bridge house and other poems.* Illustrated by J. Arnosky. New York: Four Winds. These 30 poems tell about childhood experiences, such as jumping rope, hopping after falling on a ski slope, and wondering why no one can get rags from ragweed.

Stevenson, R. L. (1885). *A child's garden of verses.* White Plains, NY: Longmans, Green. A classic book of poetry.

Viorst, J. (1981). *If I were in charge of the world and other worries: Poems for children and their parents.* Illustrated by L. Cherry. New York: Atheneum. Poems about everyday situations that frustrate.

Whipple, L. (Ed.). (1989). *Eric Carle's animals, animals.* Illustrated by E. Carle. New York: Philomel. Text includes an anthology of poems about animals.

Willard, N. (1986). *Night story.* Illustrated by I. Plume. San Diego, CA: Harcourt Brace Jovanovich. A little boy has an adventure in dreamland.

Zolotow, C. (1978). *River winding.* Illustrated by K. Mizumura. New York: Crowell. These poems for young children paint images of things seen and remembered.

Music

Come Follow Me in a Line, in a Line

Traditional

Come fol - low me in a line, in a line, oh
Come fol - low me we will go this way.

Walk, Walk, Walk to School

Traditional

Walk, walk, walk to school, Walk to school to - geth - er,
Walk, walk, walk to school, walk to school to - geth - er.

Clap, clap, clap your hands.
Wiggle, wiggle, wiggle your nose.
Blink, blink, blink your eyes.
Tap, tap, tap your toes.

Pick, pick, pick up your toys.
Rest, rest, rest your head.
Close, close, close your eyes.
Take, take, take a nap.

333

If You're Happy

American Singing Game

If you're hap-py and you know it, clap your hands,

If you're hap-py and you know it clap your

hands, If you're hap-py and you

know it, then your face will sure-ly show it, If you're

hap-py and you know it clap your hands.

2. If you're happy and you know it, tap your toe.
3. If you're happy and you know it, nod your head.
4. If you're happy and you know it, do all three.

Ten in the Bed

American Folk Song

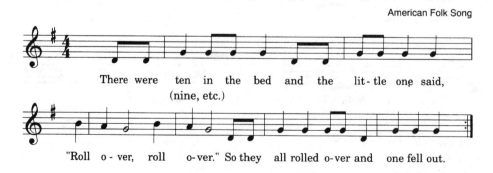

There were ten in the bed and the lit-tle one said,
(nine, etc.)

"Roll o-ver, roll o-ver." So they all rolled o-ver and one fell out.

Count down to one. In the final verse, sing: "There was one in the bed, and the little one said (whisper), 'Good night'."

Bluebird, Bluebird

American Singing Game

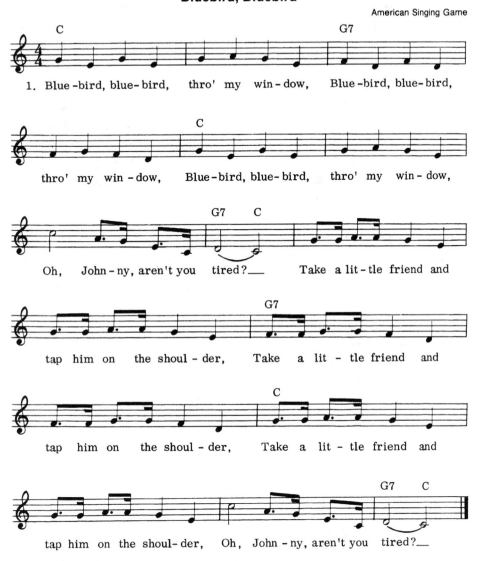

1. Blue-bird, blue-bird, thro' my win-dow, Blue-bird, blue-bird,

thro' my win-dow, Blue-bird, blue-bird, thro' my win-dow,

Oh, John-ny, aren't you tired?— Take a lit-tle friend and

tap him on the shoul-der, Take a lit-tle friend and

tap him on the shoul-der, Take a lit-tle friend and

tap him on the shoul-der, Oh, John-ny, aren't you tired?—

The Mulberry Bush

Traditional

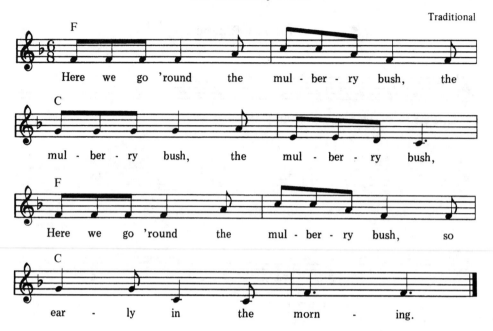

Here we go 'round the mul-ber-ry bush, the
mul-ber-ry bush, the mul-ber-ry bush,
Here we go 'round the mul-ber-ry bush, so
ear-ly in the morn-ing.

This is the way we walk to school.
This is the way we tie our shoes.
This is the way we brush our teeth.
This is the way we spin around.

A Song for Seasons

Lyrics by Linda C. Edwards

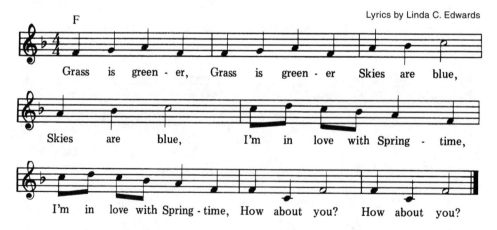

Grass is green-er, Grass is green-er Skies are blue,
Skies are blue, I'm in love with Spring-time,
I'm in love with Spring-time, How about you? How about you?

2. Leaves are golden, Leaves are golden
 Breeze is cool, Breeze is cool,
 I'm in love with Autumn,
 I'm in love with Autumn,
 Back to school, Back to school.

3. Snow is falling, Snow is falling,
 Skies are grey, Skies are grey,
 I'm in love with Winter,
 I'm in love with Winter,
 What a great day! What a great day!

Where, Oh Where

American Traditional Game

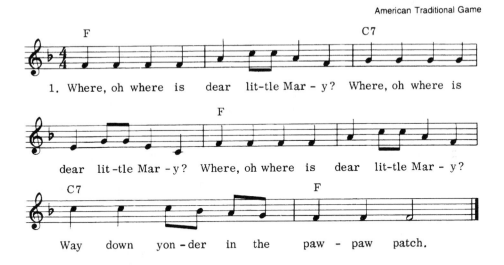

1. Where, oh where is dear lit-tle Mar - y? Where, oh where is

dear lit -tle Mar - y? Where, oh where is dear lit-tle Mar - y?

Way down yon - der in the paw - paw patch.

Hello Everybody

Traditional

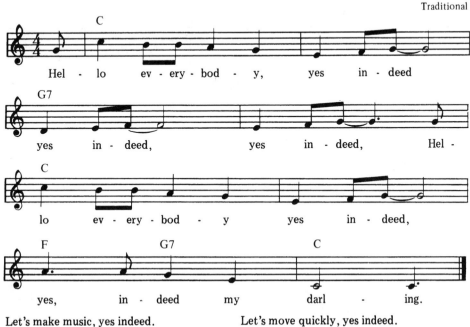

Hel - lo ev - ery-bod - y, yes in - deed

yes in - deed, yes in - deed, Hel -

lo ev - ery-bod - y yes in - deed,

yes, in - deed my darl - ing.

Let's make music, yes indeed. Let's move quickly, yes indeed.
Let's sing softly, yes indeed. Let's come together, yes indeed.

Head and Shoulders, Baby

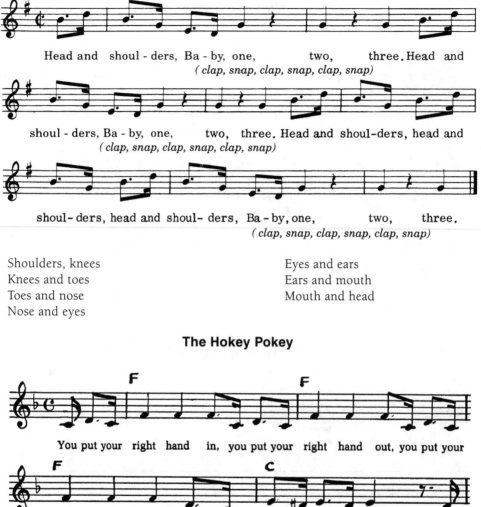

Head and shoul-ders, Ba-by, one, two, three. Head and
(clap, snap, clap, snap, clap, snap)

shoul-ders, Ba-by, one, two, three. Head and shoul-ders, head and
(clap, snap, clap, snap, clap, snap)

shoul-ders, head and shoul-ders, Ba-by, one, two, three.
(clap, snap, clap, snap, clap, snap)

Shoulders, knees
Knees and toes
Toes and nose
Nose and eyes

Eyes and ears
Ears and mouth
Mouth and head

The Hokey Pokey

You put your right hand in, you put your right hand out, you put your

right hand in and you shake it all a-bout. You

do the ho-key po-key and you turn your-self a-round.

That's what it's all a- bout.

You put your left hand in . . .
You put your right foot in . . .

You put your left foot in . . .
You put your whole self in . . .

Let's Go Zudio

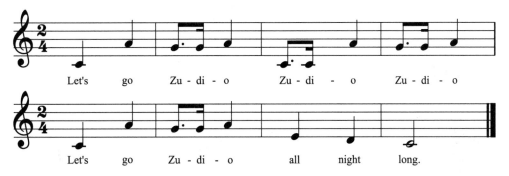

Step back Sally, Sally, Sally,
Step back Sally, all night long.

Strollin' down the alley, alley, alley,
Strollin' down the alley, all night long.

Let's go Zudio, Zudio, Zudio,
Let's go Zudio, all night long.

Kye, Kye, Kule

African

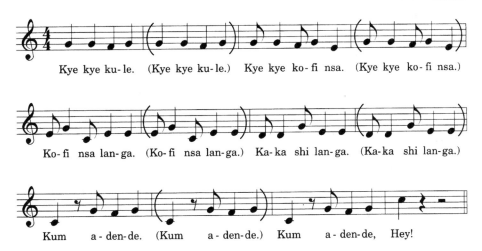

Hi Yo Hi Yo Ip Si Ni Yah
(Happy Song)

Navajo

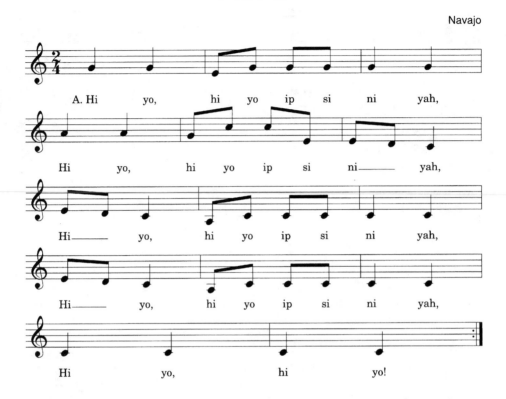

A. Hi yo, hi yo ip si ni yah,

Hi yo, hi yo ip si ni_____ yah,

Hi_____ yo, hi yo ip si ni yah,

Hi_____ yo, hi yo ip si ni yah,

Hi yo, hi yo!

San Sereni

Spanish

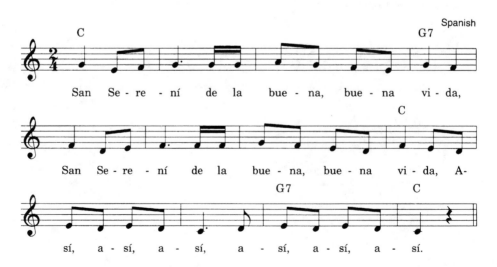

San Se - re - ní de la bue - na, bue - na vi - da,

San Se - re - ní de la bue - na, bue - na vi - da, A-

sí, a - sí, a - sí, a - sí, a - sí, a - sí.

El Coquí
(The Frog)

Puerto Rican

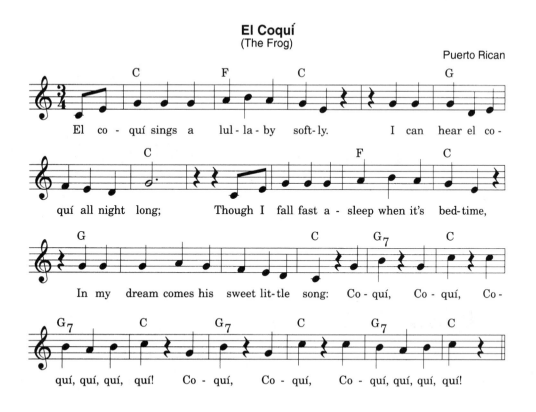

El co - quí sings a lul - la - by soft- ly. I can hear el co -
quí all night long; Though I fall fast a - sleep when it's bed-time,
In my dream comes his sweet lit-tle song: Co - quí, Co - quí, Co -
quí, quí, quí, quí! Co - quí, Co - quí, Co - quí, quí, quí, quí!

A Bedtime Song for Brian and Anthony*

Pretty little horses, up and down
Pretty little horses, round and round.
Dapple grey, come what may
Pretty little mare, don't know where.
Pretty little horses, up and down,
Pretty little horses, round and round.

*Sing or chant quietly while rocking sleepy children.

appendix 3

Fingerplays

Animals and Fishes

Five Little Chickadees

Five little chickadees
 (Hold up five fingers and bend them down, one
 at a time as verse progresses)
Peeping at the door.
One flew away,
And then there were four.
Four little chickadees
Sitting on a tree.
One flew away,
And then there were three.
Three little chickadees
Looking at you.
One flew away,
And then there were two.
Two little chickadees
Sitting in the sun.
One flew away,
And then there was one.
One little chickadee
Left all alone.
One flew away,
And then there were none.

Gray Squirrel

Gray squirrel, gray squirrel,
 (Suit actions to words)
Swish your bushy tail.
Gray squirrel, gray squirrel,
Swish your bushy tail.
Wrinkle up your little nose.
Hold a nut between your toes.

Gray squirrel, gray squirrel,
Swish your bushy tail.

Mice at Play

Softly-softly, at the close of day,
 (Make five fingers creep)
Little mice come creeping from their homes to play.
No one hears their padded feet,
As they pitter pat.
Mother mouse has warned them
 (Fingers over lips to "sh")
Of the family cat.

Naptime

"Come little children,"
 (Beckoning motion)
Calls mother hen.
"It is time to take
Your nap again."
And under her feathers
The small chicks creep
 (Fingers of right hand creep into folded
 left hand)
And she clucks a song
Till they fall asleep.

Quack! Quack! Quack!

Five little ducks that I once knew,
 (Hold up five fingers)
Big ones, little ones, skinny ones too,
 (Pantomime sizes with hands)
But the one little duck with the
 (Hold up one finger)
Feather on his back,

All he could do was, "Quack, Quack, Quack!"
(Make quacking motions with thumb and four
fingers)
All he could do was, "Quack, Quack, Quack!"
Down to the river they would go.
Waddling, waddling, to and fro,
(Waddling motions)
But the one little duck with the
Feather on his back,
All he could do was, "Quack, Quack, Quack."
All he could do was, "Quack, Quack, Quack."
Up from the river they would come.
Ho, Ho, Ho, Ho, Hum, Hum, Hum
But the one little duck with the
Feather on his back,
All he could do was, "Quack, Quack, Quack."
All he could do was, "Quack, Quack, Quack."

Little Cabin in the Woods

Little cabin in the woods
(Use index fingers to make imaginary square)
Little man at the window stood
(Index finger and thumb to make eyeglass shape)
Saw a rabbit hopping by
(Extend index and middle finger in hopping
motion)
Then, knocking at the door.
(Fist in knocking motion)
"Help me, Help me, Help me," he said,
(Shake hands above head)
"Or the hunter will shoot me dead."
(Loud clapping sound)
"Little rabbit, come inside
(Beckoning motion)
Safely, you'll abide."
(Cradle index and middle finger in other arm)

Two Little Blackbirds

Two little blackbirds sitting on a hill.
(Index finger on each hand fluttering motion)
One named Jack, and one named Jill
(Raise one hand, then the other)
Fly away Jack, fly away Jill.
(Right hand flies behind back, then left)
No little blackbirds sitting on the hill.
Come back, Jack, come back, Jill.
(Right hand returns to front, then left)
Two little blackbirds sitting on a hill.
(Both hands back to original position)

There Was a Little Turtle

There was a little turtle
(Make fist with right hand)
Who lived in a box.
(Cover fist with left hand)
He swam in a puddle
(Swimming motions)
He climbed on a rock.
(Climbing motions)
He snapped at a mosquito.
(Make a snapping motion with right hand,
extending toward audience)
He snapped at a flea.
(Repeat)
He snapped at a minnow.
(Repeat)
And he snapped at me!
(Point snapping motion toward self)
He caught the mosquito.
(Catching motion, extending toward audience)
He caught the flea.
(Repeat)
He caught the minnow.
(Repeat)
But he didn't catch me!
(Point toward self and shake head, "No!")

Let's Go on a Bear Hunt

The leader "lines" each phrase and the audience
repeats. Everyone claps hands on thighs in
walking rhythm.
Let's go on a bear hunt.
(Clap hands on thighs in walking rhythm)
All righty.
Let's go.
Hey lookie,
There's a wheat field.
Can't go around it,
Can't go under it,
Let's go through it.
All righty,
Let's go.
Swish, swish, swish.
"Bugs!"
(Rub hands and arms together in swishing
motion, then shout "bugs!" and scratch arms
and legs)
Hey lookie,
There's a river,

Can't go over it,
Can't go around it,
Let's swim across it.
All righty,
Let's go.
Side-stroke,
Back-stroke.
"Alligators!"
> (Make swimming motions, then shout
> "Alligator!" speed up actions)

Hey lookie,
There's a bridge,
Can't go around it,
Can't go under it,
Let's walk across it.
All righty,
Let's go.
> (Stamp feet on floor and make loud sound)

Hey lookie,
There's a tree.
Can't go over it,
Can't go under it,
Let's climb up it.
All righty,
Let's go.
> (Make climbing motions with hands and arms)

See any bears?
> (Hand on forehead in looking motion)

No bears out there!
> (Climbing down motion)

Hey lookie,
There's a cave.
Can't go around it,
Can't go over it,
Let's go in it.
All righty,
Let's go.
> (Clap hands on thighs in slow motion)

I see two big eyes!
> (Use suspenseful voice and hold up two fingers)

I see two sharp teeth.
I feel some nice, soft fur.
> (Stroking motion with hand)

It's a BEAR!
> (Use loud, excited voice)
> (Repeat fingerplay backward and very fast. After
> going back through the wheat field, make a big
> sighing sound and say . . . "Boy, it sure is good
> to be back home!")

Home and Hearth

A House

I will make a little house,
> (Hold hands upright with tips of fingers
> touching to form arch)

Where two playmates come to hide.
> (Slide thumbs under arch)

When I peep in at the door
> (Bend hands to look through arch)

Then they quickly run outside.
> (Slide thumbs out quickly)

My House

I'm going to build a little house,
> (Fingers form roof)

With windows big and bright.
> (Two index fingers and thumbs)

With chimney tall and curling smoke,
> (Stand with arms up in air)

Drifting out of sight.
In winter when the snowflakes fall,
> (Hands flutter down)

Or when I hear a storm,
> (Hands cupped to ear)

I'll go sit in my little house,
> (Sit down)

Where I'll be snug and warm.
> (Cross arms over chest)

Tea Pot

I'm a little tea pot,
> (Place right hand on hip, extend left hand, palm
> out)

Short and stout.
Here's my handle,
And here's my spout.
When I get all steamed up,
I just shout:
"Tip me over, and pour me out."
> (Bend to the left)

I can change my handle
> (Place left hand on hip and extend right hand
> out)

And my spout.
"Tip me over, and pour me out."
> (Bend to the right)

Children's Active Time

Reach for the Ceiling

Reach for the ceiling,
 (Suit actions to words)
Touch the floor,
Stand up again,
Let's do some more.
Touch your head,
Then your knee,
Up to your shoulders
Like this, you see.
Reach for the ceiling,
Touch the floor,
That's all now,
There isn't any more.

Two Little

Two little feet go tap, tap, tap.
 (Suit actions to words)
Two little hands go clap, clap, clap.
A quiet little leap up from my chair.
Two little arms reach high in the air.
Two little feet go jump, jump, jump.
Two little fists go thump, thump, thump.
One little body goes round, round, round,
And one little child sits quietly down.

Open-Shut Them

Open, shut them,
Open, shut them,
 (Open and close hands making a fist)
Let your hands go clap.
 (Clap hands together)
Open, shut them,
Open, shut them,
Put them in your lap.
 (Put hands in lap)
Creep them, crawl them,
Creep them, crawl them,
Right up to your chin.
 (Fingers creep toward chin)
Open up you little mouth,
But do not let them in.
 (Quickly put hands behind back)

Jack in the Box

Jack in the box all shut up tight.
 (Make fist with right hand and cover with left hand)
Not a breath of air, not a ray of light.
How tired he must be all down in a heap,
We'll open the door, and out he'll peep.
 (Raise left hand in opening motion and pop up thumb)

My Wiggles

I wiggle my fingers,
 (Suit actions to words)
I wiggle my toes.
I wiggle my shoulders,
I wiggle my nose.
Now the wiggles are out of me,
And I'm just as still as I can be.

Relax

Close your eyes, head drops down,
 (Suit actions to words)
Face is smooth, not a frown.
Roll to left, your head's a ball!
Roll to right, sit up tall.
Lift your chin, look and see.
Deep, deep breath, 1, 2, 3.
Big, big, smile; hands in lap.
Make believe you've had a nap.
Now you've rested from your play,
Time to work again today!

Sometimes I Am Tall

Sometimes I am tall.
 (Stand at full height)
Sometimes I am small.
 (Bend down close to the floor)
Sometimes I am very, very, tall.
 (Stretch on tiptoes)
Sometimes I am very, very, small.
 (Bend as close to floor as possible)
Sometimes tall, sometimes small,
 (Stretch high and bend low)
See how I am now.
 (Stand normal)

Holidays

Birthday Candles

Today I have a birthday.
I'm four years old, you see.
 (Hold up four fingers)
And here I have a birthday cake
 (Make circle with arms)

Which you may share with me.
 (Point to friend in group)
First we count the candles,
Count them, every one.
One, two, three, four,
The counting now is done.
Let's blow out the candles.
Out each flame will go.
"Wh. . . , wh. . . , wh. . . , wh. . . ,"
 (Pretend to blow out candles)
As one by one we blow.
 (Bend down fingers one at a time as you blow)

Five Little Pumpkins

Five little pumpkins sitting on a gate;
 (Hold up five fingers and bend them down one
 at a time as verse progresses)
The first one said, "My, it's getting late."
The second one said, "There are witches in the air."
The third one said, "But we don't care."
The fourth one said, "Let's run, let's run."
The fifth one said, "It's Halloween fun."
"WOOOOOOOO" went the wind,
 (Sway hand through the air)
And out went the lights.
 (Loud clap)
These five little pumpkins ran fast out of sight.
 (Place hands behind back)

Turkey Gobbler

I met a turkey gobbler
 (Suit actions to words or sing to tune "Brownie
 Smile")
When I went out to play.
"Mr. Turkey Gobbler, How are you today?"
"Gobble, gobble, gobble, that I cannot say,
Don't ask me such a question on
Thanksgiving Day."

Friend's Valentine

Listen, friend, you know what?
 (Suit actions to words)
On Valentine's Day, I love you a lot.
So I'll throw you a kiss, friend of mine.
I want you for my valentine.

Imagine That!

Fuzzy Wuzzy Caterpillar

Fuzzy wuzzy caterpillar
Into a corner will creep.
 (Make fingers creep)
He'll spin himself a blanket,
And then go fast asleep.
 (Rest head on hands; close eyes)
Fuzzy wuzzy caterpillar
Wakes up by and by
 (Children awaken)
To find he has wings of beauty
Changed to a butterfly.

Owl and the Brownies

An owl sat alone on the branch of a tree,
 (Fold hands)
And he was as quiet as quiet could be.
 (Whisper)
It was night and his eyes were round like this.
 (Make circles around eyes with fingers)
He looked all around; not a thing did he miss.
 (Turn head from side to side)
Some brownies crept up on the branch of the tree,
 (Make fingers creep up opposite arm)
And they were as quiet as quiet could be.
 (Whisper)
Said the wise old owl, "To-whooooo, to-whooooo."
Up jumped the brownies and away they flew.
 (Hands move behind back)
The owl sat alone on the branch of a tree.
 (Fold hands)
And he was as quiet as quiet could be.
 (Whisper)

Eency Weency Spider

The eency weency spider climbed up the waterspout.
 (Touch index finger of right hand to thumb of
 left hand and vice versa; make climbing motion,
 alternating fingers)
Down came the rain and washed the spider out.
 (Wiggle fingers in downward motion)
Out came the sun and dried up all the rain.
 (Arms in circle over head)
And the eency weency spider climbed up the spout
 again.
 (Fingers repeat climbing motion)

Things That Go, Things That Grow

Choo-Choo Train

This is a choo-choo train
 (Bend arms at elbows)
Puffing down the track.
 (Rotate forearms in rhythm)
Now it's going forward,
 (Push arms forward; continue rotating motion)
Now it's going back.
 (Pull arms back; continue rotating motion)
Now the bell is ringing,
 (Pull bell cord with closed fist)
Now the whistle blows.
 (Hold fist near mouth and blow)
What a lot of noise it makes
 (Cover ears with hands)
Everywhere it goes.
 (Stretch out arms)

I Dig, Dig, Dig

I dig, dig, dig,
 (Pretend to dig)
And I plant some seeds.
 (Stoop down and plant seeds)
I rake, rake, rake,
 (Pretend to rake)
And I pull some weeds.
 (Pull up weeds)
I wait and watch
 (Stoop down and watch ground intently)
And soon I know
 (Nod head)
My garden sprouts
 (Raise hands from ground as if sprouting)
And starts to grow.

Oak Tree

Here is an oak tree, straight and tall
 (Stand up straight)
And here are its branches wide,
 (Put arms up into air, fingers outstretched)
Here is a nest of twigs and moss,
 (Cup hands together)
With three little birds inside.
 (Hold up three fingers)
The breezes blow, and the little leaves play.
 (Move arms gently to and fro)
But the branches keep the little nest safe

As they sway and sway
And rock the little birds to sleep.
 (Make sleeping motion)

Picking Apples

Here's a little apple tree.
 (Left arm up, fingers spread)
I look up and I can see
 (Look at fingers)
Big red apples, ripe and sweet,
 (Cup hands to hold apple)
Big red apples, good to eat!
 (Raise hands to mouth)
Shake the little apple tree.
 (Shake the tree with right hand)
See the apples fall on me.
 (Raise cupped hands and let fall gently on head several times)
Here's a basket, big and round,
 (Make a circle with arms)
Pick the apples from the ground.
 (Pick and put in basket)
Here's an apple I can see,
 (Look up to the tree)
I'll reach up. It's ripe and sweet.
 (Reach up to left thumb with right hand)
That's the apple I will eat!
 (Hands to mouth)

The Bus Ride

The wheels on the bus go round and round
 (Use arms to make circle motion)
Round and round, round and round.
The wheels on the bus go round and round,
All through the town.
The doors on the bus go open and close
 (Bend and unbend arms at elbow)
Open and close, open and close.
The doors on the bus go open and close,
All through the town.
The wipers on the bus go swish, swish, swish,
 (Make swishing sound while waving arms)
 (repeat as full verse)
The driver on the bus says, "Move on back,"
 (Motion backward with arms)
 (repeat)
The people on the bus go up and down,
 (Stand up and sit down)
 (repeat)

The horn on the bus goes honk, honk, honk,
 (Pushing motions with hand and arm)
 (repeat)
The wheels on the bus go round and round,
 (Repeat circle)
Round and round, round and round.
The wheels on the bus go round and round,
All through the town.

Toyland

I'm a Little Puppet Clown

I'm a funny little puppet clown
When my strings move up and down.
 (Bend at knees and go up and down)
First, I'll stand up,
Then I'll fall down.
 (Fall to floor)
I'm a funny little puppet clown.
I'm a funny little puppet gay.
Move my strings and watch me play.
 (Repeat above action)
Now I'm stiff,
 (Stand tall, arms at sides)
Now I'm tall.
 (Stretch on tiptoes)
Let my strings go,
And I will fall.
 (Fall to floor)

Teddy Bear

Teddy bear, teddy bear, turn around;
 (Repeat actions as suggested in rhyme)
Teddy bear, teddy bear, touch the ground.
Teddy bear, teddy bear, shine your shoe;
Teddy bear, teddy bear, that will do.
Teddy bear, teddy bear, go upstairs;
Teddy bear, teddy bear, say your prayers.
Teddy bear, teddy bear, turn out the light;
Teddy bear, teddy bear, say "Goodnight!"
 (To extend this fingerplay, the teacher can make
 a hand-cranking motion while humming the
 melody to "Pop Goes the Weasel." At the end of
 the melody, the leader says, "Wake up," and
 children pop up!)

Seasons

Clouds

What's fluffy-white
 (Look toward sky and point finger)
And floats up high
Like piles of ice cream
In the sky?
And when the wind
 (Sway arms back and forth)
Blows hard and strong,
What very gently floats along?
What brings the rain?
 (Raise arms high, flutter fingers to the ground)
What brings the snow
That showers down on us below?
What seems to have just lots of fun
Peek-a-booing with the sun?
 (Place hand over eyes with fingers spread
 apart—peek through)
When you look in the high, blue sky,
What are these things you see float by?
 (Point toward sky)

Falling Raindrops

Raindrops, raindrops!
 (Move fingers to imitate falling rain)
Falling all around.
Pitter-patter on the rooftops,
 (Tap softly on floor)
Pitter-patter on the ground.
 (Repeat)
Here is my umbrella.
 (Pretend to open umbrella)
It will keep me dry.
 (Place over head)
When I go walking in the rain.
I hold it up so high.
 (Hold high in air)

Jack Frost

Who comes creeping in the night
 (Two right fingers creep along left arm)
When the moon is clear and bright?
Who paints tree leaves red and gold
 (Brushing motion with right hand)
When the autumn days turn cold?

Up the hill and down he goes
 (Motion of going up hill and down)
In and out the brown corn rows,
 (Hand in "in and out" motion)
Making music crackling sweet,
With his little frosty feet.
Jack Frost!

Wind Tricks

The wind is full of tricks today,
 (Make sweeping motion with one hand for wind)
He blew my friend's hat away.
 (Pretend to sweep hat off head)
He chased our paper down the street.
 (One hand chases other around)
He almost blew us off our feet.
 (Almost fall)
He makes the trees and bushes dance.
 (With raised arms, make dancing motions)
Just listen to him howl and prance.
 (Cup hand to ear)

Winter Weather

Let's put on our mittens
 (Put on mittens)
And button up our coat.
 (Button coat)
Wrap a scarf snugly
 (Throw scarf around neck with right hand and
 pull down other end with left)
Around our throat,
Pull on our boots,
 (Pull on boots with both hands)
Fasten the straps,
 (Fasten straps with fingers)
And tie on tightly
 (Pull on cap with both hands and tie)
Our warm winter caps.
Then open the door . . .
 (Turn imaginary doorknob with right hand pull
 open the door—step through)
. . . And out we go
Into the soft and feathery snow.
 (Hold out both hands to catch snow and look up)

Additional Guided Imagery Scripts and Extension Activities

The following guided imagery scripts are appropriate for young children and adults. "Walking in the Snow" and "A Rainy Day" are excellent introductory scripts for children. Some children are familiar with walking in the snow, while others have experienced a rainy day. Use these scripts as they are appropriate for *your* children's personal experiences.

"Mirror Dance" is appropriate for adults. This activity involves guided imagery, movement, and cooperation with a partner. Also included are suggestions for music. The drawing dialog enables adults to check perceptions in order to discern the accuracy or inaccuracy of nonverbal behavior.

"The Trust Circle," also appropriate for adults, encourages participants to feel relaxed and comfortable about trusting the others in their group. The last guided imagery script, "You Are Creative," provides participants with a structure for discovering their own creativity by imagining that they are growing from a tiny seed into the plant within you.

Walking in the Snow

Find a place in the room where you can stretch out or sit very still. Take two or three slow, deep breaths, and see if you can be very, very still. Listen to your breathing and see if you can breathe so quietly that no one can hear you. Try to relax, but be sure to keep your back straight so that you can breathe better.

Close your eyes and let your imagination make a picture of a beautiful snowy day. Use your imagination to put on your snowsuit or snow clothes and walk outside into the fluffy white snow. Have you ever walked in the snow before? Feel the snow as it falls gently on your hands and face. Let your imagination hold out your hands until they are full of snow.

Look at the snow you are holding in your hands, and open your fingers and let the snow fall back to the ground. Listen and see if you can hear the sound of falling snow. A gentle breeze blows the snow all around you, feeling fresh and cool and good. Imagine that you are walking in the snow. It feels crunchy and your boots make little sounds as you walk around. You find a nice place where the snow is very fluffy. Lie down and use your arms and legs to make a snow angel. You can make two or three snow angels if you wish. Look at your snow angel. You feel very good playing in the snow and making angels.

You are beginning to feel just a little chilly, so it is time to come inside where it is nice and warm. You are thinking about something warm to drink. Imagine what you would like to have to drink when you get inside. Think about our room and see if you can make a picture of it in your mind.

When you are ready to stop playing in the snow, listen to the sounds you hear in our room. Wiggle your fingers and give your body a nice long stretch. Open your eyes and look around until you see me.

A Rainy Day

Find a place in the room where you can stretch out or sit very still. Listen to your breathing and see if you can feel the air going in and out of your body. Close your eyes and let your imagination make a picture of nice, gentle rain falling down.

Listen to the sounds the rain makes. . . . Can you hear it? Let your imagination put out your hands and feel the rain. How does it feel? Is it cold? . . . warm? . . . wet? Look around to see if you can see any puddles, and watch the rain as it splashes and makes the puddles larger. Imagine that you are going for a walk in the rain. . . . What do you see? Do you see our school? Are there any trees or flowers? What happens to the trees and flowers when they feel the rain? Do you see anyone else walking in the rain? Listen and see if you can hear any rain music. Is there anything that you would like to do while you are walking in the rain? (Pause longer here.)

It is time to come in from your walk in the rain. Think about our room and see if you can make a picture of it in your mind. When you are ready, wiggle your fingers and give your body a gentle stretch. Open your eyes and look around until you see me.

The Mirror Dance Activity

This section presents you with a movement activity that combines guided imagery with creative dance. Titled the Mirror Dance, it provides the security of working in a large group and with a partner. The group and partners serve as support and reinforcement for each other. Individual work can often bring out all those old fears about performance and talent. For this reason, mirror dance utilizes the safety of numbers.

As you participate in the dance, you will explore both nonlocomotor and locomotor actions. You can stretch, bend, twist, curl, leap, spin, spi-ral, advance, retreat, or move your body in many other ways. Simple movements such as extending a finger, lifting an arm, or rolling your head from shoulder to shoulder can be used to move to rhythms and explore changes in tempo or force. As you participate in and try out these movement activities, give some attention to where your body moves, how one body part moves in relationship to another, and how you move in relationship to another person. Open yourself to all these expressive modes and allow them to come together in combinations that are flexible and natural for you. There are no correct or incorrect responses to this exploration except those that your body expresses. You are free to let go, to move, act, lead, or follow. Remember that the process is more important than the product, and in this case the process is left up to you.

Preparing for Mirror Dance

This is a large-group activity in which you will be working with a partner. If it is possible, try to pair up with someone who is about your same height, preferably someone whom you have talked to during this class or someone with whom you are familiar. You will need some instrumental music that has a steady, slow rhythm. Select something from the classics such as the Pachelbel *Canon in D,* the Strauss *Waltzes,* or a contemporary jazz recording by George Shearing, Stephane Grappelli, or Branford Marsalis. The only true requirement is that the music invites you to move!

You are probably familiar with the technique of mirroring. While seated or standing, you simply mimic the motions of a partner. If your partner bends very slowly to the right, you mimic the action. When your partner stretches an arm into space while twisting both hands in a climbing fashion, you do the same. If your partner leaps across the space of the room, you follow as closely and as timely as possible.

Mirror Dance starts with you and a partner sitting on the floor, facing each other. A designated reader begins to read the guided imagery journey, which sets the stage for the actual dance.

With that said, I invite you to find a partner and to locate a space in the room where you can sit facing each other; then give yourself permission to enter the world of expressive dance.

Mirror Dance

Find a comfortable place to sit, and then settle yourself on the floor facing your partner. Take a few minutes to find a position that is really comfortable. . . . Notice the thoughts and images that pass by your mind's eye and prepare to let them go for just a few minutes. . . . Close your eyes and imagine yourself at the edge of a large, sunny, grassy meadow with lots of spring flowers and blue-eyed grass swaying in a sweet summer breeze. Look around this place and be aware of the vastness of space and how you feel here.

Look across the meadow and you will see someone else. . . . You notice this person moving in a dance that is as fluid as the breeze. . . . This person is a dancer and will come into this meadow without even noticing you and will begin dancing freely. As the dancer moves deeper into the meadow and closer to you, watch the grace and beauty of the movements and dancing for a while. . . . Soon this dancer will notice you and will come over to see you. . . . Then the dancer will begin to move, and your body magically responds with grace and ease. You experience an effortless ability to respond in a mirrorlike manner. You and the dancer leap and spin. . . . You turn and spiral. . . . You and the dancer are free from space and time and form and practice.

Mirror the movements of the dancer as you discover pathways . . . and airways . . . levels . . . and space . . . direction and weightlessness. . . . Use your mind's eye to notice when you are following the dancer or when the dancer is following you. Notice your relationship with the dancer. Are you near or apart . . . meeting or parting . . . beside or behind . . . leading or following?

(Note to reader: Pause here for a least one full minute. You might experience your own imaginary dancing or simply count to 60 very slowly to allow time for participants to complete their imagery dance.)

In just a moment, you will hear music for mirror dancing in an imaginary meadow. . . . When you hear the music, open your eyes and begin moving . . . very slowly at first and with a different dancer . . . a real dancer . . . your partner. . . . One of you will be the mirror and one of you will be the dancer. . . . You can change roles when it feels comfortable, but remember to do this nonverbally.

(Note to reader: Begin music here.)

Let movement enter your body as you listen to the music. . . . Stand up and move around the room with your partner . . . as you create a mirror dance. . . . Follow the rhythm of the music. . . . Explore different ways of moving. . . . Dance until you grow tired or until the music has ended.

Processing the Activity

At the end of the Mirror Dance, give yourself and your partner some time to talk about the experience. You might describe what you liked or did not like about dancing in front of other people. Talk about your own level of comfort and willingness to try a new way of expressing an imaginary dance in a real setting with an actual partner. Was the music suitable for your mood? Did you have enough room to move? How much of the space in the classroom did you explore? How could you revise this dance activity so that it might be appropriate for children? These are questions you and your partner can discuss as you begin to process the whole experience.

Drawing Dialogue

You will need a large piece of drawing paper for each person; boxes of crayons, chalk, or markers to share among yourselves; and newsprint for making charts.

Procedure

1. Look at all the colors you have available to make marks on paper, and quietly choose a favorite color, a color you would like to experiment with, or a color that expresses some important aspect of yourself.

2. Next, pair up with someone who has a different color than you do. Take one of the large

pieces of paper and find a place on the floor to work. Place the paper between you and your partner and sit at opposite sides of the paper.

3. Hold your color in the hand that you do not use to write. When you feel ready, begin to draw silently together on your paper. Do not divide the paper and make separate drawings, and do not plan, discuss, or decide what you will draw together. Just begin to draw slowly, and focus your awareness on the process of drawing and how you feel as you interact with your partner. Let your awareness and your thoughts and feelings flow into the process of drawing. You might alternate drawing, or draw at the same time, or you might even gently move your partner's hand for a short time and draw with your partner's color if your partner is agreeable to this. Begin to do this now, and take about 10 minutes to interact with your partner as your drawing develops between you.

4. Allow 5 to 10 minutes for drawing.

5. When both partners have completed their parts of the drawing, take turns telling each other what you experienced as you were working on the drawing together. Express what you were aware of as you interacted and how you felt during the silent dialogue.

6. When everyone has had time to talk for a few minutes, begin the next activity, Perception Checking.

Perception Checking

We can check the accuracy of our perceptions by (1) paying attention to observable behavior, (2) being aware of inferences we make about different behaviors, and (3) asking others if our perceptions are correct or incorrect. The following behaviors and inferences are examples of nonverbal communication and common interpretations.

Behavior (Observable data)	Inference (Interpretations)
frown	angry, upset
sudden movement	scared, surprised
laughter, giggles	happy, comfortable

When we are communicating with someone else, verbally or nonverbally, we tend to look beyond what is directly observable and make our own interpretations of what the other person is saying. We also experience affective states as we develop an emotional awareness of what we are feeling throughout the interaction. We can explore this process further through a systematic approach to checking our own perceptions. The following examples outline this process.

I See (observable data)
Example: "I see you looking at my drawing."
I Imagine (interpretations)
Example: "I see you looking at my drawing and I imagine you are criticizing it."
I Feel (emotional awareness)
Example: "I see you looking at my drawing, I imagine you are criticizing it, and I feel anxious."
I Want (request for change)

Example: "I see you looking at my drawing, I imagine you are criticizing it, I feel anxious, and I want you to tell me what you are really thinking."

Other Examples
"I see you look at me when I talk, I imagine you are interested in what I am saying, I feel happy, and I want you to express your opinion."
"I see you crying, I imagine you are sad, I feel compassion, and I want to know how I can help you."
"I see you smiling as you draw, I imagine you are enjoying yourself, I feel good that we are working together, and I want to stop now."

Procedure

1. Remain with the same partner you had for the Drawing Dialogue activity. You may begin the Perception Checking activity by using the language and words in the examples provided. You might decide to respond to nonverbal communication that occurred during the Drawing Dialogue, or you can practice checking your perceptions in the here-and-now moment. Try to go through the process for at

least five minutes before clarifying, validating, or discounting each other's perceptions. Be sure to use *I* statements.

2. Allow yourself some process time to talk about your drawings and other learning that occurred during both activities. The following statements should help you process the encounter:

- The things I enjoyed about the drawing dialogue were . . .
- Some of the thoughts and feelings I was having during the drawing activity were . . .
- If I were to do the activity again, I might try . . .
- Some new thoughts I have on nonverbal communication are . . .
- Some of the frustrations I felt during the activity were . . .
- My perception of the overall atmosphere during both activities was . . . (pleasant, bored, interesting . . .)

This can be a poignant and yet revealing activity. The insight that often comes at the end of the exercise sometimes tempts my own students to take it "home" to try out on friends, roommates, girlfriends, and even husbands. Before you decide to subject your innocent friends and colleagues to this process, remember that they have not been in class with you. No matter how much you would like to involve them in the process of perception checking, keep in mind that you are becoming very knowledgeable about the affective domain, and the people in your life who are unrelated to our teaching profession may not be so well informed about this area of human growth and development. Use this experience as an opportunity to expand your professional support system, and be gentle with those people who have no idea what you are talking about!

The Trust Circle

I encourage you to participate in an experience to help you feel relaxed and comfortable about trusting the people in your group. Form groups of seven or eight people. Each group should form a circle (with the smaller, shorter, lighter participants evenly spaced around it). A volunteer or the leader moves to the center of one of the circles for a demonstration. This person crosses both arms in front of his or her chest. The participants forming the circle move up to the center person and place their hands lightly on the person's body. The person in the center closes his or her eyes and, while keeping the body straight, relaxes the body and leans toward the members of the circle. The participants forming the circle use their hands and arms to hold the center person up. As the person in the center begins to relax more, the participants forming the circle begin to pass the center person around the circle or across the circle. This "passing around" is done slowly, smoothly, and with great gentleness. When a few minutes have passed, the circle members slowly return the center person to an upright position in the middle of the circle.

The idea of the trust circle is to give the person in the center an experience of trust. That person must trust the rest of the group not to drop him or her, and the group must be trustworthy enough to provide the center person with a comfortable situation. It is often helpful to do the whole exercise in complete silence, so the center person will not be distracted.

Before implementing the trust circle, read and follow the following guidelines:

1. Everyone in the circle group should place one foot forward and one foot well behind the other. You can then hold up quite a lot of weight, even if you are not strong. If you stand close to the center person, you will have less weight to hold up, so if you are small or if the center person is larger then you, stand closer and keep the circle smaller.

2. If you are the center person, relax as much as possible while keeping your body straight. Do not bend the knees or hips. Leave both feet flat on the floor and fully centered in body alignment. If you seem quite tense, the circle should take it slow and easy, so as to encourage your trust.

3. Be the first to volunteer! The exercise should be repeated until everyone who wants to experience the trust circle has done so. This is an excellent activity to discuss, and after everyone has had a chance to participate as either the center person or a member of the circle, a leader should ask the following questions:

- ◆ What was your experience like when you were the center person?
- ◆ What are some of the things you experienced as a member of the circle group?
- ◆ Could you relax in the center?
- ◆ Did you trust the group?
- ◆ When you were a member of the circle group, did you feel trustworthy?
- ◆ How did the others pass people around—with gentle caring or as if they were loading wood on a truck?

You Are Creative

Find a good spot in the room where you can lie down or sit comfortably without touching anyone else. If you are lying on your back, be sure you are lying straight—legs relaxed, uncrossed and loose, back and head in straight alignment. If you are sitting, sit squarely on your sitting bones, with your spine straight and your hands relaxed in your lap.

Now close your eyes and let your body feel peaceful and quiet. Take a few deep breaths, and allow all of the tension to drain out of your body. Let yourself go completely; feel the soothing sense of relaxation fill your whole being. Use your mind's eye to notice the thoughts that are running through your head right now. . . . Acknowledge these thoughts as they drift in front of your closed eyes. Use your breath to support these thoughts as you breathe in, and then let them go into the space in this room as you breathe out.

Breathe in slowly and smoothly through your nose. Let your stomach fill up with breath; then fill your lungs. Breathe out smoothly and give a little puff to make sure all the air is gone. Feel yourself breathing deeply and smoothly. Listen to your breath flowing in and out of you in a smooth, relaxed rhythm.

Think of warmth. . . . Imagine a warm, yellow sun, sending golden rays of light through a dark universe . . . imagine a thread, a shimmering, golden thread of warmth drifting aimlessly in space. Breathe in and absorb that golden thread with all its warmth. Breathe out and send it traveling back into space; breathe in and send your warm, golden thread to your face and neck filling your head with pure, clean energy. Breathe out and let the golden thread carry away any tension you feel. . . . Use your mind's eye to send your golden thread speeding back to the sun, gathering more warmth. Breathe in and take the energy and warmth of the golden thread to your shoulders. Feel the glow in your shoulders as they let go of tension and relax. Relax your arms and hands. . . . Let them rest comfortably.

The center of your body is where you feel balanced. . . . Allow your awareness to find your own balance point. Watch the golden thread of light and energy and breathe it in and send it straight to the center of your body. Feel the energy flow into your center and hold it there for just a moment. Breathe out and send your golden thread soaring through the sky as it travels toward the sun. . . . Watch your thread gliding through the universe, beyond the starry host of the galaxy. Watch your radiant thread reflect the sunbeams as it absorbs the energy of the distant sun. . . . Follow your thread as it streaks toward the Milky Way. Watch it as it settles beyond the constellations and shines its ever-warming beam through the darkness . . . radiating and warming you as you rest in its light. You are calm and peaceful . . . you are alert and aware . . . you are warm . . . you feel safe.

You are centered . . . you are relaxed . . . you are aware and alert . . . you are imagining.

Imagine that you are a tiny seed. You are safely nestled deep within the earth. . . . Your seed may be a beautiful flower, or a strong tree, or a tall, lush plant in a tropical rain forest. Your seed is ready to grow. . . . Its petals are tightly closed. . . . It waits to unfold. Reach down through the center of your being and feel the ground. . . . Connect yourself solidly with the earth. Imagine that you are part of the earth . . . cool . . . dark . . . moist . . . and mysterious. Your thread of golden light shines on the earth above you. The stream of light warms you. . . . It moves through the sands of the earth and you feel its warmth.

Your legs become roots . . . roots that stir deep within the darkness. Your roots begin to move . . . slowly stretching outward . . . deep within the warm, moist earth. Your golden thread whispers a message that only you can hear. . . . It whispers the word *grow.*

Feel yourself beginning to grow . . . already touched by the warmth of the sun from above. Your arms are seedlings that stretch up toward the light . . . mysteriously finding their way through the dark earth. . . . They are tiny green seedlings. Out toward the sun your tiny buds come . . . reaching upward. Feel your seedlings as they push up through the ground . . . lovely . . . fragile . . . slender blades of green reaching for the light.

Your leaves and petals begin to spread and separate as the flower or tree or plant within you unfolds. . . . You are filled with beauty. . . . You are stately and majestic. . . . You are strong and grounded. Your roots reach down through your center and you are solidly connected with the earth.

And now let yourself come to rest . . . completely still, peaceful . . . alive . . . fulfilled . . . and centered.

When you are ready, slowly begin to return to the here and now of this room. Move your fingers and toes . . . listen to the sounds you hear around you . . . and in your own time, return to the here and now of this place.

At the end of this guided imagery exercise, there should be some time to talk about the images and sensations you have experienced. Some of you might enjoy capturing some of your images with a paint-filled brush or form them from a lump of clay. Others will look to a more solitary medium, such as writing in a journal or talking quietly with a friend. For those of you who prefer total privacy, you may be more comfortable keeping your images to yourself for personal moments of reflection. Whatever ways of processing you choose, remember that judgment by others is not permitted, and we are all free to express, or not express, our images in ways that are meaningful and right for us. You may change this guided imagery and offer the experience to children. All you need to do is shorten the narrative and narrow, or expand, the vocabulary and content so that they are appropriate for the age of your children. You will need to add the safety phrase, "Look around until you see me."

References

Achterberg, J. (1985). *Imagery in healing: Shamanism and modern medicine*. Boston: Shambhala.

Alexander, R. (1985, March). What are children doing when they create? *PTA Today,* 478–479.

American Alliance for Health and Physical Education, Recreation and Dance (2004). Retrieved October 21, 2004, from www.aahperd.org/nda/template

Aronoff, F. W. (1969). *Music and young children*. New York: Holt, Rinehart and Winston.

Arts Education Partnership (1998). Retrieved June 14, 2004, from http://aep-arts.org

Atwood, A. (1971). *Haiku: The mood of the Earth*. New York: Scribner's.

Balke, E. (1997). Play and the arts: The importance of the unimportant. *Childhood Education, 73*(6), 355–360.

Balkin, A. (1990, May). What is creativity and what is it not? *Music Educators Journal,* 30–31.

Barber, B.(1996). *Serving democracy by serving the arts*. Paper commissioned by the President's Committee on the Arts and the Humanities, Washington, DC.

Barell, J. (1995). *Teaching for thoughtfulness: Classroom strategies to enhance intellectual development* (2nd ed.). White Plains, NY: Longman.

Barnett, R. R. (1998). Children's creativity: Adult's communication. *Montessori Life, 10*(1), 39–41.

Barron, F. (1969). *Creative person and creative process*. New York: Holt, Rinehart and Winston.

Barron, F. (1978). An eye more fantastical. In G. A. Davis & J. A. Scott (Eds.), *Training creative thinking* (pp. 210–241). Melbourne, FL: Krieger.

Beeler, K. (1976). My most unforgettable teacher: Identifying effective traits. In L. Thayer (Ed.), *Affective education: 50 strategies for experiential learning*. Saline, MI: L. T. Resources.

Bennett, W. J. (1987). *Keynote address*. Presented at the National Invitational Conference, sponsored by the Getty Center for Education in the Arts, Los Angeles, CA.

Bishop, R. (1997). Selecting literature for a multicultural curriculum. In V. J. Harris (Ed.), *Using multiethnic literature in the K–8 classroom*. Norwood, MA: Christopher-Gordon.

Bleiker, C. A. (1999). The development of self through art: A case study for early art education. *Art Education, 52*(3), 48–52.

Block, C. (1993). *Teaching the language arts: Expanding thinking through student-centered instruction*. Boston: Allyn & Bacon.

Boles, S. (1990). A model of routine and creative problem-solving. *Journal of Creative Behavior, 24*(3), 171–189.

Boutte, G. (2000). Multiculturalism: Moral and educational implications. *Dimensions of Early Childhood, 28*(3), 9–16.

Boyer, E. (1987, January). *Keynote address*. Presented at the National Invitational Conference, sponsored by the Getty Center for Education in the Arts, Los Angeles, CA.

Boyer, E. (1988). It's not either/or, it's both. *Educational Leadership, 45*(4), 3.

Brademas, J. (1997). In President's Committee on the Arts and the Humanities, *Creative America: A Report to the President*. Washington, DC. www.pcah/gov/CRLetter.pdf

Brandt, R. (1987). On assessment in the arts: A conversation with Howard Gardner. *Educational Leadership, 45*(4), 30–34.

Bredekamp, S. (Ed.). (1987). *Developmentally appropriate practice in early childhood programs serving children from birth through age eight*. Washington, DC: National Association for the Education of Young Children.

Bredekamp, S. (Ed.). (1988). The National Association for the Education of Young Children position statement on developmentally appropriate practice in the primary grades, serving 5- through 8-year-olds. *Young Children, 43,* 64–84.

Bredekamp, S., & Copple, C. (Eds.). (1997). *Developmentally appropriate practice in early childhood programs* (Rev. ed.). Washington, DC: National Association for the Education of Young Children.

Brewer, J. (2003). *Introduction to early childhood education: Preschool through primary grades* (5th ed.). Boston: Allyn & Bacon.

Broughton, B. (1986). *An arts curriculum for young children—including those with special needs: Creative experiences.* Chapel Hill, NC: Chapel Hill Training-Outreach Project.

Bruner, J. (1966). *Studies in cognitive growth.* New York: John Wiley and Sons.

Bruner, J. (1986). *Actual minds, possible worlds.* Cambridge, MA: Harvard University Press.

Caplan, F., & Caplan, T. (1973). *The power of play.* Garden City, NJ: Anchor Press.

Cecil, N., & Lauritzen, P. (1994). *Literacy and the arts for the integrated classroom: Alternative ways of knowing.* New York: Longman.

Chaille, C., & Silvern, S. (1996). Understanding through play. *Childhood Education, 72*(5), 274–278.

Checkley, K. (1997). The first seven . . . and the eighth intelligence: A conversation with Howard Gardner. *Educational Leadership: Teaching for Multiple Intelligence. ASCD, 55*(1), 8–13.

Chenfeld, M. (1978). *Teaching language arts creatively.* New York: Harcourt Brace Jovanovich.

Christie, J., & Wardle, F. (1992). How much time is needed for play? *Young Children, 47,* 27–33.

Clarke, J. (1994–1995, winter). *Getty Center for Education in the Arts Newsletter,* 9–7.

Collom, J., & Noethe, S. (1994). Tips on leading poetry sessions. *Teachers and Writers, 25*(3), 2–4.

Consortium of National Arts Education Associations (1994). *National standards for arts education: What every young American should know and be able to do in the arts.* Reston, VA: National Committee for Standards in the Arts.

Cooke, A. L., Brazzel, M., Craig, A. S., & Greig, B. (1999). *Reading book for human relations training* (8th ed.). Bethel, ME: NTL Institute.

Cortines, R. C. (1997). Making the case for district-wide arts education. *Gaining the Arts Advantage: Lessons from School Districts that Value Arts Education,* p. 5.

Cowart, J., & Hamilton, J. (1987). *Georgia O'Keeffe: Art and letters.* Washington, DC: National Gallery of Art.

Csikszentmihalyi, M. (1997). *Creativity: Flow and the psychology of discovery and invention.* New York: HarperCollins.

Daniels, S. (1995). *Images of creativity: The relationship of imagery, everyday cognition, and the creative potential of high school students with exceptional abilities in the arts and sciences.* Unpublished PhD thesis, University of Wisconsin, Madison.

Daniels, S. (1997). Creativity in the classroom: Characteristics, climate and curriculum. In N. Colangelo & G. Davis (Eds.), *Handbook of gifted education.* Boston: Allyn & Bacon.

Davis, G. (2000). *Creativity is forever* (4th ed.). Dubuque, IA: Kendall/Hunt.

Demi (1980). *Liang and the magic paintbrush.* New York: Henry Holt.

dePaola, T. (1988). *The legend of the Indian paintbrush.* New York: Putnam's.

Dewey, J. (1934). *Art as experience.* New York: Capricorn Books.

Dewey, J. (1950). *Experience and education.* New York: Macmillan.

Dick-Read, G. (1972). *Childbirth without fear: The original approach to natural childbirth* (Rev. ed.) H. Wessel & H. F. Ellis, (Eds.). New York: Harper & Row.

Dimondstein, G. (1971). *Children dance in the classroom.* New York: Macmillan.

Dimondstein, G. (1974). *Exploring the arts with children.* New York: Macmillan.

Dixon, G. T., & Chalmers, F. G. (1990). The expressive arts in education. *Childhood Education, 67*(1), 12–17.

Doctoroff, S. (1996). Supporting social pretend play in young children with disabilities. *Early Child Development and Care, 119,* 27–38.

Dudek, S., & Verreault, R. (1989). The creative thinking and ego functioning of children. *Creativity Research Journal, 2,* 64–86.

Edward, C. P., & Springate, K. W. (1995). The lion comes out of the stone: Helping young children

achieve their creative potential. *Dimensions of Early Childhood, 23*(4), 24–29.

Edwards, L. (2002). *Affective development and the creative arts: A process approach to early childhood education* (3rd ed.). Upper Saddle River, NJ: Merrill/Prentice Hall.

Edwards, L., & Nabors, M. (1993). The creative arts process: What it is and what it is not. *Young Children, 48*(3), 77–81.

Edwards, L., & Nabors, M. (1994). Creativity and the child's social development. *Dimensions of Early Childhood, 23*(1), 14–16.

Edwards, S. C. (1993). Unpublished poems. Aberdeen, NC.

Einstein, A. (1934). On scientific truth. In A. Einstein (Ed.), *World as I see it* (p. 290). New York: Ginn.

Eisner, E. (1987). *Keynote address.* Presented at the National Invitational Conference, sponsored by the Getty Center for Education in the Arts, Los Angeles, CA.

Ellermeyer, D. (1993). Enhancing creativity through play: A discussion of parental and environmental factors. *Early Child Development and Care, 93,* 57–63.

Engel, D. (1989). *The little lump of clay.* New York: Morrow Junior Books.

Erikson, E. (1963). *Childhood and society* (2nd ed.). New York: W. W. Norton.

The Essential Rumi. (1995). (C. Barks, with J. Moyne, A. J. Arberry, & R. Nicholson, Trans.). San Francisco: HarperCollins.

Farjeon, E. (1956). *The little bookroom* (E. Ardizzone, (Illus.). New York: Oxford University Press.

Fayden, T. (1997). Children's choices: Planting the seeds for creating a thematic sociodramatic center. *Young Children, 52*(3), 15–20.

Feierabend, J. (1990). Music in early childhood education. *Designs for Arts in Education, 91,* 15–20.

Fox, J., & Diffily, D. (2000). Integrating the arts—building young children's knowledge, skills, and confidence. *Dimensions of Early Childhood, 29*(1), 3–10.

Franken, R. E. (1994). *Human motivation* (3rd ed.). Pacific Grove, CA: Brooks/Cole.

Franks, O. (1983). Teaching reading through music: Literacy with a plus. In J. Cohen (Ed.), *Teaching reading through the arts* (pp. 52–54). Newark, DE: International Reading Association.

Freeman, N. K. (1997). Education and peace and caring go hand in hand. *Dimensions of Early Childhood, 25*(4), 3–8.

Frosch-Schroder, J. (1991). A global view: Dance appreciation for the 21st century. *Journal of Physical Education, Recreation and Dance, 62.*

Fry, E. (1982). *David Smith: Painter, sculptor, draftsman.* New York: G. Braziller/Washington, DC: Hirschorn Museum and Sculpture Garden, Smithsonian Institution.

Gabriel, J. (2000). Drama: A rehearsal for life. *Child Care Information Exchange, 135,* 45–60.

Gambrell, L., & Bales, R. (1986). Mental imagery and the comprehension-monitoring performance of fourth- and fifth-grade poor readers. *Reading Research Quarterly, 21,* 454–464.

Gambrell, L., & Koskinen, P. (1982). *Mental imagery and the reading comprehension of below average readers, situational variables and sex differences.* Paper presented at the annual meeting of the American Educational Research Association, New York.

Gardner, H. (1973). *The arts and human development.* New York: John Wiley and Sons.

Gardner, H. (1983). *Frames of mind: The theory of multiple intelligences.* New York: Basic Books.

Gardner, H. (1987a). Developing the spectrum of human intelligences. *Harvard Educational Review, 57,* 187–193.

Gardner, H. (1987b). The Samuel Torry and June Lyday Orton Memorial Lecture. Delivered at the 37th Annual Conference of the Orton Dyslexia Society, Philadelphia, PA. *In Annals of Dyslexia, 37,* 19–35.

Gardner, H. (1991). *The unschooled mind.* New York: Basic Books.

Gardner, H. (2003). *Multiple intelligences after twenty years.* Paper presented at the annual meeting of the American Educational Research Association, Chicago, IL.

Gardner, J. W. (1996). Building community. In President's Committee on the Arts and the Humanities, *Creative America: A report to the President* (p. 2). Washington, DC. www.pcah/gov/CRLetter.pdf.

Gee, S. (1997). Connected by music: Music in special schools. *Times Educational Supplement, 4235,* A34(1).

Gerke, P. (1996). *Multicultural plays for children: Volume I, Grade K–3.* Lyme, NH: Smith and Kraus.

Getty Center for Education in the Arts (1995). Beyond the Three Rs: Transforming Education with the Arts: An Invitational Conference. Washington, DC.

Getty Center for Education in the Arts Newsletter (1994–1995, winter). p. 8.

Gibbons, G. (1987). *The pottery place.* Harcourt Brace Jovanovich.

Gilkerson, L. (1998). Brain care: Supporting healthy emotional development. *ChildCare Information Exchange, 121,* 66–68.

Godfrey, R. (1992). Civilization, education, and the visual arts: A personal manifesto. *Phi Delta Kappan, 73*(8), 596.

Goff, K., & Torrance, E. (1991). Healing qualities of imagery and creativity. *Journal of Creative Behavior, 25*(4), 296–303.

Goldberg, M. (2000). *Arts and learning: An integrated approach to teaching and learning in multicultural and multilingual settings* (2nd ed.). New York: Longman.

Goleman, D. (1995). *Emotional intelligence.* New York: Bantam Books.

Good, T., & Brophy, J. (1987). *Looking in classrooms* (4th ed.). New York: Harper & Row.

Green, C. (2002). Moving to literature. *Texas Child Care, 26*(1), 12–21.

Green, E., & Green, A. (1977). *Beyond biofeedback.* San Francisco: Delacorte Press.

Gursky, D. (1991, November–December). The unschooled mind. *Teacher Magazine,* 38–44.

Haiman, P. (1991). Developing a sense of wonder in young children. *Young Children, 46*(6), 52–53.

Hallworth, G. (Ed.). (1996). *Down by the river: Afro-Caribbean rhymes, games, and songs for children* (C. Binch, Illus.). New York: Scholastic.

Hammer, C., & Dusek, R. V. (1995). Brain difference research and learning styles literature: From equity to discrimination. *Feminist Teacher Editorial Collective, 9*(2), 76–78.

Hanrahan, C., & Salmela, J. H. (1986). Dance images—do they really work or are we just imagining things? *Journal of Physical Education, Recreation, and Dance, 61*(2), 18.

Hardiman, G., & Zernich, T. (1981). *Art activities for children.* Upper Saddle River, NJ: Prentice Hall.

Harp, B. (1988). When the principal asks: "Why are you doing guided imagery during reading time?" *The Reading Teacher, 41,* 588–590.

Harris, L. (1978). Sex differences in spatial ability: Possible environmental, genetic, and neurological factors. In M. Kinsbourne (Ed.), *Asymmetrical functions of the brain* (pp. 279–284). Cambridge, UK: Cambridge University Press.

Hatfield, T. A. (1996). Benefits analysis of adopting the National Standards for Arts Education: A view from the Arts Education Associations. *Arts Education Policy Review, 97*(5), 12–17.

Haugen, K. (2000). Using creative dramatics to include all children. *Childcare Information Exchange, 135,* 56–57.

Hazard, P. (1944). *Books, children, and men.* Boston: The Horn Book.

Herberholz, B., & Hanson, L. (1995). *Early childhood art* (5th ed.). Dubuque, IA: Brown and Benchmark.

Herrman, N. (1991). The creative brain. *Journal of Creative Behavior, 25*(4), 275–295.

Hester, H. (1987). Peer interaction in learning English as a second language. *Theory into Practice, 23,* 208–217.

Heward, W., & Orlansky, M. (1996). *Exceptional children: An introductory survey of special education* (5th ed.). Upper Saddle River, NJ: Merrill/Prentice Hall.

Hymes, J. L. (1981). *Teaching the child under six.* Columbus, OH: Merrill.

Jacobs, J. (1892). *English fairy tales.* New York: Putnam's.

Jaques-Dalcroze, E. (1921). *Rhythm, music, and education.* New York: Putnam's.

Jausovec, N. (1989). Affect in analogical transfer. *Creativity Research Journal, 2,* 255–266.

Jenkins, E. (1989). *Adventures in rhythm; Call and response rhythmic group singing; Counting games and rhythms for the little ones; Early, early childhood songs; You'll sing a song and I'll sing a song* (LPs, cassettes, and songbooks). New York: Folkway Records.

Johnson, E., Sickels, E., & Sayers, F. (1970). *Anthology of children's literature* (4th ed.). New York: Houghton Mifflin.

Jung, C. (1933). On the relation of analytic psychology to poetic art. In A. Rothenberg & C. R. Hausman (Eds.), *The creativity question.* Durham, NC: Duke University Press.

Jung, C. (1954). The development of personality. In *Collected works* (Vol. 17). New York: Pantheon Books.

Kellogg, R., & O'Dell, S. (1967). *Psychology of children's art.* New York: Random House.

Kilmer, A. (1954). The world's great religious poetry. In C. Miles (Ed.), *Poets* (p. 103). New York: Macmillan.

Kimmelman, M. (1999, February 14). Keeping the arts in mind and the mind on the arts. (Interview with psychologist Howard Gardner). *New York Times, 52,* 38 L, col 1.

Korn, E., & Johnson, K. (1983). *Visualization: The uses of imagery in the health professions.* Homewood, IL: Dow Jones-Irwin.

Koster, J. B. (1997). *Growing artists: Teaching art to young children.* Albany, NY: Delmar.

Kupetz, B. (1993). A shared responsibility: Nurturing literacy in the very young. *School Library Journal, 39*(7), 28–31.

Kutiper, K., & Wilson, P. (1993). Updating poetry preferences: A look at the poetry children really like. *The Reading Teacher, 47,* 28–35.

Laban, R. (1948). *Modern educational dance.* London: MacDonald and Evans.

Lansing, K. M. (1981). The effect of drawing on the development of mental representations. *Studies in Art Education, 22*(3), 15–23.

Leithold, N. (2000). Creative dramatics, beginnings workshop. *Child Care Information Exchange, 135,* 45–60.

Levinson, M. H. (1997). Mapping creativity with a capital "C." *ETC: A review of general semantics, 54* (4), 447(7).

Levy, A., Wolfgang, C., & Koorland, M. (1992). Sociodramatic play as a method for enhancing the language performance of kindergarten age students. *Early Childhood Research Quarterly, 7,* 245–262.

Lewis, N. (1991). Introduction. In P. C. Asbjornsen & J. Moe, *East o' the sun and west o' the moon.* Cambridge, MA: Candlewick.

Logan, W. M., & Logan, V. G. (1967). *A dynamic approach to the language arts.* Toronto: McGraw-Hill.

Lowenfeld, V., & Brittain, W. L. (1947). *Creative and mental growth.* New York: Macmillan.

Lowenfeld, V., & Brittain, W. (1970). *Creative and mental growth.* New York: Macmillan.

Lowenfeld, V., & Brittain, W. (1975). *Creative and mental growth* (5th ed.). New York: Macmillan.

Lowenfeld, V., & Brittain, W. (1987). *Creative and mental growth* (8th ed.). New York: Macmillan.

MacKinnon, D. (1976). Architects, personality types, and creativity. In A. Rothenberg & C. R. Hausman (Eds.), *The creativity question.* Durham, NC: Duke University Press.

MacKinnon, D. (1978). Educating for creativity: A modern myth? In G. A. Cavis & J. A. Scott (Eds.), *Training creativity thinking.* Melbourne, FL: Krieger.

Marley-Booker. (1992). *Smilin' island of songs: Reggae and calypso music for children.* Redway, CA: Little People Music.

Maslow, A. (1970). *Motivation and personality* (2nd ed.). New York: Harper & Row.

Maslow, A. (1971). *The farther reaches of human nature.* New York: Viking.

Mazo, J. (1991). Martha remembered. *Dance Magazine, 65*(7), 34.

McCarthy, M. (1996). Dance in the music curriculum. *Music Educators Journal, 82*(6), 17–21.

McCarty, F. H. (1976). Teaching-learning goals: Steps toward achievement. In L. Thayer (Ed.), *Affective education: 50 strategies for experiential learning.* Saline, MI: L. T. Resources.

McCaslin, N. (2000). *Creative drama in the classroom* (7th ed.). New York: Longman.

McGirr, P. I. (1995). Verdi invades the kindergarten. *Childhood Education, 71,* 74–79.

McMahon, R., Saunders, D., & Bardwell, T. (1996–1997). Increasing young children's cultural awareness with American Indian literature. *Childhood Education, 73*(2), 105–108.

McMurrin, S. (1967, January). What tasks for schools? *Saturday Review,* 41–44.

Melville, R. (Ed.). (1970). *Henry Moore: carvings, 1961–1970, bronzes, 1961–1970.* New York: M. Knoedler and Marlborough Gallery.

Metz, E. (1989). Music and movement environments in preschool settings. In B. Andress (Ed.), *Promising practices in prekindergarten music* (pp. 89–96). Reston, VA: Music Educators National Conference.

Moore, H. (1982). *Henry Moore: Carvings, 1961–1970.* New York: The Metropolitan Museum of Art.

Moravcik, E. (2000). Music all the livelong day. *Young Children, 55*(4), 27–29.

Morris, J. (2002). The Imagination Station: A drama education program for preschool teachers. *Youth Theatre Journal, 16,* 38–47.

Murdock, M. (1987). *Spinning inward: Using guided imagery with children for learning, creativity and relaxation.* Boston: Shambhala.

Music Educators National Conference (1994). Retrieved October 21, 2004, from www.menc.org

Myrick, R., & Myrick, L. (1993). Guided imagery: From mystical to practical. *Elementary School Guidance and Counseling, 28,* 62–70.

National Arts Education Association (1992). Goals for schools and interpretation. *Quality Art Education, 1,* 9–12.

National Dance Association (1994). National Standards for Dance Education, www.aahperd.org/nda/template.com

Neelly, L. P. (2001). Developmentally appropriate music practice: Children learn what they live. *Young Children, 56*(3), 32–36.

Norton, D. (2002). *Through the eyes of a child: An introduction to children's literature* (6th ed.). Upper Saddle River, NJ: Merrill/Prentice Hall.

Norton, D. (2005). *Multicultural children's literature: Through the eyes of many children* (2nd ed.). Upper Saddle River, NJ: Merrill/Prentice Hall.

O'Shaughnessy, A. (1881). Ode. In B. E. Stevenson (Ed.), *The home book of verse, American and English.* New York: Henry Holt.

Overby, L. (1988). *Imagery as a teaching tool: A survey of dance teachers.* Paper presented at the annual conference of the American Alliance for Health, Physical Education, Recreation and Dance, Kansas City, MO.

Palmer, H. (1988). *Learning basic skills through music (Volumes 1–5); Getting to know myself; The feel of music.* Freeport, NY: Educational Activities. *Multicultural Education, 5*(1), 34–40.

Parnes, S. J. (1967). *Creative behavior guidebook.* New York: Scribner's.

Parson, M. (1987). *How we understand art: A cognitive development account of aesthetic experience.* Cambridge, MA: Cambridge University Press.

Parten, M. (1932). Social participation among preschool children. *Journal of Abnormal and Social Psychology, 27,* 243–269.

Pearson-Davis, S. (1993). Cultural diversity in children's theatre and creative drama. *Youth Theatre Journal, 7*(4), 16.

Pelletier, K. (1985). *Mind as healer, mind as slayer.* New York: Pergamon Press.

Piaget, J., & Inhelder, B. (1969). *The psychology of the child* (H. Weaver, Trans.). New York: Basic Books.

President's Committee on the Arts and the Humanities and Arts. Education Partnership. (1999). A report to the President's Commission on the Arts and the Humanities. Gaining the arts advantage: Lessons from school districts that value arts education. (L. Longley, Ed.) Washington, DC: www.pcah.gov/CRLetter.pdf

Prince, G. (1982). Synectics. In S. A. Olsen (Ed.), *Group planning and problem solving methods in engineering.* New York: John Wiley and Sons.

Read, H. (1958). *Education through art.* New York: Pantheon Books.

Rhodes, M. (1961). Analysis of creativity. *Phi Delta Kappan, 42,* 305–310.

Riley, R. W. (1998). *Arts education: NAEP 1998 arts assessment report card.* Washington, DC: Office of Educational Research and Improvement, U.S. Department of Education.

Riley, R. W. (1999). Remarks by U.S. Secretary of Education, Richard W. Riley, at the National Assembly of MENC. Retrieved June 10, 2004, from www.childrensmusicworkshop.com/advocacy/riley

Rinker, L. (2000). Active learning through art. *Child Care Information Exchange, 135,* 72–75.

Rogers, C. (1961). *On becoming a person.* Boston: Houghton Mifflin.

Rogers, C. (1983). Toward a theory of creativity. In S. J. Parnes & H. F. Harding (Eds.), *A source book for creative thinking* (pp. 12–22). New York: Scribner's.

Rogers, F., & Sharapan, H. (1993). Play. *Elementary School Guidance and Counseling, 28,* 5–9.

Rousseau, J. (1976). *Emile* (W. Boyd, Trans.). New York: Teachers College Press.

Russ, S. (1988). Primary process thinking on the Rorschach, divergent thinking, and coping in children. *Journal of Personality Assessment, 52,* 539–548.

Russ, S. (1996). Development of creative processes in children. *New Directions for Child Development, 71,* 31–42.

Saint Exupery, A. (1971). *The little prince.* Orlando, FL: Harcourt Brace Jovanovich.

Sapp, D. (1992). The point of creative frustration and the creative process: A new look at an old model. *Journal of Creative Behavior, 26,* 21–28.

Saul J. D., & Saul, B. (2001). Multicultural activities throughout the year. *Multicultural Education, 8*(4), 38–40.

Schirrmacher, R. (1986). Talking with young children about their art. *Young Children, 41,* 3–7.

Schirrmacher, R. (2002). *Art and creative development in young children* (4th ed). Clifton Park, NY: Delmar Learning.

Schlessman, A. (2003). President's message: Creating creativity, steps beyond competence. *Essential Teacher, 1*(1).

Schonberg, H. C. (1981). *The lives of the great composers* (Rev. ed.). New York: W. W. Norton.

Schumaker, J., Deshler, D., Zemitzsch, A., & Warner, M. (1993). *The visual imagery strategy.* Lawrence, KS: University of Kansas.

Seefeldt, C. (2000). *Social studies for the preschool-primary child* (6th ed.). Upper Saddle River, NJ: Merrill/Prentice Hall.

Seeger, P. (1998). *American folk songs for children; Birds, beasts, bugs and little fishes.* Upper Saddle River, NJ: Scholastic.

Silvestri, L., Dantonio, M., & Eason, S. (1996). The effects of a self-development program and relaxation/imagery training on the anxiety levels of at-risk fourth grade students. *Journal of Instructional Psychology, 23,* 167–173.

Simonton, O., & Matthews-Simonton, S. (1984). A psychophysiological model of intervention in the treatment of cancer. In J. Gordon, D. Jaffe, & D. Bresler (Eds.), *Mind, body and health* (pp. 146–163). New York: Human Science Press.

Singer, J. (1975). *The inner world of daydreaming.* New York: Harper & Row.

Smilansky, S. (1971). Can adults facilitate play in children? Theoretical and practical considerations. In G. Engstron (Ed.), *Play: The child strives toward self-realization* (pp. 39–50). Washington, DC: National Association for the Education of Young Children.

Smilansky, S., & Shefatya, L. (1990). *Facilitating play: A medium for promoting cognitive, socio-emotional and academic development in young children.* Gaithersburg, MD: Psychosocial and Educational Publications.

Smith, N. (1980). Classroom practice: Creative meaning in the arts. In J. Hausman (Ed.), *Art and the schools* (p. 111). New York: McGraw-Hill.

Snow, R. (1991). *Cognitive, affect and individuality in educational improvement.* Paper presented at the meeting of the American Psychological Association, San Francisco.

Solomon, R. (1987). Trained dancers: Anatomy as a master image. *Journal of Physical Education, Recreation and Dance, 58,* 51–56.

South Carolina visual and performing arts framework. South Carolina Dept. of Education, (1993). Office of Curriculum and Standards Columbia, SC.

Starko, A. (1995). *Creativity in the classroom: Schools of curious delight.* While Plains, NY: Longman.

Stotter, R. (2000). Starting with a story. *Child Care Information Exchange, 135,* 45–60.

Stout, C. J. (1999). The art of empathy: Teaching students to care. *Art Education, 52* (2), 21–24.

Suinn, R. (1976). Visual motor behavior rehearsal for adaptive behavior. In J. Krumboltz & J. Thorensen (Eds.), *Counselling methods* (pp. 191–197). New York: Henry Holt.

Sylwester, R. (1995). *A celebration of neurons: An educator's guide to the human brain.* Alexendria, VA: Association for Supervision and Curricumlum Development.

Taylor, B. (1995). *A child goes forth: A curriculum guide for preschool children* (5th ed.). Upper Saddle River, NJ: Merrill/Prentice Hall.

Taylor, S. (2000). Multicultural is who we are: Literature as a reflection of ourselves. *Teaching Exceptional Children, 32*(3), 24–29.

Thompson, C. (1990). "I make a mark": The significance of talk in young children's artistic development. *Early Childhood Research Quarterly, 5,* 215–232.

Thompson, C. M. (1995). Transforming curriculum in the visual arts. In S. Bredekamp & T. Rosegrant (Eds.), *Reaching potentials. Transforming early childhood curriculum and assessment* (Vol. II, pp. 81–98). Washington, DC: National Association for the Education of Young Children.

Tolstoy, L. (1963). *Resurrection.* New York: Heritage Press.

Tompkins, G. E., & Hoskisson, K. (2005). *Language arts: Content and teaching strategies* (6th ed.). Upper Saddle River, NJ: Merrill/Prentice Hall.

Torrance, E. (1962). *Guiding creative talent.* Upper Saddle River, NJ: Prentice Hall.

Torrance, E. (1979). *The search for Satori and creativity.* Buffalo, NY: Creative Education Foundation.

Torrance, E. P. (1983). The importance of falling in love with something. *Creative Child and Adult Quarterly, 8* (2), 72–78.

Torrance, E. (1984). Teaching gifted and creative learners. In M. Wittrock (Ed.), *Handbook of research on teaching* (pp. 46–51). Chicago: Rand-McNally.

Torrance, E. (1992). Cited in Hill, R. *Finding creativity for children.* Paper prepared for the Leadership Accessing Symposium, Lafayette, IN. (ERIC Document 348, 169)

Torrance. E. (1995). *Creativity in the classroom.* Washington, DC: National Education Association.

Torrance, E. (2000). *On the edge and keeping on the edge.* Norwood, NJ: Ablex Publishing.

Unsworth, J. (1992). Re-thinking Lowenfeld. *Art Education, 45,* 62–68.

Untermeyer, L. (1964). *The golden book of quotations.* New York: Golden Press.

Valett, R. (1977). *Humanistic education: Developing the total person.* Saint Louis, MO: Mosby.

Van Cliburn Collection. (1992). (Compact Disc Program Notes). New York: RCA Victor.

Van der Linde, C. H. (1999). The relationship between play and music in early childhood: Educational insights. *Genetic, Social, and General Psychology Monographs, 119,* 2–8.

Van Hoorn, J. V., Nourot, P. M., Scales, B., & Alward, K. R. (1999). *Play at the center of the curriculum* (2nd ed.). Upper Saddle River, NJ: Prentice Hall.

Vygotsky, L. (1978). *Mind in society: The development of higher psychological functions.* Cambridge, MA: Harvard University Press.

Vygotsky, L. (1986). *Thought and language.* Cambridge, MA: MIT Press.

Wallas, G. (1926). *The art of thought.* New York: Harcourt, Brace.

Walls, R., Nardi, A., Von Minden, A., & Hoffman, N. (2002). The characteristics of effective and ineffective teachers. *Teacher Education Quarterly, 29*(1), 39–48.

Warner, S. (1964). *Teacher.* New York: Bantam Books.

Webre, E. (1993). *Guidelines for children's appreciation and poetry writing and suggested books and activities.* Paper presented at the annual meeting of the International Reading Association, San Antonio.

Weinstein, G., & Fantini, M. (Eds.). (1970). *Toward humanistic education: A curriculum of affect.* New York: Praeger Publishers.

Wilms, D. (1991, July). Cultural awareness: Books for all children. *Books Links, 1,* 4–8.

Wolfolk, L., Murphy, S., Gottesfeld, D., & Aitken, D. (1985). Effects of mental rehearsal of task motor activity and mental depiction of task outcome on motor skill performance. *Journal of Sport Psychology, 1,* 191–197.

Wolkstein, D. (1992). Twenty-five years of storytelling: The spin of the art. *The Horn Book, 68,* 702–708.

Wood, S. J. (1996). Implementing a successful affective curriculum. *Theory and Practice, 33*(2), 126–128.

Yenawine, P. (2003). Jump starting visual literacy. *Art Education, 56*(1), 6–12.

Zeece, P., & Graul, S. (1990). Learning to play: Playing to learn. *Day Care and Early Education, 18,* 15–19.

Index